WITHDRAWN

Forever Seeing New Beauties

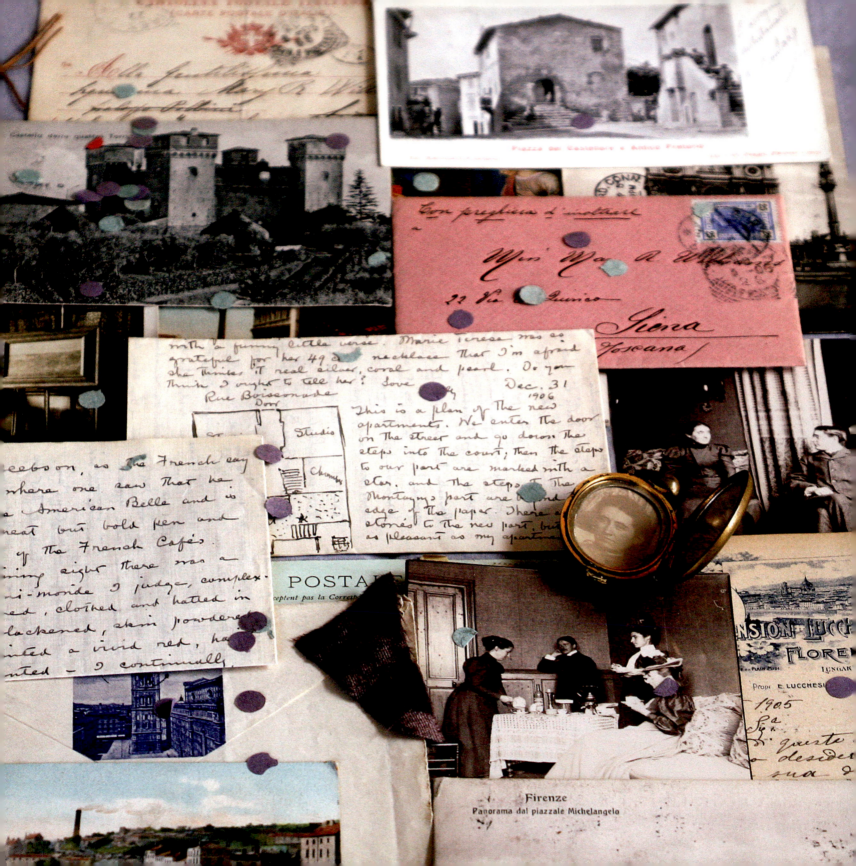

Forever Seeing New Beauties

THE FORGOTTEN IMPRESSIONIST MARY ROGERS WILLIAMS, 1857–1907

Eve M. Kahn

Wesleyan University Press | Middletown, Connecticut

Wesleyan University Press
Middletown, CT 06459
www.wesleyan.edu/wespress

Printed in China
Designed and typeset in Cariola, Mrs. Eaves, and The Sans types
by Chris Crochetière, BW&A Books, Inc.

The Driftless Connecticut Series is funded by the
Beatrice Fox Auerbach Foundation Fund
at the Hartford Foundation for Public Giving.

Library of Congress Cataloging-in-Publication Data available upon request

Hardcover ISBN: 978-0-8195-7874-7
Ebook ISBN: 978-0-8195-7876-1

5 4 3 2 1

Frontispiece caption: Mary's importance is partly due to quantities of surviving correspondence plus ephemera: dried flowers from her travels, scraps of her dresses, confetti from Paris parades. In a family locket, Mary's photo is in the left compartment. PHOTO: © KIMBERLY J. SCHNEIDER.

To Mary, for writing and painting so beautifully;
to the Whites for preserving so much;
and to my family and friends,
for putting up with so much.

Contents

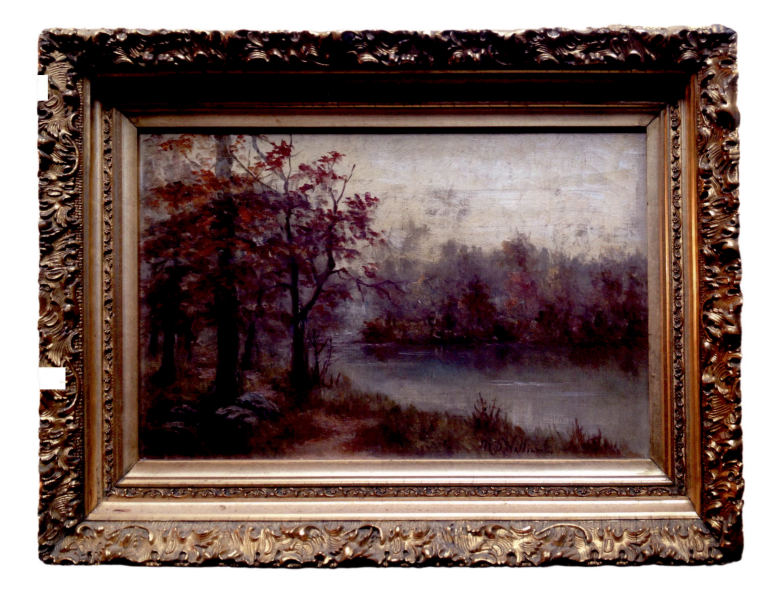

The Funny Way I Stumbled upon Her

There is a punch line to this story, trust me.

From 2008 to 2016, I wrote the weekly Antiques column for the *New York Times*. I reported on exhibitions, sales, and new scholarship related to anything old, from stone couches in ancient Etruscan tombs to 1960s civil rights posters. In April 2012, I devoted a column to shows and books about nineteenth-century American women artists. They hiked in bulky skirts to paint along European and American mountaintops, and they impressed exhibition juries from Chicago to Munich. A few weeks after it ran, under the headline "These Women Refused to Stay in the Kitchen,"[1] I visited my mother Renée Kahn, an artist and art historian in Stamford, Connecticut.

She still lived in the 1830s farmhouse where I grew up, and she was still, as she had been since my 1970s childhood, bringing home interesting old things to research from estate sales and antiques stores. I asked her to remind me of the backstories of the signed artworks, so I could write them down for posterity. In the living room, a moody nineteenth-century landscape, an autumn scene of a forest pond, had hung for decades in a high-relief gold frame. The room is kept shady by the yard's overgrown rhododendrons. I had never paid attention to the painting. My mother announced, "That's signed M. R. Williams, for Mary Rogers Williams. I looked her up once. She taught at Vassar, I think."

"Mom, I just wrote a whole column about new research into nineteenth-century women painters, and you have one of their works and didn't tell me?" She shrugged. She hadn't noticed my column topic, and, in any case, she told me, "I bought it for the frame, the frame!" She didn't particularly like the painting. She had found it at a tag sale in Cos

(facing)

I.1 My art historian mother Renée Kahn's mysterious landscape painting. AUTHOR'S PHOTO.

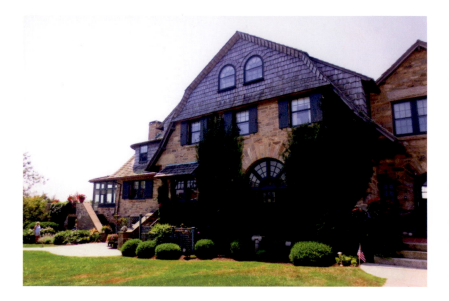

I.2 The palatial home in Waterford, Connecticut, where the White family has lived for a century, with Mary's archives slumbering. AUTHOR'S PHOTO.

(1850–1937), who used it as a boardinghouse frequented by artists. I called the museum to ask if anyone knew anything about Mary, and they put me in touch with Henry White's grandson, Nelson Holbrook White, known to all as Beeb, who had become an artist in the footsteps of his father, Nelson Cooke White (1900–1989).

Beeb had learned about Mary from his grandfather. "You're doing good research, because not too many people have heard of her—she's pretty much into oblivion," he told me. She ran Smith College's art department under Tryon, who was Henry White's close friend. "She was the nuts and bolts of the teaching," Beeb explained. His grandfather, he said, "was so fond of her and admired her as a painter." The family had inherited many of her works and always believed "these are really good quality, hold on to them, they may come into their own someday." Some of the paintings were stored at his home in Waterford, Connecticut, and he invited me to visit. My curiosity was piqued, so off I went a few weeks later.

Henry, I eventually learned, was a Hartford native who had been a friend of Miss Florence (as everyone called her) and her circle. He built homes for his family in Waterford, a beach hamlet about fifteen miles from the Griswold boardinghouse. Other bohemians, plus less interesting businessmen, set up summer places nearby in what is now a historic district called the Hartford Colony.

I met Beeb at the New London train station. He was wiry, courtly, and tanned, and he had a Yankee accent that is a priceless

Cob, Connecticut, which had been an artists' colony for American Impressionists; maybe it had belonged to one of Mary's friends?

I felt a little proprietary: here was my family's very own forgotten woman painter.

I took photos of the piece and started researching Mary. The pitiful internet trail conflicted about her dates of birth and death—1856? 1857? 1906? 1907?—and her place of death: Florence? Paris? *Benezit*, the exhaustive dictionary of artists, noted only that she was a student of Dwight W. Tryon and William Merritt Chase. Nothing of hers had been exhibited in a century except for her portrait of her painter friend Henry Cooke White (1861–1952); it had been shown in a 2009 survey of White's pastels at the Florence Griswold Museum in Old Lyme, Connecticut. The museum complex contains the ancestral home of Florence Griswold

antique in itself. He brought me to the house that Henry built, a gorgeous pile in shingles and stone designed by the Main Line Philadelphia architect Wilson Eyre. It has long belonged to Beeb's brother George, a hearty and jocular intellectual who founded Waterford's Eugene O'Neill Theater in the 1960s with his wife Betsy. (I have met not a single uninteresting person on the Mary trail!) On a breezy porch overlooking the Sound, George showed me what he had found a few minutes before: a box covered in faded floral fabric, with a handwritten label listing the contents as "Mary Williams Letters circa 1895, 1906 / Died in 1907."

I opened it, trembling. Inside was the first batch of hundreds of Mary's letters that were about to consume my life. I somehow remembered to take photos of the box before and after I lifted the lid, foreseeing how big the moment would be.

The trove was in the house's Archive Room, among boxfuls of correspondence and artwork from generations of Whites and their cultured friends. Two more boxes of Williams papers turned up that day, and more batches have emerged year after year.

With the opening of that fabric box, Mary Rogers Williams instantly changed before my eyes from a mystery, and someone I felt sorry for, into someone waiting to be documented based on thousands of unread pages.

I sat down. I'm *verklempt*, I told George. Would he, a descendant of good Connecticut stock, know the Yiddish term for "emotionally overwrought but usually for happy reasons"? But then I told him, "Oh, right, you've

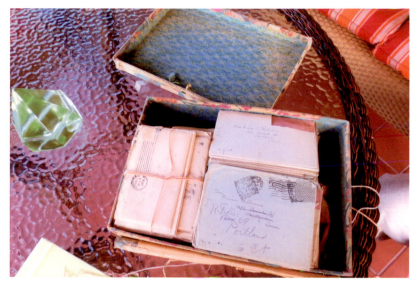

I.3 Batches of Mary's letters were saved in the White family files. AUTHOR'S PHOTO.

I.4 The Whites' boathouse built in the 1910s, and later moved inland, housed Mary's artworks. AUTHOR'S PHOTO.

worked with theater people all these years, you know that word."

Could I borrow the letters? I asked.

"Of course. I know your editors, and your address," he teased me.

That day I also saw Mary's artworks in George's and Beeb's homes and in the 1910s boathouse that Beeb and his father Nelson had used as a painting studio. In the stacks of portraits and landscapes with cryptic markings and label fragments, I started to recognize her style and favorite subjects: high horizons; nearly abstracted buildings, trees, pastures, and hills; gowned women in chairs.

Nelson eventually drove me and the paperwork boxes back to the Amtrak stop. He called his niece Carla from the station and told her what he already expected to become of Mary: "She's going to be the next Mary Cassatt!"

I.5 The signature's middle initial on my mother's painting, long misattributed to Mary, is not an "R."—it's a sloppily dotted "P." And it's not in Mary's handwriting, anyway. AUTHOR'S PHOTO.

The first few letters I pulled out, from the 1930s and '40s, were reassurances to Mary's aged sister Laura from Nelson and Henry that they would keep sending her checks: "Please do not hesitate to ask for more," Nelson would write, and she kept thanking him. Mary's story will not have a happy ending, I realized, at least not yet. . . .

I don't know if I've made a Cassatt out of my Mary, but I do feel hugely satisfied to have gotten her paintings on view and her vivid observations and tragically short life documented in print. When I finished typing the chapter about her dying days, I lay my head down next to the laptop to cry.

"Mom, you're *crazy*," my teenage daughter Alina declared, ah so affectionately.

I hear Mary's voice in my head. I get goose bumps when a new reference to her and her family and friends or an unrecorded artwork emerges, after I've spent more hours Googling. I never get tired of lecturing on Mary. Questions I have fielded afterward include "But really, how does her dead-end story further the cause of feminist art history?" (I have no idea—Mary is for the ages now. . .), and "Could you be any more excited about this?" (No!)

Now here's the punch line.

A year into the project, I took my mother's painting out to her back porch, to photograph it for my Mary inventory in progress. When the sun raked the signature, I realized the *R* was not an *R* at all.

It was a *P*, with a sloppy dot after the initial that looked the tail of an *R*.

My mother had misread the signature

decades before. And I, having seen dozens of Mary's paintings by then, knew that the handwriting on the pond scene, with a big looping initial *M*, wasn't Mary's anyway.

Oh my god, I've gone down this long trail based on a false start.

Who the bleep is "M. P. Williams"?

A few other murky landscapes with that signature have emerged for sale in recent years, with dates in the 1870s or so. They sell for maybe one hundred dollars each. They're awful. The only possible scholarly mention I could find to that artist described him or her as "active in the U.S. 19th century" and probably self-taught.[2]

My mom was right about the painting from Cos Cob: its greatest asset is in fact the frame. ~

So I have not increased the value of my inheritance with this Mary project by a cent. What I did turn up is a priceless story.

I.6 Signature on another work by "M. P. Williams" that surfaced at auction. AUTHOR'S PHOTO.

I have largely kept Mary's misspellings, as testaments to how distractedly she was writing on the fly in different countries. She sometimes intentionally misspelled words, imitating accents and malapropisms: "heggs" for eggs, in the British provinces, and "figgers" as a slangy term to dismiss her figures (portraits). While she was not averse to periods and apostrophes, she did not use them in the words Mr, Mrs, cant, wont, dont, etc., and she sometimes omitted periods at the ends of sentences. Words that Mary and her correspondents underscored for emphasis are rendered here in italics.

I have not footnoted dates for every quote from her correspondence—to do so would have created footnotes as long as this book. It would also have required confusingly sub-dating the quotes; she sometimes recorded three or four days of observations in a single batch of pages. If anyone finds errors in my transcriptions, despite my years of exploring what I have come to call Mary-land, I beg forgiveness.

I also apologize to readers for the quantity of people named in these chapters, especially women. I hope to foster further research into forgotten female intellectuals who met each other on the road.

The book has been told almost entirely from Mary's viewpoint, since few letters have surfaced that were written to or about her. At times I could clearly determine what her sisters or Henry had told Mary, in light of her responses. The loss of Henry's side of the correspondence is particularly unfortunate; he clearly shared Mary's sense of humor about more famous artists. He may have destroyed his own words years later, to avoid embarrassing disclosures.

To help make the characters vivid to modern readers, I mostly use first names and

sometimes nicknames for people in Mary's inner circle, as Mary did. Her family called her Polly, but after all these years I have never dared call her that—even to her closest friends she was Mary or Miss Mary.

I analyze her work in these chronological chapters without being certain what she painted when. (For a chronology of her exhibitions and reviews, see the appendix.) She often did not date her works, or dated them illegibly. Her letters do not record what medium she was using for her sketches, but I do know she traveled with supplies of ink, pencil, oil paints, watercolors, and pastels. Her sketches can be meticulously detailed— down to the stripes on a tabby cat and buttons on a peasant girl's bodice—but her paintings and pastels turned out far looser, and I found no record of her explaining that contrast.

It is not clear when she transformed studies into finished pastels or paintings, or when she deemed her works finished at all. Even after exhibiting them, she kept scraping and editing.

The appendix lists surviving artworks and now-lost ones that were exhibited or are mentioned in documents. But no catalogue raisonné is possible yet, given the vagueness of titles, subject matter, and media recorded in critics' reviews, Mary's correspondence, Henry's notes, and inscriptions that the Williams sisters, the Whites, and other owners scribbled on labels, frames, and backings.

More of Mary's works, and periodical mentions, kept surfacing even as I was finishing this book.

There will be more to do in Mary-land.

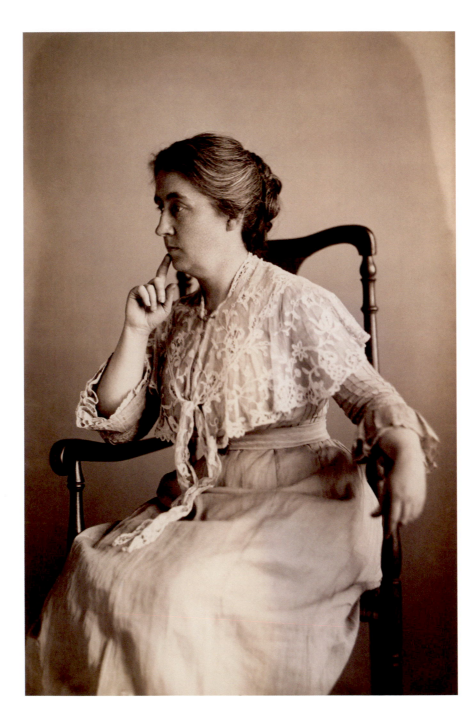

Why She Matters

Mary Rogers Williams (1857–1907) is the only nineteenth-century woman artist for whom it is possible to relate in detail where she traveled, from the Arctic Circle to Roman ruins south of Naples, along with her evocative comments on what she ate, what political scandal was splashed across the newspapers, which street urchins tugged at her heart, what plants were clinging to nearby rock formations, what smells were wafting through the streets, how much she paid for tram rides, which hotel guests fascinated or bored her, what she thought of better-known painters and men's treatment of women on the road, which museum shows and church restorations she loved and hated, what she was wearing, and how much she missed home—while she was sketching fjords, medieval doorways, harbors, chateau spires, and parched hillsides.

She is also surely the only nineteenth-century woman artist who fell into deep obscurity, while thousands of pages of her letters and mounds of other family paperwork plus virtually all her paintings were slumbering together in storage. The quantity of documentation, even about the ordinary, is part of what makes her story extraordinary.

Mary has been called "the Mary Cassatt you've never heard of." The two Marys, both Impressionists, did share a love for painting women and for bohemian living in Paris. But while Mary Cassatt enjoyed inherited money and patrons' support and socialized with Degas's circle, Mary Williams was a baker's daughter who had little uninterrupted time for art. Mary Williams taught at Smith College for nearly twenty years to help pay her family's bills.

But please do not feel sorry for her, or think of her as a martyr. Mary, above all, had fun, within the limitations of her budget and her era's misogyny.

(facing)

1.1 Undated photo of Mary in a chair reminiscent of ones that she used for posing sitters. WFC.

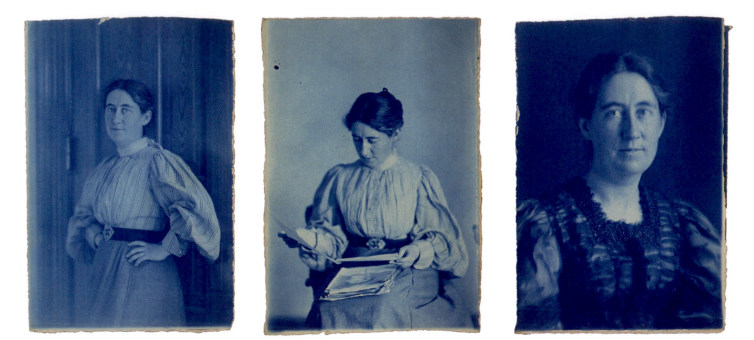

1.2, 1.3, and 1.4 Undated cyanotypes of Mary. WFC.

Her writings record not only her travels but also the travails of teaching female pupils and competing with men for space on gallery walls. Her story affords a rare woman's perspective on nineteenth-century cosmopolitan life: why were women not allowed to linger on ocean liner decks at night, why did Italian waiters urge her to get married already? Why did Dwight Tryon, her Smith department head, believe that women could be taught so little about art? Why did he get the credit for what students achieved, although he spent only a few mornings each semester on campus?

About 100 of Mary's oil paintings, pastels, and watercolors and 160 sketches survive, many of them long kept in the Whites' boathouse. She exhibited in Paris, New York, Philadelphia, Indianapolis, Hartford, Boston, and Springfield and Northampton, Massachusetts, and she was lauded in publications including the *New York Times*. Henry White compared her to "those New England women of artistic temperament of whom Emily Dickinson, the poet, was an example." But while Emily Dickinson scribbled in her upstairs bedroom, for Mary there was almost no such thing as too much time on the road. In her travels, Mary would try almost anything, including escargots, subways, wood carving,

bookbinding, and sneaking out at night to see comets.

At Smith, along with teaching art and the history of art and sculpture, Mary hung exhibitions of student pieces and borrowed artworks, organized faculty parties, tried to flatter donors, handled her own housework and cooking, painted landscapes as well as portraits of Smith students and staff, and submitted and shipped her paintings and pastels for American exhibitions. She published a few writings about art, and she occasionally sold a work. On vacations with her family, she took charge of feeding everyone, and while living in Europe, she cooked, stoked heating stoves, painted and papered walls, waxed her floors daily, and made and repaired her own clothes. A single male artist of her time, even under similar financial constraints, would have not been expected to handle much of the chores that fell to her.

She knew celebrated artists, including James McNeill Whistler, Albert Pinkham Ryder, William Merritt Chase, and Childe Hassam. She liked Ryder, despite his absentmindedness and chaotic home, and she did not mind Chase, who had critiqued her early on for "too much timidity!" But she found Hassam's work repetitive, and as for Whistler, she concluded after a few classes at his Paris school that he was a pompous fop surrounded by fawners. She dropped out of the school— and in general, she was anything but a joiner.

In artistic style, she has been classified recently as a Tonalist and an Impressionist. From the 1880s to the 1910s, Tonalist painters used a limited and largely somber palette to evoke the moods of landscapes rather than fine details. The Impressionists, who emerged in the 1860s in France, likewise set out to break away from realism, but they favored brighter hues and broader subject matter—from factories to brothels— than did the Tonalists. Neither category, as we now conceive them, existed in Mary's lifetime. And while she knew Tonalists and Impressionists who congregated at Florence Griswold's boardinghouse in Old Lyme, she scarcely socialized with them. She lived in Paris for years (1898–1899 and 1906–1907), but she befriended no Parisian art world celebrities—she does not seem to have met, for instance, Mary Cassatt.

Mary simply described herself as "forever seeing new beauties." She did not analyze her brushstrokes, which at times gave only suggestions of buildings, foliage, land contours, and faces. In 1894, in her only published interview, "when asked what style she proposed to adopt, she replied: 'If I cannot have a style of my own, I trust I may be spared an adopted one.'"

Little trace of her remains in the archives of more famous people; if anything had been filed there, historians might have rediscovered her before I stumbled upon her in 2012. She died unexpectedly; she had no time to organize her papers and place artworks in private and institutional collections. Henry and her unworldly sisters tried futilely to perpetuate her legacy.

Imagine what she could have accomplished if she had been longer lived, or rich, or a married man—if she had been allowed to con-

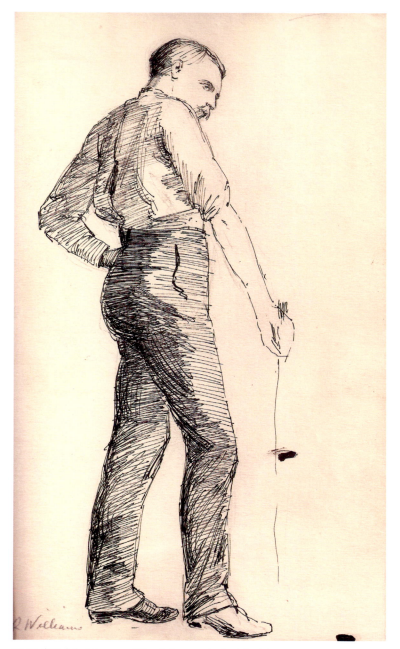

1.5 Undated sketch, one of Mary's few works that depict men. WFC.

centrate year-round in her own studio, with servants or a spouse or lover or dutiful child to help, if anyone had promoted her in her lifetime or concentrated after her death on sharing her work widely with dealers, scholars, and collectors.

Mary, however, would likely scoff at any suggestion that she would have been better off privileged. She disliked wealthy people. Her letters are full of anecdotes about boring namedroppers, Americans who learned nothing while traveling and mangled foreign languages, and artists who repeated themselves or copied Old Masters. And she doubted her own talents for painting, teaching, and writing. "I know I was not built for an imparter of information," she told Henry. In 1908, the *Springfield Republican* eulogized her: "She had an almost pathetic tendency to think less of her work than it deserved."

One professional feat she apparently never attempted or even wanted to, unlike so many of her colleagues, particularly men, was painting a self-portrait.

When Mary was told that people loved her letters, and were delightedly passing them around, she was surprised that she had not bored anyone, or so she said. She must have suspected that her words sent across the Atlantic were powerful, as she sat in the glow of oil lamps or candlelight scribbling descriptions of radishes and cauliflowers striped and stacked on a French produce truck, mauve clouds during an Arctic Circle eclipse, and tasseled uniforms on British palace guards. (For unknown reasons—see figure 1.12—she

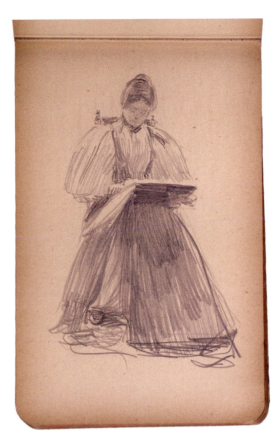

1.6 A page from Mary's sketchbook, which contains works dating as far back as the 1880s, mostly portraits of women relaxing or engrossed in hobbies. WFC.

1.7 Undated sketch. Mary sometimes meticulously sketched her sitters' clothing, although she left out that level of detail in her final portraits in pastel and paint. WFC.

Mary R Williams

almost never sketched on her correspondence pages.)[1] Mailing the letters home to her sisters from Europe, she told them, gave her "one moment when I feel sure that I've done just the right thing."

A few more facts you should know about Mary:

She attracted crowds when she sketched on European streets.

She loved sports. Her letters mention occasionally playing basketball; she bicycled around New England and Europe; and around 1900 she developed a passion for golf.

Mary tried to save money, riding in the cheap seats on buses and forgoing temptations in stores.

Mary had devoted friends who, by the end of her life, were supporting her by buying her paintings and financing her purchases of theater tickets and clothes.

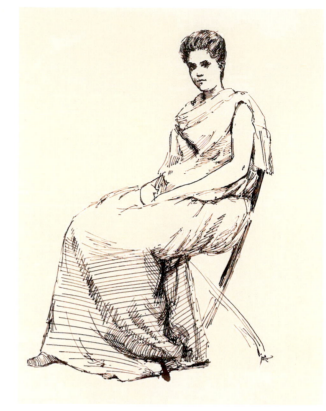

1.8 Undated sketch. A number of Mary's sketches depict women in pairs, reflecting her tight relationships with her friends and sisters. WFC.

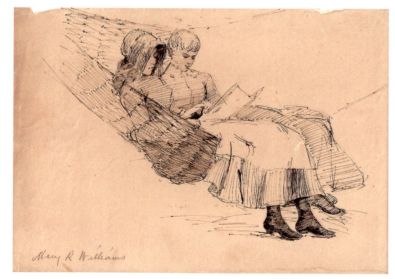

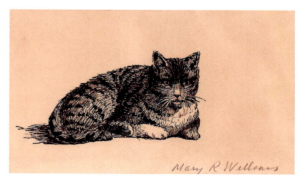

1.9 Undated sketch of a woman in a toga-like robe. The confident, elegant sitter may have been Mary's close friend Mabel Eager. WFC.

1.10 Undated sketch, probably depicting Williams sisters at their family farm in Portland, Connecticut. WFC.

1.11 Undated sketch of a tabby cat with finely rendered stripes and whiskers. WFC.

Mary was grateful for her blessings, describing her trips and friends' gifts as more than she deserved.

If she had been born a century later, she might have been openly lesbian (a term that she would have considered vulgar), or gender nonconforming. Passages in her letters, to a modern ear, sound stereotypically butch. She longed to try on military menswear, and she joked to her sisters that she might not return from Europe because she had dressed up as a soldier and run off with a regiment. She joked about punching clerks who delayed her mail. The vast majority of her portraits depict women. While this was not atypical for male and female artists of her time, her sketchbooks are obsessively filled with young, attractive American and European women standing, sitting, reading, writing, sketching, carrying fans and parasols, playing cards and string instruments, and absorbed in needlework. She did paint a few affectionate oil por-

traits of male friends, but when she sketched male strangers on the road, they look haggard and unappealing.

Mary had a favorite friend, Mabel Eager, a Boston philanthropist (who never married), who massaged her back and showered her with presents.

Mary smelled nice. Henry's son Nelson recalled "the atmosphere of gentle charm which pervaded Miss Williams' presence and also a faint but agreeable fragrance of sandalwood which she must have used as a perfume."

The epitaph she wrote for herself in 1901, paraphrasing Keats's gravestone: "Here lies one whose name was writ in pastel."

A Cosmopolitan Emerges

If the traumas of relatives dying young had any effect on Mary, her letters do not record her mourning losses or pitying herself. Nor did she mention any sense of triumph over adversity, although she and her surviving sisters, Lucy Sage (1853–1912), Abby Maria (1855–1895), and Laura Charlotte (1859–1943), were orphaned as teenagers. Mary's letters, in fact, hardly speak of the past.

There is one trace of reaction to the tragedies. At some point she sketched a baby, laid in a padded coffin (figure 2.1).

Henry White's son Nelson interviewed Laura in her old age and made preliminary steps toward writing a biography of Mary. From his notes and other archival sources, it is clear that Mary, although she preferred adventure in Europe, came from "good Connecticut stock."[1]

Mary's mother Mary Ann French (1824–1861) was the daughter of British immigrants

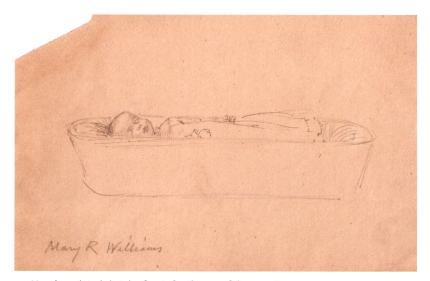

2.1 Mary's undated sketch of an infant's peaceful corpse in a padded coffin. WFC.

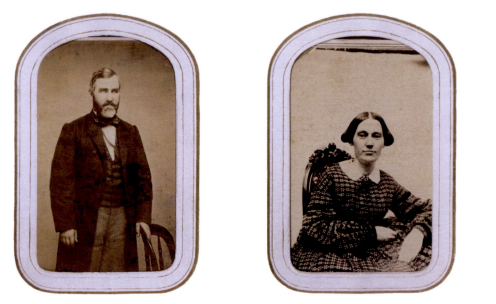
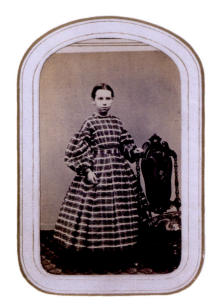

2.2, 2.3, and 2.4 Williams family album photos of Edward, Mary Ann French, and Lucy. WFC.

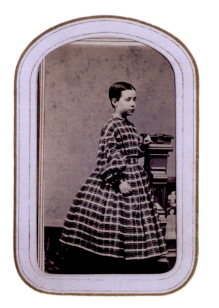
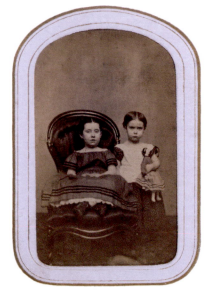
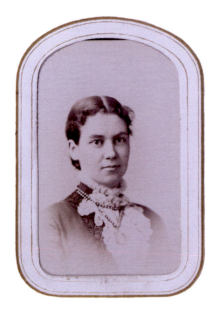

2.5, 2.6, and 2.7 Abby (probably in the same dress Lucy had worn), Mary seated alongside pouting Laura, and a youthful Lucy. WFC.

2.8, 2.9, and 2.10 Williams family album's high school photos for Laura, Abby, and Mary. WFC.

to Connecticut, Jane and John Calvin French, who also had two sons, Isaac Makepeace French (1822–1887) and John Calvin French Jr. (1820–1869). In 1845, Mary Ann married Edward Williams (1822–1871), a prosperous Hartford baker born in Portland, on the Connecticut River across from Middletown. Edward's father David (1790–1863), a Portland farmer, was married first to Laura Sage (1788–1828), Edward's mother, and then in 1833 David became the second husband of Sally Clark Norton (1805–1888). David, Laura, and Sally had at least eleven children among them. The three parents share a grave marker at Center Cemetery in Portland, which also lists siblings that Edward had outlived by age eight: twin sisters Mary (1826–1827) and Martha (1826–1829) and brother Charles (1820–1830).[2]

Two of Edward's half sisters played roles in Mary's life: Eleanor Norton Williams Fuller (1833–1887), who married Robert James Fuller (1827–1860) in 1856, and Wilhelmina Niven Williams Pelton (c. 1838–1914), the second wife of Nelson Pelton (1828–1894), a Portland farmer. Eleanor and Wilhelmina lost their only children as infants and treated Mary and her sisters as surrogate daughters.

Eleanor and Robert's baby Mary Seymour Fuller (1859–1860) was nicknamed "Little Mary," perhaps to distinguish her from her toddler cousin in Hartford, Mary Rogers Williams. Laura recalled stories of her uncle

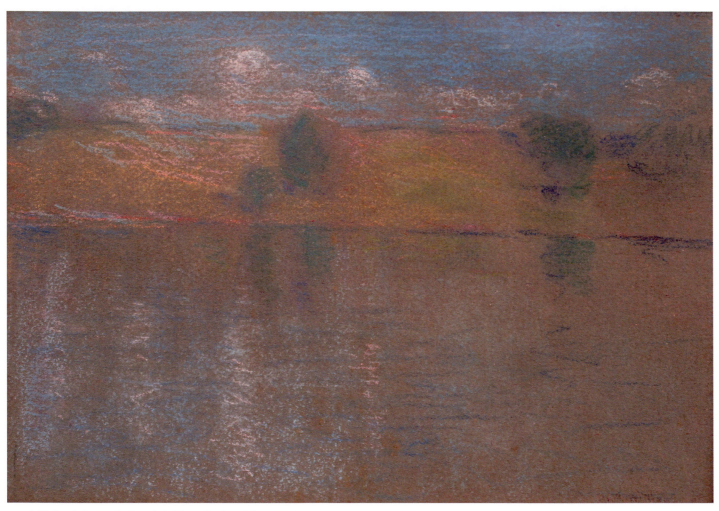

2.11 *Job's Pond, Connecticut*, undated (pre-1895) pastel,
9 x 12 in. WFC (PHOTO: TED HENDRICKSON).

Robert as "quite a favorite" of the Seymour clan and "a young man 'of great promise.'" Robert's mother was a part of Connecticut's venerable Seymour clan, so the Williamses were related by marriage to George Dudley Seymour, a New Haven lawyer and historian who became Mary's patron (see chapter 8).

Eleanor, after she was widowed, took care of Edward's motherless girls (Eleanor's daughter, her husband, and her sister-in-law Mary Ann had all died within the span of a year and a half). Laura told Nelson, "My Auntie being without a home was free to undertake the care of my father's house, and his four young daughters. She was a wonderful woman—everyone said so.—and *I surely* say so." Nelson replied, "Your aunt must have been a wonderful woman to guide and inspire you and your sisters as she did—the results prove it!"[3]

Wilhelmina, known as "Aunt Willie," and Nelson Pelton farmed on Penfield Hill, in a hamlet at the Portland outskirts called Cobalt. Trees and suburbia now obscure its pastures sloping to the riverfront. But a few of the white farmhouses and weathered barns that Mary liked to paint are extant, and vantage points reveal the rolling hills and high horizons that she captured.

Generations of Peltons farmed and quarried there. Abandoned mines still pock the hills; among the stones dug there, along with cobalt, were garnets, tourmalines, and aquamarines. Portland was also famed for its now-shuttered brownstone quarries, which fed demand from nineteenth-century architects and builders—Trinity Church there (the Fullers are buried in its cemetery) is a lavish 1870s study in brownstone turrets.

Visitors including Mary's family would take trains to the tiny wood-frame Cobalt depot; a grassy ghost of a train line runs along the base of Penfield Hill. There were mushrooms and berries to hunt, hammocks for napping, and plentiful servings of Willie's succotash. The family took trips to Block Island after "haying would be finished—first crop—and 'everybody' was ready for a day off—and a breath of salt air," Laura recalled. The place seems to have turned Mary into something of a naturalist. Her sketchbooks include detailed drawings of wildflowers and blackberries. As an adult she was considered the family's "mushroom fiend on Penfield Hill"; she knew where to find "beautiful great boletus, brownish red on top, bright yellow inside turning green when broken."

Wilhelmina was hardworking and hospitable but uneducated, and she was fearful of disaster befalling loved ones. Mary, as an adult, would reassure Willie upon taking long hikes with Laura: "We have proved on former occasions that a walk of that length is not necessarily fatal." Willie's anxieties seem understandable, however, given how many relatives had short lives.

Nelson's parents and one of his brothers died when he was a teenager, and another brother was killed in the Civil War. Nelson's first wife, Ettie, died in 1863, days after giving birth to a son, Charles (1863–1929). In Portland's Center Cemetery, at the base of Nelson and Wilhelmina's worn obelisk, an 1872 plaque for their infant son Robert has

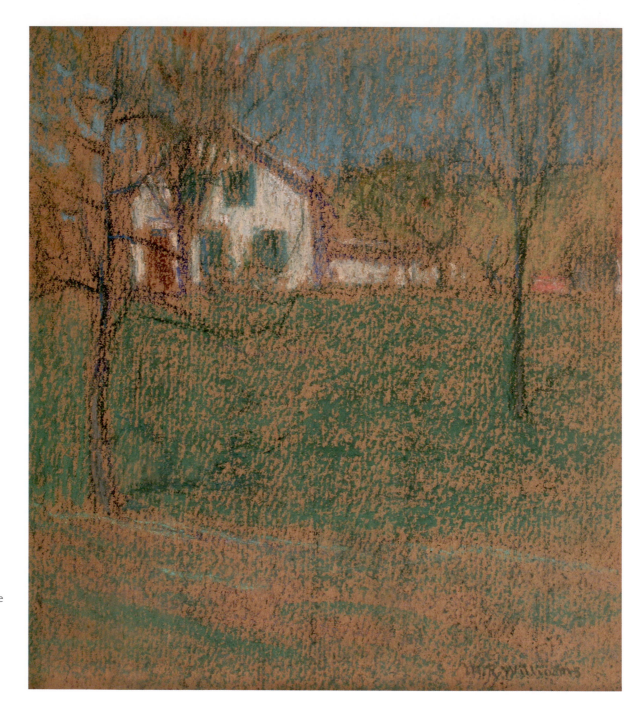

2.12 *The White House*, undated pastel, 8 x 7 in. The building depicted was likely near her family's farm in Portland. WFC (PHOTO: TED HENDRICKSON).

2.13 Untitled, undated landscape (possibly central Connecticut), oil on canvas, 20 x 27 in. WFC (PHOTO: TED HENDRICKSON).

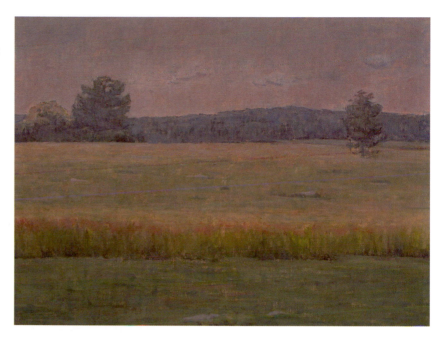

2.14 *The Tree*, 1895 pastel, 8 x 11 in. WFC (PHOTO: TED HENDRICKSON).

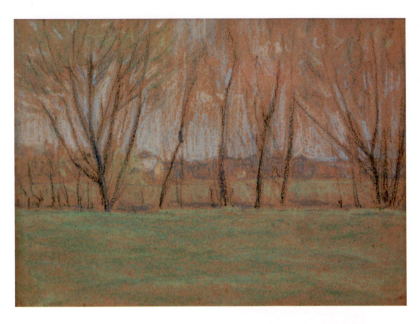

2.15 Untitled, undated tree row with farmhouses faintly visible, pastel, 7 ½ x 10 ¾ in. WFC (PHOTO: TED HENDRICKSON).

2.16 Untitled, undated tree row with house, pastel, 7 x 9 in. WFC (PHOTO: TED HENDRICKSON).

2.17 Mary recorded spiny weeds in her sketchbook. WFC.

2.18 Undated sketch of pendulous lilies and buds. WFC.

2.19 Undated watercolor of a stem of purple flowers. WFC.

fallen (as of 2013) and weathered to the brink of illegibility. Wilhelmina's brother David Stocking Williams (1835–1901), a dry-goods merchant in Meriden, Connecticut, had a son, Emmet Smith Williams (1859–1886), a Yale football player (class of 1882), who died of "quick consumption." Another son, David Williams (1869–1935), lived at the Pelton property. After Nelson Pelton's death, Dave tended the farm with a hired hand named Arvid. Dave was unsophisticated but adventurous—in 1898 he traveled to Paris with Mary (see chapter 13).[4]

Mary's parents Mary Ann and Edward had a few happy years together in Hartford and Cobalt. On Sunday, September 21, 1845, Edward wrote a diary entry: "Stormy day untill [sic] about the middle of the after-noon then cleared up quite pleasant went to the North Baptist church in the evening and was married By the Rev. E. Cushman." On the following "very pleasant" Sunday, he

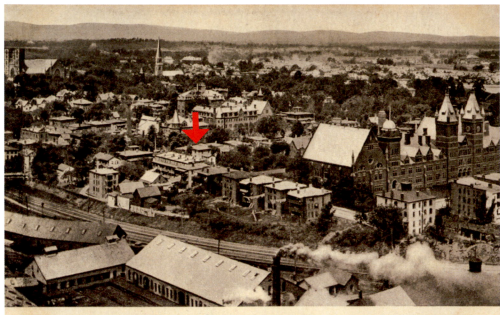

2.20 Mary grew up in a row of neat wood-frame houses behind Hartford Public High School (the multi-turreted masonry building in right foreground of this postcard from Wright's Panoramic View series). Arrow points to what is likely a glimpse of her home's roof and rear elevation. AUTHOR'S COLLECTION.

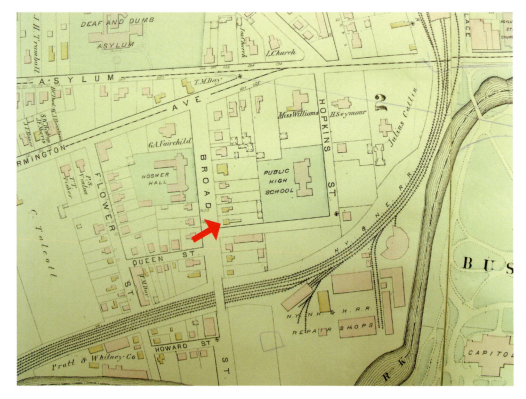

2.21 Mary's wood-frame childhood home (1492 Broad Street) had a rear wing and an outbuilding for her father's bakery. This 1880 map shows the outbuilding extended to the lot of the home next door (1500 Broad), which her family long rented to the Hubbell family. COURTESY MARY FALVEY, HARTFORD PRESERVATION ALLIANCE.

"attended church all day for the first time with my wife."[5]

In Mary's correspondence, Mary Ann seems to be absent altogether. There is one substantive reference to Edward. In 1907, after Mary had taken pity on a crippled beggar in Paris and visited the woman's rat-infested home, she wrote to her sisters that the experience reminded her "how I used to go with father sometimes into the slums and how he would say 'Aren't you thankful that you have a nice home?'"

Mary's birthplace was a wood-frame building, 1492 Broad Street (in Edward's lifetime it was numbered 12), on a genteel block at the corner of Hopkins Street and just south of Farmington Avenue. Two servants lived with the family, and the property had backyard outbuildings for Edward's business. It backed onto Hartford Public High School, a rigorous institution founded in 1638, which the girls attended. The Williamses worshipped around the corner at Trinity Episcopal Church. Other neighborhood landmarks included America's first school for the deaf, founded in 1817, where Lucy eventually worked, and the Retreat for the Insane, on grounds designed by Hartford native Frederick Law Olmsted and his partner Calvert Vaux. (Abby was institutionalized there at the end of her life.)[6]

Edward's "Bakery, and Ice Cream Saloon" made deliveries by wagon, and he sold some goods on-site. He offered "cake at short notice, and on reasonable terms," especially for weddings and other celebrations, to buyers in "Washington, New York, Jersey City, Middletown, Portland, New Britain and Farming-

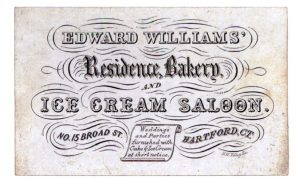

2.22 Edward's business card. WFC.

ton." He suggested that customers "will do well to give him a call, before or after looking elsewhere." His only caveat: "orders on the Sabbath day will not be attended to." Newspaper ads for his favorite brand of vanilla extract noted that "we all know how nice his articles are," and he was also known for his "cow cookies" (possibly made with fresh milk from a neighbor's cow).[7]

In April 1853, Edward announced his plan for "doing business on a broader scale." That ad also expressed "sincere thanks to all those who were so kind to him in the severe affliction he has been called to pass through during the past year."[8] His affliction was the loss of two children within weeks of each other, Joel Cornish (December 1846–May 1852) and Sarah Jane (April 1851–April 1852). The baby and her brother share a worn obelisk grave marker at Hartford's Spring Grove Cemetery. Mary's letters do not seem to mention the siblings she never met. In 1940, Nelson C. White wrote about this part of Laura's family tree: "It seems very wrong that those two children—a

brother and sister—could not have lived to maturity." A few weeks after Edward's bakery ad mentioned his "severe affliction," Mary Ann gave birth to Lucy, the first of the surviving daughters.

Edward's renown reached a peak in 1856, when he engineered a wedding confection for Samuel Colt, the Hartford gun tycoon. Colt married a minister's daughter, Elizabeth Jarvis. (Six years after the wedding, Elizabeth was left a pregnant widow with a dying baby and two other children; she eventually became an art collector and philanthropist—she helped found the art school where Mary trained.) The *Courant* reported, "The Bridal Loaf at Colonel Colt's wedding was the admiration of all beholders. It consisted of three several cakes, the largest about 5 feet in circumference, rising above the other in the form of a pyramid, to the height of 3 or 4 feet." The dessert, frosted in wreaths, scrollwork, and the Colt and Jarvis coats of arms, was "unanimously pronounced unrivalled in this portion of the country."[9]

Just before Mary Ann's death, family photos were taken at Hartford's fashionable Moore photography studio (Laura, late in life, added identification notes to the album in which they were tucked). Edward was plump, bearded, graying, and dignified. Mary Ann posed in an unostentatious checked dress with a scalloped white collar. Lucy and Abby (who had amblyopia—"lazy eye"—in her left eye) wore matching plaid hoopskirted dresses. Mary and Laura posed together twice, taking turns slumping in an armless upholstered chair. Mary wore a high-waisted dress trimmed in dark ribbons—the scaled-down version of an adult gown makes her look like a somber tiny teenager.

The portraits, with repeating poses and fabrics, foreshadow how inseparable the girls would be for the rest of their lives.

In 1861, Mary Ann was buried next to her first two children, under a white gravestone shaped like an open Bible on a pedestal (a 2013 visit showed it eroded like melting ice cream). By 1869, Mary Ann's brother John, who lived not far away in Willimantic, had died, and Edward briefly took John's three young sons under his wing; Laura recalled that her father "helped them always very much." In 1871, Edward died suddenly. The official cause of death was erysipelas, a bacterial skin infection. A newspaper obituary described him as "a well-known and much esteemed citizen."[10]

His substantial estate included the Broad Street house with a barn, cookhouse, and woodshed; six acres with a barn on Prospect Hill Road in Hartford; thirteen and a half acres of Portland pasture; livestock, carriages, tools, and stock in banks and textile and insurance companies.[11] The family also owned a neighboring wood-frame house, 1500 Broad, which the sisters eventually rented to the engineer Lindley Dodd Hubbell, who designed bicycles and automobiles (see chapter 14). Edward's German-born employee Edward Habenstein (1846–1919) took over the bakery's "thriving trade." (He and his wife Adelia eventually expanded the business into a restaurant and catering service that served Hartford's elite; ads for "Haben-

stein of Hartford" described it as "not surpassed even by the New York Caterers.")[12]

Aunt Eleanor became head of the household. The girls were also appointed an official guardian, Miles Wells Graves (1834–1906), a bank director with a reputation for "exactness and unswerving integrity." Mary considered him a "grand good man" and the sisters' "best friend." His scholarly interests may have influenced her. He collected coins, art, and antiquities, and he was a "zealous and expert genealogist" who traced New England pedigrees. He was a friend and financial adviser for the family of the artist Frederic Edwin Church (a Hartford native); Graves's collections at some point included Church paintings. He and his daughter Martha traveled in California, Mexico, and Europe, and among their companions over the years were Mary, her sisters, and Frederic Church.[13]

Starting in grammar school, the Williams girls won prizes for their class work, competing with boys who were headed to Yale and Trinity College. In the high school's "classical department," the girls ranked near or at the top of their classes. Given their "brilliancy of scholarship," a local librarian recalled in 1937, "aspiring but discouraged aspirants for honors would wail 'there is no use trying for prizes so long as a Williams girl's left in school.'"[14] Aunt Eleanor signed the glowing report cards. Abby gave the high school's 1874 valedictory speech, with a eulogy for the principal Samuel Mills Capron, who had just died at forty-one. She bid farewell

to the school (where she was about to spend her career): "long may thy lofty towers watch, like sentinels, over our fair city; long may it be thy mission to guard it from the enemies Ignorance and Lawlessness." At Mary's 1875 class day ceremony, students performed a song with her lyrics that compared falling autumn leaves "borne far o'er the land" to classmates about to scatter. At Laura's 1876 graduation, she read a Longfellow poem, won a fifteen-dollar scholarship, and gave a valedictory speech "with marked emotion and earnestness." There was only a little time for fun at school. Lucy's 1872 notebook records classmates teasing that her initials LSW stood for Looks So Wicked and predicting that she would become a man: "a dancing master who had eloped with Miss Wenk."[15]

By the time Laura and Mary finished high school, Abby had already become a science teacher there, "particularly of chemistry and astronomy." She taught until 1887, "when ill-health ended her work."[16]

Of the accomplished four, only Mary ever lived anywhere but Hartford. Yet she does not seem to have lorded anything over her sisters. Wherever she studied and traveled, whatever she achieved, she wrote home to make sure that her sisters could visualize the scenery and crowds, hear the accents, and get a sense of the cuisine.

In all the detail she recorded about her adult life, however, she left few clues about how she became a respected teacher and painter.

No Salvation but by Hard Work

Mary's letters reveal little about her student experiences, but other painters wrote recollections of classrooms like the ones that she attended. Her mentors, including Dwight W. Tryon, James Wells Champney, and William Merritt Chase, were at times supportive of women, but they could also be cruelly undermining.

Hartford had long been relatively open to the idea of educating women. In 1823, the reformer Catharine Beecher founded the Hartford Female Seminary; prominent graduates included her sister Harriet Beecher Stowe. The region's nineteenth-century magnates, in the fields of textiles (the Cheneys), weapons (the Colts), sewing machines, typewriters, and bicycles, supported coed schools. Mark Twain built a mansion in Hartford, and Henry White described Twain's circle as "cultivated men" who were "very liberal and advanced in their religious views and quite

ahead of their time."[1] The citizenry was also ethnically tolerant to an extent; Chinese students, sent as ambassadors by their government, started attending the public high school in the 1870s.

In 1877, wives of the richest industrialists formed the Hartford counterpart of a New York charitable effort called the Society of Decorative Art. The Connecticut group's 1883 annual report described its objective as "especially to give employment to women," by training them to produce marketable artwork as well as fabrics, ceramics, and other handicrafts. The New York organization had been founded by Candace Wheeler (1827–1923), an interior decorator and textile designer, who had Connecticut ties—the Cheney factories produced her metallic silks, and the Twains were her clients. The new Connecticut school (now known as the University of Hartford's Hartford Art School), where Mary

3.1 Mary trained and later taught at Hartford's Society of Decorative Art. Its 1883 annual report showed typical classrooms and student artworks. CONNECTICUT DIGITAL ARCHIVE.

3.2 In the Society of Decorative Art's 1883 annual report, a skeleton looms in the background of art supplies including plaster casts and wooden geometric forms. CONNECTICUT DIGITAL ARCHIVE.

3.3 Holiday fundraising events, according to the Society of Decorative Art's 1883 annual report, offered textiles, paintings, sculptures and ceramics. CONNECTICUT DIGITAL ARCHIVE.

apparently enrolled soon after it opened, went by various names, including the Art Society. It was considered important for post–Civil War Connecticut partly because so many male breadwinners had been incapacitated or killed while serving in Union regiments.

The Hartford society's founders, "about fifty of our public spirited ladies," included Harriet Beecher Stowe, Twain's wife Olivia Clemens, the silk scion Mary Bushnell Cheney, and Elizabeth Colt, whose wedding cake had been made by Mary's father.[2] Soon after the Art Society opened, James Wells Champney (1843–1903) became its head teacher. He was a charismatic figure, sometimes known as Champ. His wife Elizabeth (1850–1922) was a novelist and journalist, known for her fiction series *Three Vassar Girls Abroad.* (Her 1894 article about women artists featured Mary—see chapter 7.) The society's initial thirty students were "vexed and per-

plexed over perspective drawing but owing to the skill and patient teachings of Prof. Champney are gradually emerging from the mists and doubts."

The society rented classroom space in various buildings, including the Cheneys' 1870s turreted stone structure designed by the Romanesque Revival architect H. H. Richardson. Classes were also held at the "picture gallery" at the Wadsworth Atheneum—a pioneering museum founded in 1842. The

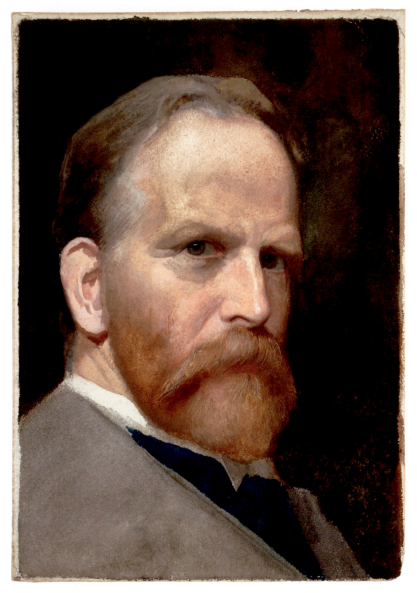

3.4 Watercolor self-portrait by Mary's Hartford teacher and later friend James Wells Champney. MUSEUM OF FINE ARTS, BOSTON, GIFT OF MAXIM KAROLIK FOR THE M. AND M. KAROLIK COLLECTION OF AMERICAN WATER-COLORS AND DRAWINGS, 1800–1875.

society's 1883 annual report illustrates women learning to use charcoal, crayon, oils, and watercolors in classrooms equipped with blocks, plaster reproductions of ancient busts, and a skeleton.

The society charged membership fees of one dollar, "within the reach of those of small means," and gave out some scholarships. It raised money partly by selling tickets to lectures by experts including Twain and Champney. It held holiday sales of needlework, paintings, and painted china made by philanthropic women and by "ladies in reduced circumstances," who "with aching head and tired hands" eked out time to produce wares. Women handled all aspects of the society's management, while male benefactors were called the Friends in Council. The society minutes praised the men contributors as "plainly believers in the divine right of woman to manage her own affairs as they have religiously abstained from that most common and most freely bestowed of friendly gifts—Advice."

The society's more successful male and female graduates continued studies at the Museum of Fine Arts' school in Boston or found factory jobs as designers. Still, shaping wives and mothers remained its main goal: "by making our houses and homes beautiful, we refine and elevate life, making it sweet and pure."

Champney, while teaching there and eventually at Smith College as well, illustrated his wife Elizabeth's books and painted realistic genre scenes and landscapes. In 1877, he became Smith's first drawing teacher, working

there part time until 1880. By 1885, he had left teaching to focus on his own work, dividing his time between homes in Manhattan and Deerfield, Massachusetts. Mary fondly remembered his Hartford classes, although she eventually lost interest in his tight style: "Mr C. guided my infant feet in the paths of Art, and now I feel as if I had somehow wandered into a different path from his," she told Henry in 1897. Her teacher, however, had not always encouraged her, she recalled to Henry in 1906: "Mr Champney once told me that I had not self-conceit enough to succeed."[3]

Mary stayed in touch with the Champneys and their daughter Marie (1876–1906), riding her bicycle from Smith to visit them in Deerfield. Mary ran into them in Europe from time to time—she was puzzled by his efforts to copy Louvre paintings. Champney, for his part, particularly admired Mary's pastels. In 1908, the *Springfield Republican* quoted his praise for her: "Mr. Champney, one of the most expert and fortunate of pastelists, said, 'She can teach us all.'"[4]

In 1885, Dwight W. Tryon (1849–1925), Mary's future boss at Smith, became Champney's successor at the Art Society. He was a Hartford native, and prickly, blunt, and self-made. His father had been killed in a hunting accident when Dwight was a toddler, and his widowed mother held a low-level job watching over galleries at the Wadsworth Atheneum. Tryon, like many male and female painters in his day, had taken classes at Paris academies—American art schools, in the 1870s, were still young and considered inferior. When he returned home, he earned a living partly by

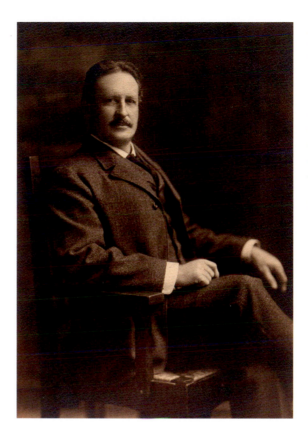

3.5 Mary's Hartford teacher and later boss Dwight W. Tryon. DWIGHT WILLIAM TRYON, 1918 / MARCEAU MARC, PHOTOGRAPHER. MACBETH GALLERY RECORDS, 1838–1968, BULK, 1892–1953. ARCHIVES OF AMERICAN ART, SMITHSONIAN INSTITUTION.

giving private lessons at his studio and holding formal teaching jobs. Mark Twain is said to have warned him away from an art career that could lead him to "probably starve to death in a garret."

Tryon specialized in landscapes and seascapes in a muted Tonalist palette. The Cheneys were among his first supporters and students, and he eventually became a favorite of the collector and philanthropist Charles Lang Freer (see chapter 5). Tryon was also apparently popular as a teacher for women. In an 1879 book surveying the Connecticut art

scene, the writer Harry Willard French included 29 thumbnail biographies of "female artists," and at least 3 of the women (and none of the book's 139 men) studied with Tryon.[5]

Like Champney, Tryon commuted for a while between the Art Society and a teaching post at Smith. The society reported that Tryon praised his Hartford students who "do stronger and better work than his class at Smith's College [sic], and better than the work of the same number of any school in New York City, two or three of the scholars might even rank with professionals."

Mary trained further with Tryon for a few months at his New York studio, while also studying at the Art Students League under Chase and other teachers.[6] In 1906, Mary told Henry how Chase "once looked at my work in his dramatic way and then said fiercely 'Too much timidity!'" Chase was known as an electrifying teacher; audiences filled his classrooms as he doled out "quick, quotable, and often harsh comments."[7]

Henry's unpublished 1950 memoir and his 1930 biography of Tryon suggest that female art students had some miserable moments in the New York classes. A year or so after Mary, Henry studied at the Art Students League and at Tryon's Manhattan studio. League instructors offered little advice or criticism, and Henry spent his time there practicing what he was learning from Tryon, who had brought home from Paris "the severe discipline of Ingres," which was "passed on to us and driven home with all the force and clearness of Tryon's scientific mind and dynamic personality." Tryon's curriculum included drawing and painting plaster casts, live models, still lifes, and landscapes, as well as modeling in wax and clay for students "whose sense of form was weak." Tryon emphasized "the importance of precision" as well as "loose and suggestive" brushwork. Henry labored there alongside one or two other men and half a dozen women, several of them also attending the Art Students League. "Once in a while the severity of Tryon's standards drove a weak sister from his class," Henry recalled. But after studying elsewhere for a while, "she would appear in Tryon's studio to rejoin his class. She had found no substitute for his teaching and was ready to admit that there was no royal road to success, no salvation but by hard work and plodding."

In some New York sessions, Henry recalled, a "wealthy and aristocratic" young woman named Miss Post came with "a chaperone, an elderly woman who always sat by her" with needlework in progress. Henry described the heiress as "a tall, dignified girl . . . who painted animals as well as any professional." Although the heiress had led a "cloistered existence," Henry observed, "Tryon was impartial in his criticism and at times ruthless." In class, Miss Post "never spoke a word to anyone but Tryon and seemed unconscious of the rest of us." Henry recalled that "Tryon did not overpraise her in her presence," but when she was not at the studio, he "often pulled out her studies . . . to show to his class as examples of good work." (Likewise at Smith—see chapter 5—he was known for praising girls when they were not around.) At the end of one morning session, she told Tryon that she

was exhausted, had a headache, and wanted to leave for lunch, but he insisted that she complete her promising study: "If you don't finish it now, you never will. Stick to it and put it through!" She stayed in the room, Henry wrote: "Thus fortified, the girl desperately threw herself at the canvas again, and the day was won." Miss Post was probably Edwina Margaret Post (1863–1953), an Astor cousin who had also studied with Chase. Edwina Post was a member, like Mary, of the New York Woman's Art Club. She did have some success painting pictures of animals. But however much Tryon left her "thus fortified," little record of her artwork and career survives.[8]

During the summers, Tryon brought students to his home in South Dartmouth, Massachusetts, where he was famous for his prowess as a sailor and fisherman. While the class painted, Henry wrote, Tryon criticized their work "at irregular intervals when it did not interfere with his recreations. As they were mostly women they did not go cruising or sailing with him and he and I were together nearly every day, either on the water or occasionally sketching together on shore."

Henry summarized his friend's misogynist attitude toward teaching: "Tryon claimed that landscape was a man's art, and that few women are good landscape painters. The rea-

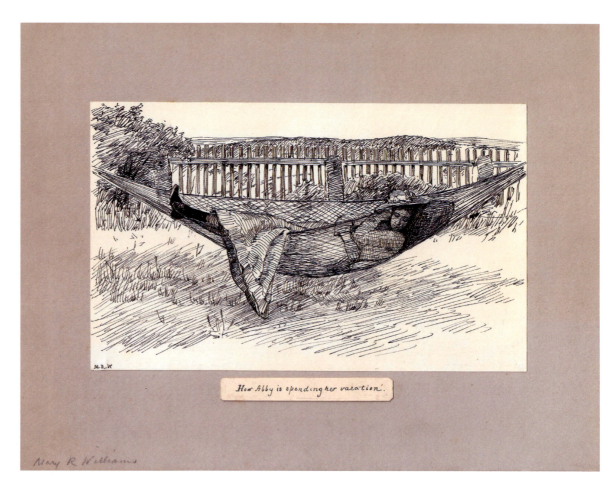

3.9 Mary's 1885 sketch of Abby cocooned in a hammock. WFC.

How Abby is spending her vacation.

Mary R Williams

sons for this he thought to be occult and not generally understood. He also philosophized frequently upon the fact that women usually learn to draw with difficulty, though their feeling for color is often strong and true; this proving them, he thought, to be creatures of emotion rather than of logic. He also believed women to be, as a rule, more appreciative of art than men, though less able to produce distinguished work themselves."

There was nothing unusual for the time about Tryon's sentiments and treatment of women students. Louise Howland King Cox, a contemporary of Mary's at the Art Students League (and who eventually married one of her instructors, Kenyon Cox), recalled that the league teacher Carroll Beckwith "disapproved of women painting" and "never failed to give them a dig when the opportunity arose."[9]

Mary, a baker's daughter, somehow stood her ground. Henry praised her in his Tryon book: "Now and then, however, a talented woman, under Tryon's severe discipline, produced charming work of lasting worth. Mary R. Williams, his assistant for many years at Smith College, painted extremely well."[10]

Around 1880, Mary started teaching at the Art Society. By 1885, she listed herself in the "artist" category in a county directory. By then, Abby had been teaching science at the high school for more than a decade—among her students was Henry White—and Lucy was teaching at the school for the deaf.[11] The sisters had summers off, and in Mary's earliest dated sketch (figure 3.9), from August 1885, Abby sleeps in a hammock alongside a picket fence at Penfield Hill, with one corner of her skirt brushing the grass. It is captioned "How Abby is spending her vacation." A few other

sketches (figures 3.6, 3.7, and 3.8), from August 1887, a month before Mary's aunt Eleanor died, portray women in hats sketching at Penfield Hill pastures, seated on rocks and split-rail fences.

Mary left no record of her reaction to Eleanor's death, or to her move to Smith the following year, leaving behind her tight-knit sisters. By then Abby was too sick to work. (In 1887, the *Courant* had optimistically reported that Abby's symptoms were "daily more favorable.") In early 1888, Lucy took time off from teaching, probably to help Abby.[12]

Mary's known writings do not reveal her thoughts on her sisters' worsening situation and the burdens of breadwinning. (It is not clear how much income was generated by Edward's estate.) What Mary did document is how hard she worked at Smith, while often tempted to run outdoors and paint apple blossoms.

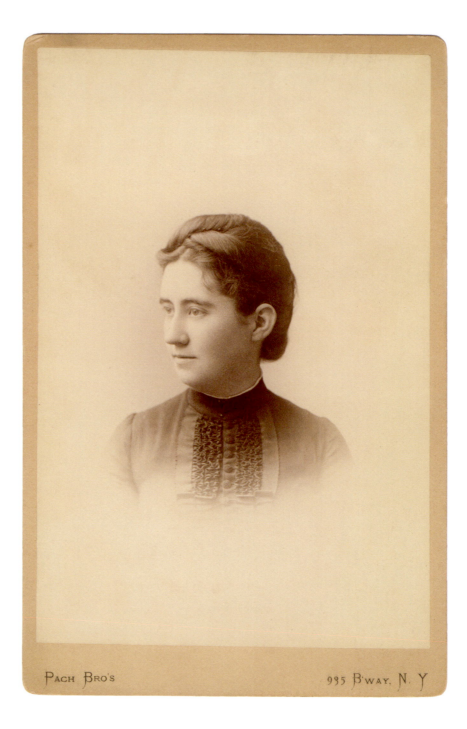

Pach Bro's 995 B'way, N. Y

Conveying the Rudiments of Art

In 1888, Mary became the only full-time staff member in Smith College's art department. (The liberal arts school was founded in 1871, to give women access to educational opportunities comparable to those available to men.) Tryon and other scholars gave talks or critiques from time to time, while Mary taught painting and drawing, handled most of the art history instruction, organized shows of student work and collectors' loans, hosted parties, and dealt with administrators and philanthropists who were expanding Smith's collection of paintings for a pioneering museum. Mary also found time to produce and promote her own artwork.

Mary's predecessor at Smith, Mary Louise Bates (1855–1917), had studied art at Yale, exhibited at the Pennsylvania Academy of the Fine Arts (1885) and the American Water Color Society (1887), and "sketched her way through Holland, Belgium, Germany and elsewhere." Bates resigned after four years at Smith (1884–1888) to train further in Paris. She kept traveling and painting in Europe while raising children and stepchildren with her husband, the Massachusetts judge Everett C. Bumpus—unlike most of Mary Williams's female colleagues, who stopped working when they married.[1]

Throughout her Smith career, Mary Williams was officially called teacher or instructor of drawing and painting. Tryon was titled "professor of drawing and painting" and "director of the art school." Two physicians, Dr. Grace A. Preston and Dr. Mary Damon, lectured occasionally on anatomy to the art students.[2] The British-born engineer Frederick R. Honey, who also taught geometry at Yale, gave perspective lessons, and the art historian Herbert E. Everett, who taught at the University of Pennsylvania, took on some survey classes.

(facing)

4.1 Mary Rogers Williams, Art Instructor, soon after she arrived at Smith College. PACH BROS., NYC. FACULTY, INDIVIDUALS, COLLEGE ARCHIVES, SMITH COLLEGE (NORTHAMPTON, MASSACHUSETTS).

4.2 Postcard of Hillyer Art Gallery, Mary's workplace, an imposing masonry building designed by the Boston firm Peabody & Stearns. The first major museum on a women's college campus, it contained galleries for paintings and plaster casts as well as classrooms and artists' studios, illuminated by skylights. AUTHOR'S COLLECTION.

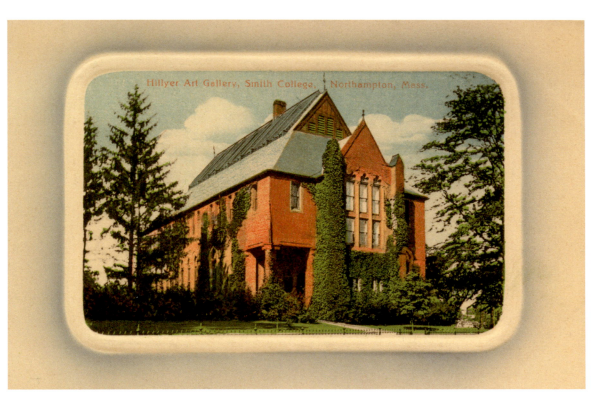

Hillyer Art Gallery, Smith College, Northampton, Mass.

Students could enroll in the art school as a separate track, while girls in other college tracks (including literary and scientific studies) could pay extra to add on art instruction. The art department offered "practical and theoretical instruction in the principles of the Arts of Design—Drawing, Painting and Sculpture, including the elements of Architectural Styles and Decoration." The curriculum progressed from "free-hand drawing from casts and artistic objects" to "drawing with crayon or charcoal from living models" and still lifes and then drawing "from nature, with outdoor practice" as well as "modeling in clay." Lessons in oil, watercolor, sculpture,

and etching would be imparted "as soon as the rudiments of art are sufficiently comprehended." Mary's course descriptions over the years included "study of design with practical work," "artistic anatomy," and "the history of sculpture beginning with Egyptian, and including Assyrian, Greek, Roman, Italian, and French."[3]

The course catalogs praised the "rare advantages" of Smith's Hillyer Art Gallery, built in 1882. The first major museum on a women's college campus, it occupied an imposing masonry building designed by the Boston firm Peabody & Stearns. Its original funders, the Hillyer family, made bequests and gifts to

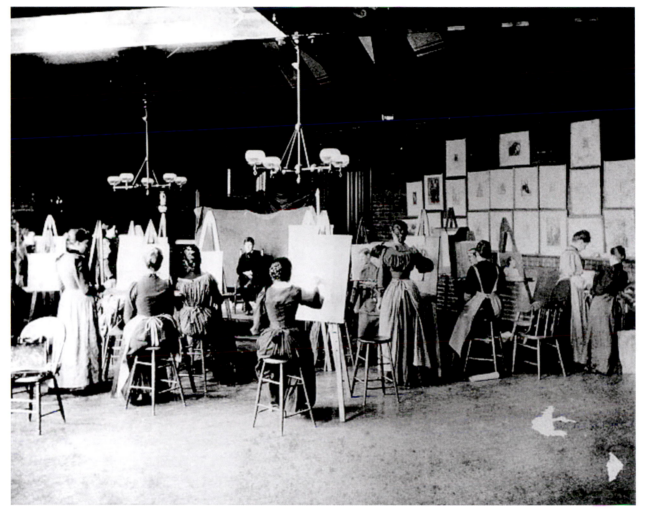

4.3 Art Class in Hillyer Hall, Smith College, sketching live model,
March 1893. PHOTOGRAPHER UNKNOWN. 22. BUILDINGS, COLLEGE
ARCHIVES, SMITH COLLEGE (NORTHAMPTON, MASSACHUSETTS).

4.4 Among Mary's few published writings is her 1898 catalog of Smith's now-lost collection of plaster casts, mostly made from ancient sculptures in European museums. AUTHOR'S COLLECTION.

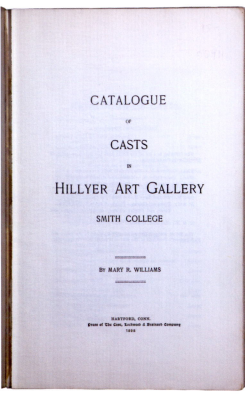

CATALOGUE

OF

CASTS

IN

HILLYER ART GALLERY

SMITH COLLEGE

BY MARY R. WILLIAMS

HARTFORD, CONN.
Press of The Case, Lockwood & Brainard Company
1898

4.5 Smith's cast of a marble discus thrower sculpture at the British Museum inspired one of Mary's sketches. WFC.

build and expand the structure out of their fortunes earned in Northampton businesses and Hartford insurance. It contained galleries and classrooms, and skylights supplied steady northern light. The college quickly assembled a collection of contemporary American paintings (now partly dispersed) to show there. By the mid-1880s Smith owned works by Thomas Eakins, Winslow Homer, Albert Bierstadt, Frederic Edwin Church, Louis Comfort Tiffany, Samuel Colman, George Inness, Lockwood de Forest, William Gedney Bunce, and Champney and Tryon. J. Alden Weir's portrait of Smith's president, Laurenus Clark Seelye, was also hung. The public could visit the gallery only on Saturdays, so as not to interrupt classes.

In 1884, the *New York Times* suggested that travelers visit Smith's campus, given the "interesting sight" of female students going about their rounds. It noted that under Smith's art teachers, led by John H. Niemeyer (Tryon's German-born predecessor, who also taught at Yale), "close application is all that one requires" to succeed in the field. The newspaper described Hillyer's collection of engravings, plaster casts, and paintings, listing works by dozens of men. The reporter then mentioned the museum's portrait by German-born Ida Bothe (who taught art at Wellesley College before her marriage to a Prussian baron), "a very attractive figure piece of no ordinary merit in its flesh tints." That is, not surprisingly for the time, a women's college hung almost nothing painted by a woman in its lauded galleries.[4]

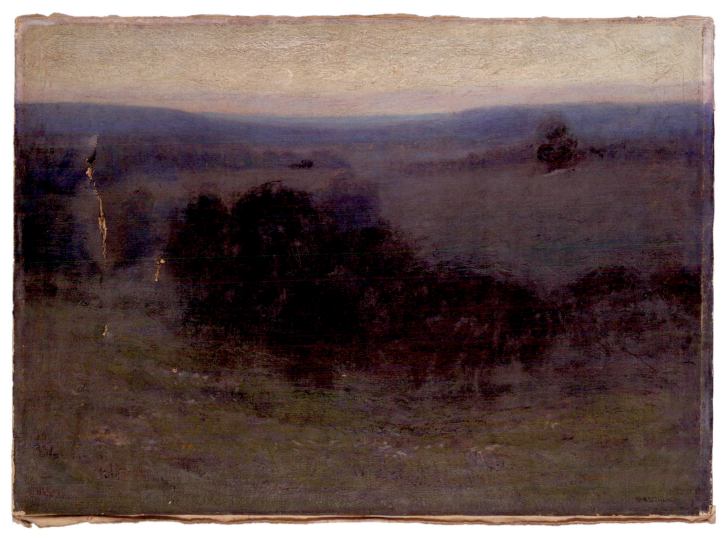

4.6 *Evening*, undated oil on canvas, 26 x 36 in. Mary's view of Connecticut River Valley scenery, a canvas that she continually revised and considered her masterpiece.
SMITH COLLEGE MUSEUM OF ART, NORTHAMPTON, MASSACHUSETTS, GIFT OF ALUMNAE AND FRIENDS OF THE ARTIST, SC 1908:5–1.

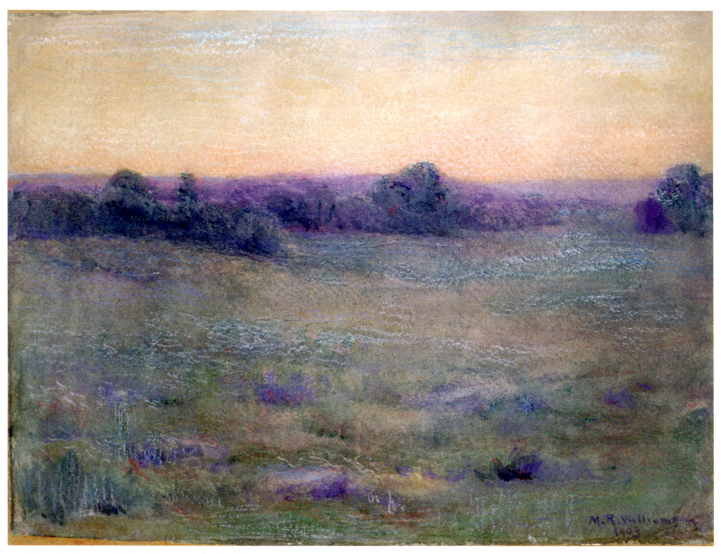

4.7 *Green Landscape—Hills in the Distance* (probably Connecticut
River Valley), 1903 pastel, 12 ½ x 22 in. SMITH COLLEGE MUSEUM OF ART,
NORTHAMPTON, MASSACHUSETTS, GIFT OF THE SISTERS OF MARY ROGERS
WILLIAMS, SC 1911:3–2.

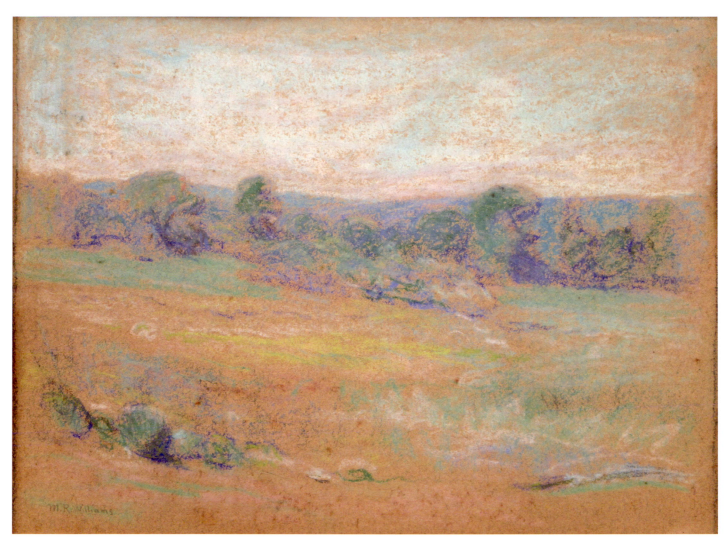

4.8 Untitled landscape (probably Connecticut River Valley),
pastel, 10 x 13 ½ in. WFC (PHOTO: TED HENDRICKSON).

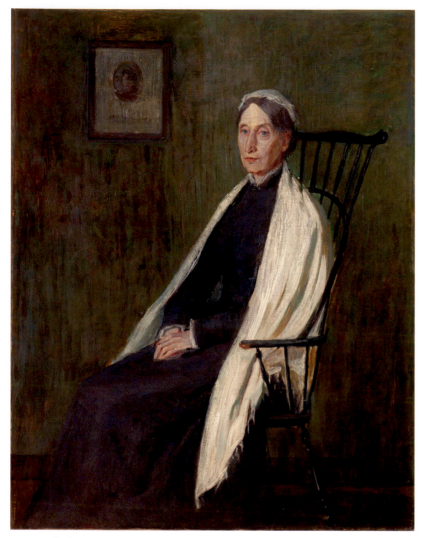

4.9 Mary's 1895 portrait of her Smith landlady, Mary Smith Tenney. Oil on canvas, 32 x 25 in.
SMITH COLLEGE MUSEUM OF ART, NORTHAMPTON, MASSACHUSETTS, SC 1900:63–1.

Mary helped the administration acquire more contemporary paintings, and she published a catalog of the casts: 384 copies of ancient, medieval, Renaissance, and modern sculptures and reliefs, including numerous pieces at the Louvre and the British Museum. The collection (now lost) spanned from Egyptian sphinxes to a bust of Seelye. Mary, who would go on to critique museum contents from London to Rome, worked some opinions into the dry listings. Smith's version of the Vatican's Venus of Knidos statue, she wrote, was inferior: "The drapery on this copy is a bad modern addition."[5] She occasionally sketched in the galleries, too; one of her drawings (figure 4.5) depicts number 62 from her catalog, a cast of a marble discus thrower in the British Museum.

Mary lived at the campus outskirts, in eighteenth- and nineteenth-century houses; she referred to her quarters as "my convent cell" and to her housemates as "the other inmates." She also had a studio in the Hillyer building, where friends, potential customers, and sitters for her portraits stopped by; among her subjects over the years were Smith students and teachers and Seelye family members. Mary often could barely keep warm in her work space, and she complained to Henry about housekeeping with no servants on hand: "It is hard to find anyone to do such humble and menial things here."[6]

By 1891, Mary had made a noticeable impact on the students and museumgoers. At graduation receptions that year, one thousand

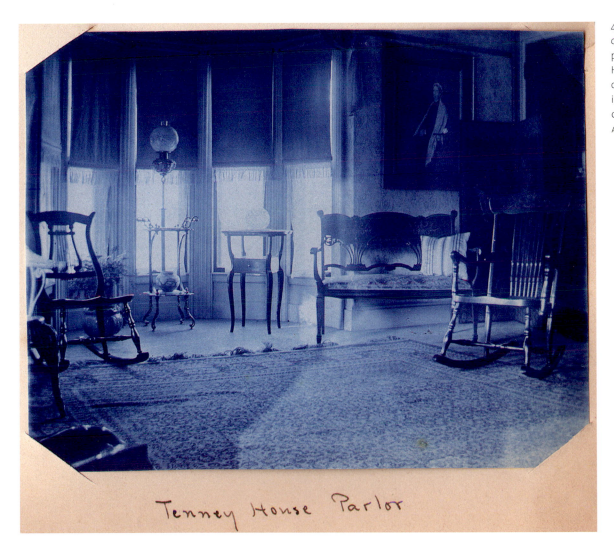

Tenney House Parlor

4.10 In this circa-1900 cyanotype of the parlor at Smith's Tenney House, Mary's portrait of the building's donor is visible at upper right. COURTESY PHOTOSEED ARCHIVE & GALLERY, LLC.

visitors filed past the girls' work "in oil, water, black and white and clay modeling. . . . No year has shown greater progress," the *Boston Journal* reported.[7]

Mary, however, saw less progress with every year at Smith amid "too much of the presence of the young feminine." But she had some affection for her colleagues, the scenery, and the students willing to pose for her.

In and around Northampton, she sketched and painted Mount Tom (which overlooks an oxbow loop in the Connecticut River),

eighteenth-century buildings, tree-lined streets, and orchards—her struggles to render apple blossoms on canvas even gave her occasional nightmares. One of her Northampton sketches, dated December 1888, shows a young woman in a classical toga-like costume, arms upraised; it may represent a student dancer. Mary painted one of her landladies, the philanthropist Mary Smith Tenney (1813–1895), who owned 33 Elm Street. The work (figure 4.9), dated 1895, may have been a posthumous tribute, depicting, as an alumna described the portrait in 1910, "a grave woman in gray, with a white shawl drawn over her shoulders, seated in an old-fashioned high-backed chair, simple, quiet and dignified." Mrs. Tenney had run a girls' school in Marietta, Ohio, with her husband Lionel Tenney (1802–1868). She bequeathed her eighteenth-century home to Smith, provided that rich and poor students would live together there in a "spirit of social equality."[8]

The portrait bears similarities to Whistler's seminal image of his mother, which Mary admired, including the white bonnet, black dress, and pale folded hands. On the background wall, Mary put in a framed oval portrait that may represent Lionel Tenney, whereas Whistler showed his own view of the Thames. Mrs. Tenney gazes sympathetically at the viewer from the embrace of her antique chair, a New England piece known as a bow-back Windsor armchair with comb. She has none of the jowly despondency of Whistler's sitter in profile, staring at her own son's artwork.

As Mary labored for Smith and sometimes for herself, Tryon relied on her but did not much notice her. And she was careful to praise him, at least in print.

Art, Her Boss's Jealous Mistress

Dwight Tryon, after an impoverished, fatherless childhood, enjoyed good fortune as an adult. As one artist friend joked, "If Tryon fell down a sewer, he would find a gold watch at the bottom."

By the time Mary arrived at Smith, the railroad manufacturing magnate Charles Lang Freer (1854–1919), a self-taught aesthete from an impoverished family in upstate New York, was amassing works by a few living painters, including Whistler, Tryon, Thomas Wilmer Dewing (1851–1938), and Abbott Handerson Thayer (1849–1921). Freer commissioned murals from Tryon for his Detroit home, and he ranked Tryon among "the greatest of American landscape painters," with a reputation that "will live forever." In 1923, when the Freer Gallery of Art opened in Washington, DC, one of the eighteen galleries was devoted to Tryon. Smith eventually used bequests from Tryon to build him a gallery there, too. (Mary had her own pleasant although less profitable interactions with Freer—see chapters 12 and 15.)

Each year, Tryon produced half a dozen canvases, sometimes spending only a day or two on each. With the proceeds from art sales and conservative investments, he told Henry, "I cannot begin to spend the money I earn."

Tryon and his wife Alice, who had no children, divided their time between a Manhattan apartment and their house in South Dartmouth. At their country place, Tryon caught fish by the hundreds, and he took mental notes on meadows and waterfronts to paint later. Tryon also fished in Maine and Canada, among other places. His winters were spent in New York, "committing fond memories of warmer days to canvas," the art historian Linda Merrill wrote in a 1990 study of Freer's Tryon holdings.[1]

During the school year, every few weeks,

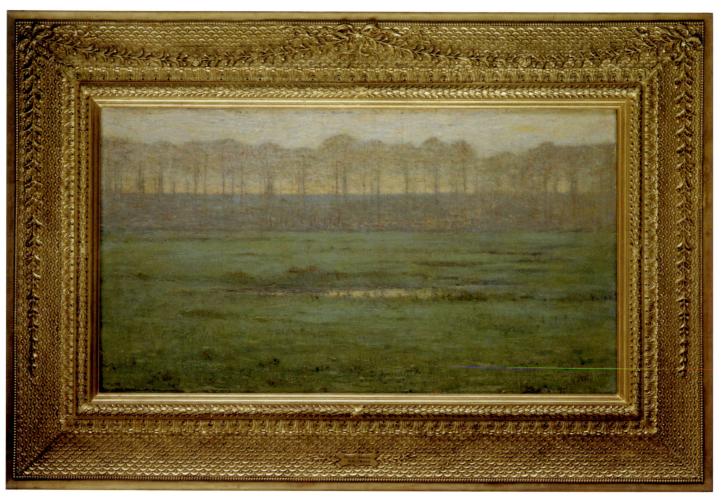

5.1 Dwight William Tryon, *Dawn—Early Spring*, 1894. Oil on wood, 20 x 36 in. An example of Tryon's signature scenes of tree groves.
THE METROPOLITAN MUSEUM OF ART, GIFT OF MRS. GEORGE LANGDON JEWETT, 1917, 17.140.4. IMAGE © THE METROPOLITAN MUSEUM OF ART. IMAGE SOURCE: ART RESOURCE, NY.

Tryon arrived in Northampton by train late on a Thursday afternoon. After settling into a hotel, he would spend the evening with friends or at the Forbes Library, a Richardsonian Romanesque masonry building completed in 1894. On Friday mornings, Tryon critiqued students for three hours (sessions that Mary apparently did not attend), and then he headed off to one of his homes or on vacation. President Seelye, meanwhile, consulted with Tryon to build the college's art collection.

In 1925, the Smith art professor Alfred Vance Churchill (Mary's successor) recalled Tryon's attitude toward school duties: "He was interested along the broad lines rather than in administrative detail, which he disliked, though he could master it if necessary. He never attended departmental meetings." An older faculty member, Churchill wrote, "used to say to me with a smile that he believed Tryon was a myth."[2] Teaching "never was drudgery or routine" for Tryon, and he mostly focused on his own painting, Henry recalled: "Tryon often said that Art is a jealous mistress, that one must give himself whole-heartedly and utterly to her. All else must give way. So he allowed nothing to interfere with his routine of daily labor." Henry was also frank about Tryon's conviction that since "women usually learn to draw with difficulty," they should aim to have a "refining effect" on their husbands and children rather than aim to become serious painters.[3]

Virginia J. Smith, class of 1907, recalled in 1926 that for art students, "the Friday of every third week was indeed a red letter day."

She described Tryon as a "short man with the keen, farsighted eyes of the seafarer, lighted with the whimsical twinkle of the great of heart." She praised his "utmost patience and a sympathetic understanding" that left the class "a-tiptoe with effort and desire for better things." In remembering what students had shown during his previous visits, "He seemed to feel instinctively the moment for praise and the moment for blame." He encouraged the women to "find our own method of expression." When asked "why he continued his trips to Smith when we were showing such poor results for his efforts," he replied that interacting with students "forces me to get away from my work and I always come back to it with a new vision."[4]

Some less flattering recollections from Tryon's students survive that were not meant for publication. He offered encouragement and "very mild criticisms" but at times grew "rather severe," Angel De Cora (1869–1919), a Winnebago tribe member from Nebraska, told a friend in 1892. (Smith's first American Indian student, she became a successful illustrator and teacher.) In 1899, the art student (and future botanical illustrator, political cartoonist, suffragist, inventor, color theorist, and birth control advocate) Blanche Ames (1878–1969) scribbled about Tryon in her diary. She found out that he had "praised my work highly" behind her back. Susanne Lathrop, an illustrator who was substituting for Mary at Smith (Mary was on sabbatical in Paris), had shared Tryon's comments. Blanche summarized them in cramped handwriting: "He thought I ought

to go on and see what I could do at art, which is a thing he almost never advises a girl to do thinking it better that she should sew & cook & keep house. At first I didn't care for his praise,—he is such a ninny—but considering that he doesn't like me—perhaps his praise means something—Miss Lathrop told me lots more he said but I can't remember it."[5]

Mary's only published writing, along with her cast catalog, was an essay in Smith's monthly about the museum's Tryon paintings, including a new acquisition, *Salt Marshes* (which Smith no longer owns). Her review shows none of her usual blunt, wry prose style. "Almost numberless are the prizes and medals which his work has received," she effused. She described her boss as "much more than a painter of landscapes; he is above all a poet of nature, and sings her moods with brush and color. All his life a most earnest student of nature, his breadth of painting is based upon most accurate knowledge. His creed like Corot's is; Truth: The first thing in Art, and the second, and the third. He studies nature unceasingly; his winter studio overlooks New York's great Park, and from May to December he is out of doors at South Dartmouth, much of the time on the sea." The silvery moonrise in *Salt Marshes* conveys "the mystery of the transition time from day to night in early summer," with "horizontal lines producing a feeling of quietness and repose." She defended him from those who considered his work monotonous: "Has the art critic who once declared with assurance that Mr. Tryon's trees were too flat, ever realized that the man who studies nature out-of-doors, may know her better than the man who studies her in art galleries?"[6]

Tryon's own papers scarcely mention Mary. But she managed to outshine her unappreciative boss in one respect: while he was fishing, she was crossing oceans to expand her horizons and meet one of her idols.

A Rare Dear Overseas

During Mary's 1891 summer trip, on a whirlwind through England, France, and Germany, she began a lifelong practice of writing home every day. Elements of her descriptions recur throughout her thousands of pages: she exulted over rough sea crossings, mocked royalty and uncultured tourists, admired men in uniform, reported on her sketching spots and passersby's fashionable clothing, and longed to have her sisters with her. She made sure the family could picture her meals, store purchases, transit rides, and visits to museums, churches, and theaters. She told her sisters of dreams that she was home—she remained rooted in Hartford, even while feeling ever more European.

Her first travelogue is also worth quoting at length because of her encounters with Whistler. And it amounts to her only illustrated travelogue; her dated sketches from the trip show the mossy stones, steep stair-cases, and unsupervised children that she was describing.[1]

Mary crossed the ocean with a Smith art school graduate, Minna Talcott (1859–1931). While watching passing ships, porpoises, and birds, Mary wrote home: "The sea makes you too lazy to even want to read. . . . If this is getting tiresome dont read any more. . . . Such lots of men have been sick. It makes me feel quite pleased at my own behavior . . . the rougher it gets the better I like it I like to get on the top of a big swell and go plunging down and up again. . . . It was so grand it made me cry." The ship, Mary wrote, "is a splendid creature. She seemed like a live thing last night 'dashing' through the waves. . . . If the rest of the trip is as delightful as the beginning it will be more than I deserve. . . . How I wish you were with me, I'd like to give you all a squeeze." She wanted Uncle Nelson, who was apparently skeptical of Mary's

To Whistler.
Dear Sir.
Will you kindly admit
to your studio two American artists who
have crossed the ocean in pursuit of
the "dainty Goddess." We have admired
from afar your work and writings and
would consider it a great favor to be
admitted received in your studio.
Very respectfully yours.

6.1 Mary kept a draft of the note she wrote Whistler in 1891. WFC.

adventurousness, to know that men onboard were weak with seasickness. Since Minna could barely leave her stateroom, Mary felt "almost heartless to be enjoying the sea so thoroughly."

On July 1, upon arriving in Chester and attending cathedral services, Mary told her sisters, "I shall never be happy till you have had the same experience. It makes me cry now to think how beautiful it was and I had hard work not to make a spectacle of myself during the service. . . . I dont know but I shall *bust with feelins* if I see much more." She reported home, "I am at last beginning to realize that I am myself and three thousand miles from home."

A boys' choir, Mary wrote, quoting Milton, was able to "dissolve me into ecstasies and bring all heaven before mine eyes." She toured the church with "the jolliest and most elegant old verger" who showed them a

"hoak" cabinet full of vases and embroideries. She joked about her breakfasts of "am and heggs"—Mary never ceased to be amused by the provincial English habit of misplacing h's. She sent home a sketch of a girl carrying flowers, labeled "Ye Henglish Child," to illustrate how English children "wear very short dresses, showing much leg and bare arms and necks, and wear great cotton bonnets."

En route to London, she was impressed to see female professionals: "All these Inns seem to be managed and served by women." London itself was "brighter and cleaner" than she had imagined, and in her first museum visits, she saw enough "to make me almost wild. . . . My mind is just full of the lovely Botticelli's and Fra Lippo Lippi's, Velazquez's and Rembrandts. . . . I think this is all more than I deserve." Her other favorite displays included "autograph letters of Kings, Queens, and noted men. I copied part of one of Browning's. . . . We do seem to be having a most successful time. I am beginning to feel at home here."

She began her lifelong practices of seeing major stars onstage—"Ellen Terry was delicious in the farce"—and critiquing men and women painters "thick as flies" at museums producing "most atrocious copies" of masterworks: "I think it ought not to be permitted. . . . You cannot imagine the horrors that were being made in front of our idols. I abhor artists, so called." Near the British Museum, she and Minna lunched at a hotel's grill room, the sort of establishment she would likely not have frequented back home: "Nice place for men. Only one other woman there."

She and Minna splurged on bleacher seats to watch Kaiser Wilhelm cross through central London en route to Buckingham Palace: "William of Germany is visiting his granny." Londoners who realized they were American "jeered us for wanting to see the Emperor. Said our independence was only skin deep."

During the kaiser's parade of carriages with bewigged footmen, "the flags of all nations swung out everywhere, our own stars and stripes among them. . . . All traffic was stopped and the streets sprinkled with something that may have been gravel or possibly gold dust. . . . The Emperor looked a little uneasy and did not bow as gracefully as he ought, but the Empress was charmingly beautiful and smiled and bowed most graciously. It was a thrilling sight I can tell you. . . . We think from the size of the crowd that turned out to see Royalty that there is not much danger of a revolution at present; but they may have been only curious." It was the first of many times that she would be unimpressed by awkward royals.

Her July 11, 1891, letter is radiant: she had asked Whistler for an audience, and he agreed immediately. The scandal-plagued master, she could not have realized, was preparing to leave London, and he had broken off contact with his patron Frederick Leyland, who owned Whistler's Peacock Room (which Freer eventually acquired). Whistler was still smarting over a lampooning portrait that William Merritt Chase, his former acolyte (and Mary's teacher), had done of him in 1885 (now a beloved attraction at the Metropolitan Museum of Art). Although by 1899

Mary would quit Whistler's Paris school in disgust, in 1891 she saw him on a pedestal:

This has been the greatest day yet. We have seen the great Whistler. We looked him up in the directory and started out bright and early this morning for his house 21 Cheyne Walk Chelsea. I had a nice note written all ready to send up to him. We found the house without any trouble and through the high iron grating saw a maid scouring the steps. We inquired if Mr Whistler lived there and found that he did so we rang the house-bell and gave our note to the maid who came to the door. I was nearly scared stiff at the audacity of our proceeding. The maid disappeared and soon a young man came and invited us into a most artistic dining room and said that Mr Whistler would be with us soon. In five or ten minutes he came in and O, he was so nice to us He was not in the least like Mr Chase's portrait of him, but entirely different from anything I had imagined. He seemed pleased and entertained at our calling upon him asked us a great many questions about our plans and was so interested and interesting, kind and jolly. He took us into his studio which is a rather unattractive room at present as they have just moved into that house and are going to build on a studio. He showed us several things that had never been exhibited and was much amused when we told him we wanted to see the Peacock Room. Gave us the address

and said "You need not let them see my writing as I have heard that they do not like me." After a very pleasant time in the studio he said, "Now wouldn't you like a turn in the garden, and he took us into such an entrancing place He seemed to appreciate it fully himself said his wife managed it. While we were walking about his models came and so we took our departure he going clear to the street gate with us and inviting us most cordially to come again on our next visit. He wore a glass in one eye and looked at us and laughed in the most bewitching way when we paid our little compliments. O, he is a rare dear, and I adore him. On our way back we stopped at Piccadilly and saw the Portrait Painter's Exhibition, where were two of our dear Whistler's paintings. They stood among the others like an oasis in the desert, and were really the only things that we cared to look at. I think Mr Tryon was quite right in warning us against modern exhibitions. . . . Miss T. says she feels like praying all the time she is so happy.

In her diary Mary tucked a copy of the note she had sent to Whistler:

Mr Whistler / Dear Sir. / Will you kindly admit to your studio two American Artists who have crossed the ocean in pursuit of the "dainty Goddess." We have admired from afar your work and writings and would consider it a great favor to be received in your studio.

Her diary description of the visit adds a few more details, starting with her arrival in "the breakfast room a most esthetic apartment in old blue and white, plain old blue carpet, table with very long cloth and set with old blue canton":

We sat on a queer old upholstered settle and awaited the presence in much awe. Miss Talcott said my eyes were as big as saucers. . . . Mr Whistler came in, broad-brimmed soft grey felt hat in hand. . . . He was all the time most entertaining and kind. Showed us an Amsterdam etching and some pastels that have never been exhibited. Three pastels of woman and child, one in blue, one in yellow and one reclining. One water-color of reclining figure. One choppy sea and one other etching. Then he took us for a walk in his most ideal garden, out of the back hall-door between brick walls overgrown with moss and vines through an iron gate, into an ideal spot A beautiful green sward in the middle with a mulberry tree, Japanese seats and stands all about a little summer-house at one side a cozy little room with a corner fire-place and all around lovely walks and plots of flowers. My wife does all this he said, she attends to the garden. He seemed to take great delight in it. There was a sort of cloister walk all around the garden and just as we were about to enter it his models came in, a dear little child and two girls. We walked around the garden and then told

him that we would take no more of his valuable time and so we went accompanied in the most hospitable way by Mr Whistler to the door and even to the very gate. He invited us most cordially to come and see him when we visit England again. He was much amused when we told him that we were going to Barbizon, Said he supposed we must have that experience, like whooping cough. He did not seem to know any American artists except Chase and Sargent. Said Chase had painted a vile portrait of him which he was sorry to say had been exhibited much. He did not look in the least like the portrait or as I had imagined him. He was a small thin man, iron gray curly hair with a most peculiar white lock sticking up in front. He wore one eyeglass and laughed in a hearty but rather nervous way. He was all that was kind and hospitable to us.

After the elating meeting, Mary visited the Society of Portrait Painters' show at the New Gallery on Regent Street: "Saw Whistler's portrait of his mother and a girl in white, the only things worth seeing. The rest of the Exhibition did not compare with our American Artists." (That patriotic observation, however, marked only a brief phase in Mary's tastes; her subsequent overseas trips inspired her to defy American critics' opinions that their homeland's art was superior.)

Mary next barged in at Whistler's Peacock Room, "the second of the two things that I had set my heart upon." In *Harper's Mag-*

azine the previous December, she had seen illustrations of "the great Leyland House" at 49 Princes Gate, with its Peacock Room and pre-Raphaelite and Old Master paintings. She and Minna left a note at Leyland's door, "a note of humble supplication, asking that we might be admitted in the afternoon. The manservant treated us very kindly, and promised to be on hand at two o'clock to let us know our fate." They whiled away the interim at what is now the Victoria and Albert Museum, seeing "more gorgeous, lovely, and priceless things than I can ever remember half of! I made a quick sketch of a charming window from a Mosque." Her pencil drawing (figure 6.2) from that visit shows a pointed-arch window from Srinagar, its shutters left tantalizingly half open.

When she and Minna returned to Leyland's place, a bewigged footman let them in, and a servant chaperoned them. She

6.2 Travel sketch, 1891. Mary drew a mosque window, its shutters tantalizingly half-open (on view at what is now the Victoria and Albert Museum). WFC.

suggested that her sisters read the *Harper's* article:

> But you can never have any idea, until you see it yourself, how beautiful it all is. We went first right up that beautiful staircase into a beautiful drawing room, I suppose, the whole tone of which was a dull gold, and on the walls Rossetti's beautiful paintings. The prints in Harper give you no idea of this wonderful beauty. There were several by Burne-Jones in this room which was divided from the next by a most unique brass openwork screen. The next room had a sort of alcove at one side, lighted from above and hung with pictures we went into a room looking out on a beautiful garden, and hung with the priceless Old Masters. The Botticellis were in this room, and an exquisite Memling, I did wish I might stay there a week and see everything. We went into the hall from this room and our attendant turned on the electric light that we might see three Burne-Jones pictures on the wall. We went slowly down the staircase, stopping to look at Circe and the Loving Cup along the way. The hall is hung with pictures, mostly Rossetti's and his portrait by Watts. We looked into the Tapestry Room and another small room and then across the hall into the celebrated Peacock Room which I shall wait and tell you about. Our man was very kind and showed it to us by daylight and electric light. We wanted to stay all the after-noon but as we knew that was out of the question we gave our man a slight token of our appreciation and tore ourselves away. I assure you we felt very much elated at our visit.

Mary's diary entry for the Leyland visit identifies more paintings, and she reports of the Old Masters gallery: "Such an air of repose in it all. It was a room to be quiet and dream in." In the Peacock Room, she wrote, "The man closed the three shutters of the room and turned on the electric lights. It is a most gorgeous room."

On the trip so far, she told her sisters, "We have not yet been crossed in a single desire."

The rest of Mary's weeks in and around London went by in a blur of hotels, churches, castles, third-class train rides, museums, and after-dinner hours writing home: "We are scratching away now by the brilliant light of two tallow dips." Of the church vergers tipped to give tours, there was one who "did not show us anything that we had not already seen," but another amused her as he "recounted the list of all who had passed away in his time." She became a critic of sanctuary interiors, too. St. Helen's Bishopsgate, built in twelfth century, seemed "a queer little affair with a very strong odor of sanctity." Temple Church was "the cleanest place we have found in London." At St. Paul's, "a bad echo spoiled somewhat the effect of the music." She sketched a twelfth-century Norman arch at St. Bartholomew-the-Great (figure 6.3), with a plane of sunlight visible beyond massive columns and gloomy alcoves.

The baker's daughter dismissed some major tourist attractions. Dulwich Picture Gallery's collection "is very valuable but there were few that were especially interesting to me. No fine examples of the early Italians." She encountered a "head-waiter inclined to be snifty" because she preferred sightseeing to eating. She was annoyed at having to check her bags at the Tower of London: "This performance has been in vogue since the dynamite scare about four years ago," she wrote (referring to threats from Irish independence fighters, and foreshadowing modern complaints about antiterrorism measures).

She ran into acquaintances, including the Hartford journalist and Twain collaborator Charles Dudley Warner (he and his wife Susan had been supporters of the Art Society) and President Seelye. Mary called her boss by his popular nickname: "Prexie seemed quite pleased to see us, said he thought we were in Holland!" (Other Northampton women artists did go to Holland at that time, including two sisters who eventually taught at Smith, Susanne and Clara Lathrop.)

Mary wondered "a dozen times a day" what her sisters were doing at Penfield Hill: "I think I shall have to get a Ouija board to find out." She jokingly warned that she might not come home, given her urge to dress up in "fetching" men's uniforms: "I am just gone on the military any way. If I dont turn up on time in September you may know that I have joined a regiment."

On July 20, Mary reported that the English Channel during their crossing had been "as calm as a stone saint. I think it has been

6.3 Travel sketch, 1891. Mary revealed a plane of sunlight beyond an archway at St. Bartholomew-the-Great church in London. WFC.

Norman Arch.
St Bartholomews the Great.

maligned and henceforth I am its devoted champion." In Calais, she wrote, "At last I feel like a stranger and wanderer." Her sense of smell was offended—as it often would be on the Continent: "The gutters are used as sewers, so the air is not really ambrosial." Upon stepping into provincial French cathedrals, she longed for the removal of "glitter and artificial flowers" and other "gaudy modern atrocities." She was appalled at France's

Third Class.
Chartres a Le Mans.

Mary R. Williams

6.4 Travel sketch, 1891. A young train passenger captivated Mary on the road. wfc.

6.5 Travel sketch, 1891. A trellised plant snakes between windows in Mary's view of Millet's house in Barbizon. wfc.

Mary R. Williams
Barbizon July 29.

"barbaric and heathenish" practice of decorating hearses with "hideous emblems of black and white beads." At Chartres, she encountered the "strange sight" of a priest chanting throughout a funeral while "all the congregation sprinkled the casket with holy water." On the train to Le Mans, she sketched an old priest (figure 6.6) asleep alongside his bundles. She began her lifelong practice of sitting through Catholic Mass at several churches on Sundays, admiring "priests in gorgeous gold embroidery" and "clouds of incense rising over it all." She never tired of complaining about French parishioners gathering offerings in "a continual jingle of sous and centimes" and pew space wasted on "impolite Americans who talked and consulted their Baedekers."

6.6 Travel sketch, 1891. An aged priest dozed in a train car, unaware that Mary was sketching him. WFC.

6.7 Travel sketch, 1891. Mary drew Saint-Malo doorways framed in Ionic pilasters and crowned in scallop shell carvings. WFC.

A week in Paris left her almost feeling at home: "Si vous pouvez voir votre soeur Polly, la prosaique dans la belle Paris, what would you say? And talking French too." She made enough progress in French that Minna, who was relatively fluent, "is not afraid to trust me alone anywhere." Mary made trips "all alone to the Louvre. What do you think of that? I had a pleasant time with my early Italians.

. . . I saw some most beautiful frescoes by Botticelli, the actual piece of wall brought from Italy. O! They are so beautiful! . . . I have been three times and have not seen the Venus de Milo yet. . . . I have made myself a present of an autotype of two of the figures in my favorite Botticelli fresco. I thought I could afford it as I bought no Paris clothes." Her other Louvre favorites included Giotto

6.8 Travel sketch, 1891. Mont Saint-Michel's layers of archways seem to have left Mary pleasantly disoriented. WFC.

6.9 Travel sketch, 1891. Mary captured low-slung commercial buildings amid Mont Saint-Michel's monumental religious fortress. WFC.

6.10 Travel sketch, 1891. Potted plants add a domestic touch to an unmarked recessed doorway at Mont Saint-Michel. WFC.

6.11 Travel sketch, 1891. Steep gables and steps adjoin Mont Saint-Michel gateways. WFC.

frescoes ("Beautiful as a dream"), Millet's *The Gleaners*, and a Constant Troyon tableau of cattle at dawn, which perhaps reminded her of Connecticut pastures.

At Notre-Dame, she was relieved to find "none of that tawdry glitter that we saw in Amiens." She was amused to see "a most ambitious artificial waterfall" in the Bois de Boulogne, and regal facilities set up at a railroad terminal for President Marie François Sadi Carnot (who would be assassinated three years later by an Italian anarchist): "He had a crimson carpet spread down for him at the station, a private waiting-room elegantly furnished. This is a republic, Aha!"

As in England, where she was surprised that women ran hotels, she marveled at male hairdressers in France. When a hotel keeper sent over someone to wash Minna's hair, the two Americans, accustomed to female company, were not fully dressed when there was a knock at the door: "To our horror a *man* stuck his head in and was speedily invited to wait a few moments on the other side of the door. The whole performance was very entertaining."

She complained about hotel soup that "tasted as if it would be good to mount photographs with" and pined for Connecticut's "succotash, corncakes, summer squash, and all the delicacies of the season. Do eat an extra portion for me." She bought brushes and paints and presents for her sisters at Bon Marché, "squandering our money." Letters from home, which a bank was supposed to forward to her, were stuck in limbo—"It is dreadful to be so long without them"—and she

looked in vain for the *Hartford Courant* at Paris reading rooms. When the sisters' misdirected envelopes finally arrived, she wrote, "I would like to punch the head of the Cheque Bank."

Minna began to get on her nerves. A letter page is marred with words crossed out: "Miss T. is talking to me, that is why I make so many mistakes." Minna had misplaced so many possessions, including a raincoat, that "she has lost all confidence in herself and has forty fits a day over imaginary losses." Minna was horrified when Mary talked to a man on a train, who was identifying passing birds: "She said she should send for my sisters if I flirt with any more Frenchmen." After Mary overheard piano music at a convent, she wrote home, "I would like to hear the Misses Williams give a little musicale, and I might assist if I was pressed. I am a great trial to Miss T. because I sing before breakfast." (The family was somewhat musical: Mary could play piano, and Laura eventually trained as a lieder singer.)

Minna was useful, however, at helping Mary stay within her budget: "She wishes me to save for another trip." Although the sisters worried that beggars had tugged at Mary's heartstrings, "Miss T. keeps a sharp eye on me and scoots me by the mendicants." Minna also dismissed porters offering services, telling them "with some spirit and in plain French that we knew what we wanted and they could 'git.'"

Mary ventured out, usually without Minna, to draw scenery, and she paid villagers a few sous to pose for her. At Barbizon, she sketched Millet's house, with a trellised

plant snaking between shuttered windows. At Fontainebleau, she found "wild rocky places like great expanses of Uncle Nelson sheep-pasture. . . . I could imagine that I was not far from Penfield Hill and would soon see you all. That was very pleasant." In Breton slums that left her with "a very bad heart-ache" she sketched a "dear dirty little model." During the session, "one of her comrades appeared in quick spotless condition and hair most agonizingly dressed in would be curls, evidently wishing to serve as model also." Mary felt conflicted about admiring the architecture and inhabitants despite the filth:

O, such wretched houses—but so "picturesque." You cant imagine how quaint and odd they were, the mullioned windows full of flowers in bloom. It made my heart ache to see the babies toddling about on those steep stones. We met one dear little girl carrying a great water-jar and she agreed to pose for me this afternoon. . . . The little girl met me according to appointment and I worked at her for about an hour. I had an admiring circle before I finished, seven very dirty children and an old woman and a baby. The old woman planted herself calmly between me and my dear little model. I think she wanted to be "took" too.

At one point Minna shooed away "an old beggar" who "came up and struck a most picturesque attitude near me." While she sketched a house, she found herself "surrounded by an interested crowd of the cutest dirtiest children you ever saw. . . . One small boy kicked over my water in his attempt to get quite near. How scared he looked! He ran to the pump like a little spider to make good the loss." As she finished that session, "There was a slight shower and one of my audience held my umbrella over me." Passersby asked if her folding stool was from Paris: "I told them with great pride that I bought it in Amérique!"

In Dinan, she drew Saint-Malo church's twin doorways topped in scallop shell carvings. In her sketch of Saint-Jacut, serene parkland takes up much of the foreground, at the base of abbey spires. She took out her watercolors at low tide, observing Saint-Jacut's stranded sailboats: "I sat down on the rocks and began a sketch, but had done very little when the tide began to come in and soon my drooping boats were erect and bobbing up and down merrily." She saw three rainbows in one afternoon, and she had "a most novel experience" of hiking up her skirts and walking barefoot "a mile and a half across the wet sands. . . . It was great fun in spite of the broken shells. . . . The hardest walking was where the sand had been furrowed by the waves and it was like corduroy."

At the coast, the future writer of thousands of pages approached a loss for words: "Quaint, queer, interesting, charming, wonderful, très-joli, très-gentil, très-merveilleux and fifty more adjectives are not enough!" Four of her Mont Saint-Michel sketches survive, giving a sense that she was pleasantly disoriented along the narrow stairs, recessed doorways, and layers of arches.

She wrote home about "women washing

clothes in the streams, and doing all sorts of work in the fields," as well as cute babies in train cars, including "a perfect beauty that I could not take my eyes off." (Mary was a lifelong admirer and sketcher of children, although she made fun of herself for not helping raise any, unlike her sisters in Hartford—see chapter 14.) While watching peasants and tourists dancing around a bandstand, illuminated by candles hanging from wires, "I laughed till I was weary."

Still, travel had downsides. She found fleas on her clothes, and she used cologne to mask smells in trains and slums. When they fled one malodorous hotel early, Minna told the proprietor "that I was an artist and had not found what I expected to at Granville." French people stared at them: "I feel sometimes like passing around my hat and think I might get enough for our expenses."

Home was always on her mind. The Rance river "winds about like the Connecticut and is not a bit more beautiful, rather different in detail however with its castles fishing boats and quaint houses." Her sisters praised her descriptions: "I am quite overwhelmed with all the taffy I get as to my poor letters." In between coastal towns, she wrote, "I dreamed last night that I was on Penfield Hill and had promised to go to ride with Dave [her farmer cousin] this afternoon, and was very much worried because I did not see how I could do it and go to St. Jacut." She wanted to make her uncle Nelson a version of the "very becoming" blue pinafores worn by French road workers.

She wanted to buy her sisters a market full of flowers, and she devoured the *Courants* they sent, "even to the advertisements."

In Germany, given Mary's fondness for Prussian soldiers, Minna ended up "afraid she will lose me entirely." Mary scorned the excess of images of the kaiser, "in plaster, paint, chromo and photograph." Berlin museums "have a way of restoring and varnishing that I do not approve of," but she did deem a Botticelli or two "a perfect wonder" that "carries me far away." The Cologne cathedral looked "monotonous (made by the yard and cut off in lengths to suit)." She pitied zoo animals in a heat wave—"I would have been pleased to let out all except the man-eaters"—and overheard Americans spouting "conversation on finances and matrimony that was almost too much."

In late August she promised to head for 1492 Broad "as soon as the Custom House fiends let me in." She started planning to rework her hats and clothes, to make them "more serviceable for the fall." In her diary she recorded the return ship's violent rolling ("Glass and breakables smashed in all directions"), the color of the sea ("Deliciously blue. The most luminous exquisite tone") and how she entertained another passenger, the Indianapolis artist and educator Susan M. Ketcham, with travelogue: "Read Miss Ketcham my diary in the p.m." Ellis Island records for the trip show that Mary and Susan Ketcham proudly listed "Artist" as their profession.

Wholly in Pale Tints

Mary's first sightings of Europe, which made her "almost wild," helped her make inroads in the art world. She impressed New York critics with paintings and pastels shown at the American Fine Arts Society on West Fifty-Seventh Street, which also contained her alma mater, the Art Students League. By 1894, an image of her work had been published for the first time (and only time, in her lifetime). The praise never went to her head—her letters scarcely mention that her name appeared in print.

In February 1892, she exhibited for the first and apparently only time with the American Water Color Society in New York. She asked thirty dollars for *Old House at St. Jacut, Bretagne* and twenty-five dollars for a Nantucket landscape, *Twilight at Sconset*. Her prices were at the low end of the show's offerings—and they never rose much in her career (a handful of her oils were eventu-

ally listed at a few hundred dollars each). In the early 1890s, she had made a number of trips along the Massachusetts shore. Sketches dated 1892 depict Marblehead shorefront scrub and water views that she later turned into *Moonrise Provincetown* (figure 7.1) and *Marine with Sailboats* (figure 7.3). Mary had traveled to the beaches, Abby told their friend George Dudley Seymour (see chapter 8), "for the sole purpose of making some sketches." Mary, then, can be considered a pioneer artist on Cape Cod; not until 1899 did the painter Charles Webster Hawthorne set up a formal art school in a Provincetown barn.

She was drawn to the Cape's weathered structures hunkered down on windswept, sandy slopes—they bore some resemblance to the arid terrain that would later fascinate her in Italy. She also captured shattered reflections of buildings, hills, and marine craft in Massachusetts waters, motifs that would

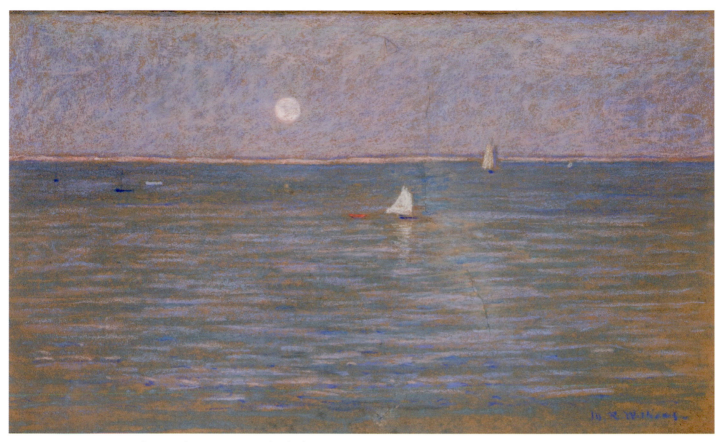

7.1 *Moonrise Provincetown*, 1892 pastel, 11 x 20 in. Mary sketched at Cape Cod long before formal art schools and colonies were created there. WFC (PHOTO: TED HENDRICKSON).

7.2 Sketch for *Moonrise Provincetown*. WFC.

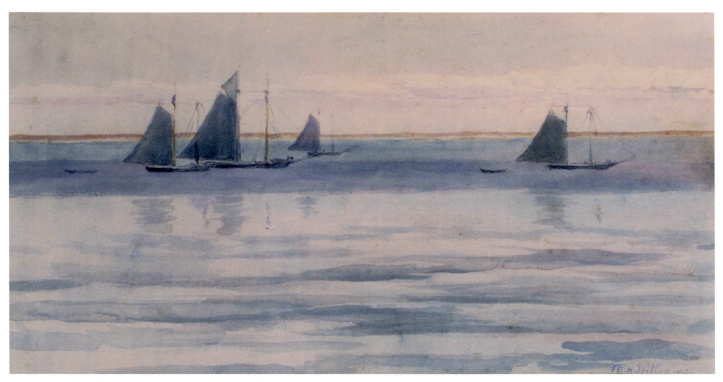

7.3 *Marine with Sailboats*, 1892 watercolor, 10 ½ x 20 ½ in.
WFC (PHOTO: TED HENDRICKSON).

7.4 Sketch for *Marine with Sailboats*. WFC.

recur in her works sketched at French chateau moats, Venetian canals, and Norwegian fjords.

In December 1892, she sent seven works to the New York Water Color Club's exhibition, including portraits of women and views of Provincetown and Connecticut. The *Critic* singled out her pastel of a girl in white as "worthy of special notice." The *New York Herald* described her pastel of a seated young lady wearing black as "distinguished and artistic, delightful in color and in its suggestive handling." The *New York Press* praised Mary's "charming bit of color and handling" and noted the "exceptional value" in general of the women's artwork on hand, since the "gentler sex" was particularly drawn to and skilled at using watercolors rather than oil. The *Herald* similarly reported that in the exhibition, "The women make a remarkably fine showing."

Condescending mentions of women's accomplishments were common in art reviews of the time; the writers, mostly men, were reacting to a wave of women's paintings on display. The New York Water Color Club had been founded in 1890—the same year as the New York Woman's Art Club, which Mary joined—as a female-friendly alternative to the American Water Color Society. That society, established in 1866, had been long resistant to exhibiting women's work, and it allowed only a handful to become members.[1]

In the 1892 Water Color Club show, the *Art Amateur* ranked Mary's *Connecticut Pasture* among "many excellent landscape studies." The reviewer described the work's "expansive foreground of rolling green hills and bolder forms in the distance." Mary particularly favored the format, with a high horizon, for Connecticut views (see chapter 2), such as *The Tree* (shown at the 1899 Paris Salon) and *Hills*.

Late in 1893, Mary sent six pastels—two landscapes, one of them titled *Rolling Ground*, and four portraits, including two of women in white and one of a young man—to the New York Water Color Club. Her reviews were mixed, and by then her prices, for unknown reasons, had dropped to the range of fifteen to twenty-five dollars. The *Critic* called *Rolling Ground* "excellent" and speculated that "her aim has been to produce an effect of relief with as few tones as possible." The *New York Sun* described her as "a new comer of distinct talent" who produced landscapes with "hazy, silvery light and delicate sentiments" and portraits with "character, well expressed and preserved . . . under a smoky veil that hangs like a dream of sea fog over the surface of things." The *Art Amateur* ranked her contributions among "the best examples of what promises to become the prevailing fashion. They are wholly in pale tints, so cleverly managed as to give quite satisfactory relief and sufficient variety of tints, though perhaps not one third of the range of her color-box has been utilized." The *New-York Daily Tribune* described her drawing style as "timid" and her colors "so pale as to be watery," but the writer also found "a suggestion of originality" that could "eventually be productive of good art." The *New York Times* misspelled her name as Mary A. Williams and summarized her portraits as "curious in their shadowy quality."

7.5 *A Friendly Sitting*, undated (pre-1894) pastel, 17 ½ x 10. PRIVATE COLLECTION (PHOTO: KAREN PHILIPPI).

The 1893 show sold well; *Rolling Ground* (whereabouts unknown) brought twenty-five dollars.

In early 1894, Mary gave her first and apparently only press interview. Her friend Elizabeth W. Champney wrote briefly about dozens of female painters in a thirteen-page feature, "Woman in Art," in the *Quarterly Illustrator*:

> Some of the most talented of the women of the day are among the youngest, and some who have never profited by the European schools have yet found their own expression in a most acceptable manner. Mary R. Williams is one of these; an artist with rare poetic instinct and feeling. Her pastels and water-colors have been received with enthusiasm by the New York Water Color Club when those of many an old professional were rejected. She is a woman of conscience as well as feeling, and of a fine scorn for all shams. When asked what style she proposed to adopt, she replied: "If I cannot have a style of my own, I trust I may be spared an adopted one."

The article included a line drawing of Mary's pastel portrait *A Friendly Sitting* (figure 7.5), of a pensive, seated young lady in a high bun with a book or papers in her lap. Mary rendered the ruffled gown in soft pink and blue squiggles, which contrast with the glossy black chair. Simple strokes suggest the floorboards, and a hint of a doorway and wainscoting add depth.

By the time the story appeared, Mary had attracted her first major patron.

7.6 *A Friendly Sitting,* Mary's only published artwork, appeared in *The Quarterly Illustrator* in spring 1894. AUTHOR'S COLLECTION.

He Certainly Is Unregenerate

George Dudley Seymour (1859–1945), a patent lawyer in New Haven, was a meticulous workaholic who practically never threw out a piece of paper. He knew intellectuals far more famous than Mary, including the artists John La Farge, Bela Lyon Pratt, and Cecilia Beaux, the architect Cass Gilbert, and the landscape architect Frederick Law Olmsted. He considered Mary important enough to commission at least three portraits from her. He owned two or three more of her landscapes and portraits, and he tried to keep them on public display.[1]

Dudley, as Mary sometimes called him, had likely met the sisters at Hartford Public High School. (They were related by marriage—Aunt Eleanor's mother-in-law was a Seymour.) In addition to his law practice, he advocated for the preservation of open space and historic buildings, collected Connecticut furniture, and researched genealogies and the Revolutionary War martyr Nathan Hale. Dudley practically became obsessed with Hale; he bought and restored a Hale family home in Coventry, Connecticut, and had Hale immortalized in bronze statues (designed by Pratt) and even a postage stamp. (In 2015, Seymour descendants gave Mary's 1897 full-length portrait of him—see figure 8.1—to Connecticut Landmarks, which runs the Hale museum in Coventry.)

Like Mary, he was fascinated by Italy and traveled there—some friends even nicknamed him Giorgio. "Casa Bianca" was his name for his Italianate house built in the 1840s in New Haven.

In 1889, when he started becoming "a frequent visitor" at the Williams house on Broad Street, he scribbled a note to himself: "I like Miss Mary very much." He asked the Williamses for some paperwork related to a mutual friend's wedding, which he apparently

8.1 *The Connoisseur*, 1897. Mary painted her New Haven-based patron George Dudley Seymour, gazing down at a thin-necked Chinese vase in his hand. Oil on canvas, 22 x 18 in. CONNECTICUT LANDMARKS (PHOTO: JOHN GROO).

8.2 Undated sketch. Mary depicted an eighteenth-century New England home—the kind of buildings that Seymour advocated to preserve—with a fanlight and sidelights around a doorway below an equally elaborate window. WFC.

8.3 Undated sketch. Mary created a still-life of New England antiques from the seventeenth and eighteenth centuries, the kinds of objects that Seymour collected. WFC.

wanted for his genealogy files. Abby told him that her stoic Yankee family, while searching for the elusive document, "came as near being thrown into consternation as they ever allow themselves to be." She warned him, "We, the Williams Family, always destroy our letters." (She may have been teasing—if that statement were true, this book would not exist.)

The sisters shared his interest in Americana. In Mary's portraits, she carefully rendered the contours of vernacular chairs. Abby told him of the family's amusing encounters with "the 'Cromwell thieves'—the Prior brothers," Connecticut antiques dealers notorious for fobbing off stolen goods and reproductions; they had promised her "be-e-utiful things." Mary's sketches (figures 8.2 and 8.3) include close-ups of New England

architectural ornament and a still life of a New England carved chest, a turned-wood armchair, and a pair of andirons with silhouettes of eighteenth-century Hessian soldiers.

In the summer of 1892, Abby and Mary visited Dudley in New Haven, but he was too preoccupied with work to spend time with them. Mary was mortified: "She made herself positively unhappy about it for two whole days—for if there is *one* thing that she hates to do, it is to intrude," Abby told him. Abby described herself as "so '*emancipated*'" that she mainly felt "awfully sorry that you have to work so hard." (Abby comes across in her few surviving letters—all of them to Dudley—as cheerful and more efficient than her artist sister. Little else is known about Abby except for her *Courant* obituary de-

scription: "Noble, warm-hearted, faithful, self-forgetful and widely sympathetic, she was also a fine and accurate scholar, of fine taste in music and art.")[2]

Mary offered, by way of apology, to paint Dudley's portrait based on a photo he had sent them years before: "You were taken in a famous old coat—very dim & interesting," Abby recalled. Eleanor had compared his image to "the mummy of Ramses II." (Over the years he posed in a dramatic cape for numerous portraits and photos, including paintings by Beaux.) Dudley instead asked Mary to paint a portrait of his mother, Electa, based on a daguerreotype; she had died when he was a teenager.

Abby wrote him from Penfield Hill that Mary would start on it soon, although she had a backlog of paintings promised to friends and family, "which she is always going to do 'when she has time and feels just like it.' Last week a sudden spasm of industriousness came upon her, and she actually made a sketch for me that she has been promising me for years—a pastel, of the view from my window here. . . . And now she is gone off to Cape Cod, till College opens. She seemed to feel that it was her duty to do some real work this vacation, & she has gone there for the sole purpose of making some sketches. It is simply impossible to work in this lovely lazy place: —there are too many ways for having a good time here." (Among other distractions at Aunt Willie's farm, the sisters would sometimes spend hours on dawdling trips to the post office.)

That "lovely lazy place" in Connecticut

also appealed to Dudley's preservationist side—he eventually bequeathed funds for the state government to set aside hundreds of acres in the region as parkland. One of the reserves, George Dudley Seymour State Park, is a few miles from Penfield Hill.

Mary told Dudley that she would have "a good time working from" the daguerreotype of his bonneted mother: "Would you rather have something just as it is, with the bonnet— or without the bonnet? I may not be able to get anything satisfactory out of it, so be prepared for the worst."

While she spent months painting Electa, Mary updated Dudley on art world gossip. Freer was competing with the New York lawyer Howard Mansfield, she wrote: "If Mansfield gets a new Whistler Freer is unhappy until he has one too." She had curtailed some sketching trips: "Abby has been quite sick and does not get well very fast, and I dont think I can be away very much." (It is not clear when Abby was sent to the insane asylum.)

In January 1894, Mary invited him to see her progress on Electa: "I'll not make you take it if you dont like it. . . . I have taken several liberties with it that may not be as pleasing to you as they are to me. That is, I have not exactly copied details." Seymour did take the portrait (whereabouts unknown), although he apparently thought it did not look enough like Electa. Mary reassured him: "You must get well acquainted with it and try to look at it from my point of view—that a portrait should always be what the original suggests to the painter, and not a colored photograph. Do you remember what Emerson

8.4 Bust portrait of
Seymour, 1894 oil
on canvas, 22 x 17 in.
CONNECTICUT HISTORI-
CAL SOCIETY, 1945.1.13.

says in his essay on Art about portraying 'the struggling original within'?"[3] Mary's Smith colleague Emily Norcross (later Emily Norcross Newton) offered to take Electa's portrait if he rejected it. When he offered to pay for it, Mary refused: "I think it is very unkind in you to continue to mention that—to me—most unpleasant subject. . . . why cant you accept it gracefully." She had already accepted his gift of some shimmering Scutari velvet from Ottoman lands: "I am enjoying that as much though I am haunted by the thought that you really ought to keep it yourself. . . . It is beautiful and so unique." He had also given her career advice, which she rejected: "Your suggestion of an agent is amusing. I never bother my head about selling my pictures and dont like to think about it."

Whatever his feelings about the liberties she took with Electa, he offered to buy more of her paintings. She meanwhile worked on portraits (now lost) of President Seelye's wife Henrietta Chapin Seelye and a Seelye niece, Cornelia Chapin Moodey, Smith class of 1890, who later became a painter—Mary nicknamed the girl "Miss C. Highbred." Seymour hoped to acquire the girl's portrait, but Mary was not sure the family would agree. She decided to "give Mrs Moodey a good long day of grace and then I shall do what I please with the picture." (Among Seymour's now-lost paintings by Mary was a portrait of a Smith girl in pink, identity unknown.)

Around 1894, Mary painted a bust portrait of him, which he eventually gave to the Connecticut Historical Society (figure 8.4). In 1896 he lent portraits by Mary (it is un-clear which ones) to the Society of American Artists and the Pennsylvania Academy of the Fine Arts. In 1897, at her Hartford home, he posed for a full-length portrait (figure 8.1), gazing at a thin-necked green Chinese vase in his hand. Above him floats a Seymour family crest with angel wings and a motto, "A L'Amy Fidel Pour Jamais." Both of Mary's surviving portraits of him have background colors layered into iridescent greens. The image of the pale, bearded intellectual seems to have been almost an excuse for her to entertain herself mixing whites, pinks, blues, and yellows.

In one of Dudley's scrapbooks now at Yale, he pasted a black-and-white photo of Mary's full-length painting and wrote a slightly catty caption: "The picture was to be called 'The Connoisseur.' It was a fine likeness, but out of proportion as to my figure. I am sure I should be a six footer on my feet as thus portrayed."[4]

In 1898, at the beginning of Mary's Paris sabbatical, she responded to a startling suggestion from Henry White's wife Grace: "I'm surprised Grace that you are so anxious to marry me off. I really couldn't take Mr Seymour even to please you and I've no doubt he would say the same thing about me. Yes, he certainly is unregenerate."[5]

Whatever she meant by "unregenerate"— a hoarder? a confirmed bachelor, possibly homosexual? a workaholic impossible to live with?—Mary and Dudley stayed in touch until her death. His gift of Scutari velvet remained in her estate. (See chapter 28 for details of his fond memories and attempts to exhibit her work.) And in 1894, she went to see his beloved Italy for herself.

Strange and Beautiful Things

In the summer of 1894, Mary discovered Italian towns, villages, and cypress groves that became signature images of her career, on the road with Laura and their friend Minna Talcott. Mary and Laura wrote to Abby at the asylum, reassuring her that she would recover. Mary asked Lucy to "keep Abby's letters till she is well enough to open and read them herself." It is not clear whether they knew they were sending home false hope.

Mary apologized to Abby for having slipped away without informing her of the travel plans: "We are glad you took our base desertion so philosophically . . . we could not bear to tell you and have to say goodbye. . . . When you get real well and strong we must bring you over and show you all the strange and beautiful things."[1]

That summer, while Mary modestly worried that her letters were read aloud to "more people than care to hear them," Laura added more anecdotes to the pages, "for my share of the literary work." She tried to cheer up Abby, using Mary's family nickname: "Polly tells stories about me, doesn't she?"

During the crossing, Mary sketched a swaddled baby in steerage, "done up in regular bambino style," and was unimpressed by an aristocratic passenger: "There is a Count with us, but he hasn't many teeth and his knees are bad." Minna was felled by seasickness, as usual. Laura mocked her sister's fondness for soldiers onboard: "Polly is again struck by the stunning appearance of the German officers."

Minna and the sisters worked their way from Gibraltar ("a queer beautiful place creeping up the rocky sides of the mountain") to Genoa, Pisa, Florence, Venice, Milan, the South of France, Paris, and London. The letters could barely keep up with the new sights and sounds.

9.1 *Grand Canal*, c. 1894 pastel, 11½ x 17 in.
WFC (PHOTO: TED HENDRICKSON).

While collecting dried flowers in Genoa's Campo Santo cemetery, Mary concluded, "The monuments are exceedingly realistic, and are pronounced wonderful. We think the wonder is that any one should want such hideosities." At Pisa, Benozzo Gozzoli's faded frescoes seemed "as beautiful as pastels." When Laura sang a note inside Pisa's cathedral, "we heard a choir of angels answer back." In Florence, they stayed at the Lucchesi pension, where Mary would return often (it was there, in 1907, that fatal tumors overcame her). Florentine doves "sit on your fingers and eat out of your hand," and her own restaurant serving of stacked rice and chicken "looked like a fortified tower of the 14th century." The Lucchesi adjoined a barracks, and Mary enjoyed the view of hundreds of soldiers bathing together in the Arno.

Venice especially captivated her, and she advised Lucy to "be very thankful" for any letters from there. Pen Browning, the artist son of the poets Robert and Elizabeth (whose grave Mary had visited in Florence), was spotted boarding a gondola: "We could not distinguish much but a pepper and salt suit, but we have the satisfaction of knowing that our eyes rested for a moment on 'The Browning.'" She sent home a drawing of oval pearl and diamond earrings in vogue among Venetians. When a flirtatious gondolier learned that his American passengers were unmarried, "I think he would have proposed if he could have decided which one to take. . . . He insisted on seeing all my sketch book." At the feet of Carpaccio's saint portraits in Venice's San Giorgio degli Schiavoni, "I nearly stood on

my head with delight." San Giorgio Maggiore had doubtful Bellinis on display alongside a "ghastly array" of wax heads of Franciscan friars. Laura meanwhile found Venetian fleas "promenading up and down Polly's backbone," and Mary tired of the region's "sauciest most persistent little beggars you ever saw. Well, every one begs here. It is not safe to admire a pretty baby on the street, the mother immediately puts out her hand for a sou."

When Mary left behind Venice's canal streets, "Solid ground seemed so unattractive and the horses looked so prosaic." En route to prosaic Milan by train, she consoled herself by studying a widowed passenger, "a most bewitching, round, fat beauty, in beautiful new mourning. . . . Such gestures and rolling of her beautiful eyes, such shrugs." The Milan cathedral "sadly needs a good New England housecleaning," and "an old codger in every church" sought payment for unlocking doors. Equally irritating were the usual misdirected luggage and letters. American tourists, "tired out and sick of seeing things," would ask "why we were wasting so much time here" and declared "there is nothing here finer" than Hartford's churches.

The sisters bought Abby a set of Browning poems, and they tried to help her picture Europe. "The light this morning is very weird just like that yellow day that we had once upon a time," Mary reported to Abby. Mary and Laura were homesick enough to jokingly wish that Lucy had the supernatural powers of believers in Theosophy (a mystical religion founded in New York in the 1870s) "and could transport your astral bodies

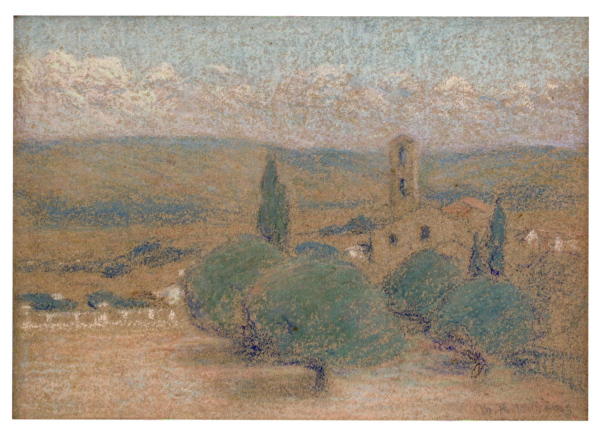

9.2 *Assisi*, 1904 pastel, 7 ½ x 10 ½ in. WFC (PHOTO: TED HENDRICKSON).

hither (without expense!)." Laura had a dream about being at home, sitting in silence because "we had written so much there was nothing left to talk about!"

About fifteen of Mary's pastels of Italy are known to survive. They depict, among other attractions, Assisi's cathedral (figures 9.2 and 9.3), a Venice canal (figure 9.1), Siena's spires and passageways (see chapter 18), Arezzo's cathedral interior (figure 9.7), the hills beyond Fiesole's Roman ruins (figures 9.4 and 9.6), Florence's San Giorgio gate relief

of the saint on horseback battling a dragon (figure 9.5), and all manner of cypress rows. Her letters, exhibition reviews, and family papers mention now-lost landscape pastels of Florence's Arno banks and the Naples harbor, among other subjects. Her palette for the Italian views ranged from dusty copper on San Giorgio's shadows and tawny gold on Fiesole hillsides to teal in Siena skies and plum along cathedral niches. She rendered vegetation and terrain in quick strokes, and added flicks of white and pinkish-red to suggest

9.3 *Assisi* (also called *Church in Assisi*), 1904 pastel, 6 ½ x 9 ¾ in. WFC (PHOTO: TED HENDRICKSON).

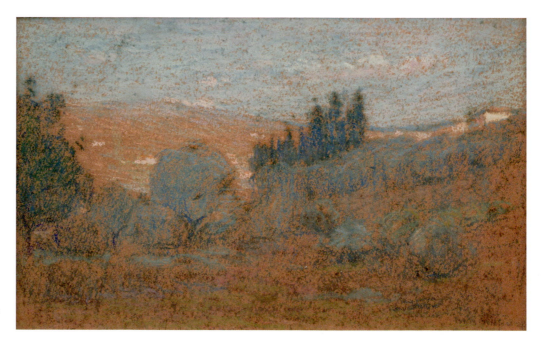

9.4 *Fiesole*, 1904 pastel, 6 ½ x 10 ¼ in. WFC (PHOTO: TED HENDRICKSON).

stucco walls and tiled roofs. In her close-ups of buildings, there is often a dreamy lack of detail, as if she were remembering the scenes through veils of church incense.

Many of the works are not dated, so it is difficult to determine whether her style grew more abstract. *Grand Canal* (figure 9.1) may have been executed in 1894, around the time she and Laura were "anchored in a gondola near the Lido." Mary's patchwork of windows and doorways is reflected in waters that the art historian Amy Kurtz Lansing has described as "a series of colored dashes."[2] Henry considered Mary's take on the subject "entirely personal and original, and not at all reminiscent of other pictures of Venice."[3] Over the years, in fact, he and Mary both developed a horror of artists who fell into ruts by painting salable views of gondolas afloat.

But in late 1894, when she exhibited scenes of Florence, Venice, and Fiesole, plus one portrait at the New York Water Color Club, critics were not impressed.

The *Art Amateur* misspelled her name as Mary M. Williams and described her as part of a movement "trying just now either in water-colors or in pastels to see what may be done with a slight scumbling of color." The author liked her contribution of a "profile of a handsome young woman, correctly drawn and not lacking solidity, though so slightly treated," but deemed her Arno scene "less satisfactory." *Vogue* considered the show unfair to club members, since nearly a third of the 216 works came from nonmembers. The unnamed author asked, "How comes it that when members of the club were crowded off the

9.5 Untitled, undated pastel of San Giorgio gate relief in Florence, 8 x 6½ in. WFC (PHOTO: TED HENDRICKSON).

walls a non-member, Mary R. Williams, has five accepted sketches?" (The only club Mary joined was the New York Woman's Art Club.) The *Sun*, which had called her a "new comer of distinct talent" in 1893, decided that the latest works by Mary and by Arthur B. Davies (he was then newly returned from Europe and inspired by Puvis de Chavannes's chalky palette) were both "of disputed quality." While some artists were predicting that Davies's pictures "will be recognized a few years hence," others admired Mary's "slight and sketchy methods" that "may pass for breadth." Still, the reviewer conceded, her work was "undeniably clever."

Mary had more luck with journalists the following May, when the Art Association of

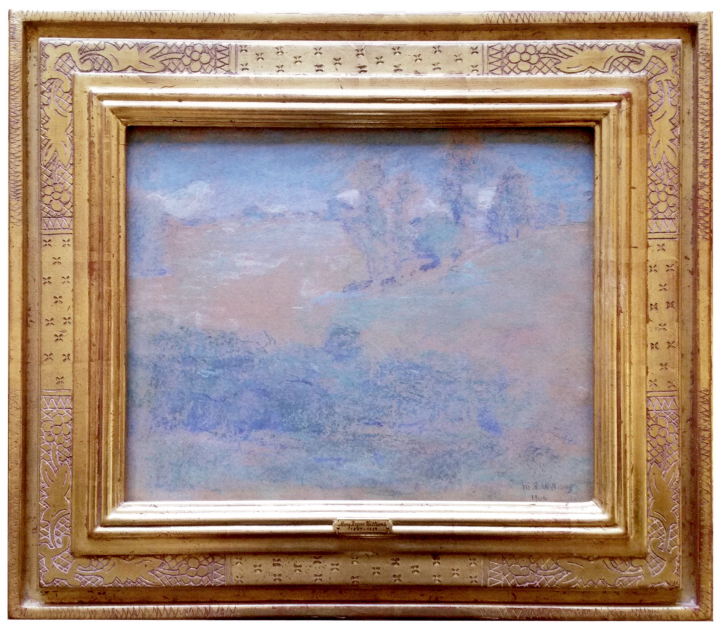

9.6 Untitled landscape, probably Fiesole, illegibly dated
(1904? 1907?) pastel, 9 ½ x 12 in. AUTHOR'S COLLECTION.

Indianapolis exhibited twelve of her pastels—portraits including *The Girl in Grey* plus Venice and Florence views—in its annual exhibition. (Susan Ketcham, one of the association's founders, may have provided the invitation, along with William Merritt Chase, an Indiana native who had stayed connected with his home state's art scene.) The show combined contemporary paintings with eclectic European antiques from the studio of the Indiana painter Samuel Richards (1853–1893), including swords, pistols, ceramics, jewelry, and embroidered bodices. There were large groups of artworks by Richards, Childe Hassam, and the Swedish-born painter August Franzen. Two dozen other painters were represented, including the Indiana luminaries Theodore C. Steele and William Forsyth. Mary's dozen pieces amounted to the largest contingent of that secondary group.

The *Indianapolis News* enthused on the front page that the show overall represented "more brilliancy of light and color than has ever been seen in any exhibit in Indianapolis." The writer focused on Hassam and Franzen but also noted that Mary's Venice pastels "add not a little to the exhibition."

It is not known how Mary reacted to her large cluster of works on view. Those kinds of career insights do not surface in her writings until she became friends with her intellectual soul mate, Henry White.

9.7 *Interior of Cathedral at Arezzo*, undated pastel, 9 x 6 in. PRIVATE COLLECTION.

Misfit in This Workaday World

In Henry's lengthy unpublished autobiography, he devoted a page to Mary: "Miss Williams was one of the most gifted women painters I ever have known. She was one of my dearest friends and my wife and I always enjoyed her visits to us at Waterford. She fully appreciated the beauty of the country here and sketched and painted it during her visits." Henry had much else in common with Mary, including a Yankee lineage, staid upbringings, and a "fine scorn for all shams." They both became amusedly resigned to a world suspicious of unconventionality and unappreciative of subtle artwork.

In their correspondence, they mocked pompous, dogmatic people and kitschy, mainstream paintings. His family long remembered his affection for her and made room in their homes to store the Williams paintings and papers. Without Henry's commitment to Mary's legacy, this book would not exist.[1]

Like the Williamses, he grew up in a prosperous, pious family—he was the only child of John Hurlburt White, a lawyer who also served as a probate court judge—and had hardworking farmer relatives nearby. He remembered the "hot, dusty, suffocating job" of helping mow hay at a family dairy farm. His ancestors included Mayflower immigrants as well as a Spanish orphan who had been found wandering wharfs in Spain and ended up adopted by an American ship captain named James White.

As a child, Henry sketched constantly, particularly ships and locomotives, and was left largely unsupervised. By age eight, he would clamber onto moving freight trains. One fall onto the track left him with a heel "badly crushed" and a lifelong limp. While he was

playing on a railroad bridge, a train passed, and he managed to cling to a side girder, dangling over a river. That is, he enjoyed, of course, far more freedom than the Williams girls would have been allowed—but he could understand Mary's wanderlust.

During his high school years, Abby the science teacher assigned him "to draw diagrams on the blackboard to illustrate her demonstrations." But unlike the prize-winning Williams girls, he was a terrible student. His father, "a rigid observer of the morals and mores of his time," wanted him to be a lawyer. Just as he was about to flunk out of high school, "Divine Providence came to my rescue": the building burned to the ground. All records of his "disgraceful standing" were lost, and all seniors were allowed to graduate. If there had been any accusations of arson, he joked in the memoir, he would have made an easy suspect: "In some of my darkest moments I subconsciously wished the schoolhouse would burn."

His father still hoped that Henry would pursue a law career—"My longing to study art seemed impossible of fulfillment"—and he became a clerk in his father's court. He felt like a "misfit in this workaday world, the potential artist, the day dreamer, the gentle and harmless lunatic." His mother Jennie somehow convinced his father to let the miserable young man try to paint instead. Henry never

10.1 *Portrait of Henry C. White*, c. 1896 oil on canvas, 36 x 20 in. WFC (PHOTO: TED HENDRICKSON).

learned "what form of persuasion she used," but his father shifted to being "most kind and helpful" to his art career.

Henry, as Mary had just before him, trained in New York with Tryon and at the Art Students League. Henry also followed Tryon to his summer painting grounds in South Dartmouth. While still in his twenties, Henry successfully submitted landscapes to juried exhibitions in New York. He set up a studio on the grounds of his parents' house and gave private art lessons. Around 1888, he took a full-time job at the high school, and when Tryon left the Art Society for Smith (taking Mary with him), Henry began teaching at the society as well. Henry wanted steady paychecks partly to prove himself to the shoe-manufacturing magnate Caleb M. Holbrook, the father of Grace Holbrook (1863–1921), Henry's longtime sweetheart. The Holbrooks, with a fortune made partly from sales of footwear to Union soldiers, built a mansion across the street from Mark Twain's property.

In 1889, Henry and Grace married. Their son John was born the following year. For a decade the family lived with Henry's parents. But he found much of the scenery around Hartford "not inspiring." In 1891, he took a train to Waterford, a fishing hamlet on Long Island Sound near New London. A few miles' walk to a shore bluff convinced him "this was my Promised Land." He persuaded a farmer to rent rooms for his family there and then bought a few acres. His good fortune "had a dream-like quality of unreality." His parents financed his first four-bedroom house in Waterford, which he designed and helped build. He fished, sailed, and sketched harbors, pastures, and sailboats there, and he loved the primitiveness of hand-pumping the water supply and living by candlelight: "No electric wire or current invaded this Arcadia."

By 1898, he could afford to spend months at a time at his retreat from Hartford. Grace had outlived family members, including Caleb and two of his wives, Elizabeth (1825–1873) and Anna (1831–1898), who were sisters. The bequests meant that Henry never again needed to work at anything but art: "Her income from her inheritance was now so disproportionate to my modest earnings from my teaching."

The Connecticut shore attracted other early American Impressionists. Artists' colonies formed around Cos Cob, within easy reach of New York, and in Old Lyme, about fifteen miles west of Waterford, where a hospitable and impoverished sea captain's daughter, Florence Griswold, ran a boardinghouse at her family's home built in 1817. Miss Florence catered to artists, whether or not they could pay much. Grateful boarders and friends, Henry among them, competed for space to paint on her doors and walls. Many of them, like Mary, had traveled widely but still loved Connecticut. The murals' subject matter ranges from local pastures and beaches to Venetian gondoliers, a Dutch fishing fleet, a fortress in Granada, Manhattan skyscrapers at night, and a Chinese sailing ship.

Over her dining room fireplace, the artist Henry Rankin Poore's frieze portrays Miss

Florence's frequent customers chasing a fox—Poore was caricaturing the art colony's members while also parodying the era's popular sporting prints. Henry White is shown driving a car, specifically an air-cooled Knox, a novelty that he acquired in 1903. Although he loved his electricity-free Arcadian home, his boyhood fascination with transportation led him to an adult interest in autos and yachts. Mary joked, in later years, that she wished she were a man so she could drive and keep up with him.

Henry and Grace at times lived in a brick rental building alongside Miss Florence's place while maintaining the Waterford house. In the winter, at his Hartford studio, he turned sketches into paintings. "I do not remember that I ever had a picture rejected by the jury of an exhibition," he wrote in his memoir. The manuscript briefly lists his one-man and group shows, from Hartford to Chicago, and his 1910s membership in "the Pastellists" (along with Davies, George Bellows, Walt Kuhn, William Glackens, Everett Shinn, and Robert Henri). Henry conceded that he would have been more successful had he been "willing to make the necessary sacrifices of my other interests." But he had no need to sell work, and he suffered from "a natural lack of ambition or desire for publicity." He was blissfully content with his hobbies and his "incomparable wife"—he was particularly grateful to Grace for accepting that he no longer attended any church—and their sons John and Nelson.

Which means he was a perfect artist friend for Mary. He had no competitive streak and nothing but platonic affection for her. He had the financial resources to host her, the art world connections to help her, and the time to write and visit her. They shared notes about encounters with eccentrics, hacks, and ignoramuses. She sent him travelogues from Europe, which he visited only a few times. She told him how much she enjoyed his letters and lamented that, unlike him, she never had enough time to paint. The two friends bought each other art supplies, and she painted and sculpted portraits of him and Nelson.

Mary once wrote to him that "next to my sisters there is no one I love more than Grace and you."[2]

For his portrait (figure 10.1), she posed him in a honey-colored Queen Anne chair. Her jauntily mustached friend looks energized and focused, against her luxuriantly polychrome backdrop.

In her first surviving letters to him, from June of 1895, she invited him to Smith's commencement art show; she warned that his friend Tryon would likely not be around, "as he has not stayed for the reception for several years." That summer, Henry hosted her for the first time at his Waterford paradise. "I did have such a good time with you all and shall never forget it," Mary wrote as she settled back into her fall routines. She had enjoyed beachcombing with their son—"Tell John I wish I might go crabbing with him this minute"—and she sent a thank-you present of sweet-pea flowers for Grace: "I hope she will get them before their beauty and fragrance are all gone."

By late September, she and Henry were discussing their fondness for Japanese art (a taste shared with Freer and Whistler). "Wouldn't it be fun to go to Japan and collect before everything nice has been seized," she wrote. She offered to tour Henry around Northampton: "I would let my girls take care of them selves and show you the beauties of Northampton and the way to Mr Kingsley's." The painter, photographer, and engraver Elbridge Kingsley (1842–1918) lived in Hadley, Massachusetts, and collaborated with Inness, Ryder, Champney, and Tryon, among other art luminaries. (He was a local character, known for traveling around in a "sketching car," a wheeled hut that also served as a darkroom and sleeping quarters.)[3]

Nothing in the correspondence reveals what Mary and Henry expressed to each other that fall about the death his former teacher, Abby Williams, a few months before Mary headed off to see her first fjords.

A Pastel Every Five Minutes

Abby died in December 1895, "after eight years of alternating suffering and cheerful convalescence." The official cause of death was exhaustion, a ruptured bladder, and enterocolitis.[1] Mary's letters only seem to mention the loss once. During her Paris sabbatical, she dreamed she was in Hartford: "Abby was there too as she always is in my dreams."

That fall, Mary had sent works to the New York Water Color Club and the Pennsylvania Academy of the Fine Arts. She exhibited, among other pieces, the pastels *Clouds, Job's Pond, Connecticut* (figure 2.11), and *The Pink Gown* (figure 11.2) and an oil, *A Profile* (figure 11.1). In *Job's Pond*, blue paper represents the water at the foot of Aunt Willie's pastures, reflecting streaks of clouds and trees. Kurtz Lansing has noted that the blue sheet serves "to bring out the radiance of the pigments" and has compared the pale, glowing *Profile*

to Whistler's "symphonies" in single hues. Its "silvery palette" also echoes paintings by Puvis (Mary made pilgrimages to see his works in France), "who shared her admiration for the chalky color schemes of Italian fresco paintings." In *The Pink Gown*, Mary rendered shadowy facial features, white slashes of lace, and blue-brown shadows of the hem on the pinkish-brown floor. As Kurtz Lansing observes, Mary was part of a movement to capture female models in states of "dreamy detachment . . . transported into the realm of imagination."[2]

In the *Buffalo Evening News*, "one of the leading New York artists and critics" wrote that Mary "has a style all her own in her poetical and dreamy pastels. Strange (for a woman) in art, her work does not recall that of any other painter. (Not my feeling speaks here, but my observation.)"

Alas, there is no record of any choice words

11.1 *A Profile*, c. 1895 oil on canvas, 21 x 16 in. Shown at the New York Water Color Club and the Pennsylvania Academy of the Fine Arts in 1895. WFC (PHOTO: TED HENDRICKSON).

Mary had about being called *not* an imitator, something "strange (for a woman)."

Her correspondence trail picks up again in June 1896, when she thanked Henry for sending some boards: "I have just made a sketch of a girl on one of the panels that I think would delight [William Merritt] Chase. It has so much spirit and so little construction—I mean such poor construction." She reflected on how much she and Henry loved to paint nature: "We are in the full bloom of summer now and I think the world was never as beautiful as it is this year. I wonder if we shall go on forever seeing new beauties. I dont like to think that we may not."[3]

She was leaving school soon for her most demanding European trip: "You may be sure I am not sorry to get away." She hoped to finish a portrait of Henry (figure 10.1) before he headed off to Europe for the first time that fall (he would rely on Mary's travel advice). She asked for news of John's development: "You must save all his choice expressions."

That summer, she traveled with a Smith colleague (and future housemate), Sophia Cook Clark, and a Hartford housemate, the high school science teacher Clara A. Pease (Mount Holyoke 1876, and a Wesleyan student from 1878 to 1882—she volunteered there at the now-shuttered natural history museum).[4] The trio wended from Germany to Denmark, Sweden, Norway, the Arctic, England, and Scotland. They attracted attention by having fun: "If you could have heard our merry laughter you would have felt easy in your minds about us . . . you know how I

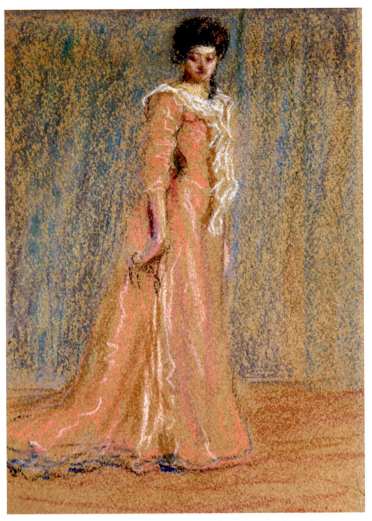

11.2 *The Pink Gown* (also called *Woman in Pink*), c. 1895 pastel, 12 x 8 in. Shown at the New York Water Color Club and the Pennsylvania Academy of the Fine Arts in 1895. PRIVATE COLLECTION (PHOTO: STAIR GALLERIES, HUDSON, N.Y.).

am always ready to laugh," Mary wrote to her sisters.

They traveled by train, steamer, foot, and horse-drawn buggy with little boys at the reins. All the while, Mary wished she could ride bicycles, her new obsession. From midocean, she wrote to Laura and Lucy: "I wish you two would join us, and please bring the bicycles. I long to have a turn around this deck." Mary's interest was part of a nation-wide craze; wheelwomen were forming clubs, organizing races, and promoting the hobby as a tool for developing "self-confidence and pluck."[5] Mary may also have been influenced by her family's tenant next door, the car and bike designer Lindley Dodd Hubbell, who worked for the Pope factory. The company targeted women buyers with its chainless Columbia bikes, which would not snarl long skirts.

During the ocean crossing, Mary felt her customary lethargy: "I have my little box of pastels with me but I am not sure I shall be moved to do anything." She roomed with a Hartford high school languages teacher, the Swiss-born Louise G. Stutz, and found distractions in storms and sightings of "porpoises, gulls, and distant steamers." She stayed up late: "We are enjoying the moon as much as we planned." Clara, who never took time to relax in Hartford, "went to sleep in her chair yesterday, make a note of that. . . . She looks so rested and well." Mary was relieved to find that steerage passengers "have a beautifully clean room to wash in." As the ship approached land, she was miffed that a recent Harvard graduate onboard had "no sense of beauty"—he was unmoved by Dover's cliffs.

Mary helped her sisters visualize every-thing, starting with a German fishing village "looking so mysterious with its twinkling lights set here and there all over the hill and reflected in the water." In between the orderly villages and orchards, "a New England farmer would smile to see the great flat fields, with-out a stone." Streetscapes after rainstorms looked "brushed and scrubbed." Clara, the scientist, brought along a camera, and as she took photos, "she was followed by admiring children." In one narrow thoroughfare, a policeman informed them, "the people were expected to go down the street on one side and up on the other." As she sketched in Lüneburg, a local woman haughtily declared that "the building wasn't worth painting."

Mary's group shook off their own New England uptightness. They stayed up late "and drank beer like natives." All the while, bicycles stayed on Mary's mind: "Everywhere the smooth level roads make us long to spin through them on our wheels." Hartford ex-ports were for sale in Germany: "You would laugh to see us stop at all the bicycle stores and feast our eyes on the wheels. We have seen three where the Columbia's displayed."

When the trio took an overnight steamer ride across the Baltic to Copenhagen, they encountered four Americans "who look like the rich helpless kind. I am afraid they think that we laugh too much." The sun rose at 3:30 a.m. over waters "full of white jel-ly-fish." She was enraptured by "the red sailed and white sailed and yellow sailed boats [and]

11.3a Mary favored Pope's Columbia bikes made in her hometown; chainless versions, less likely to ensnare skirts, were marketed to women. AUTHOR'S COLLECTION.

11.3b Mary's letters praise the comfort of her Cooper bicycle outfit, which may have been the work of Connecticut inventor Ella Hood Cooper. Patent US555211-0, 1896.

the shore dotted with pretty little villages and just enough mist over all to please me. It makes me think, Laura, of the day we anchored in a gondola near the Lido and made a pastel."

They had quibbles about Denmark: "The women ride the wheel here as much as in Hartford—but not as well. Have seen no bloomers. They all wore skirts just a little short, and rather scant." The train cars were stuffy, and although there were open-air seats above, "we did not dare to climb up as

we had seen only men in those places." As they barreled through Sweden, fellow passengers would "come and look at us by turns at intervals. I am afraid we are a thought too hilarious for them." In one town, crowds had lined up to see King Oscar II: "In sooth he was a fine looking man," wearing a "gold band around his hat" instead of a crown. Mary had not much else to report yet, so the king was "real kind" to "help me fill out my letter for I am anxious to send you one from every country we pass through."

Getting to Norway required entire days in trains: "That is almost enough to tucker even me." Her handwriting jiggled as she described road food of endless fish and one strange flat square "with a curious band of embroidery around it, which we contemplated long and finally tasted. It seemed to be soap flavored with cheese and sugar."

Opening train windows and lifting luggage built up her muscles: "We'll be regular sluggers when we get home." She admired, as always, women passengers, including "such a pretty Swede sitting near us—the brown haired type—with a lace edged, black silk kerchief tied over her head. We want to pack our hats and wear kerchiefs and see if we cant improve our looks." The countryside reminded her of Cobalt and Northampton, with "long stretches of meadow and then suddenly a hill jumps up. We have seen several that looked like the Holyoke range, only more rocky. . . . Everywhere the carriage roads are superbly hard and smooth, and we dream of wheeling on them."

Norway, along with Italy, would eventually inspire one of her largest bodies of work: "We are going through such glorious country I want to get out and shout, it is so beautiful I want to make a pastel every five minutes and if this rapid express were a little less rapid I might do it with greater ease." While rushing through Skien, she made no pretense of documenting it with historical accuracy: "I had time to make a pencil sketch at the dock and I have labeled it the birthplace of Ibsen. He was born somewhere in Skien and it might just as well have been there." At a roadside hotel, "I made a very scratchy pastel sketch which one of the men seemed to enjoy much. He hung over my shoulder and breathed loudly in my ear and called out the names of well known land marks as I set them down in what seemed to me rather mysterious scratches."

As they crossed through "wild, weird places," she found more reminders of New England: "There are little fertile spots that make us think of Hockanum lying at the foot of Holyoke." The naturalist from Penfield Hill recognized flowers, even on farmhouse roofs, including fuchsias, clover, bluebells, willow-wort, yarrow, and heartsease, and she picked wild strawberries. Clara, the scientist, "climbed down beside the road and got some snow to eat." Mary wrote home about gray and purple labradorite knobs and "a gouge out of the rocks way up the side of a mountain and a little flat fertile spot with a tiny farm house that looked set up on a shelf." At one nearly perpendicular farm, she wondered how a farmer raking "could stick on, and what kept the hay from tumbling down into the river." The waterfalls all around "sounded like wind in the pine trees," and a dainty one "came fluttering down like a pretty ribbon." She would import one for Hartford, "but Miss Clark said she was sure it would crowd the yard, and that the neighbors would not like it."

Her group's horse-drawn carts were mostly two-person ones known as "stolkjaerre—pronounced by the natives stoolcherer—pronounced by us soul-jerker or chokecherry according to our mood." Mary relied on her "good bicycle legs" to hike alongside carriages

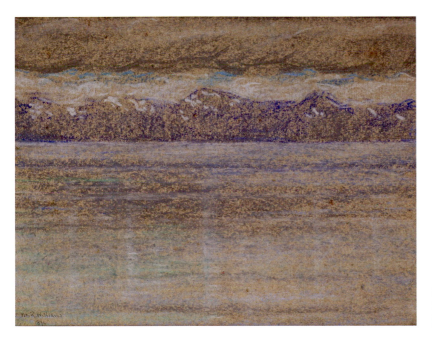

11.4 *Tromsö—Midnight (Norway)* [*sic, Tromsø*], 1896 pastel, 8½ x 11½ in. WFC (PHOTO: TED HENDRICKSON).

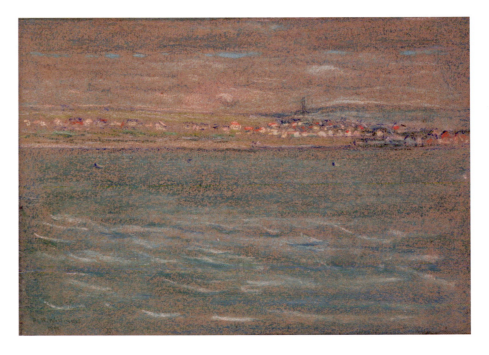

11.5 *Vadso (Norway)* [*sic, Vadsø*], 1896 pastel, 8½ x 12 in. WFC (PHOTO: TED HENDRICKSON).

and "save the horses, cutting cross-lots from bend to bend. It is lovely to drink from the clear mountain streams." The roads had "innumerable serpentines and sharp curves that would be quite scaresome to some people," as well as ominous "avalanches of fine stone." Boys were eager to be hired as drivers: "I wish you might have seen the casual manner of that infant as drove we down a steep hill that dropped off sheer on one side into the lake." Mary and her companions sometimes took over "clothes-line reins" from the drivers and grew "quite attached" to a driver named Mikkel, "about as big as a match." When they found someone to translate their praise for him, "It brought to Mikkel's face the most animated smile we have seen in Norway. They do not get excited here over little things, nor give way to their emotions."

Children opened farmyard gates, in expectation of coins tossed from the carriages. Girls in head kerchiefs "curtsy to us as we pass [and] the tiny little boys take off their caps in the prettiest way." Porters waited around to help women maneuver their trunks, even sluggers like Mary and her friends: "an old one with red whiskers fixed us with his glassy eye." At hotels, Mary admired Norse murals and fragrant pine paneling. In one cluttered bedroom, although the door and window locks were broken, "we slept in peace, feeling that no one could find his way through all that furniture."

She picked up some Norwegian, "useful sentences like 'Have you any mushroom sauce?' and 'Are there any donkeys in Norway?'"

Bicyclists from Connecticut popped up in the hills. At one point Mary looked down from a hotel veranda and "caught a glimpse of a woman with a wheel—a Victor—and lo!" it was Dr. Kate Campbell Hurd Mead, a physician from Middletown, with her husband, William Edward Mead, a professor of English at Wesleyan.[6] The couple was rain-soaked but bubbling with sightseeing plans. Mary described Kate Mead as "one of the wildly enthusiastic kind who wants to see it all and have everyone else see it too. She proposed several new trips for our itinerary . . . that we had to firmly refuse."

After tiring of waterfalls ("Miss Clark says it looks as if the sky leaked"), and finding time to sketch vistas, woodcarvings, and locals in embroidered clothes, Mary wrapped herself in a newly purchased fur cape meant as a gift for Laura and took off by steamer for the glaciers. "Your cape climbed the North Cape last night, Laura," she wrote, after hiking along slippery cliffs in stiff winds.

"Just think of my being in the Arctic zone! And that in company with a king. He amuses me immensely," she wrote home. At first King Leopold of Belgium, traveling under the alias Count Ravenstein, mostly stayed in his stateroom: "I saw him at the door of his cabin as I came out, and I think he saw me, for he put up his eye-glass. He has a white beard and a limp, and looks quite like an ordinary handsome man in his yachting cap. He does not wear his crown on board ship—keeps it under his berth, I suppose." Mary and her friends called him "the Bird" and tried to eavesdrop on his French-speaking servants.

He eventually emerged for meals—"He almost picked up our bottle of olives for us when we dropped it"—and bowed to Mary's group and even chatted with Clara. When the passengers competed in tug-of-war, "the dear old King joined in the merry-making [and] took off his coat and lent a hand—two in fact. It was pleasant to see the edge of a red flannel sleeve peeping out from under his black shirt sleeve and to know that he is dressed warm underneath. He is getting very social." When he disembarked, after handing out diamond *L* pins to crew members, Mary lamented: "Alas! This is a sad and dreary day since our dear King left us this morning . . . the sun has scarcely dared to shine since. You really have no idea how we miss him. He was so kind and sociable and loveable. We shook hands with him and wished him bon voyage." (In fairness to Mary's naïve enthusiasm, the bloody colonial ruler's atrocities in Africa were not yet widely known.)

The other passengers, Mary reported, "were not all entertaining." Men onboard kept interrupting and correcting women. The Connecticut-born diplomat Frederic C. Penfield "has been hobnobbing with us most of the morning—evidently quite delighted to get an American audience. . . . I did not let Mr Penfield know that I had recognized him but made him tell me his name—just for fun." He was so sure that his stories and opinions were interesting, Mary wrote, that "I shall be able to give you his history from the day of his birth, when I get home." Her conversations with him degenerated: "We nearly had a blow out with Mr Penfield over the defini-

tion of moraine." Men and women scientists were onboard, too, observing ice and skies: "One will tell some strange effect that she noted, and some man will tell her that such a thing was quite impossible." (Mary seems to have anticipated modern complaints about man-splaining.)

As the ship's four-gun salute announced their crossing the Arctic Circle, Mary tried to capture emerald water and shoreline turf: "I would like to use my pastels if the captain would only anchor occasionally." Natives onshore "waved their fish at us [and] seemed to consider us a great show." She stayed up late with the sun to work, and she envied Englishmen onboard who could sketch more quickly—one could draw in between taking "his turn at ring-toss." Purple clouds descended during an eclipse: "In this beautiful gloom we could see just a golden edge on the distant hills; then a lemon light all around the horizon, and suddenly it was full daylight and the great show was over." In winter, she wrote, "this must be a most dreamy deathlike place."

As she sent off her mail by rowboat, she could hardly believe the postal service would wind "through the labyrinths of fjord and mountains" and deliver her "choppy and queer" missives. Her sisters worried that their own news of farm and church would bore her. But she reassured them that nothing in Norway was as precious as their letters: "Your thrilling accounts of walking to the Cobalt P.O. for one of my stupid letters spur me on to write more." (That summer, Mary also received letters from a Smith literature profes-

sor, Marie Elizabeth Josephine Czarnomska, the imperious daughter of a Polish aristocrat, nicknamed "the Czar" and sometimes "Czarina," and the American Indian art student Angel De Cora.)

When the steamer finally turned back toward civilization, the crew sent up rockets to celebrate Fridtjof Nansen's latest exploration, which Mary described sarcastically: "One little man has gone four degrees nearer the north pole than anyone else and has been travelling on snow shoes for nearly a year—that makes Norway the greatest country in the world!"

The rest of her summer adventures were familiar. English churches had "simply absurd" modern additions but "heavenly music." A Methodist preacher, mangling his *h*'s, spoke of "hears that 'ear not, and the h'ashes and 'usks of worldly riches." Mary's favorite soldier spotting was a "fetching sentry in the kilt and tartan uniform with a great bearskin hat with four long tails that swirl around his face." For one novel experience in England, Mary and Clara rented bicycles that were clunky by Hartford standards: "I wish you might have seen us start off on the elephants we finally secured. I made lines of beauty all over the narrow little street and felt as if I could never make a straight line. The English wheel is like the nation that produces it, solid and substantial but not built for beauty; however I will say that the saddle was very comfortable, and we were soon skimming along like birds."

Clara's letter survives in Mary's files, too. She saw Mary wobbling at first, "and I thot,

'if *Mary* has forgotten how to ride where shall I find myself?' But it didn't take us long to become one with our animals."

Mary apparently did not hear from Tryon that summer, but he knew about her trip. In July, he wrote to Henry: "Miss Williams is doubtless sliding down a glacier or roosting on a terminal moraine or making pastels of the scarps or fiords of Norway."[7]

Her roosting on moraines resulted in pastels that she soon exhibited. In November 1896, she updated Henry: "I sent all my Norway sketches to N.Y. and they were kind enough to hang them in a group." For her only major New York show, the Water Color Club filled half a gallery at its annual exhibition with sixteen of her views of fjords, scarps, glaciers, and harbors.[8] (The club devoted the other half of the gallery, improbably, to North Carolina scenes by Elliott Daingerfield.)

While tempted "to make a pastel every five minutes," Mary had covered the Norwegian coastline plus inland hamlets. Although she misspelled the names of almost every site, she was thorough in her explorations from Båtstø and Telemark county near Oslo through Haukeli, the Nærøyfjord, Sandane, Hellesylt, Trondheim, Tromsø, and Vadsø at the Russian border. Her artworks capture blue-gray and snowy peaks, stone outcroppings, green slashes of farmland, and thin lines of colorful buildings at the waterfronts. The foregrounds, instead of her familiar New England pastures, are blocks of icy water mottled with reflections of the vast empty terrain and puny settlements.

The *Art Amateur* observed that she "possesses much feeling for composition and color [but] needs to pass through a severe course of drawing." The *Daily Tatler*, a short-lived humor publication, ran a front-page review by the young journalist (and future Nazi sympathizer) Edwin Emerson Jr., deriding the whole show with adjectives like "commonplace," "amateurish," and "grotesque." Mary's "strange Norwegian scenes," he wrote, "serve to point the patriotic moral that American landscape artists do well to stay at home."

Mary did not take the criticisms to heart, apparently. A year later, when she organized a traveling exhibition for herself and Henry—the only two-person show of her career—she weeded out some New England scenes. As she explained to Henry, in a burst of self-confidence (or maybe she was being sarcastic), "the public would like to see Norway."

The large New York showing may have emboldened her to undertake ambitious exhibitions. At Smith, she would soon install loans that foretold a major gift to the nation: Freer's art collection.

To Exhibit in the Provincial Towns

While her Norway pastels were on view in Manhattan, Mary sent art world commentary, gossip, and travel advice to Henry in Europe. Her opinions about life at Smith became increasingly uncensored: "My fondness for being amused makes me enjoy and almost admire really disagreeable people."[1]

Her suggestions were specific to the point of noting that at an English-owned hotel in Genoa, "there is an interesting old painting on the staircase wall." She asked if he had "seen *my* little [Gerard] Terburg" at the Louvre. She sent him to sketching perches in Fiesole ruins and warned that Marseille was "the dirtiest city on record." She was pleased that he adopted her habit of taking stationery from hotels, and she wondered if he was meeting dressmakers and milliners "as boresome as their kind in this country." (Mary grumbled whenever required to have clothes fitted by professionals.) When he was in Paris, she urged him to visit Whistler, as she had done in 1891, but Henry was turned away at Whistler's home. News (probably unflattering) of Whistler, who was newly widowed and embroiled in the usual legal spats, had reached Northampton: "I heard a good story about him the other day but it is too long to write and no doubt you have heard it too."

Teaching, she told Henry, "I am beginning to dislike very much." Smith had saddled her with classes in the "odious Art History business" for one hundred students, and she was "diligently cramming for their benefit." Since she was required to "grub now in Assyria," her artwork was sidelined: "I get desperate about not having any time at all to paint." The Seelyes wanted her to update the sleeve shapes on her portrait (now lost) of Smith's first lady, Henrietta Seelye, to keep

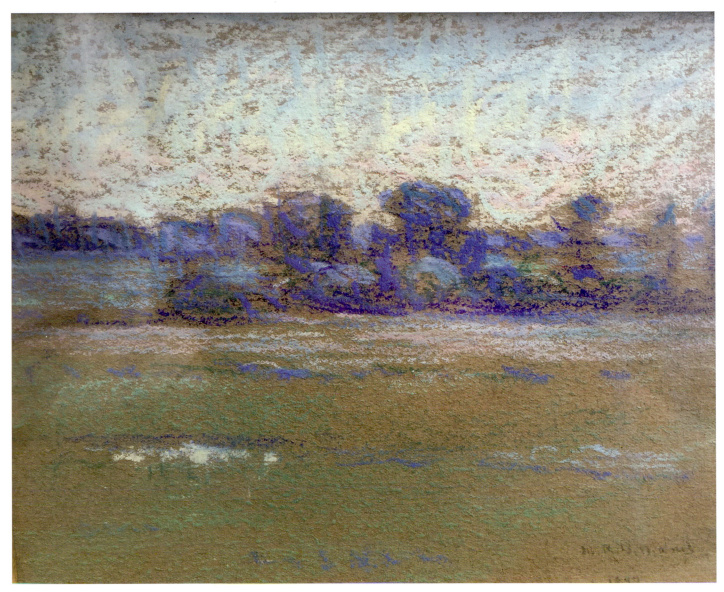

12.1 *Early Morning—Waterford* (also called *Aurore* and *Morning— Waterford*), 1897 pastel, 5½ x 7 in. AUTHOR'S COLLECTION.

up with fashions. Mary did not have time for that editing, although she jokingly offered to update Henry's portrait with a beard, "to please Grace."

She had one small exhibition triumph: the Pennsylvania Academy of the Fine Arts showed one of her portraits (it is not clear which one), lent by George Dudley Seymour.

Tryon at one point begged off a Friday critique in order to decorate some new quarters in New York. "I am never surprised at anything he does—except that he comes up here at all," Mary told Henry. She wondered if her boss was "making a gradual disappearance like the smile of the Cheshire cat." Among other annoyances in Northampton, a prudish landlady hid away one of Mary's Botticelli prints: "We wonder whether she selected the cellar or the attic as a suitable place."

There were benefits, however, to a boss who was friends with elite collectors. Tryon helped arrange for Smith's gallery to borrow about thirty of Freer's Japanese kakemonos (scroll paintings) and screens. "It was an awful lot of work to get them up and arrange them and I had not imagined anything quite so swell and imposing when I planned it. . . . Mr Freer must be a remarkable man to allow his treasures around in this way," she told Henry.

Hundreds of visitors came to the two-week display. Freer told Mary that he was "delighted to hear of the interest" in his loans. She shipped them to be shown next at Williams College, and he thanked her for her "most considerate handling." She reported that the museumgoers favored a work by Mori Tetsuzan, and Freer replied that he preferred "several others in the collection" including pieces by Soami, Ogata Korin, and Kano Eitoku.[2]

Smith's show was the first public outing for his Asian art. Partly owing to its "warm reception in western Massachusetts," the art historian Fan Zhang has pointed out, Freer would soon "withdraw completely from the railroad business and devote himself, over the next two decades, to collecting Asian art."[3] And thus Mary, at the grindstone on a remote women's college campus, played a part in midwifing Freer's collection on permanent view in its own building in Washington.

In the summer of 1897, Mary invited the Whites, newly returned from Europe, to Penfield Hill—she wanted Henry to see her beloved hayfields. She explained that Aunt Willie's horse-drawn carriage would retrieve his family at the tiny train station. She promised "chickens and turkeys, pigs and a cat for John to play with and lovely views for you all," and she made sure to "warn you all that it is a genuine country house you are coming to and a place even less thickly settled than Waterford." She suggested bringing old shoes for mushroom hunts, and she lamented that in one meadow, "They are cutting the grass now I wish you might have seen the place before that was down." One now-lost pastel listed in her estate, *The North Lot*, probably depicted Cobalt's unmown slopes. She told Henry to visit again anytime (and he did visit several times): "I know my Aunt will take care of you if she is well and you can paint as much of it as you want to." She sometimes traveled there from Hartford by bicycle with Laura, "to the

consternation of some of the neighbors who think Laura ought not to perform such feats; they consider me a tough old thing that nothing can harm or hurt."[4]

That summer, she came to Henry's Waterford home, "where everything is just right," and his nearby painting grounds. "I can imagine just how your trees and fresh water pond looked this morning at sunrise," she wrote afterward. In a pastel from that visit, *Early Morning—Waterford* (figure 12.1), she separated a streaked dawn sky and pale green meadow with a grove of purple-blue trees.

In her 1897–1898 school year, her most productive moment, she created a traveling exhibition for herself and Henry, with about sixty works, mostly pastels and mostly hers—by far her largest showing in her lifetime.

Early in the fall, she scouted for Hartford exhibition space and then chose a room in an office building at 42 Union Place, next to the main train station. She stopped by the high school, which Henry had supplied with a "charming collection" of photos of fine art. Images that included nudes had been relegated to a vault—Mary lamented to Henry "how foolish they all were to be so squeamish."

For the Union Place show, she invested in what she called "Whistler frames" (with simple ridges and planes rather than ornamental reliefs), hoping to entice Hartford burghers with at least fresh taste in gilded woodwork if not art. She considered running advance newspaper notices of "our little exhibit that Hartford may have at least the joy of anticipation"—that is, the prospect of the show would at least appeal to the provincials, if not the actual hanging. Mary set aside room for Henry's latest works from Waterford: "I shall want to see them all when he returns," she told Grace.

Mary had no new work of her own on hand: between teaching and organizing the exhibition, "it is needless to say that I have done no painting whatsoever." She did take breaks to bike through Massachusetts, to visit Kingsley in Hadley and the Champneys in Deerfield. Mary told Henry that she had outgrown Champney's realistic work: "Mr C. guided my infant feet in the paths of Art, and now I feel as if I had somehow wandered into a different path from his; perhaps we shall arrive at the same place sometime. He has been copying the old masters in pastel, and what I consider most astonishing, some concern in Boston is reproducing his copies in black and white! Why reproduce from a copy?" She did not care for Kingsley's landscapes, either: "he has been having a perfect orgy with red bushes and trotted them all out with impish glee knowing how much I dislike them."

Nature itself most entranced her on the road: "I wish you might have seen the meadows north of Deerfield last night in the moonlight."

She did not tell her boss about her forthcoming shows. Tryon, she wrote, "is what the English would call 'so comical.' The last time he was here he said 'Well I shall not be up for two weeks any way and *possibly* not for three,' as if he were in the habit of coming oftener but this time would be an exception." As for her own classroom contributions, "I am more

impressed than ever this fall with the utter uselessness of teaching I mean of my teaching for I know I was not built for an imparter of information. I am not riding my wheel as much as I want, but probably as much as I deserve or is good for me."

While Mary was stuck at Smith, her sisters and the Whites installed the Hartford show. Just before the opening, Mary counted the artworks going on view and warned Henry: "I am *aghast* to find that I have more than you. I recommend that you haul down some of mine and put up more of yours. If you find that my pastels do not cover the allotted wall I have two Waterfords and a Penfield Hill that I would fill in with. I would rather have them in than some of the Norways but suppose the public would like to see Norway."

During the November showing, Laura and Grace minded the gallery. Henry published an unsigned review in some periodical (it is unclear which one), comparing Mary to Gerard Terburg (commonly known as ter Borch), the Dutch Old Master—as he often did, in her lifetime and after. She was jokingly miffed at the praise: "Think how embarrassing it is for me to be asked who wrote that alarming article! It is not myself who will have an account to square with you but it is the immortal Terburg who'll be after laying you out for coupling him with a mediocre modern. I have told you before that you are a sad flatterer, and you persist in keeping it up."

No one bought the art: "Is Hartford going to 'write itself down Philistine'? Alas! Do you suppose they would take them as gifts?"

The visitors included the painter Allen Butler Talcott, a Hartford native who later frequented Florence Griswold's boardinghouse, and Mary Dawson-Watson, the wife of Dawson Dawson-Watson, a British-born, Giverny-trained teacher at the Art Society. Three carriage drivers stopped by, probably taking breaks from their train station shifts. "I would like to know what they thought and said," Mary wrote drily.

By mid-December, she was sending out reams of invitations to the next display, at a gallery in Springfield, Massachusetts, run by James Dwyer Gill (1849–1937). Gill's expansive shop on Main Street, founded in the 1870s, offered books, stationery, pens, and frames, and he reserved two stories of grand interior rooms for paintings from floor to ceiling. His artist roster over the years included Church, Homer, and Bierstadt, as well as countless figures now fallen into obscurity (among them Mary's eventual successor Clara Lathrop). Gill also published books; a Springfield handbook from his press described the store as a cultural center that has "led the public taste by feeding it with the best art of the country." His lofty halls "bear comparison with those in New York" and had improved the sensibilities of locals who were "before almost unknown as patrons of the fine arts."[5]

The *Springfield Republican* ran two unsigned reviews of the two-person show, both devoting far more column inches to Mary. Her surviving letters to Henry do not quote them.

The first reviewer found "something delicious in the refined tonality of these

impressionists." For a visitor, "these pictures are opening to him as it were a door into a dreamland, where nothing seems as he ever saw it when wide awake, but where it is very agreeable to linger, and to feel the puzzling suggestion of what the earth would be under these poetizing circumstances." The reviewer ranked Mary's Norway scenes as her best and also praised her *Moonlight* ("the sky and water are very subtly and beautifully brought into unity of impression"), her Venice canal view ("good effects of iridescent light on the water"), and her "fascinating" Connecticut landscapes. The writer found her portraits "less attractive," although *Light* ranked as "a really effective rendering of light from above on a woman reading." Henry's depictions of Venice and Avignon, by contrast, seemed "rather vague than subtle."

The second review recommended the show, which was lasting "only a few days," as essential for "those who love art." The author assured potential buyers "they will make no error in liberal patronage of a display so beautiful and exceptional." In Mary's *Moonlight*, "The sky is filled with tumultuous forming storm clouds, through which the moon pierces with calm brilliancy, and casts its long path across the waters, whose sparkling and trembling light leads the eye to the horizon and over it, bearing witness to the rotundity of the sphere. The magic of such a scene as this is seldom so well represented." Her Venice scene had "refined magic," and the Norway pictures, including *In the Telemarken*, *Sandane*, and *Hellesylt*, "present a scenery quite unlike anything we know; every one is

first seen on Mr. Gill's walls, and many of these have remained in Springfield. Among the large works shown as central attractions for the public

Gill's Art Galleries.

on these occasions, have been "The Pioneer's Home," by F. E. Church; "In the Autumn Wood," by James M. Hart; Walter Shirlaw's famous "Sheep-shearing in the Bavarian Highlands;" Edgar M. Ward's "Tobacco Field, Old Virginny;" "La Cigale," by F. A. Bridgman; and one of George

12.2 James Gill hung paintings floor to ceiling at his gallery in Springfield, Massachusetts. AUTHOR'S COLLECTION, FROM MOSES KING, *KING'S HANDBOOK OF SPRINGFIELD* (SPRINGFIELD, MA: JAMES D. GILL, 1884).

worth attention and study; the treatment is purely impressionistic, but it is certainly such as presents the stern and rugged force of the rude land." Her New England scenes, *Spring Morning* and *In May*, represented "the charming sweetness of early spring," but a Hadley view of tree-lined streets and parkland amounted to "one of the slightest of her landscapes." The writer singled out *Penfield Hill*, *Clouds*, *Pasture and Pool*, and *Hills, South Glastonbury* as "noteworthy for their effects of sunlight and their sense of the structure of the earth." But in Henry's contingent, the reviewer found "a certain baldness about Mr White's buildings, which hinders his success."

Nothing sold. In fact, a number of the works remained in Mary's estate.

After the traveling show lost money, Mary ended up resenting Gill, who was apparently unhelpful and tightfisted. She told Henry that Gill had sent a note, "saying that he must have his gallery at once and where shall he send our pictures. Isn't it pleasant to see that he can be prompt, business-like and energetic on occasions." When the dealer had informed her "there had been considerable appreciation—no sales," Mary retorted that she was pleased the locals "were even mildly interested in our work" since they clearly preferred sweeter, more realistic art by genre painters like John George Brown and Seymour Joseph Guy. Mary wondered if Gill "will read between the lines and call me sassy? I really could not resist the opportunity." Gill charged two dollars to pack the paintings. Mary joked to Henry: "Dont you think we ought to send in our charges for laboring for

him that afternoon I dont know what your charges are but mine are high and may scare him."

Mary reimbursed Henry for her share of the expenses, teasing him that he should invest it: "Let me urge you to try something safe and not to speculate."

Her Smith housemates were apparently happy to have her undistracted again. They gave her a tiny toy pig, in honor of her fondness for cooking pork, and "insisted on coming into my room to hold a service over it." (Mary did have some fun in her Northampton convent life.)

She never organized a show again (although she was later tempted, after winning over Salon judges during her Paris sabbatical). "I shall rest in peace from exhibitions for the rest of the year for surely no one could ask any more of me," she told Henry. The public "would much prefer me in a restaurant or a corner grocery or a foundling asylum but I insist on boring them with my feeble pictures a while longer. Well, we can still look upon nature and enjoy it in our peculiar and somewhat restricted way. Thanks be!" She quoted a Smith night watchman, who fortified himself for winter rounds with "a jolly big drink of—cold water! I suggested that he might have found something more warming but he said no, he must keep his 'ead clear. You know said he that if you lose you 'ead you're a goner. Do you think we'll ever lose our heads again sufficiently to be enticed to exhibit in the provincial towns?"

By early March, she had recuperated and was eager for snow to melt so she could bike:

"My wheel is being cleaned to be ready to snatch the first opportunity." She invited Henry to "bring your wheels and let me show you the country."

By May, she was sending him savage anecdotes about acquaintances. The Hartford-born artist William Gedney Bunce, known for his Venice scenes (Smith acquired one but no longer owns it), came to Smith with his sister, Ellen Bunce Welch, the wife of a Hartford insurance executive, Archibald A. Welch. (Mary had taught the Bunces' niece, Anne, in Hartford, and the Welches helped run the Art Society.) The entourage also included Smith's Hartford-based benefactors, Charlotte and Drayton Hillyer, and a Hartford art teacher and society portraitist, Charles Noel Flagg, who was there to install his own portraits of the Hillyers (since deaccessioned).[6] Mary told Henry that she "really liked" Gedney:

> Isn't he inexpressible! but O! the rest of the people who were with him!!! Mr Flagg—Ugh! with two portraits of the Hillyer family, painted by himself; which he was to superintendent the hanging of. . . . I think if Gedney had not been along to relieve the dull monotony of the other Philistines

I might not be here now. Gedney spotted his own adorable Venice and worshipped it all morning. . . . Mrs Welch asked me if I was a lunatic too. I think she found out that I had a will all my own. Wasn't it sad to have to waste half of a beautiful day on them. Such is life. Isn't Flagg an object. I can imagine how he fascinates the wealthy I find him repulsive.

A few weeks later, she tried to appease the Hillyers at commencement events: "I just laid myself out to be agreeable to them." She hoped she had succeeded at "removing the curse. I dont wish to injure the prospect of future donations!"

By the time Mary was trying to hide her contempt for philanthropists, she was preparing for a sabbatical in Paris, the "heavenly" chance "not to be in the mill." Still, she told Henry that "there are a number of people I hate to leave," and with the semester ended and students gone, "Northampton is a perfect paradise."

She paid one last entrancing visit to Cobalt before boarding the ocean liner: "Hasn't the moon been glorious Sunday night it rose dusky and red. . . . The country here is more beautiful than ever if that were possible."

My Own Femme de Ménage

Mary's happiest year was a time of bicycling, independence, artistic triumph, classes at the École des Beaux-Arts, and giggly house parties, with only minor downsides of muddy streets, worker unrest, and public anti-Semitism. There was one serious disappointment, which Mary turned into grist for humor: she discovered that Whistler was pretentious and a terrible teacher.

In late September 1898, as she headed for New York to catch her steamer, she finished her catalog of Smith College's plaster casts. During her brief Manhattan layover, the dealer Newman E. Montross accompanied her to the Cottier & Company gallery. There she saw Ryder's *Christ Appearing to Mary*, "one of his finest works," along with "no end of beautiful things Corot, Millet, Rousseau, and many more. . . . Mr Montross kept taunting me all the time with the remark that I would not see anything as fine as that in Paris, and

if I did would I let him know?" It is not clear whether she ever let Montross know how much she saw in Paris that was indeed finer than Cottier's inventory.[1]

She set off on the steamer with her farmer cousin Dave, whose preference for realistic art seems to have never bothered her. She told her sisters that Dave "can never get tired of watching the waves . . . he'd like to keep right on round the world." The other passengers, as usual, annoyed or amused her. A drunk young man onboard "furnished conversation for the whole dining-room." Violinists played "without invitation or urging." Sexism prevented her from seeing as much moonlight as she liked: "It is against the rules for ladies to be on deck after twelve. This is a most properly conducted ship." Two young passengers became her longtime friends: the Brooklyn-born architecture student Alfred Gumaer (later a professor at the University

of Pennsylvania—he eventually designed Mary's gravestone), who had graduated from Columbia and was off to study at the École des Beaux-Arts; and the musician Ruth Gray (later Ruth Gray Brodt, a Detroit Symphony patroness).

Mary and Dave agreed on ground rules for the road: "We'll never hurry for anything and never fuss." During their week in London, she noticed that the bicyclists "dont ride as well as Americans." She longed to try on "breast plates, helmets and steel petticoats" at the Tower of London. She coaxed her cousin through the British Museum: "Dave bore it like a man." They ran into acquaintances, including John Franklin Crowell (he had headed Smith's economics and sociology department and run what is now Duke University). At Westminster Abbey, Dave's interest flagged: "I'm sure he thinks it a dirty smelly old pile."

In Paris, the cousins walked for miles, and they rented American bicycles to ride as far as Barbizon and Fontainebleau ("The forest was glorious, a perfect dream, and the wheeling ideal"). She tried Dave's recipe for splashing cognac in coffee and wondered what Yankee friends would think: "Aren't you shocked? I am sure Grace is," she wrote Henry.

People assumed she and her cousin were married, although she was twelve years older. She mocked herself for being a burden, mistaken for his wife: "Dont you think it is pretty hard on Dave?" He seems to have complained only about musty churches; he smoked after those tours, "to fumigate." He did not mind that men were not allowed into the reading

13.1 During her 1898–1899 sabbatical on rue Boissonade, Mary had photos taken during her studio parties. *From left*: Mary, American expat architecture student Hugh McLellan, American painter Florence Vincent Robinson, and an otherwise unidentified "Miss Handley" (*seated*), who was next headed off to Tangier. WFC.

room at the American Girls' Club (more about that bastion of propriety below). She did not much mind that he went to the Moulin Rouge without her: "So you see I shall not get too gay while he is with me," she wrote home. She hoped "he wont tell any naughty stories about me" upon return.

Throughout her sabbatical, she wrote Henry once a month or so, and every day

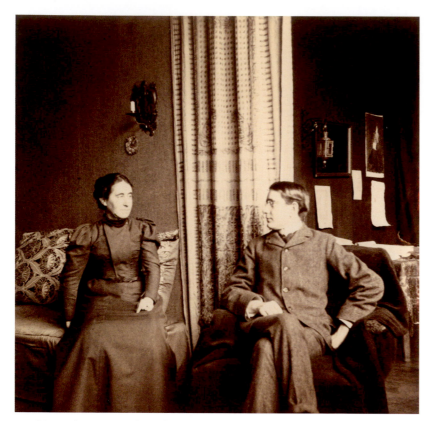

13.2 Mary at her Paris studio with architecture student Alfred Gumaer. WFC.

in postage and hoped her sisters "will at least enjoy opening the envelope." To convey anything potentially embarrassing, Mary would "write a separate private page."

She recorded what she considered foolish French behavior: the "excitements and musses" of the Alfred Dreyfus affair (the Jewish soldier had been falsely accused of spying) and unrest caused by "socialists & anarchists and half a dozen other ists." She listed expenses, down to centimes for renting chairs in a park. She rhapsodized about scenery at all times of day: "The city is a dream of beauty when the sun is gone and the lights are all sparkling," she wrote home after her first twilight bike ride. In decent weather, she rode the buses' open-air top seats: "I get a magnificent show for 3 cents." When night skies were clear, Mary thought of how it would please Clara Pease, whose school equipment included a telescope and observatory. (Those have been preserved at the school, now in a 1960s building.)

Sending letters, amid the insecurity of being on her own, gave Mary her only moments "when I feel sure that I've done just the right thing."

She told her sisters that no news from home was too small to report: "To be sure, mention the weather always." They sent photos of themselves, friends, the servant Mary Colbert, and details of housekeeping and day trips, which Mary lovingly called "racy and exciting." They reported on Laura's studies of German lieder with the singer Villa Whitney White—"I'd give a lot to hear those new songs and some of the old ones," Mary replied. The

she added paragraphs to what she called her "home letter." Twice a week, she mailed batches of pages to her sisters, to be handed around to family and friends. (Some envelopes have initials from people who read the pages—as if Mary's reports were an early form of interoffice mail.) She wanted to create "an endless and continuous chain of dates. . . . I think I shall turn into a writing machine." She worried that the letters with "countless blunders" were not even "worth five cents"

sisters sent copies of the *Courant*—Mary particularly liked the political humorist Finley Peter Dunne, who wrote under the pseudonym Mr. Dooley. As she worried about expenses, her sisters concealed a gold coin in a *Courant*. When it fell out, Mary reported, "You might have knocked me down with a feather and blown me away with a breath."

Mary's letters scarcely mention Smith. "The thought that I shall not have the Art Gallery on my mind for a whole year is simply blissful," she told Henry.

She stayed at first at the Hotel Louis-le-Grand, on the Right Bank near the opera house. (Henry had lodged there the previous year and befriended the proprietor, Émile Blet.) Its only flaw: "the guests are nearly all Americans and not interesting, so far." Dave helped her find a Left Bank studio to rent. The hunt was stressful: "O the nasty places I've been into!" One potential apartment had three young male tenants "of the long haired soiled variety, the genuine artist-type of Paris," and one of the men did not know the name of his own street below. She finally found a comfortable work space at 6 rue Boissonade (she would rent studios on that sleepy side street for the rest of her life).

In late October, she accompanied Dave as he headed to Antwerp to catch his ocean liner home. At Waterloo, she considered Lion's Mound, a grassy pyramidal war memorial from the 1820s, "the most satisfactory monument I've ever seen." When he left, she was "terrible lonesome" but firmly "decided that I wont be homesick." Her weeks with Dave amounted to "a lovely long play spell," and

after he was gone, she "discovered that Paris is after all a work-a-day place."

She left the Blets' hotel briefly to live at a widely advertised pension near her studio at 117 rue Notre-Dame-des-Champs (where Rodin's artist mistress Camille Claudel and her sculptor friends, including Jessie Lipscomb, had a studio for a few years). But she hated the mediocre food and overcrowding; seventeen people were crammed into a dining room "built for not more than six."[2] Mary then moved back to the hotel, wangling a discount "which I'm not to tell any one about." She wanted to be comfortable in Paris, even "if I have to pawn my pictures."

She fell into her routines of critiquing buildings and paintings. Versailles struck her as "horribly deserted and useless." Puvis "is the only mural painter who satisfies me" as well as "a charmer [who] has sat at the feet of the early Italians." She agreed with Henry's approval of Puvis's allegorical murals of science, philosophy, and poetry in a stairwell at the Boston Public Library. By the time she arrived in Paris, Puvis was in failing health and mourning the death of his wife Marie, a Romanian aristocrat. Mary wrote home reporting his death on October 24: "To think he should die just as I got here and before I had time to see him!" But her next sentence, in that letter, muses on bringing her sisters to visit some Puvis works in Amiens the following summer. So often in her correspondence, she mentions a tragedy or disappointment and plows onward.

She bought a copy of the Catholic Mass in French—"Dont let it get about Hartford,"

she joked to Henry, her fellow non-devout Protestant. She attended Protestant services for Americans on the same Sundays that she sat through Catholic Masses, admiring the pageantry and music while irritated by feet shuffling, men snoring, and "the everlasting clinking of coppers" from people raising money for the church and the poor. At opera, ballet, and theater performances, she evaluated sets and costumes and praised women performers. "O, such limber ladies, and so many of them, really very pretty," she wrote home after her first sighting of the Paris ballet corps.

Gumaer joined her at church services, and people mistook him for her brother. She described him as "such a 'folksy' fellow, and we enjoy the same things." She called him "my young man" or "Gummy," his nickname from his male friends. Her time with him troubled Grace, who was always more concerned about Mary's reputation than Mary was. Mary reassured Grace that Gumaer was "the most naïve kind of boy, just out of college. He treats me just like another chappie and likes to enjoy things with me. I assure you that we are both perfectly safe and that it is very pleasant for me [to have] such an escort occasionally. He tells me everything he does as if I were his big sister or his fairy godmother."

The watercolorist Florence Vincent Robinson invited Mary to parties at her studio at 31 rue Vaneau and attended Mary's rue Boissonade gatherings with Gummy and Hugh McLellan, a Columbia grad studying at the École des Beaux-Arts (he later became a sculptor and small press owner). A handful of other expatriates and tourists met Mary's standards. The California-born painter Clara McChesney (1860–1928), Mary's neighbor on rue Boissonade, lived with "a wonderful great Angora cat" and offered advice on finding studio supplies and classes. Irene Jones Harland (1840–1925), the wife of a Connecticut lawyer, Thomas Harland, and the mother of the London-based editor and novelist Henry Harland (who traveled in the circles of Henry James, Aubrey Beardsley, and Kenneth Grahame), asked Mary to witness her will.[3] The widowed writer Jennie Bullard Waterbury and her Bostonian companion, Sally Merry Simmons, were living at the Louis-le-Grand hotel. They praised Mary's paintings and the Smith cast catalog: "they think it represents a tremendous amount of work." Jennie and Sally, "the dearest, kindest creatures," would drop off flowers at Mary's studio. When the Blets served champagne at a christening party for their son Raymond, Jennie Waterbury joked about writing an article for the *Courant* on Mary's experience, titled "Her First Glass." (Around the time that Mary met Jennie Waterbury, Lippincott published her novels about intrigue among Americans in Paris, *An American Aspirant* and *A New Race Diplomatist*.)

Jennie talked too much, however, and she considered Mary too new to Paris to make valid aesthetic judgments yet: "Mrs W. is one of those people who think that Art is absorbed without effort by merely existing in Paris and that one who has not sojourned in this center of Art can know nothing about it. Consequently when I meekly venture an opinion on

'my own subject,' she tells me I show my igno-
rance, and I who am schooled in taking sass of
that sort do not even notice the rudeness of it
till she apologizes shortly after."

Some acquaintances drove Mary away
after just a few meetings. Grace Hubbard,
an associate professor of English on leave
from Smith, tiresomely complained about
"points which might be improved at Smith."
Mary deemed one Mrs. Carpenter, an Amer-
ican married to an Englishman, as "a tri-
fle too frisky and Parisienne for my taste."
Mrs. Carpenter had striking white hair
and "a most beautiful profile," but she kept
name-dropping about her friendship with
the dancer Loie Fuller. Mary wrote home
that Mrs. Carpenter "serves Loie up to me
hot and cold on all occasions." A mother
and son visiting from Connecticut had
been misinformed that Mary was Smith's
president—"Imagine my consternation"—and
Mary summed up the pair brutally: "The son
is pleasant company but the mother bores
me." Mrs. E. L. Van Pelt, a widowed Phila-
delphian who ran a Paris pension, "came to
Paris a number of years ago to educate her son
whom she worships"—the son, John Vreden-
burgh Van Pelt, was a Beaux-Arts-trained
architect. Mrs. Van Pelt showed Mary "all his
photographs from a baby up."

Mary occasionally visited a Smith graduate,
the Rockford College philosophy professor
Julia H. Gulliver, at the American Girls'
Club on rue de Chevreuse, a few blocks from
her studio. Julia liked it there, Mary wrote
home, "but I'm almost certain I would not. It
was smelly and dirty and chilly and too many
females. . . . Isn't it sad to be so fastidious,
and to mind smells and bad food. It makes
living in Paris expensive, for you have to
pay to be clean." Minna Talcott stayed there
during trips to Europe, but Mary "would not
live there if they'd give me the whole place."

The club, founded in 1893, was the brain-
child of Elisabeth Mills Reid, a banking
heiress and the wife of the journalist, dip-
lomat, and politician Whitelaw Reid; Mary
caught sight at the club of Mrs. Reid, "a plain,
vivacious woman in an elegant gray gown."
The seventeenth-century building had a few
dozen guest rooms, and parlors for dining,
playing music, reading, and exhibiting art. It
was run by a Connecticut native, Julia H. C.
Acly, and meant as a haven of camaraderie
and clean morals for young art and music
students. It imposed curfews and rules about
where male guests were allowed, and it reas-
sured American families that their daughters
would be shielded from Paris decadence and
predatory men.[4] On one of Mary's early visits
to the club's tearoom, "who do you think
came and looked in at the door—Mr Whistler!
. . . He looked much older than when I saw
him last." An elderly man sent by Connecti-
cut friends came to look for Mary there: "It
quite impressed the natives that I should have
a gentleman come to call on me."

Mary set about improving her studio,
"palatial for one person"; she had no desire
to take in roommates and repeat her "exper-
iments in co-operative living" at Smith. Her
kitchen on rue Boissonade came with "brass,
copper and enamel ware—enough to cook for
a large family," she reassured her sisters. She

sent home a floor plan, showing the kitchen, coal bin, storage cabinet "where I can stow away no end of truck," and, separated by a curtain, a bedroom and a work space. One wall "is nearly all a great window which gives me north light."

After two months of daily crosstown commuting by bus or on foot from the hotel, she moved to rue Boissonade for the rest of her sabbatical. "I am going to be my own femme de ménage and shall be fitted to serve as butler, second girl or laundress in your new house," she told the Whites, who were moving out of Henry's parents' Hartford home to a new shingled pile in a leafier part of town. Mary invited them to her bohemian Paris paradise: "I'll let Henry work in my studio all the time if he wants to."

That fall, as the days shortened, she steeled herself: "I'm glad I served an apprenticeship at being cold in Northampton it was excellent training for a winter abroad." She learned to keep smoke from puffing out of the cracks in the studio's heating stove; while pouring in coal, she wrote home, "I shall keep my muscle up without basket-ball this winter."[5] Mary replaced the previous tenant's red wall coverings with burlap and his red upholstery with plain fabric, and she swept out his "cobweb and dust and microbes." She applied gray-green paint to wainscoting that had turned a "dirty nasty color," and she brought in brass candlesticks, an American oil lamp, and Italian majolica tableware. It turned out attractive and uncluttered: "There are no Turkish rugs, Cashmere shawls nor any of those appurtenances of a second-hand museum."

When her paintings crate arrived from America, she opened it with a meat chopper. She found stores supplying canvases, fish glue, and clay primer. The neighborhood had so many artist tenants that salesmen with paint, brushes, and pastels knocked on her door almost daily. Italian men hoping to model showed up, too.

Unlike many other American women studying art abroad, she did not seek out a mentor: "I want principally to work by myself." She did enroll in anatomy drawing classes at the École des Beaux-Arts. She attended for six months, despite the stuffy classroom that smelled of bones with "flesh left on some of them." The students were eventually presented with a "horrible defunct" cadaver: "it looked as though every effort had been made to produce the most repulsive and horrifying effect. Yet we all sat there calmly for an hour." Week after week, the same corpse was brought out. As it deteriorated, it looked "a bit less dreadful . . . he looked less alive." The male students were long-haired and unwashed: "I wish I could send you pictures of some of the freaks who frequent the lectures—artists I suppose."

One rainy day, Mary sat next to a young woman "who had come on her wheel, in bloomers and black jacket. She was spattered with mud." Mary sent home descriptions of other Paris bikers: they hung Chinese lanterns from their handlebars, and women riders wore bloomers "just about like those I had for basket-ball." She called her own riding outfit, brought from Hartford, a "Cooper skirt"—she was probably referring

to a "safe, modest and comfortable" split skirt for bicycling (figure 11.3b) that the Connecticut inventor Ella Hood Cooper had patented in 1896.[6] Mary wrote that her Cooper outfit "is all right for the wheel and does not bother at all in mounting it is so stiff." Her sisters kept offering to send her a bike from Hartford (and by spring, she could not resist the offer).

Paris's "dark, dreary, rainy, desolate days" spurred her to work harder. Under one blackening sky with "queer coppery light at the horizon" that in Connecticut would signify "a cyclone or a tornado at least," Mary kept painting "to the astonishment of all, for it was almost too dark to see." A young student, Miss Mackenzie, sat for her portrait while reading a book "so that she may combine study with posing." Friends dropped by: "I am so giddily social that I can scarcely find time to write." By early December, the Girls' Club had put three of her landscapes (two of Waterford and one of Hadley) in a juried show. Mary had been told the exhibition would also include one of her portraits, a pastel bust so abstract that it "suggested a snow storm to so many people." But the piece ended up misplaced in storage and was never hung: "the concierge had carried it away thinking it belonged to the Club and so it was not presented to the jury. I've always refused to exhibit at Women's shows and I shall continue to refuse after this." (In later years, however, she showed again at the Girls' Club and at the New York Woman's Art Club.) Julia Acly "quite went into raptures over my 'little Connecticut views,' wanted to know the exact location of

Waterford; said my pastels had been admired by all and pronounced the best things in the show. If you had seen the show you would understand why I did not weep for joy at such praise." The directress "wishes the club to purchase some of my pastels and would like to have one herself also knows of another lady who would like one. I rather think she meant they'd all like one if I were giving them away. I find that these women over here will pay cheerfully twenty-five dollars for the latest thing in corsets but they consider ten dollars too much to pay for a picture. Queer old world, isn't it." No one from the club did close any deals with Mary: "I suppose they haven't the money, that is the way with people who like my pictures."

Her studio was close to stores and tram lines, protected after dark by a locked gate, and more appealing than "any of my quarters in Northampton," she reassured her sisters. Mary found an affordable housekeeper and laundrywoman, and she paid a nominal amount for dinners with the Montagnys, an artistic family at 8 rue Boissonade.[7] Mary told her Hartford worriers that she could resist clothing stores: "I begin almost every day with a little mending." She took in her sleeves, tightening them to hide holes. Her sisters shipped her an old green silk dress. She repaired an umbrella until it was "beyond the care of my faithful needle." By sewing her own cotton curtains, she wrote, "I'm doing just what I please." She ate healthily and lost weight (Mary apparently considered herself chubby): "I am very well and sleep better than I have for more than a year. I've walked off a

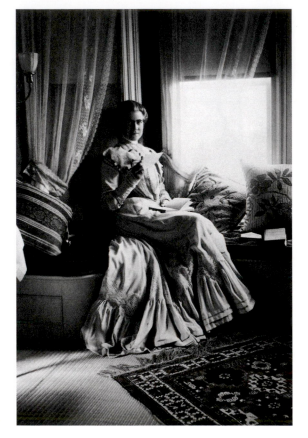

13.3 Mary described her friend Mabel Eager, a Boston-area business-woman and philanthropist, as tall and elegant, "with a streak of gray in her hair." AUTHOR'S COLLECTION, FROM DONALD J. WINSLOW, *LASELL: A HISTORY OF THE FIRST JUNIOR COLLEGE FOR WOMEN* (BOSTON: NIMROD PRESS, 1987).

fabrics, and shapes of gowns, capes, and veils worn in church, and the misery of children and the infirm begging outside. She marveled at a barely visible choir of nuns singing without intermission, "now antiphonal and now in unison," continuing after priests and congregants had left and "weaving up and down like flowers in the wind." Mary sounds eerily foresighted, to modern ears, as she complained about "fat, fiery" priests who "ranted too much about the Jews" and decried Islam as an "infidel religion" that should be abolished. (Mary herself, a woman of her time, was not above a minor complaint or two about Jewish shopkeepers who were said to overcharge.) She attended a lecture by the drama critic Francisque Sarcey ("old and fat but very entertaining"), and she was dazzled by playwright Edmond Rostand's *La Samaritaine* starring Sarah Bernhardt and *Cyrano de Bergerac* with Coquelin. What she had "no curiosity to see" was the demimonde of the Moulin Rouge, which strayed too far from the mores of her "staid Nouvelle-Angleterre."

Young American women were drawn to sensible, resourceful, observant Mary—and she to them.

By early 1899, the studio visitors included Ruth Gray, the pianist Mary had met on the ocean crossing, and Mabel Tower Eager, a Mayflower descendant, violin student, and office supplies heiress (and future philanthropist) from the Boston area. Marie Squires, a Mayflower descendant and art student (and future pioneer, with her husband Herbert Hopper, of the Baha'i movement in the United States), was taking classes

little bit of my superfluous adipose deposit I believe though you might not notice it."

She packed letters with sightseeing reports. At the Tuileries, "the bare trees were lovely in the twilight with the lights shining through them." She survived patches of "simply diabolical" weather: "The wind nearly blew my eyebrows off." After visits to posh Right Bank neighborhoods, she wrote home mocking "ladies in blue velvet and white fur and rich feathers." She recorded the colors,

Mary Rogers Williams, 1857–1907

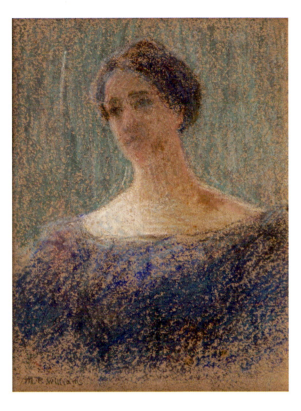

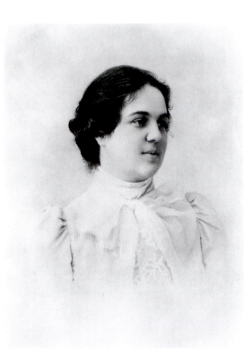

13.4 In 1899, Mary's artist friend Marie Squires posed for a pastel portrait, 8 x 6 in. WFC (PHOTO: TED HENDRICKSON).

13.5 Marie Squires. She and her husband Herbert Hopper were among the first American expats in Paris to convert to the Baha'i faith. NATIONAL BAHÁ'Í ARCHIVES, UNITED STATES.

with Whistler and living in the Montagnys' building.[8]

When Mary's back ached, Mabel "insisted on spending the night with me and massaging me. She did it so well that I am almost well today." (That letter goes on to admire "a gorgeous soldier in the tram this afternoon; his red trousers were beautiful and his gold epaulettes kept hitting me.") Mabel became Mary's lifelong friend and patron, and Mary painted her portrait (now lost). Mary considered Mabel "just the kind of girl I like to be with—quiet & sensible and bright and thoroughly kind-hearted."

Marie Squires, like Mary, was paying to eat dinner at the Montagnys. Mary reassured Lucy and Laura about the cuisine by describing Marie: "she certainly looks well-nourished, is buxom and has a bewitching dimple in her left cheek. I dont suppose they give them with the meals."

Mary's bust pastel of Marie shows a pensive young woman with a dimpled cheek and her head slightly cocked. Mary formed the mottled green background out of bold verticals, and the dark gown out of playful crosshatching. Marie asked for pastel lessons from Mary: "She admired my original way of using them.

I told her it would be much better for her to go home and use them her own way."

Ruth Gray, soon after she returned home from nearly a year in Paris, married Charles H. Brodt, a bank teller in Geneseo, New York. In 1902, she wrote Mary a reminiscence of the rue Boissonade studio. Mary had sent her a pastel souvenir, and Ruth thanked her: "How the little pastel takes me back to Paris & the little apartment, with its funny little kitchen & oil stove that exploded. I had such a lively time there with you—there was simply no end to your goodness.—I don't know how I could ever have let you do so much for me.—I often think of it now with humiliation & think I must have been in a sort of dream—being in love. Forgive my heedlessness in those days, for I think I was almost irresponsible, & let everything drift as it would." (Ruth's 1902 letter also invited Mary to come to Geneseo and "make me a more respectable visit.")

Amid the socializing, nurturing, and borderline flirting, Mary worked on New England landscape paintings and pastels. And as she grew "more and more contented" in Paris, she enrolled in Whistler's new school, on Passage Stanislas, near her studio. She planned to paint there every morning and then continue all afternoon at home. Whistler was financing the school, the Académie Carmen, which was run by one of his long-time favorite models, Carmen Rossi. It was also known as the Académie Whistler and the Anglo American School. Founded with fanfare in October 1898, it lasted less than three years.

The art historian Robyn Asleson has pointed out that the Académie's tuition "was about double that of other ateliers." Women students paid twice as much as men. Mary, even on a budget, could not apparently resist training with a man she had described in 1891 as a "rare dear."

The Académie's female customers later credited Whistler with "transforming our ways of seeing" and toning down leanings toward a "gaudy palette," and they tried to "prove ourselves worthy of our great privilege" of the widowed master's attention. Whistler largely ignored his male students, giving them advice in the form of shrugs and cynical smiles, and they quit in droves; "the *men* are less interesting than ever," he told his apprentice, Inez Eleanor Bate, who served as *massière* (monitor) of the school.[9]

Before Mary signed up, she stopped by Whistler's "very attractive" home at 110 rue du Bac. His front hall "is done in the same colors that I have done the walls of my studio, isn't that odd," she told her sisters. After keeping her waiting for nearly an hour, he "rushed in apparently not at all in the mood for a visit from a stranger" and sent her to check with his school manager. She squeezed in "one or two questions about the exhibition that he had in London last year."

Mary started off in a coed class at the Académie: "there are no startling freaks there and they all seem earnest workers." The young students "smoked pipes and didn't look as if they had a chance of ever arriving." A male model amounted to "the conventional, dirty, picturesque old chappie." She preferred

sketching "my beloved Assyrians & Egyptians" at the Louvre instead. But she was still "very curious" to hear what Whistler would say during his Friday sessions; she predicted the critiques would offer "much sport and exercise."

As for Carmen Rossi, Mary was repelled: "The woman is Italian, from the lower classes I should say, rather pretty & quite vulgar. She has . . . a most comic air of owning us all; she is familiarly called Carmen I'm not sure about her last name and I have an idea that maybe she is not, either." The tuition fees totaled nine dollars: "I trust a good deal of it gets to Mr Whistler for they say the old chappie is rather hard up." (It did not help his financial state that Carmen Rossi was demanding a hefty salary. She was eventually caught stealing artworks from him.)[10]

The beleaguered master kept not showing up: "Mr Whistler did not gladden our eyes this morning, reason not stated." About twenty women were in the room: "We had an exceedingly feminine time this morning choosing a model and getting her posed, women are très-amusantes at times." As another scheduled Whistler critique approached, Mary wondered "if he'll favor us with his presence this time? They say 'he do talk beautiful.' I wonder if men are ever quite as impressed by a teacher as women are." Her classmates "are all trying most faithfully to follow their master."

He arrived one morning, carrying excerpts from his 1890 book, *The Gentle Art of Making Enemies*. Mary, who already owned a copy, found the session "worth more than the price of admission":

> In the first place the air of nervous expectancy was touching. *He* was a bit late, but when he arrived a hush fell upon us that I have never experienced except at funerals It was "the little tin god on wheels" and the class was prostrate before it. O, it was such fun! I felt like a heretic and heathen because I was amused.

Mary was not yet feeling ready to submit to a critique. But her hesitancy seemed to upset Inez Bate, so she "walked right up" and presented her work to "the little tin god." He seems to have been too distracted to respond:

> Our master was faultless in his attire kept on his black glove; pulled out that is took off his monocle I noticed when he really wanted to see, and carried in his hand a roll of white paper. His white lock was elaborately arranged as usual that is it is pulled out and sticks up like a little feather—most carefully arranged. No work was done while he was in the room not a sound was made and all followed the master from easel to easel to catch every word that fell from his lips. When he had criticized all the work he sat on a low stool and unrolled the paper which had been so effective in his hand. It proved to be some of his "Propositions" which are in his "Gentle Art." He read them out to us and then suggested having them tacked on the wall for constant perusal.

The next day, Mary's classmates were "in a state of almost complete collapse" from the effort of impressing him: "I seemed the only one really anxious to work, for the rest it was 'the day after the ball.'" A Whistler quote ended up framed on the classroom wall: "Art is the science of the beautiful." Aphorisms from *The Gentle Art* were printed up for students to purchase; Mary bought two and promptly resold one to a "lady in sore need." The class, she wrote home, "flourishes & increases We have Americans, English, Russian, and Spanish, all bowing at his feet." In the poorly lit and crowded room, the teased hairdo on a classmate, Emily Childers (known as Milly), blocked Mary's view: "It seemed to be my fate to get next to a galumphing English maiden by the name of Childers who had a bristling bang that was always in evidence when I particularly wanted to see the model."

In mid-February, the master finally told Mary what he thought of her paintings: "He criticized my color he wishes everything dark & rich. The class really are silly over him; what fools women can be." She took a break from the Académie to work on Mabel's portrait, "to get filled up with fresh air and to recover from the depressing effect of too much adoring female." She would likely miss a session with him, a classmate told her: "She seemed to think I ought to feel desolate." Mary was only a little tempted to return to the Académie, "to see some of the dear freaks again."

She lost all interest in returning once she detected days lengthening and "the willows already showing a delicate green." She was considering spending another year in Paris, she told her sisters, although she was unsure "whether I'll really have the grit to stay away from you all." She told Henry about her homesickness, too: "There is nothing over here as nice as our own beautiful country and no one as nice as my friends."

She heard from colleagues including Elizabeth Czarnomska (the Czar), and Susanne Lathrop (who was serving as Mary's substitute). Tryon, she found out, "does not approve of my being away another winter." Mary was left "feeling almost a bit low in my mind" upon learning that her friend Frederick A. King (1865–1939), a Connecticut native and Wesleyan alum who was filling in at Smith's English department for Grace Hubbard, had suffered a breakdown and left the job after a few months. Jennette Barbour Perry Lee, a prolific novelist and the wife of the philosopher Gerald Stanley Lee, took over King's post. (Jennette at some point posed for a portrait by Mary, now lost.)

Henry sent news of William Gedney Bunce, who had apparently cut short a trip to Europe. Mary joked that his abrupt return to Hartford "left all the crowned heads desolate." Bunce wanted to socialize with the Whites, and the feeling was not mutual. Mary envisioned Henry's new Hartford house with "a moat, drawbridge & portcullis" where she would serve as gatekeeper: "if you want me let me know in time to get a suit of armor." At the gates she would "accost Gedney thus: 'Ho, Thou of the red beard my master will have none of thee; get thee gone!'" Mary was irritated to learn that Flagg, the Hartford artist she detested, was pleased with his own success:

"Does he really think he has anything to do with Art?"

Henry suggested that Mary submit work to the annual spring Champ de Mars show. She agreed that "perhaps I ought to," if she could get "anything half decent" by humbly "scrubbing away" at canvases and pastels.

She stopped scrubbing away every Thursday, to host her official calling hours. Sometimes half a dozen guests stopped by and later exchanged notes about her hospitality: "Did I tell you that the fame of my coffee has gone abroad into the American Colony? . . . I tell them all that I make it just as my sister told me." Marie Squires found her own apartment noisy and spent nights on Mary's sofa, carrying bedclothes back and forth as curious neighbors looked on. Minna Talcott invited Mary to head off to Greece with her, but Mary had "just money enough to keep me in Paris till the end of May." Mary consoled one "Miss Weingar," who was "in trouble," almost undoubtedly a euphemism for pregnant: "I've tried to do what I could for her which was precious little."[11]

During a party at Mabel's pension, Mary observed the "mad & dizzy whirl" of dancers, with women in décolleté outfits "from the ordinary low-necked gown to the kind that made you wonder why the lady had any waist at all made." Florence Robinson, her hair full of confetti, showed up with Gummy at Mary's place after a Mardi Gras parade. Mary marveled that the French, "old & young, rich & poor," would spend days "throwing little colored papers at one another" while the government was "at sword's point with several

nations." Mary sent home confetti samples in a letter describing what may have been the most fun evening in the life of the baker's daughter. Her friends doused her with confetti upon arrival: "They said they had tried to get it as artistic as possible to please me and had selected green and purple. . . . They continued to throw it at me after they got inside till the floor was quite covered with it. . . . We scrapped with it all the evening off and on and everything was finally covered with it. I've had a great time cleaning up this morning. It stuck so to the cottony covering of the divan that I had to comb it off with me comb."

In mid-February, she allowed herself one more distraction: the funeral of the French president, Félix Faure, who had died during a tryst with his mistress, Marguerite Steinheil. Mary joined the mourners and curiosity seekers filing through the President's House, overseen by motionless guards "like wax figures." The coffin and bier were sheltered "under a canopy gorgeous with black and silver . . . in the room where he was to have given a great ball Thursday." During the day's street procession, anything convenient to climb on was thronged: "the trees were full of men." Mary paid a few francs to be boosted onto the roof of a vendor cart. She took notes on the parade of "steel helmets & cuirasses shining in the sun," flags, politicians, women in crepe bows, and men carrying huge floral wreaths. The new president, Émile Loubet, brought up the rear of the procession, "on foot and bare-headed." Faure's funeral at Notre-Dame was impenetrably crowded, so Mary headed off instead to a sixteenth-

century fountain sculpted by Jean Goujon: "We have casts of the reliefs at Smith and I have wanted for some time to see the originals." She never hid her rounds of parades and parties from her sisters: "Aren't you glad that I went, so as to have something to write about?"

She hoped for no more irresistible ceremonies: "it is fatal to work; I must try to make up lost time now." She did make time to visit the Louvre, discovering sculptures she had never seen and scornfully observing a woman at work on "a copy of Velazquez's Infanta that looks like a Spiritualist portrait." She strolled through Paris's "fascinating haze that seems always to wrap it, like a Botticelli veil," and along its riverbanks: "I dont believe I shall ever get over having emotions in seeing the Seine at twilight." She hosted a party for George Washington's birthday, with patriotic decorations in her gray-green studio. Mabel played dancing music and the national anthem, and Mary served fruit punch "of the temperance variety" and a cake "trimmed with candied cherries" (perhaps inspired by her father's confections). At one of Florence Robinson's gatherings, she ate a huge slice of mince pie and then slept restlessly. Abby came to mind, perhaps because the pie had been imported from America: "It may have been that that made me dream of you all, of being with you. Abby was there too as she always is in my dreams. Laura looked sad and Abby told me it was because I had not admired Madge's last picture." (Madge Hubbell was a Hartford neighbor—see chapter 14.)

When Mary did buckle down "to be gen-erally industrious" for her Salon submission, she was wracked with doubts about what the jury would think. She wrote home: "You must think with all my work I must be covering metres and metres of canvas but you know Art is long and I'm just pegging away at a few things." She refused to have anyone contact jurors on her behalf: "I have not the slightest 'pull' anywhere and I hear that things go mostly by favor over here. Miss McChesney has been working her cards well for 'pulls'; seems to me I'd rather sell matches than have to manage that way. . . . I have not a bit of influence to help me, and am told that they may not even look at my work, but I shall feel that I have at least done my duty by sending."

Neighboring artists were buzzing with hope and Salon preparations: "you see frames trundled through the streets everywhere." She retouched her gilded frames and splurged for a new one, although "there is so little chance of having my work accepted." She requested an extra inner molding strip from the frame maker Paul Foinet, who also worked with Whistler (and who would supply her a few more times). But the frame's original designer, the artist Edmond Aman-Jean, somehow heard of her request and bossily "objected to having it improved, so I did not get the extra molding; isn't that droll!"

Visitors, including her neighbor Frank Edwin Scott, encouraged her: "Everyone who has seen my 'gems' has been polite enough to say that if they are not hung it will be only because I have no influence." Minna "jumped around in ecstasy" over the pastels, and after Irene Harland had a hard time finding the

rue Boissonade apartment, she told Mary that "the sight of my 'Twilight' more than repaid her and that it had been a joy to her ever since." Also keeping up her spirits was Lucy's offer to ship her own Columbia bike overseas: "It gives me pangs to think it is parted from its lawful mistress that is an act of self-denial that I shall endeavor to live up to." Mary sent home a sketch of her membership pin from the Touring Club de France, a wheel enameled "in red white and blue—very pretty." She borrowed a bicycle to try out the Paris pavement with neighbors—the families of two doctors, Henry Smith Williams and his brother Edward Huntington Williams—and they found themselves "quite an exhibition and a free show for all the street who apparently enjoyed it." When Lucy's bike came, Mary expected "to be a little lazy and be out of doors as much as possible."

By early April, she had earned her relaxation. Of her seven works submitted, the Salon jury accepted three Connecticut pastels, two of them in "Whistler frames." Two were Penfield Hill scenes, "one with the sky full of clouds," and the third was sketched at Waterford. The catalog's titles were *Nuages (paysage)*, *Un jour gris (paysage)*, and *Un pâturage. Nouvelle-Angleterre (paysage)*. On the back of an 1895 view of a treed meadow (figure 2.14), a faded inscription in Mary's hand records that it was one of the Salon successes. Its title over the years has been listed as *The Tree*, *New England Pasture*, and *Hill Country*. It divides a vista into three bands: clouds, an undulating line of dark green trees, and a grassy foreground.

Clara McChesney "had only two things

accepted in spite of a master on the jury," and her Madonna portrait "that she has worked on all winter" was turned down.[12] Jennie Waterbury was astonished that Mary had been accepted with no strings pulled; only rarely had the novelist seen "merit succeed." She and Sally Simmons teased Mary that she was "a cold-blooded New Englander because I was not wildly excited over it and had not cabled to everyone in America." Mary did feel a little warm-blooded over her triumph: "Just think! I shall go to the vernissage and see all the swells and cranks."

But there was a burning question, which has faced successful artists for millennia: what should she wear to the opening?

Although she had a newly repaired "black and white silk" outfit and hated dressmaker sessions, she could not resist splurging on new clothes. She sent home fabric samples with apologies "for having it silk lined, but it doesn't cost any more and I thought I must be as 'chic' as possible." The fashion of 1899 called for a flare of yardage at the back: "all the Paris gowns are long (even mine is long Lucy, can you forgive me)." In late April, she attended two Salon openings in one day: "The afternoon was the gay time and the great place was crowded with all sorts and conditions and all kinds of costumes from corduroy to point lace & velvet—such gorgeous costumes and I suppose distinguished people though I had no one to point out celebrities. . . . The street outside the building was crowded with people watching the swells arrive in their carriages." Among the art highlights was Augustus Saint-Gaudens's statue of

Sherman on horseback (now a gilded land-mark in midtown Manhattan), "a grand thing it is." Her Waterford pastel was displayed at eye level, "and the others just above, all very well hung." Elsewhere her eye was offended: "There were the usual number of fantastic and bad pictures that made you wonder how they ever were accepted and hung and I noticed it was always the weird, the fantastic or the vulgar that attracted the crowd—my faith in the artistic taste of the French as a people has been sadly shaken this winter." Historical, religious, and allegorical tableaus did dominate that year's Salon; Mary may have been objecting to the rather bombastic images of angels aloft and soldiers dying.

The rest of her sabbatical unspooled lazily. She stopped going to Beaux-Arts lectures once the professor brought out skull bones. She took French lessons with Mabel, and Mabel played violin at the rue Boissonade studio, accompanied by Mary on a newly rented piano. Lucy's bike arrived, and the Williams doctors on rue Boissonade helped get it in shape: "Boulevard Raspail is as uneven as a country road in spring but I found some beautiful side streets. . . . Columbia has a new front tire and seems in every way in good condition. I keep her by the coal box."

Mabel and Mary went to England and spent two weeks bicycling around Canterbury, Mary wearing her Cooper outfit: "The roads about are beautiful for wheeling, a bit hilly, but that just gives you a chance to walk." She left larger spaces between words and lines in her letters, as there was not much to report, and the sisters were about to spend

the summer with her. There was talk of street riots, but they fizzled out: "The Frenchman, always a child, dislikes to have his play-day spoiled." As for Dreyfus, "The tide is turning tremendously in his favor and how can it be otherwise."

Her homesickness deepened: "I would rather see Waterford than any place I can think of this side the big water," she told Henry. "Really there is nothing here quite as attractive as Waterford and Penfield Hill." With her Salon success, she mused to Henry that perhaps "my credit will go up in Hartford now [and] we can venture another exhibition. I am anxious to see what you have been doing this winter." She told President Seelye that she would return in the fall only if she no longer had to teach art history: "I have actually got up enough spunk over here to refuse to run two departments." She stood her ground when he insisted that she change her mind. "I am waiting to see if that was equivalent to a resignation," she told Henry (in a foreshadowing of her Smith downfall). The school acceded to her demand; Tryon was "anxious to have me back."

She packed up in Paris with regret: "Some of the roots had stuck in pretty deep. . . . I have brought away no end of delightful memories." Tryon had written to her before heading off to Canada: "I am so amused that he thinks it foolish to enjoy life in Paris. I dont believe he knows about the kind of time I had." She looked forward to telling Henry about a Whistler show that she saw in England "and also about my month in his school." In Holland, she wrote, "So far I have not seen

anything that seems worth coming across the big water to paint—that is if you have the felicity to live in New England." At the Frans Hals museum in Haarlem, the paintings "look to me a bit like pot-boilers." Dutch folk costumes made her wonder if Connecticut women could be persuaded to adopt "short black skirts, bare arms, bright kerchiefs, and white caps and sabots."

Although there was no sign of her slowing down, one of the sabbatical's last letters to Henry contains an offhand comment, about her considering a side trip to Switzerland: "As I have not been very well this spring I long to be where it is quiet." Her letters do not much mention illness that year, though. Was she beginning to be affected by the abdominal tumors that she had just noticed?

The Most Magic House in the World

During Mary's absences, her sisters made their own small impact on the world. They nurtured a future celebrated poet who hated almost everything about Hartford except for the Williamses.

Mary mocked herself as "a stony-hearted wretch" with little interest in children, unlike her sisters. Still, two dozen of her works depict children, from babies in high chairs to older girls huddled over books. *Self Examination* was her title for a sketch of a decapitated doll, its impassive porcelain head looking down at its splayed body. And children in the Williams circle never forgot the cultured house on Broad Street, with a studio for Mary, and the Cobalt farm.

Lucy retired from full-time teaching in her early forties (just before Abby's death) and then led Sunday school classes and hosted parties for children. Mary considered Lucy sweet and retiring to the point of having "a

constitutional dislike ever to answer a question directly." (Lucy's 1906 diary gives more sense of her timidity—see chapter 23.) If Lucy had seen Paris displays of Christmas toys, Mary told her, "all your infant friends would have fat bulgy stockings Xmas morning, and that drawer where you secrete treasures would be too full to shut." Henry described the Broad Street house as "filled with little chairs, dolls and toys to be ready at a moment's notice for a small visitor." In 1941, he mused to Laura, "What a pity Lucy never married! How she would have luxuriated in a numerous progeny!" He considered Laura "the most quiet and retiring" of the Williams sisters, "a true citizen of the world" who had "a wit that was as gentle and kindly as it was penetrating and brilliant, a philosophy as broad as it was profound."[1]

Mary did share Lucy and Laura's affection for the Hubbells, the tenants at 1500 Broad,

14.1 *Self Examination*, undated sketch of a decapitated doll impassively gazing at its body parts. WFC.

Mary R Williams Self Examination

14.2a and 14.2b Undated watercolors of European children. Mary often documented children's traditional clothing on the road. WFC.

Mary R Williams

brother, the poet Lindley Williams Hubbell (1901–1994).

The patriarch at 1500 Broad, Lindley Dodd Hubbell, known as Lin, was a designing engineer for the Pope company, a maker of Columbia bicycles (Mary's brand) and electric cars. He and his wife Nettie's oldest child, Madge Delano Hubbell (1891–1915), wrote to Mary, and Mary's letters are sprinkled with worries about Madge's ailments and praise for the girl's smudged letters and school progress. "Kindergarten has improved her very much I think," Mary told Henry in 1897. Mary sent Madge souvenirs: Norwegian tricolor wrapping paper, gloves from Antwerp, some Paris confetti. Little Madge even wished to marry the Williams sisters. (In 1914, Madge married John H. Tweed, a daredevil aviator and grandson of New York's infamous politician Boss Tweed. Madge and her newborn are buried in the Williams family plot.)

Lin and Nettie gave their son, Lindley Williams Hubbell, his middle name in honor of their landladies: "Isn't that a noble reward for all Lucy and Laura have done and will do for him," Mary told Henry. Lindley went on to serve for decades as a map librarian at the New York Public Library, and in 1953 he emigrated permanently to Japan. He taught and wrote prolifically there, and he took Japanese citizenship under the name Hayashi Shuseki. He was a friend and possibly lover of the Mississippi poet and planter William Alexander Percy (the cousin and guardian of the writer Walker Percy), and a friend and early supporter of Gertrude Stein.

Lindley despised his hometown. His

and for Arthur Van Riper Tilton (1897–1974) and Herbert Tilton (1899–1915), the sons of Trinity Church's organist and choirmaster, Frederick W. Tilton. The Whites eventually sought out reminiscences from Arthur and from the Hubbells' youngest child, Laura Virginia Hubbell Burlingame (1909–2003), who was Laura Williams's goddaughter. Glimpses of life on Broad Street can also be gleaned from writings by Laura Burlingame's

autobiography, a poem of fifty sentences, included the scatological line, "Number Two on Hartford, Connecticut." He described its inhabitants as "insensitive / And without imagination."

Nettie had tried to cater to him. She let him skip school and took him to Shakespeare performances; he memorized the plays while still in elementary school. He remembered his father as "only interested in hunting and fishing, killing things." Mary, however, liked Lin—she would join him on fishing trips. Lin was nonetheless kind, uncritical, and "very generous with money" for his gay son. Lindley considered Laura his aunt: "I mostly stayed at her house. She brought me up. She was a lieder singer and studied in Germany and lived in Italy, and she started me on French, Italian, and German. She was a very cultured woman and she was the greatest influence in my life. That's why I use three names, be-cause her name was Williams." He dedicated his 1931 poetry collection, *The Tracing of a Portal* (Yale University Press), to Laura.[2] Mary had brought Laura to Europe for months at a time, but contrary to Lindley's memories, Laura most likely never studied there; she learned German lieder in Hartford. It was partly fearless Mary's influence on Laura that he appreciated. At some point he bought one of Mary's works, titled *Isle of Jersey* (now lost).[3]

Arthur Tilton became an insurance exec-utive, and his after-work interests spanned from medieval history and Tolkien to mod-ernist poetry. He recalled 1492 Broad, decades after its "very wrong and cruel" demolition around 1911, as "the most magic house in the world." He remembered field trips with Lucy, and her "quiet charm, her tranquil strength, her wealth of affection and understanding." In middle age he could still imagine walking through every room:

I have always liked to think that Alice stepped through one of the looking glasses in that house when she set out on adventure. I met Alice in Wonderland in the Williams living room, and I still consider it the only proper setting for her. I remember the cool, dark front parlor [and] the low ceilinged dining room in which there was a sofa with slippery mohair upholstery. . . . I shall always smell the warm, sweet fragrance of [Irish servant] Mary Colbert's bread, fresh from the oven, as I near this part of the house. Now, on a rainy day in October, I can take refuge in Miss Mary's studio, if I wish. In the spring, lillies [*sic*] of the valley still grow along the North wall in the moist shade. . . . Miss Lucy and I had many strange ad-ventures. I believe that she prepared a catalogue of all the important things a child should know, and saw to it that my Education received a proper start. . . . I was introduced to all the important per-sonages to whom Miss Lucy had access. I remember an impressive day, when I could not have been more than six years old, which included a visit to a session of the state Legislature and a private interview with the Governor of the State of Connecticut. . . . We visited school

and college, factory and museum, flower garden and engine round-house. She read and talked to me by the hour.[4]

His mention of "important personages" suggests that the Williamses had maintained some of their status after the death of their father, who had baked for the Colts.

Lucy took Arthur to the Pelton farm, to teach him "about the primitive life of New England." On a winter visit, "I slept in a feather bed, pre-heated with a warming pan, found ice in the water pitcher in the morning, rode with Arvid, the hired man, on a sledge drawn by oxen, and helped make sausage in the big farm kitchen. Once, I expressed some curiosity about a peach . . . and a busy farm manager was persuaded to stop his work and lead a small boy through orchards and packing sheds." (His family eventually owned a group of Mary's works in oil, watercolor, and pastel, including views of Norway, France, Italy, and Penfield Hill.)

Soon after Mary returned from Paris, the Whites had a second son, Nelson, and "stony-hearted" Mary developed a soft spot for him.

Crisp and Free in Treatment

Mary returned from Paris elated. For the next three years, until her next trip to Europe, she busied herself by exhibiting in New York, perfecting her golf game (a hobby that for unknown reasons replaced bicycling), and painting while caring only a little whether anyone else approved.[1]

Soon after she reentered "convent life" in Northampton, six of her pastels were accepted at New York shows. At the Water Color Club, the *Artist* magazine reported, her portrait of Mabel and her view of a moonlit tree allée "stand out distinctly in our recollection." *Harper's Bazaar* called *Moonlight* "quite charming" and the portrait "exceedingly clever." Although in Paris she had resolved to avoid "women's shows," she sent works to the Woman's Art Club—the *Art Amateur* mentioned her "several good landscapes" on view there.

By February 1900 she was jokingly pitying herself: "Are you painting now Henry? If not you ought to for your souls sake I think that must be why I struggle on; I'm growing meeker every day but not so meek that I dont want every one to have just as hard a time as I do."

In New York, Newman Montross had displayed about forty landscapes by Tryon, as well as works by Thomas Wilmer Dewing (a friend of Henry and Tryon and a Freer favorite). Mary did not have "energy enough to get down there. I'm getting fat, and stupid and lazy." Tryon said she was "missing much in not seeing it. . . . Dwighty doesn't approve of my work at all lately; he thinks it is more like Whistler than it really is. . . . Mr Tryon has certainly been influenced by a number of the French painters even the so-called impressionists. That doesn't sound as meek as it ought to I'm afraid." Tryon boasted to her that Hartford's Atheneum had been "talking of buying one of his pictures but they con-

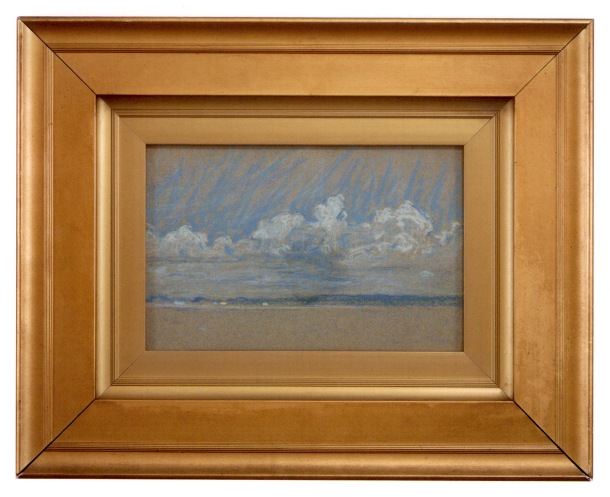

15.1 Untitled, undated cloud pastel, 6 x 9 in.
PRIVATE COLLECTION
(PHOTO: KAREN PHILIPPI).

sidered so long that he sold it to someone else."

Mary asked for Henry's thoughts on the New York shows. Mabel was visiting New York, too; Mary told Henry to keep an eye out for "a tall young lady with a streak of gray in her hair, slightly resembling my portrait of her." Mary kept working on her masterpiece, *Evening* (figure 4.6). She did not submit it or anything else to the spring 1900 show of the Society of American Artists (she only exhibited there in 1896): "I dont dare send it to the S.A.A. for fear they wont appreciate it I've decided not to send anything for I've nothing small and fear they'll think my things either too big or too bad. . . . There are times when I wonder why I kept at it."

Her time was swamped with anatomy and

15.2 *Clouds*, undated pastel, 6½ x 7½ in.
WFC (PHOTO: TED HENDRICKSON).

15.3 Mary's last Northampton housemate was her Smith colleague Sophia Clark, Class of 1882. PACH BROS, NYC. 80. CLASSES, INDIVIDUALS, COLLEGE ARCHIVES, SMITH COLLEGE (NORTHAMPTON, MASSACHUSETTS).

design classes: "I am wickedly trying to divert the young—I'm not conceited enough to call it teaching. I'm going to break away to the golf links just as soon as I can." When the French symbolist poet Henri de Régnier lectured in Northampton, Mary deemed the experience "such a breath from the other side." In staying at Smith, she felt like Giocante Casabianca, the French folk hero who died aboard his father's burning warship in 1798: "Like Casa-

bianca I shall stick to the deck I suppose—what a stupid boy he was!"

Imminent spring distracted her while she was teaching girls "the form and structure of the human figger. I trust they enjoy it more than I do, but possibly not. It went better than usual this morning because I had heard the birds for the first time. They were singing joyously as I left the house at 7.30 and I was tempted to turn west and run away to the fields and woods but custom was too much for me and I ambled to breakfast and work. How sad to be the victim of a habit! . . . What a comfort it is to find Spring not only just as beautiful but really more beautiful every year, and to feel that there is one thing that will always be satisfying."

She was living by then (as she would for the rest of her Smith career) with Sophia Clark and Sophia's widowed mother Ellen at 52 Crescent Street, a gabled then-new house set on a slope. After spending a few sick days at home, Mary recorded the view from her windows: "The sky over Mt Holyoke at the end of the day is fascinating and to see the clouds, all amber with violet shadows, change to purple and then to pale gray is worth living for. The color and form of the mountains is satisfying in itself and the color of the tangle of trees between is 'not to describe.' I like to feel really worthy of so much beauty." The view of "such skies as do hang over the mountains!" made her want to paint them, "but my admiration and respect is growing so great that I may not dare." When a golden-crested kinglet crashed fatally into a Forbes Library window, Mary eulogized it for Henry. A year

before, she had been regaling Yankees with stories of Whistler and the Salon. Northampton must have felt small as she mourned the kinglet's colors, a brief gift to the campus, and the interrupted journey of something "so beautiful, a soft warm greenish gray, with a spot of brilliant cadmium on his pretty little head. How strange that he should not still be making the spring more beautiful! There are many birds that pass through Northampton on their way farther north; it is pleasant to think they are fond of us."

In March 1900, she sold *Moonlight* to a student. Discussing payment with the girl was uncomfortable, "for us both the money question being mutually distasteful." The student confessed she would have paid even more than Mary asked. Mary planned to order a frame from the Manhattan gallery H. Wunderlich & Co., "which is as much glory as any pastel ought to expect."

That summer, she met the Whites' newborn in Waterford: "I miss Nelson very much and would like to have a good long talk with him; his conversation is most soothing and satisfying; it is sad to think that he probably does not miss me one bit." She bought copies of a publication—it is not clear which one— that mentioned Tryon and the Indiana landscape painter Theodore C. Steele (whose work had appeared alongside Mary's in Indianapolis). Tryon apparently looked down on Steele, and Mary teasingly marked up copies of the clipping for her boss: "I linked 'Tryon and Steele' still more affectionately together with my pen; I wonder how many copies D.W.T. has already received from sympathizing friends."

15.4 The Clark family home at 52 Crescent Street in Northampton. AUTHOR'S PHOTO.

By September she was girding herself for winter: "I mean to paint a little if I have any spare minutes from twelve yards of long-cloth that I am converting into underclothes." She rejoiced in being the kind of person who liked changing leaves around the golf course: "Isn't the autumn glorious. I hug myself furtively to think I'm one of the favored. . . . The golf links have been heavenly, and are still, though a bit too brilliant at present; but when the twilight violet and the new moon

are added I feel like spending the night out there. I haven't been out there as much as I'd like; I've wasted time getting off some poor things to the Water Color Club—they dont have to hang them if they dont like them—comforting thought. I want to see what you did all by yourself in Waterford—Henry was it pastels or oils." Tryon was showing up on schedule—"he hinted that the class is unusually interesting"—but Mary suspected he was actually "on his way to Maine."

The Water Color Club accepted three of her "poor things," including a view of Penfield Hill. The *Evening Post* listed them among the fare "worthy of a pause on the part of visitors." The philanthropic Hillyers visited Smith, and Mary "behaved so prettily that Mrs Hillyer offered to come and see me in Hartford." The *Atlantic* had just published Flagg's long feature, "Art Education for Men," giving advice on conveying technique down to the correct positioning of fingers and thumbs around crayons: "Some men get listened to without any apparent reason," Mary complained to Henry.[2]

She invited him to visit her, promising golf links "worth a journey to see" and "a Bohemian lunch in my studio." By March 1901 she had something more tempting: Freer's loan of thirty-five kakemonos, dating from 1660 to 1850, by artists including Hokusai and Hiroshige. His 1897 show at Smith had represented various styles, but this time the works were all from the Ukiyo-e school, known for its looser interpretations of portraiture and landscape traditions. Mary, once again, played a role in inspiring Freer to keep

his collections on view. He wrote to Mary with evident respect for her as a steward and teacher. He expected the focused exhibition "would perhaps give yourself and students keener pleasure and more direct knowledge of the aims and methods of the principal masters of the school which was first to break away from academic practices." Freer asked Mary to reroll the scrolls carefully afterward, at the same level of tightness in which they had been shipped: "This is necessary to avoid cracking of the paint and wrinkling of the paper and silk."[3] Mary suggested that the Whites "bring Nelson up to see the kakemono and give him the advantage of their educating influence."

Smith kept its coal bills low and its buildings chilly: "This old Art Gallery is like a tomb." She envied Tryon's fishing escapes: "How pleasant it would be to feel it ones duty to flee from teaching to some really desireable [*sic*] occupation I am almost able to do it but not quite. . . . I am sure the bass must be in fine biting trim, I feel ready to snap at almost anything myself." She was assigned to hostess Smith parties: "What a mistake it is to know how to do things!" She had "no time to produce doubtful works myself" while "arranging tin-ware, fruit, vegetables and flowers" for girls learning how to compose still lifes and "how to remove paint from their clothes and wash their brushes with the least labor."

The Society of American Artists, she wrote Henry, "did not see fit to accept my pictorial offering. I thought for about fifteen minutes that I felt real bad about it, but I had some very lofty and enlightening conversation with myself which might perhaps be summed up in

the homely but effective words 'Rats! whats the difference.' . . . I only wish that I had back the money I squandered getting the things down there. I could buy several golf-sticks with it. If I were young I suppose I would mind it more but as it is I shall audaciously continue to try to paint."

A student offered to buy one of Mary's works: "I almost sold a pastel this week, think of that! The girl was waiting for mamma's approval and mamma did not approve—she was sure some had rattled off because the paper showed and she did not wish to buy anything that rattled off." That is, the mother mistook Mary's poetic exposure of background paper for sloppiness and fragility.

Mary grew ever more resigned to her lack of sales and fame: "I'm writing a new epitaph now 'Here lies one whose name was writ in pastel.'" (She was paraphrasing Keats's enigmatic epitaph, "Here lies One Whose Name was writ in Water.")

In June 1901, she apologized to Henry for sending no present on Nelson's first birthday. But she did offer an anecdote about the artist Abbott Handerson Thayer, a Freer favorite and a friend of Tryon and Henry (and the eventual subject of one of Nelson's books). Thayer, a Boston native, had trained in Paris and remained a frequent visitor to Europe. He was known for luminous portraits of angels and for close studies of nature—he analyzed animals' camouflage patterns and tried to persuade government officials to adopt them for military gear. He lived with his children and long-suffering second wife Emma in an unheated house full of wander-

ing wildlife in Dublin, New Hampshire. He was prone to depression and eternally dissatisfied with his own work, sometimes erasing it after days of labor.[4] At Smith's gallery, Mary watched him set upon one of his own paintings on display. He wanted to make edits, inspired by the Florentine artist Gozzoli. (The museum owned his depictions of a winged figure and a nude—both have been deaccessioned.)[5]

Mary lamented that neurotics like Thayer were somehow drawn to her: "In the words of Henry why do they all come to me?—The fact remains, come they do." Thayer had been headed home to Dublin but then ended up spending a night in Northampton "quite by accident having got into a muddle in Springfield over his luggage." In the morning, Seelye sent for Mary to help Thayer, who had "entertained himself by a sight of his picture in our gallery." Mary reluctantly ambled over and found that Seelye's daughter Henrietta, a would-be artist, had already given Thayer paint and brushes "to improve his pictures . . . and he was busily at work." In Italy, "he was smitten sorely with the greatness of Benozzo Gozzoli; B.G. is all simple and flat and A.T. is full fired with a desire to make his works all simple and flat so I had the pleasure of watching a part of the flattening process. He worked away till he had just twelve minutes to get to the station and then off he rushed." Mary suspected that he would take the wrong train at the tiny station, "wondering why he doesn't get home."

The semester yielded one more entertaining episode for Henry. During Smith's 1901

year-end exhibitions, a woman who painted china as a hobby prattled to Mary about a favorite painting. Mary sarcastically quoted the description: "It was a kitten on a polished wooden table; it had just knocked over a vase of roses and the water was running on the table and dripping down and the cat was just as natural, looking scared, with its back up and its tail all swelled out, and spitting, such a wonderful picture! so much in it, cat in action flowers, polished table, running water—was it just splendid." The unnamed artist was a man, and the visitor's detailing of his cheesy work, Mary wrote, "almost made me want to see *him* for a few minutes." Was Mary wondering what kind of person would make such a thing, or joking that she would have harmed him?

In the summer of 1901's heat wave she spent sleepless nights in Hartford "trying all the sofas and floors"; she played golf; and she visited Aunt Willie, Mabel in the Boston suburbs, and Isabelle Williams, an author and French instructor at Smith (Mary called her "Cousin Belle") in Deerfield. Mary covered a swath of Canada with her sisters: "Quebec we found a delightful town. . . . P.E. Island did not interest me at all and our day in Halifax was too stupid to mention." Henry must have teased her about her golfing habit, since she sent a jokingly wounded retort: "I am grieved, Henry, that you should think me a sport—you who have a yacht and a horse and build houses and boats; and all I do is just a little golf for my digestion." She did try to use her time wisely: "I have made just three pastel sketches in the vacation; can you best that Henry?"

In November, she exhibited landscapes, *Sunshine* and *The Edge of the Wood*, at the New York Water Color Club. The press seems to have not noticed. In early 1902, *Sunshine* drew little attention at the Pennsylvania Academy of the Fine Arts—it was the third and last time she showed there.

One ray of professional hope did emerge. Frederick A. King, who had left Smith in poor health four years earlier, set out to help her. He had joined the New York literary crowd as an editor and bibliographer. He had met the art dealer William Macbeth (1851–1917) and come up with what Mary called "a most mistaken idea" for her to market her works through Macbeth's thriving gallery on Fifth Avenue near Twenty-Seventh Street. "I'm afraid he is doomed to disappointment. It is however very kind of him to be anxious to do it," she told Henry.

Macbeth was the first major dealer to offer contemporary American paintings. A native of Ireland, he had settled in New York in his early twenties and found work at a print gallery owned by a fellow Irish émigré, Frederick Keppel.[6] Macbeth married a Brooklynite, Jessie Walker, and founded his eponymous gallery in 1892. With patrons as elite as the department store tycoon Benjamin Altman, he promoted American art to collectors "who have hitherto purchased foreign pictures exclusively."[7] By the time he exhibited Mary's pastels, he had demonstrated the foresight to offer works by painters including Tryon, Hassam, Arthur Davies, Maurice Prendergast, and Henry Ward Ranger, the first artist to board with Florence Griswold in Old

Lyme. Macbeth also set up solo shows for a few women, including the printmaker Helen Hyde, who spent decades living in Japan.[8]

Macbeth published musings on his inventory in his periodical, *Art Notes*—Mary described its prose style as "so ladylike, like a piously pleasant old maid." His April 1902 issue announced that he was showing Mary's "very charming" pastel landscapes, which were "poetic in sentiment and crisp and free in treatment." That issue of *Art Notes* began with his advice on prospering through stock market fluctuations: "It has been shown in the auction room that well selected American pictures have been very profitable investments, while on the other hand the average foreign picture, as a dividend earner, has proved to be a snare and a delusion."[9]

Macbeth optimistically brought in twenty-one works by Mary, mostly pastels priced from eighteen to twenty-five dollars. They depicted seated girls and views of Connecticut (including Waterford), Norway, Bruges, the Isle of Jersey, and the River Cam's banks in Cambridge. Even before Macbeth published his praise for her "crisp and free" art, he attracted one customer. On March 8, Mary wrote to thank him for a check: "It is pleasant to have ones works approved and to have them sold is doubly assuring."[10] She relayed the news to Henry: "to my great surprise he sold one and I was wondering who could have been moved to buy one Imagine my feelings when I heard who it was. I'll come out and describe them to you when I get home." Macbeth had sold *Job's Pond* to Henry for $25, and her share after commission was $16.67. (Henry, her

WILLIAM MACBETH.

1892 1906
The First Macbeth Gallery, 237 Fifth Avenue

15.5 Mary's editor friend Frederick A. King persuaded the Macbeth Gallery in Manhattan to give her a show. MACBETH GALLERY, CA. 1896 / UNIDENTIFIED PHOTOGRAPHER. MACBETH GALLERY RECORDS, 1838–1968, BULK, 1892–1953. ARCHIVES OF AMERICAN ART, SMITHSONIAN INSTITUTION.

guardian angel, clearly hoped to encourage Macbeth's interest in Mary by covering the dealer's fee.)

That spring she kept working on *Evening* and could "see no sign of the end." Henry had sent her four panels for oils: "They look so peaceful and placid that it seems a pity to disturb them by putting dirty paint on them— yet I believe I shall; I have one or two small pastel sketches that I'm keen to work out in oils. . . . I think people who dont paint have too easy a time." She told her friend about a rare moment of religious awe: "I really am

eager to see what you've been doing. As for me I've spoiled no paint or pastel yet, but I've been looking a great deal and thinking too thoughts quite similar to yours of God and immortality and your quoted verse has been in my mind too with another that is always there when I feel nature: 'Heaven & earth are full of the majesty of Thy glory.'" In nature's recovery from winter, she told Henry, "everything has come so slowly that the blossoms have been very perfect."

While regretting not painting enough, and annoyed at Tryon's "cheerfully intermittent" sessions, she was nonetheless planning to distract herself: "I've promised to go to Europe with Miss Eager this summer; it is very hard to leave all my nice friends and your remarks about Waterford add a pang more, for next to my sisters there is no one I love more than Grace and you. I have a hope that I may perhaps improve my mind a bit this summer but it may be a vain hope." As she packed her trunk, she thanked Henry for a photo of Grace in drag: "I was a little queered at first to know why you had bestowed on me the likeness of such a gay young feller but when I knew it was Grace I was so pleased, and of course shall always treasure it." She wished that Grace would teach Smith's actresses "how to look just like a man; they dont make a success of it usually." She wondered if Grace would put on menswear in Waterford and added wistfully, "I wish I had some."

Late that spring she somehow bungled an opportunity for a show, possibly of her own work: "I did not make my plan for an exhibition succeed through losing a letter that Mr Tryon allows he wrote to me; it saved me a lot of work."

What she really wanted to do was play, in Europe. The summer of 1902 did turn out to be somewhat productive. Swiss medieval towns and French chateaus inspired her to work in watercolor and pastel. Her itinerary led to just one brush with death, in a train trapped and aflame.

A Serene and Confident Air

For their 1902 vacation, Mary and Mabel swung through England, France, Switzerland, and Italy and then stopped by rue Boissonade. Letters she received from Laura and Lucy survive (along with, for some reason, some lightly censored copies of Mary's own letters, in a different handwriting). Mary became ever firmer in her aesthetic opinions and more infatuated with sightseeing—a poplar or two was thrilling.[1]

Mary, the breadwinner, left checks for her sisters' vacations (they ventured to Hadley, Northampton, Cobalt, and Waterford). The Atlantic steamer passengers included Frederick King (who was headed to London), a woman singer "so vulgar it made me gasp," the Hartford horseshoe nail tycoon George J. Capewell, and the politician and orator Chauncey Depew. Waves sloshed under the deck chairs, while the passengers somehow managed to bathe in seawater: "I nearly gave up my dip this morning it was so very rough and I didn't have much faith in the slippery tub, but it was too good a thing to let go lightly." Moonlit deck walks helped her recover from the dining room's cheap music and Depew's tiresome "jokes of about his own age," which left his tablemates roaring "after every meal, Chauncey himself loudest of all."

During a Paris stopover, she returned to the Louis-le-Grand hotel, where the guests included "an objectionable old American man . . . talking jingo at a great rate and defending lynch law. He said there were too many d— women in America." King sent news from London, where the future Edward VII's surgery had delayed his long-awaited coronation; masses of uneaten food were left. (When the coronation did take place, Mary wondered if Edward would take his crown "to bed with him for a while.") Isabelle Williams (Cousin Belle) was in town, and she introduced Mary

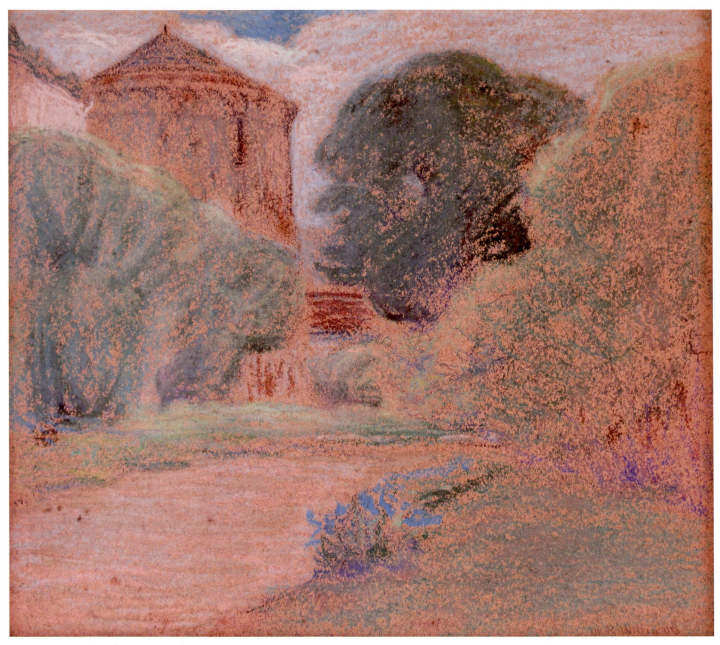

16.1 Untitled, undated (probably 1902) pastel landscape with domed tower,
probably rural France, 8 x 9½ in. WFC (PHOTO: TED HENDRICKSON).

to Alice Kuhn, a Frenchwoman who was heading off to Smith, to teach French and study American women's education. Mary reported that Alice was "a harmless young thing," while Belle had described her as "a young jew-parisienne of twenty-two with a huge pompadour and a tiny waist who declared herself a socialist."[2]

At a Paris theater, Mary ran into Elizabeth Czarnomska; the Czar was traveling that summer with the photographer Vida Hunt Francis (Smith 1892). At a Palace of Industry exhibition, Mary "found a little Whistler that was worth the trip over, though he had five other things that did not seem to me worth showing." She sent her sisters a sketch of Paris's fashionable elbow-length sleeves and reported that the latest clothes "look about like what one sees in New York. England is the place to see the real freaks."

Paris seemed cleaner and with fewer beggars than on her last trip, and Switzerland looked as perfect as a stage set. Mont Blanc's reflection on Lake Geneva had "something a little unreal about it as if they might shift the scene at any moment and give us something different." Mary's lack of hobnail boots kept her away from an Alpine summit or two: "I being no goat nor yet a fly decided that I'd got as high as I cared to." In Gruyères, during a "grand pyrotechnique display" for the Fourth

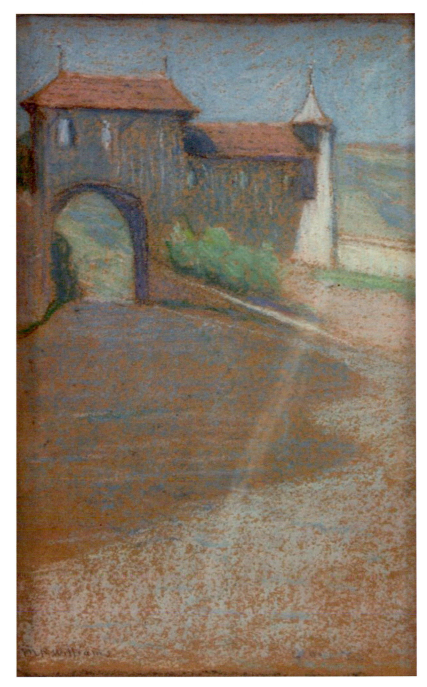

16.2 *Gateway—Gruyères*, 1902 pastel, 10 ¼ x 6 ½ in. SOLD AT MYERS FINE ART, ST. PETERSBURG, FLORIDA, NOVEMBER 30, 2008, LOT 348, ORIGINAL OWNER MABEL EAGER, LOCATION UNKNOWN.

of July, firecrackers had an unpleasant way of "chasing around and getting underfoot." Nuns in Gruyères ran a school for deaf children that would have interested Lucy. Mary sat with a girl who was learning to lip-read: "The sister said it was the first time the child had taken words from the lips of a stranger." The students made crafts to sell, which Mary described with her usual jokingly stony heart: "I picked out two little white mats, that seemed less objectionable than the other things."

During one tunnel train ride, fire broke out in a second-class car and set off a panic. Mary and Mabel were supposed to have been seated in the car that was later engulfed in flames, but it had grown too crowded, and they had been redirected at the last minute to first class. Mary wrote home calmly about the misadventure: "I noticed a flash of light that grew brighter and brighter till there seemed to be a tremendous blaze. . . . The passengers were screaming and jumping from the coach and rushing down the tunnel I called to Miss E. to get out and jumped out myself and ran down past the end of the train. I wasn't frightened till I found she had not followed me. I turned to look for her and as I looked the terrible light died suddenly down; then I went back and found her with our hand bags, one in each hand; she had tried to get off the other end of the coach which was locked. The panic was all over then, and we learned that the whole performance was the burning out of the motor fuse, or something of that sort." (Leave it to Mary to dismiss a tunnel explosion as a "whole performance.")

A German boy onboard ended up with a serious leg injury. The train was stuck in darkness for half an hour. But a few lines later in her letter, Mary told her sisters about checking into a hotel and irritably overhearing English tourists "murdering duets in the parlor." She did concede, however, that in setting off from there to Italy by train, "somehow we are not as keen for tunnels as we were."

Italy looked more kempt than she remembered. The guides expected tips, as ever: "Italy ought to have an open hand on its coat of arms." She ran into Hartford friends (including Martha Wells Graves and the teacher Louise Stutz) and avoided Americans spending a day or two in major capitals: "the grand tour, all in no time at all; true American style." Artworks in churches and museums amounted to "lovely old friends," although a few now benefited from electric lights. In Florence, she admired the Palazzo Medici Riccardi's well-preserved paintings by Gozzoli, the artist who had inspired Thayer to redo his own creation at Smith. At the Uffizi, she overheard "a nasal, New England, feminine voice giving out facts," which were dutifully recorded in notebooks by a dozen young women on campstools: "They looked so serious and sad, as if art were not to be taken in a festive mood."

Bad news from elsewhere reached her. She was appalled at American assaults on the Philippines, English cruelties against the Boers, and France's anticlerical government evicting nuns, "because they have stolen nothing." (She is likely the same "Mary R.

Williams, Northampton, Mass." who signed a 1902 petition to Congress "favoring the suspension of hostilities in the Philippine Islands.")[3] Fire ravaged a paper mill in Massachusetts that belonged to Mabel's family. Fire ravaged the horseshoe nail factory owned by George Capewell, who had been on Mary's steamer to Europe. In Venice, St. Mark's bell tower collapsed: "Isn't it sad to think of that beautiful campanile a pile of stones!" At the Duomo campanile in Florence, a workman hung from ropes and "swung from side to side evidently looking for defects." A cynical Lucchesi waiter told her that at least the reconstruction of the Venice tower "will give many men work."

Mary, in fact, liked to quote waiters, whether witty or ignorant: "some day I'm going to write an article on 'Waiters I have Known.'" In Pisa, a waiter had pitied her and Mabel as "two poor females without a man." He encouraged them to find mates, and he was puzzled that "Italian women all marry but it is different with English and Americans."

The sisters reported on Hartford gas pipe repairs, new upholstery, and a lost purse. A friend wanted Mary to know that since the Capitol near the family home was newly illuminated by electricity, "you will see nothing finer in Europe." The sisters' correspondence arrived so erratically that Laura threatened, in a masculine tone reminiscent of Mary's, "to go and choke the Union Bank of London." Mary's sabbatical friend, Ruth Gray, now married to Charles Brodt (see chapter 13), wrote to reminisce about her heavenly time in Paris and confided that she had a

miscarriage "by over-exertion" and lost "my long wished-for baby." There is no record of Mary's reaction to the raw emotional note. In fact the only sign of emotion in Mary's letters that summer is an apology for not reporting Mabel's feelings for the family: "Miss E. always sends love but I'm afraid I dont put it in," Mary signed off, while heading into chateau country.

On the road, she and Mabel exuded "such a serene and confident air that ladies who have husbands even" wanted them as day trip escorts. The pair chaperoned only a few groups of Americans, avoiding those speaking "perfectly comic French." To help "improve my mind a bit," Mary tried strange food: "At lunch, what do you think, they had escargots, snails, and I ate two! They haunt me still." She grew accustomed to churches' supplies of saints' reliquaries with "a bit—a very small bit of the head." Trees alone amazed her on the road, including "the fantastic poplar that knows so many ways to make itself unique and amusing."

She came up with metaphors for varied chateaus, whether "a pretty toy" or "a large boathouse" or "more on the rich summer home order." She hiked along crenellations and "peered down the holes where they used to pour boiling oil and hot lead on unwelcome visitors; how very tame and inartistic our modern warfare seems in comparison!" The Chinon chateau-turned-prison-turned-ruin sent her into reveries about the passage of time and violence: "It seemed fitting that it too should have been allowed to crumble and pass away as had the kings who once made

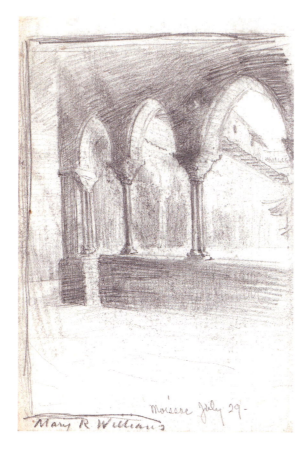

16.3 In 1902, while sketching at Moissac's Romanesque cloisters, Mary thickly shaded arches above dainty columns. WFC.

Moissac July 29 -

Mary R Williams

water," but found the interior unremarkable: "its boasted pictures are mostly poor copies." The staff at Chaumont catered to the last private owner, the Princess Henri-Amédée de Broglie, with a kind of fragile art installation: "They had the stable floor decorated with the arms of the princess in gay colored sand; we were politely requested not to brush it with our skirts."

Mary and Mabel wound their way back to Paris, with about fifteen watercolors and pastels in their baggage, and rented a studio on rue Boissonade. The Harvard-educated artist George H. Leonard Jr. (1869–1938) had moved into Mary's sabbatical quarters. He kept her color scheme but covered the walls in "a much finer quality of burlap." Mabel adapted to bohemianism, Mary told Henry: "You should see the elegant Miss Eager marching home with a roast chicken wrapped in newspaper clasped fondly in one arm and a large head of romaine in the other; we feast on mushrooms and I tell Miss E. how the first one I ever ate was picked from among your rocks and bayberry bushes and fried in a tin cup by Grace."

Minna Talcott, staying at the Girls' Club, admired Mary's new paintings and her figure: "Minna thinks I'm not as fat as I used to be but I'm sure it is only because she has grown so fat herself." The club was also hosting the artist Adelene Moffat, who was about to head off to Crete with the Smith archaeologist Harriet Boyd (later Harriet Boyd Hawes). Moffat, Mary wrote, "is not a prime favorite of mine but I thought it would be kind to call on her in a strange land. She was so

themselves safe there and entertained or murdered their friends." At Moissac's Romanesque cloisters, she sketched "dainty pillars with wonderfully carved capitals no two exactly alike." She thickly shaded the arches above the columns, to emphasize the shafts' surprising slimness.

She wished that she were a Carnegie, to buy Azay-le-Rideau, which was priced at $12,000. She deemed its exterior "a dream of sweet beauty looking at herself in her mirror

glad to see me that she said she thought the Lord had sent me; she is a bit of a poseur and I was amused at her account of her English summer—visiting only in 'great houses,'" where just tips for servants used up twenty-five dollars per week. (Moffat, who was of modest means, had visited the Carnegies at Skibo Castle in Scotland.)[4]

Marie Squires had married a Beaux-Arts and Whistler alum, Herbert Hopper, and converted to the Baha'i faith. Mary deemed Marie "prettier than ever" and sounded maternal (and not a little bossy) after dining with the couple: "Her husband seems a good fellow and I think it is well for her to be married."

Mary ran into the Champneys: the husband was copying more Louvre paintings, and the wife was writing a historical novel set in European castles. The young novelist Josephine Daskam (later Bacon, and a buyer of Mary's artworks) was "duly appreciative" during Mary's Louvre highlights tour "and prattled without interruption." Mary avoided the museum's new roomful of "flaunting Rubens things," and at the Musée du Luxembourg she was mainly drawn to sculptures by Saint-Gaudens and Rodin and paintings by Whistler. She told Henry that Whistler "has been very ill and one of the Paris papers reported his death, whereat J. McNeil [*sic*] went into one of his mad fits and gave the paper some of his artistic rhetoric. Forthwith a humble apology was sent to Mr W. so choicely written that he pronounced it a bijou and was completely pacified."

She avoided shopping at Bon Marché amid

16.4 *Azay-le-Rideau near Tours, France*, undated (probably 1902) pastel, 9 x 5 in. WFC (PHOTO: TED HENDRICKSON).

16.5 *Chateau d'Ussé*, 1902 watercolor, 5 x 6½ in.
PRIVATE COLLECTION (PHOTO: KAREN PHILIPPI).

"bored looking husbands," and she mocked Americans who wore Parisian fashions "and still look just like Americans." (But she still ended up with twenty-four pairs of gloves, gifts for friends and family, to pack into her trunk.) She checked on the Sorbonne's Puvis mural and squeezed in day trips. In a Chantilly garden, peacocks "would eat out of our laps when we dropped crumbs." At Ville-d'Avray, "I expected to see Corot's house and the pond he loved to paint but I found some thing I wanted to paint myself and before I knew it t'was time to come home."

At the opera house, she spotted Persia's shah on the grand staircase. But for once, her sisters could outdo her in summer celebrity spotting. President Theodore Roosevelt processed along Broad Street, Lucy reported: "He took off his hat to me when I waved a small flag and my handkerchief."

As Mary prepared for the return crossing, her prose turned swoony again: "Paris is simply entrancing today; she has put on her prettiest mood I suppose to make me regret leaving her. . . . The Seine fascinates me in all moods & lights, even in the rain it is adorable. . . . I feel so related to certain places in Italy and France that I feel absolutely at home in them."

At least four works from the 1902 trip are known to survive. In watercolor, Mary rendered a Gruyères church tower as a luminous white block against purplish blue slopes and a brooding sky. Her pastel of a medieval gate in Gruyères (figure 16.2, auctioned in 2008, whereabouts unknown) is a study in triangular shadows and sunlit roofs. In her pastel of a doorway and slit windows at Azay-le-Rideau (figure 16.4), she concentrated on the moat's zigzagging reflections, a vertical slice of the mirroring of "sweet beauty." In her watercolor of the Chateau d'Ussé (figure 16.5), the conical spires loom inaccessibly over outbuildings, unpruned shrubs, and a lawn—she seemed to be emphasizing the domain of the common man, rather than the absurd formality of the distant fairytale castle.

Two years would pass before she could travel overseas again. In that interim, despite some professional success, she missed Europe's opportunities to bury her "New England conscience, and just revel in doing pleasant things."

I'd Like to Run Away

During nearly two years deprived of Europe, Mary exhibited for the last time in New York, and she was praised for the last time in the New York press. She was swamped with not unpleasant Smith responsibilities, including decorating the campus for celebrations of Northampton's 250th anniversary. And there was golf, gossip, family vacations, art supplies shared with Henry, and visits to her friend Albert Pinkham Ryder in New York to keep her entertained. There was one last New England summer, for hunting mushrooms and admiring unmown pastures.[1]

She finally deemed *Evening* finished enough to show and sent it to the New York Woman's Art Club. The *New York Times* noted that her "fine landscape with dark foreground and high horizon . . . calls for remark." At the Water Color Club, she exhibited scenes of Florence, a Gruyères belfry, and the Chateau d'Amboise, and by December the show had traveled to Boston's Copley Society. She had begun framing her watercolors and pastels in matte gilded frames from Macbeth (see figures 2.16, 9.7, and 15.1). She specified broad inner rims that leave visible "an inch and a half of plain gold under the glass"; the protective rims also kept the glass relatively high off the pastel and watercolor surfaces. (I call them "aquarium frames.")[2]

In January 1903, *Evening* spent a month at the National Academy of Design—it was the first of two times that Mary made it onto those walls. The academy apparently did not inform her that the painting had been accepted. She had been "sure it was not in," but then she learned through the grapevine that it was there: "O, Henry what do you think! I've just heard the [*sic*] my 'Evening' is a-hanging at the Academy of Design; and someone who

saw it says it is very well placed on the line. . . . I feel very pleased to think it is hung."

Evening (figure 4.6) survives at Smith's museum, in poor condition. Mary set a sliver of pale New England sky over purplish hills and irregular horseshoes of trees and fieldstone enclosures. (A few months before her death, yet another layer of paint on *Evening* was barely dry when she set it in an expensive frame and submitted it futilely to the Paris Salon.) Around the time *Evening* was "a-hanging at the Academy," Mary visited the Whites and made a portrait of their toddler. In her Northampton studio, she told them, "it is admired by all." (The family owns Mary's 1906 plaster bas relief of Nelson in profile and her 1903 bronze and plaster castings of his hand—those seem to be the only sculptures she created in her career.)

Tryon stopped by the studio and praised one of her spring scenes as "very true." Further brightening the school year were visits from the "great and the celebrated." Shakespearean actor and director Ben Greet's troupe came to town to perform *Everyman*. The production reminded Mary of "an old picture or an animated tapestry." She helped Greet prepare the costumes: "He asked me to touch up Death's bones which were getting a little rubbed off." On weekends, she ended up "roped in, lassoed" for faculty teas. She had also been lassoed into teaching art history again, and she worked some sarcasm and strong opinions into her lectures. She warned students against basing embroidery designs on the popular Charles Dana Gibson images of women with upswept hair: "I read them a lecture (all my own) on the bad taste in putting a pen & ink Gibson head on a sofa pillow."

By February, Northampton's "thick discouraging blanket of snow" left her longing for something green to paint: "I dreamed that we were having a mild day and the apple trees suddenly burst into bloom; at first I was very happy and thought how good it was for me to have another look at them to help me with the painting I am struggling with then I was overwhelmed and quite miserable at the thought that the blossoms were quite unseasonable and that we'd have more frost and snow and no apples from the blossoms—quite distressing." A traveling friend wrote to inform her that spring had already arrived in Greece: "She says the colors are wonderful there and I ought to come and try to get some of them. I've been thinking for more than a week that I'd like to run away to Sicily or to Greece. About this time in the year I get dead sick of teaching; but I know it would be still more trying not to have some good regular work to do; all the same I'd make a first-class tramp."

That spring, Macbeth put her pastels back on view. She worried that they "belong to the class of the unsaleable" and thanked him for "wishing to give my works another trial. I'm afraid that I am difficult and you may have to resort to an auction or a rummage sale to dispose of me." But he soon sent her a "doleful note" and shipped the unsold pastels to Northampton. She tried to cheer him up: "Indeed the end is not yet. Aren't there

Homes for the Destitute that I can give my little works to? I've never had one refused as a gift. Surely not defeated, for I had the joy of doing them and that is their only reason for being."[3]

Henry sent her some panels to work on, and she sent him some new oil paint sticks invented by the French artist Jean-François Raffaëlli: "I'll wait and see how you like them before getting any." Better weather made her "fret in the harness and feel very balky when the girls ask me to take them out sketching I feel as if I'd like to spill them all and run far, far away." She was tempted to submit works for the 1904 world's fair in St. Louis, which was setting aside space for women, but hesitated: "I dont suppose I have anything that they would want." She grumbled to the Whites about the jury's gender segregation: "It is very sweet of them I'm sure to be willing to include women. I was told the other day that it is a sad fact they [sic] there is nothing a woman can do that a man cant do much better. I'm sure there is one thing, and that is being agreeable; I think Grace will agree with me." (Henry's work Old Mill at Waterford was accepted for the fair's Connecticut building.)

Mary read, at Tryon's suggestion, the German-Japanese-American critic Sadakichi Hartmann's new survey of American art. Was she jokingly trying to sound arrogant about her place in the pantheon when she told Henry that she disliked the book partly because "he hasn't you and me in it"?

Henry, by that time, had acquired a Knox, the first car in his patch of rustic Connecticut shore. Mary imagined herself behind its wheel: "I dont wonder you find the auto engrossing I'm sure I'd want to play with it all the while. It must be almost as nice as golf." She envisioned his car amazing the natives and "dutifully doing all it can for the cause of Art, assisting at sketching jaunts."

By mid-May, with Tryon headed to Maine (leaving his wife Alice behind, as usual), Mary was feeling "as if I'd like to elope with myself and have another Paris studio or Italian pension." In Maine, a quarter of a million acres of woods were burning. Mary told Henry that her boss "may be cremated in the forest fires for aught I know; we seem to get on quite comfortably without him. He said he told Mrs T. not to expect him till she saw him; if I were she I'd have as jolly a time as possible." While installing the students' year-end show, Mary wished that Tryon, for his soul's sake, would take on "some little hard job to do once in a while just for his sanctification which I'm afraid will otherwise not be accomplished."

During her summer visit to Aunt Willie's, as the resident "mushroom fiend," Mary unearthed fairy rings and puffballs. She found the scenery too beautiful to believe she could ever paint it: "I made up my mind after a ramble in the pastures yesterday that I would not consider swopping it for Lyme; such things as I saw—if I could only do them!" Mary also vacationed at Christmas Cove, Maine, about halfway up the coast. Readying the cottage and taking care of her family ate up her time. She preferred painting Connecticut oaks, birches, and willows anyway; in Maine's pines, she told Henry, "I am sure it

17.1 *Monhegan*, 1903 pastel, 4 ¼ x 5 ¾ in. The island off Maine inspired some of Mary's loosest pastels. WFC (PHOTO: TED HENDRICKSON).

17.2 *Monhegan*, 1903 pastel, 4 x 5 in. WFC (PHOTO: TED HENDRICKSON).

would have been an effort to get up a mood." She stumbled upon mushrooms that she had never seen before, "tho I'm shy of trying new varieties fourteen miles from a drug store." At some point she ventured about ten miles offshore to Monhegan Island and produced some of the loosest pastels of her career. She turned stunted trees into wisps of green, suggested shoreline rocks with sinuous dark veins, and added dashes of white clouds and sea foam.

Just before a late summer trip to Waterford, she warned the Whites: "I'm getting older and more uninteresting every day 'tho I've made up my mind never to be over forty, which seems a good age limit, methinks." The Griswold boardinghouse walls and doors were filling with landscapes, exotic and local. To Mary, they looked a little cluttered: "I would not want to live with those handpainted doors in the house at Lyme. They hurt my decorative soul." Still, Mary described herself as "quite envious" of Miss Florence's life, with no demands of teaching or painting: "Please tell her I'll swap even on jobs."

The return to Smith for the fall 1903 term left her blasé: "Here I am grinding away at the mill again. If I were sure of turning out a superior quality of meal I might not mind it so much. . . . I feel as if I'd like to kick and kick and kick and get them all off and run away. I think I'd run to Paris or to Italy for there one can bury ones New England conscience, and just revel in doing pleasant things; and painting would not be squeezed just into odd minutes but would be done whenever I felt like it." She envied Henry his

car and "other joys unnumbered" and wondered if he had endured burdens "in some previous existence and dont need it now, following the idea of the German lady who says she was married in a previous existence and so does not need that experience again." Mary suffered through a "painfully long" sermon from President Seelye, praising Northampton's eighteenth-century minister and theologian Jonathan Edwards, whose family had included broods of up to fifteen children. Seelye, she told Henry, "referred to the productiveness of woman in such a way as to make me feel like a poor spinster with no excuse for being. . . . Personally it seems to me that I'd want to take a flat in some other planet if every woman had fifteen children. I'd choose one where the climate did not call for too many clothes." She reported that she made her own "claim to existence" by babysitting and sewing baby clothes for a German professor, Ernst Mensel, and his wife Sarah, who were adding a sixth child to their brood. The Mensels sent their older children to visit Mary, "so I do not live quite in vain you see; but wasn't I glad 'tho when they went home!" Lucy, meanwhile, was inviting deaf children to play in the Broad Street yard: "I feel very negligent of my opportunities when I see what Lucy accomplishes."

Henry sent her more panels, although she had no time "to finish what I have begun." She kept reworking *Evening* and tried to finish some church embroideries in progress "going on a year now." Her life paled in comparison to Henry's jaunts in cars: "I'm awfully afraid you'll be thinking me a little too slow

to run in your class." By November he had lent her a "very becoming" frame for a panel painting, *Spring*, which she was submitting to the National Academy of Design. She hoped the frame would be "a mascot and will cast a glamour over my Spring." When Tryon stopped by, "I had the frame out in a sightly place hoping he would froth a little over it but he did not." William Butler Yeats, on his first North American tour, lectured at Smith and

proposed largely abolishing theater scenery: "I wish his remarks on artistic stage settings might be heeded but I dont suppose they will."

In December, the Woman's Art Club exhibited her pastel portrait of Katharine Andrews Healy (figure 17.3), absorbed in a book and wearing a pinkish-gold gown against a pinkish-gray plane.[4] The club also showed Mary's oil landscape *In Summer*, and the *New York*

Times critic Charles de Kay described it as "excellent." His exhibition review, like so many others in Mary's lifetime, condescendingly praised the female participants: "It shows that women are beginning to paint and model with originality as well as skill."

Mary hoped a Christmastime visit to New York would bring "a recluse from Northampton" up to Henry's speed, "so that I can associate with you a little." The trip, with Mabel and Gumaer, gave her a chance to critique exhibitions and share her rather wicked opinions with the art world. She and Mabel, having "the gayest kind of a time," stayed at the Park Avenue Hotel, at Thirty-Third Street, newly rebuilt after a devastating 1902 fire. In an exhibition at the New-York Historical Society, Mary liked "one lovely thing" attributed to Bernardino Luini. But she mostly came upon "things that look like very poor copies and they are most absurdly labelled, for instance there is something attributed to Giotto that must have been painted a good two hundred years after his time." (She was likely referring to the institution's Old Master paintings, acquired in the early 1800s by the pioneering collector Thomas Jefferson Bryan; they were largely dispersed starting in the 1970s.)

She dreaded visiting Montross's gallery, for fear he would mention Tryon's large scene of Massachusetts pastureland that had been shown there in 1902: "I'm scared to think what I may say. . . . I am afraid I do not respond to it sufficiently." Mary found the landscape "a little wild, woolly and western and not my own New England. Do you think

I am losing my capacity to appreciate?" She worked up her nerve to ask Montross about it, and about Smith's paintings by Edward August Bell (1862–1953), a New Yorker who had trained in Munich and is known for gauzy portraits of women. (Smith's museum no longer owns Bell's works.)[5] Mary had a "lovely time" with Montross: "We stayed over two hours. I was so afraid he would mention the big Tryon you know, but he did not; and then, woman-like, I was disappointed because he didn't. I knew however it must mean that he did not care to talk about it, so I decided to introduce the subject. I wish you might have seen how pained he looked when I mentioned the picture and asked him if he liked it. He leaned over the back of my chair and asked me solemnly how I accounted for it that a man like Mr Tryon could paint a thing like that, and could like Mr Bell's work so well." (But there is puzzling evidence that at one point she splurged for a $350 Tryon painting from Montross—see chapter 28.)

Montross also wondered why Thayer had painted "a thing like" *Caritas*, which depicts a female angel protecting two children at her knees. "I could not offer any solution, but I do not believe it is ever safe to get beyond being willing to paint out some things," Mary told Henry. "Sometimes I wonder why I keep on and yet I'd hate to give it up. One does get so many other things in the struggle, tho the end is always just out of reach there are so many lovely things by the way."

When the National Academy exhibited *Spring*—her last Manhattan showing in her lifetime—she was disappointed: "It seems

17.4 Mary draped Smith's campus in fabric planes for Northampton's 250th anniversary, contrasting with the busy bunting treatments on downtown buildings. AUTHOR'S COLLECTION, FROM *THE MEADOW CITY'S QUARTER-MILLENNIAL BOOK* (SPRINGFIELD, MA: F. A. BASSETTE CO., 1904).

room in its usual condition, enough to furnish a suite, all right where you could put you [*sic*] hand on it easily. He made a path for us by removing a few things. I took Miss Eager and Mr Gumaer and it was a great thing for them to see a man so perfectly oblivious to what we consider really necessary comforts He puttered around in slippers, without stockings, dressed in blue jeans, but he showed us some corking things."

In early 1904, upon returning to Smith's "steady old harness," she started planning a summer trip to Italy with Laura "to improve my mind a little." The prospect relieved the tedium of lecturing to local teachers about landscape painting and Italian art: "Which do you pity most me or the audience? . . . I'm perfectly willing to paint and dont understand why it is the things that I dont like to do seem to be in demand. . . . I have not painted for so long I'm afraid I may forget how—not that I ever knew. I'm thinking of having a sale of my old pastels up here some time before the end of the year; dont you think I have good courage to try a sale again? I'm going to sell them to the lowest bidder."

She wondered if Henry's undistracted output of landscapes would leave her so far behind that she would "have to go back to just painting portraits and figgers." When she was invited to exhibit at Edward Malley's upscale department store in New Haven, she asked if Henry was also on the list: "I dont want to accept unless I'm to be in good company." (It is not clear whether either of them accepted the store's offer.) But she did take pride in her own travel résumé. Tryon wanted to start

to me one is bound to be more or less uncomfortable if one paints and to have many opportunities of being very disagreeable. I'm sure I felt very disagreeable when I saw my 'Spring' at the Academy show hung in one of the 'Coffins' in such a bad light that it might better have been placed face to the wall. However, I thought much better painters than I have been treated much worse."

By then she had introduced Henry to her friend Albert Pinkham Ryder; it is not clear how she met Ryder and wangled invitations to his entertainingly disorganized studio on West Fifteenth Street, although Macbeth may have provided the connection. Mary told Henry about spending a freezing morning with Mabel and Gumaer at Ryder's hermitage: "Wasn't his room cold; just a bit of fire in a grate about as big as your pocket; the

spending winters in Florida, and when she suggested Europe instead, "he looked scornful and said he did not care to go there he preferred his own country." By early June, he had "faded away into the landscape with a smile." She hung the year-end exhibition while also draping banners artfully all over campus: "Northampton is getting lightheaded over its 250th anniversary and is conducting itself in a way quite out of harmony with its age and usual habits. It is breaking out in most fiendish decorations and I am to be responsible for those of the college."

The town was densely bedecked in red, white, and blue stars and stripes, which Mary likely considered gaudy atrocities. A lavish 1904 book about the festivities praised Mary's "unique and original" alternative for Smith, "the conventional colors and arrangement being wholly discarded. . . . Her conception of taste in this matter was generally approved by those who recognize the fitness of things." To cover multistory buildings, Mary brought out American and Smith class flags plus festoons of "white cheesecloth, caught up with rosettes of magenta colored cloth and wreaths of laurel."[6]

By the time the fabrics were coming down, she was headed off for her first sighting of the Palio race pageantry in Siena, and Laura's next-to-last overseas trip with her cosmopolitan sister.

Old Friends and Some New Ones

In the summer of 1904, while extending her list of European places visited, Mary began a years-long process of almost turning Sienese. She updated Henry a few times, and Laura wrote the bulk of the sisters' letters to Lucy—just a handful of pages from the trip contain Mary's lively travelogue.[1]

On the steamer, Mary mocked herself for trying Italian wines at dinner: "O! ye shades of Bacchus!" Gumaer was onboard, and her cabin-mate, the Cincinnati music teacher Tecla Vigna, became a new friend. Among the self-important crew members and passengers, a bulky ship doctor "invites you to pinch his legs to see how hard they are," and a chatty, wealthy Italian widow told Mary of paying $13,000 for her late husband's mausoleum. Mary paid more attention to the steerage passengers below: "I've made a sketch on board, just think of it, of a beautiful Italian, a bride, I used the half-hard pastels; that is a good beginning for the summer isn't it. . . . We decided the second day out that all the interesting people were in the steerage and every day we've hung over the rail fascinated by the madonnas with pretty children and we've assisted as audience at many of their impromptu concerts. You should see the pale-faced black-haired man with light grey clothes and red tie caress his pink accordion as he accompanies the clarinet artist." The crew was receiving messages from other ocean liners via the new Marconi telegraph, and a passenger on another ship "offered to play a game of chess with anyone on this steamer who cared to take the offer. I have not heard that it was taken." Mary kept busy making lace and reading Browning and Shaw. She suggested that Henry would enjoy Shaw—and he later credited Mary for recommending Shaw as far back as the 1890s, "when he was little known and considered a radical novitiate."[2]

18.1 *Noon Siena*, n.d. (probably 1906), pastel, 7 ½ x 10 ½ in. Mary edged the cityscape with scalloped teal suggestions of vegetation. SMITH COLLEGE MUSEUM OF ART, NORTHAMPTON, MASSACHUSETTS, GIFT OF THE SISTERS OF MARY ROGERS WILLIAMS, SC 1911:4–1.

18.2 *Morning—Siena* [crossed out] *Paysage—Sienne*, 190? (date indistinct) pastel, 7 ½ x 10 in. Mary rendered buildings as wisps of stucco walls and tiled roofs. AUTHOR'S COLLECTION.

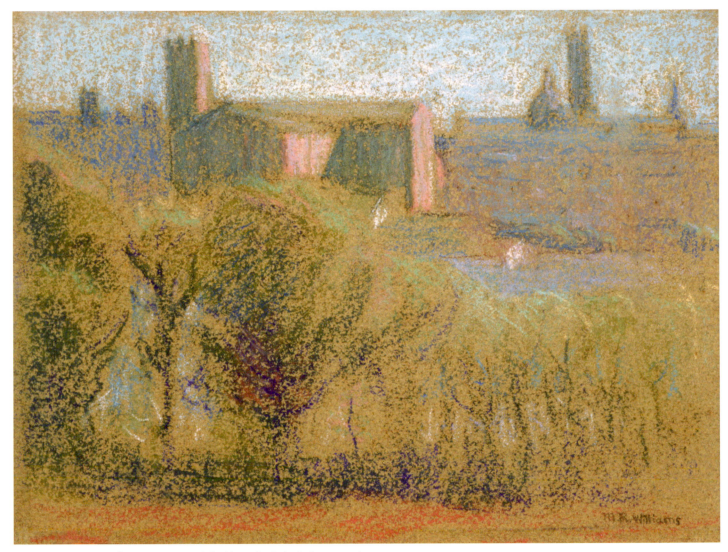

18.3 *San Domenico and Duomo*, 1907 pastel, 7½ x 10 in. A shady foreground grove contrasts with Siena's sunlit skyline. SMITH COLLEGE MUSEUM OF ART, NORTHAMPTON, MASSACHUSETTS, GIFT OF THE SISTERS OF MARY ROGERS WILLIAMS, SC 1911:5–1.

18.4 *Street in Siena*, undated pastel, 10 ¼ x 7 ½ in. WFC (PHOTO: TED HENDRICKSON).

18.5 *In Siena Cathedral*, 1907 pastel, 9 x 6 in. SMITH COLLEGE MUSEUM OF ART, NORTHAMPTON, MASSACHUSETTS, GIFT OF THE SISTERS OF MARY ROGERS WILLIAMS, SC 1911:6–1.

Laura and Mary disembarked at Naples, wound their way along the Amalfi Coast to Paestum, and then headed northward. Mary's Italian skills had improved, so peddlers left her alone: "They dont seem to consider you lawful prey if you can address them in their own tongue." She had grown inured to beggars: "We never know who will accost us in the streets; but we treat them all alike and pass by." Children who were not begging amounted to "quite a new experience." Dogs barely distracted her when they wandered onstage during outdoor theater and opera performances, "usually at the most tragic places."

She appreciated "nicely arranged surprises" of running into the Smith philosophy professor Anna Cutler (who eventually owned one of Mary's Siena scenes) and Elizabeth Champney and her architect son Frère. (Marie Champney had married John Sanford Humphreys, a Beaux-Arts trained architect, and become a miniaturist acclaimed for portraits on ivory.) News of American weddings reached Mary and Laura. Martha Graves had married Edward Wallace Bush, a civil engineer, and Mary's former Smith housemate Emily Norcross, at age forty-four, had resigned upon becoming the second wife of James Hale Newton, a Holyoke paper mill entrepreneur nearly three decades her senior. "Mary knew about Miss Norcross just before she left but only as a profound secret," Laura confided to Lucy, as the two travelers poked around Italian stores for wedding presents.

Rome left Mary with "no sensation except bewilderment at its inharmoniousness; but I

18.6 Mary wrote home on hotel stationery, and hotelkeepers kept in touch with her. WFC.

suppose one has no right to record an impression of a six days glimpse of Rome." At St. Peter's, "I imagine if one stayed here long enough one might get to feel like a mere atom in its presence." She found herself "interested every moment" in Viterbo; she described it as "indescribably quaint built on all sorts of levels the narrow streets arched over often to strengthen the houses, everywhere beautiful crumbling sculptures, the record of some pope." At Ravenna, mosaics intrigued her

and mosquitoes bothered her, "but it seemed quite proper to bear patiently any sort of an affliction in San Francesco's town." Near Fiesole, she saw "tremendous cloud effects that made me long for palette and brush." In Florence, she was tempted to stay on at the Certosa hilltop monastery, "and live on the views," and to paint the riverbanks at dusk in Whistler fashion: "A dim romantic light is most becoming to the Arno, in the glare of noon day it is shallow and muddy."

She headed home "simply loaded with memories of frescoes and sculptures by all our old friends and some new ones," she told Henry. From Siena, Laura sent Lucy a description of the Palio's women spectators in feathered hats and male horseback riders in glittering embroidered uniforms. Mary told Henry how strange it felt to attend: "Think of two puritans from New England who never went to a horse-race at home, going to two of a Sunday over here!"

Mary would eventually spend three summers in Siena and feel ever less of a New England puritan. Which was fortunate, because upon her return to Smith that fall, the administration laid the groundwork for her academic downfall.

I Feel Like Thirty Cents

During her second-to-last school year, Mary sneered at Smith's museum, tried to keep up with the New York art scene, envied Henry and Grace their marital bliss, and painted and repainted. It was a year of treading water and craving escape, even if that meant changing genders.[1]

In December 1904 she traveled to New York with Smith's first daughter, Henrietta Seelye, nicknamed Prossie (the girl's father, after all, was Prexie). Mary spent hours in the Art Students League building at the Comparative Exhibition of Native and Foreign Art, which Charles de Kay described in the *Times* as "the most epoch-making show of fine arts the country has ever had." The organizers and lenders, mostly private collectors (including Freer), aimed to stimulate respect for American art by alternating it with similar European paintings: Tryon's and Corot's landscapes, for instance, and rosy-cheeked children by Abbott Thayer and Sir Thomas

Lawrence. The show, de Kay predicted, would help the American artist "take the lead and force the world to give him his rightful place."[2] It sent Mary into a daylong "mad painting fit," and afterward she told Henry, "I feel like thirty cents today and cant do a thing."

In New York, she also visited Montross's gallery, which she called the "Holy of Holies." With a crowd around that day, "I could not be as sassy as I'd have like"—that is, she could not worm out his real opinions. Montross, who had firmly informed Mary before her sabbatical that American art was superior, was planning a European trip: "I'd like to go along and tell him what to look at!" Montross was showing paintings by Hassam, which Mary found repetitive, but she wondered if the display boded well for her own prospects: "Next you know he'll be exhibiting the whole Lyme school and maybe some distant day he will get down to my strata."

She liked New York's new subways ("in every way worthy of our metropolis") and the "solid comfort" of her new telephone at home. But when surprise invitations came by phone, she lamented to Henry, "it is difficult to make a graceful refusal." (Henry hated his own phone, which was fortuitous for this book—otherwise she would not have written copiously to him.)

The National Arts Club in New York displayed one of Henry's evening scenes; the jury for the National Academy's annual exhibition had turned down the painting. The work would have outshone the winning academy submissions anyway, Mary told him: "I wasted a small part of an hour at the Academy show: their standard was far below your evening— it seemed to me I had never seen so poor a show." She had submitted nothing to the Society of American Artists: "I had nothing ready to send and I thought the last time I was down and went in to see the Academy show that I'd never send anything again—that was such a dreadful collection." She and Henry shared their era's growing disgruntlement with official pronouncements from art experts: "Picture-show-juries are certainly as you say a rum lot, I call them an ungodly lot; no doubt their duties queer them. Isn't it pleasant to think that some of us may never be placed in that trying position."

She visited Ryder, who had tried to impose order with a "summer cleaning." Henry was hoping to buy a Ryder painting that Mary called "Prince Charming." Ryder had made coffee, hominy, and oatmeal for her group, but he apparently forgot to serve them.

They were "boiling sociably on his stove all the time we were there." The painting that Henry wanted "had his face washed with a rubber sponge for our inspection, and while I hope you may some day have it I advise you to call often and urged Mr Ryder to work on it. Mr Ryder took a pair of spectacles from the pocket of his coat and looked at them a minute and then said, 'I never waste any time hunting for things now; after a while they always turn up; here are my glasses that I could not find.' I am now following his great example." Henry wrote an essay years later about Ryder thwarting his attempts to buy the painting; Ryder insisted, "I have only worked on it for about ten years."[3]

At Smith, Mary was upgrading the cast displays and advising Seelye on acquisitions of paintings. She did not share his taste for works by Frank Weston Benson (1862–1951), known for portraits of children playing in forests and men hunting, among other subjects: "Prexie and I have bought two Benson's for the Gallery I had to restrain him from buying three." From Montross's Hassam show, Smith acquired *Union Square* and *June*, "the latter I do not care for at all." (Smith still owns *Union Square*, but *June* and both Bensons have been deaccessioned.)[4] She had no workplace set up in Hartford anymore, so she lost momentum on trips home: "I wish I might bring down my studio with me." *Evening* was still on her Northampton easel: "I'm almost willing not to work on it any more; it is such a joy to see what a quality you can get by working over and over."

Mary started experimenting with the

Raffaëlli paint sticks that Henry had adopted: "I like so much to work on the texture." She longed to see his new works and show him her two panels in progress for a year: "They begin to look as if in a few years they might arrive at something. . . . It seems just as well for me to keep scrubbing at the old things so I keep on à la Ryder, 'tho I may never arrive anywhere; it is a long, exciting and endless voyage, whose end seems still remote, and eternity I'm sure is none too long for it."

Tryon begged off from Smith more than usual, citing illness: "it is astonishing how often he has the grippe." Mary kept "trying to be agreeable and harmless" while her department was "growing more and more popular." In February 1905, apparently without her knowledge, Seelye set out to expand the faculty. He offered a resident professorship to Alfred Vance Churchill (1864–1949), an Oberlin alum who had trained at Berlin and Paris art schools and taught at Columbia. Smith wanted to impart "an intelligent appreciation of the art treasures which the world contains," Seelye told his recruit, and the workload "would probably not be great enough to interfere seriously with the individual work in art which you might desire to accomplish." Tryon made biweekly visits, Seelye wrote, "and the daily work is under the supervision of Miss Williams, who was one of his pupils."[5] What would Mary have thought of the president's unimpressive summary of her résumé, inaccurate report that Tryon visited every other week, and offer of responsibilities that would not "interfere seriously" with Churchill's desires to paint?

By March 1905, she felt as burdened as ever with "too much of the presence of the young feminine." She suffered "a real pang" of wanderlust upon receiving a friend's letter from southern France, describing "almond trees in bloom and the air sweet with violets." From her chilly Smith studio, she began imagining an escape impossible in her time: "I've been wishing ever since yesterday that I were a man, that I might have nerve and head enough to drive an auto—then I'd spend my last penny for one."

Yet she would not have minded a husband, she decided after visiting the Whites at Old Lyme's Brick Store, where they displayed some Whistler works: "You dont know how I envy you Lyme and that cosy little house and the Whistler room. . . . You have such a wonderful capacity for having a good time yourselves and sharing it with others. Really Grace do you ever think what encouragers of matrimony you and Henry are? And what can you expect but that Miss Florence and any other poor lone one will be wanting to go and be likewise settled and happy. The only thing that keeps me from rushing after someone, after a visit with you, is that I dont know anyone to rush after. That is fortunate isn't it, for I'd hate to have Grace put on that disgusted expression over me, and say as the old lady did 'Well! The fool-killer aint ben round lately I guess.'"

For male companionship, Mary brought along Gumaer on her next trip to Europe; Grace did not approve and scolded her. And within a year, men at Smith had cut Mary out of a job.

Light So Exquisite

In her 1905 summer in Siena with Gumaer, Mary recharged herself for what she expected would be just another "boresome" school year. She sketched hillsides and convents, critiqued frescoes, studied Italian and book-binding, observed aristocrats and Palio riders, made a new intellectual friend, and avoided clingy pets. Letters from Connecticut caught her up on art world gossip and a family health crisis. And she decided that she still liked Florence (where two years later she would be buried) best of all.

Her ocean liner cabin mate, for the second year in a row, was the music teacher Tecla Vigna. On the previous crossing, the singer had been shy, but this year she turned into "the life of the boat." She told Mary that a piano professor from Cincinnati, a member of the famous Gorno family, had been aboard in 1904: "She always finds him chilling." Mary befriended "il Commandante" and the crew:

"One of the little under-officers comes out to talk to me, Miss Vigna calls him my new beau, he is such a pretty little fellow and adores il Commandante it is so pretty to hear him talk about his idol."[1]

As the ship made landfall, "Vesuvio was a dream against the early sky." Mary bought Mabel a coral necklace in Naples and then headed north by train: "Rome looked as if we had only left it yesterday." She had the usual glimpses of celebrities; there was "a most fleeting vision" of King Victor Emmanuel III "in a carriage closely surrounded by the royal mounted guard." (He needed protection; he had come to the throne in 1900 after his father was assassinated.) On a feast day, Mary saw a bronze statue of Saint Peter "togged out in gorgeous vestments, and papal crown, with rings on his fingers. I didn't see any bells on his toes but there was always a crowd about kissing his toe so I dont know what they may

have done for his feet." She declined to hike to a hill town during a heat wave, despite the temptations of Etruscan tombs, and avoided a frescoed basement: "it seemed like a plunge into ice-water." In Perugia, a female saint's relics were arrayed at the Sant'Angelo cylindrical church: "each bone was decorated with a rosette of pink paper-satin ribbon with a paper flower in the middle." In one hotel, a talkative "old Irish duffer" with a heavy accent asked if there were any "natural curiosities" to see in the region: "We wanted to tell him that as long as he staid here there would be one."

In Siena, she settled for nearly two months into the Palazzo Pollini, a polygonal building from the 1520s that is attributed to the architect and painter Baldassare Peruzzi. From her room, she could hear wafting church bells and choirs. The palazzo hosts, the Bontade family, became Mary's friends. She studied Italian with the signora, Amelia, who praised Mary's writing skills: "She must think it queer that I'm not more fluent at talking, but I'm not a chatterer in any tongue." Her husband—Mary called him "il Capitano"—was a blind army veteran. Mary was asked to read to him when his wife traveled, in search of respite from frequent headaches, and he would "look grateful and polite. I usually reduce him to sleepiness." The couple had a teenage daughter, and a son, age twenty, at home. Guests dined on the rooftop, treated to the occasional "grand display of vivid lightning." The family shook hands with Mary upon each arrival, departure, and meal: "We have all the ceremony of a palace I suppose."

The Bontades spoke little English—they

86 Siena - Palazzo Pollini, già Celsi, attribuito a Baldassarre Peruzzi.

20.1 In Siena, Mary boarded with the Bontade family in a polygonal palazzo from the 1520s, attributed to the architect and painter Baldassare Peruzzi. WFC.

wrote to Mary and her sisters for years in Italian. (But the signora managed to run ads in the British press, describing herself as a "lady of good family" seeking English-speaking female boarders and offering opportunities "for learning French and Italian and for Art and Music.")[2] Jean Carlyle Graham Speakman (1846–c. 1925), a widowed British writer, had become a "permanent boarder" there. Mary described her as "one of the most charming women I have ever met. She writes

on art and is wonderfully bright and entertaining." The two travelers had a "heart to heart talk" about the Old Masters expert and Florence-based American expatriate Bernard Berenson, "whom we neither of us seem to admire."[3] Speakman had written poetry as well as essays and books on, among other subjects, folk traditions in the Pyrenees and the Perugia artist Fiorenzo di Lorenzo. That summer she was finishing a history of San Gimignano, a nearby hill town; it would be published after Mary's death.[4] The British author was lovable but disorganized, trying to corral a menagerie of pets. Her dog, Wolf, aka Wolfie and Il Marchesino Wolfino, barked during meals, nuzzled Mary's skirts, and chewed her possessions. He followed her around town: "To our horror after we were in the church we heard his little bell tinkle in after. I tried to look as if I'd never seen him before. . . . I said he was not mine, had followed us in the street, at which point the beast came and lay down at our feet as if he had no other friends."

Mary, when not learning Italian, took bookbinding classes and eventually made five bindings; "the whole week is disposed of you see," she reassured her sisters. The bookbinding teacher and a teenage apprentice tried to dissuade the American from experimenting with the messy processes. But Mary insisted on preparing leather with aging egg whites, and she acquired some skill at gilding: "It is a mighty fussy job but I got on very well with it." She studied the history of bookbinding, looking at covers made with "cord and leather and nails." She visited government archives,

guided by the maimed war hero Niccolò Scatoli, who "had been through many wars including the Crimea; had lost a leg somewhere but none of his ardor. . . . I bought several stamps that he had made from antique models; he had some that he had made from the irons taken from his worn out wooden leg."

She produced a summer harvest of drawings "more or less impotent or even impudent and hope to be forgiven," she told Henry. Among her subjects were a walled orchard, the Osservanza basilica, and the view from a convent window. While she was at work at the San Francesco monastery, the monks "touched their fuzzy hats politely and one asked to be permitted to see what I was doing." During a San Gimignano outing, Mary longed to sketch a restaurant owner "who seems to have just stepped out of a quattrocento fresco by Ghirlandaio or Pierro della Francesca." Mary envisioned posing the woman in "the setting of San Gimignano and also the three strings of old pearls around her neck to bring out her points."

She described more than she sketched. She recorded details as vivid as coarse wool robes on nuns, girls' gold-embroidered veil fillets for confirmation ceremonies, and a kitten in church that "stayed composedly through the service." During the Feast of the Assumption celebrations, she saw hillside bonfires "shining out like lights at sea." She told Henry that Siena's striped cathedral pleased her most by "young moon; full moon is too light for it," or at sunset, "when the light is streaming into its vaults and all the unpleasant striping of the

lower part is subdued and blurred. . . . Light is such a wonderful medium isn't it, now so ordinary and again so exquisite."

In San Gimignano churches, she was disappointed by Gozzoli's over-restored frescoes but found Lippo Memmi's works "beautifully toned by time and unspoiled by restoration." Work by the Sienese painter Matteo di Giovanni "has a dignity and distinction quite wonderful to behold." She toured Belcaro castle at the outskirts of town; its design and frescoes are attributed to Peruzzi, the architect of the Bontades' house. "B.P. was better

at architecture than at painting," she concluded. The castle's hilltop setting enchanted her—"Siena from there looks like a dream city"—and she could understand why Medici armies had seized it: "I'd like to besiege it myself if there were any chance of taking it."

At some point she picked up a new hobby: photography. She took shots of Palio teams representing different neighborhoods. Decked out in silk and velvet, "they were all ready to do any amount of posing for us," and they asked her to mail them copies of her prints. Eight undated snapshots of the Palio

20.3 Palio riders happily posed for Mary and her travel mates. WFC.

from the working-class Torre district. The team was considered "republican, anarchistic and all the other radical things," and it was accused of somehow cheating: "They said as they always do that it was a bought race."

Music in Siena did not meet Mary's standards. During Donizetti's *Lucrezia Borgia*, a tenor sang so off-key that "Lucrezia looked as if she'd like to kill him on the spot." In a boys' orchestra, "the little eight year old who smashed the cymbals was the only one who played in tune."

Among the local aristocrats, a countess had a "very common looking son," and a count's German wife was "almost as plain as they are ever made." A boarder at the Bontades' kept mangling Italian: "You should hear her say 'interess-anty,' sounds like a game of poker." Cars had come to Siena, which sent Mary cowering in doorways to avoid "a great puffing, smelling monster that seemed to more than fill the street."

Everywhere she went, children begged; Mary made herself popular giving out candy. But the beggars especially wanted, of all things, foreign stamps. Mary cut supplies off letters from America: "If you could see all the pretty eyes and hear the pretty voices that ask for them you'd feel rewarded," she told her sisters.

The supply of letters from Hartford dwindled in August; "perhaps you've decided that one a week is all I deserve," Mary joked. Then she learned that Lucy had been bedridden with typhoid. The fever had subsided by the time Mary left for Florence, fortified for the train with cake and kisses from the Bontades.

in the Williams files include blurry crowd scenes and portraits of helmeted riders (if Mary did take them, she was a better painter than photographer).

During the pre-race rituals, a "dapple-gray horse" was blessed in a chapel: "the little beast toned in beautifully with the dim gray tones of the church and behaved as well as anybody." When a rider was thrown, his "knowing beast stopped short" of trampling him. She watched the wine-guzzling feats of the winning team,

Mary Rogers Williams, 1857–1907

When the family patriarch kissed Gummy farewell, Mary told Henry, the young historian's "patient reception of the proffered salute amused me greatly." Henry sent news that Allen Talcott had become engaged to Katherine Agnew (1870–1956), the daughter of a Manhattan physician. Florence Griswold apparently had a crush on him, although he was sixteen years her junior (or maybe Mary was joking); Mary guessed wrongly to Henry that the fiancée "is a young thing of eighteen or so to offset Miss Florence, poor lady." Walter Griffin (1861–1935), a painter who had been teaching at the Hartford art school, was separating from his wife, the writer and photographer Lillian Baynes Griffin (1871–1916).[5] Walter moved in with Henry for a while, and Mary archly wrote to Henry that she was curious about Lillian's side of the story: "How fortunate for Mr Griffin that he has a haven of refuge with you; but what of his forlorn former wife and her numerous relatives, who is comforting them?"

In Florence, Mary returned to the Lucchesi pension, where Henrietta Seelye had stayed the previous summer: "Prossie is much missed and frequently mentioned in Firenze. There is a place set for her at table." The contrast between the city and Siena at first made Mary feel like a rube: "Soon, however I began to feel as usual as if I owned most of it." She admired watermelon stand customers illuminated in "flaring oil lights," and she sketched along the Arno and at Fiesole. She doubted the authenticity of some newly purchased Botticelli works at the Uffizi (it is not clear which ones she meant), but she none-theless concluded that Florence "still has first place in my heart." New England friends and acquaintances had taken their vacations instead in the "wild and wooly" American West, but Mary could not fathom "how anyone who might go to Italy could want to go to Salt Lake City."

Upon returning home, after a rough ocean passage, she joked to Henry that she could envision herself "automobiling" or running a steamer line for a living, or "opening a pension in Florence," or simply becoming an industrious maid for the Whites: "a happy home with a model family seems attractive." Over the summer, Seelye had bought a Hassam scene of Old Lyme's Congregational church—the painting had won a prize at the 1904 world's fair. Mary found it overly realistic and hopelessly inferior to Italian art: "Prexie got another Childe Hassam this summer—may he be forgiven. It had a gold medal in St Louis—may they that gave it be forgiven. It is a portrait of the old Lyme church seen through the leafless elms, the representation is so faithful that one can easily see that Lyme has been a sufferer from the elm-tree-pest. I'd like to introduce Hassam and Matteo di Giovanni of Siena and see what they'd make of each other. I'm sure Matteo would thank his saints that he lived in the quattrocento." (Smith no longer owns the work.)[6]

Tryon had somehow complained about her, she found out from the Whites: "I dont seem to care much what Mr Tryon says about me; talk is so very inexpensive; I wish he'd give us a little more of his very valuable time." Grace, for her part, seems to have complained about

the unseemliness of Mary traveling with Gumaer. Mary grew almost indignant: "It grieves me Grace that you, my own familiar friend, should make remarks about how I spent my summer; that you should criticize my playing a little with my young brother." Grace seems to have apologized, but Mary was still hurt. Happily married women could not understand the hardships of older single women like Mary and Miss Florence: "I dont think your penitence for your critical remarks is anything but feigned," she told Grace. "If you had to live in Northampton and 'sociate' with shoals of girls you'd know how nice it would seem to sociate with almost any kind of man. Of course living with such a fine one all the time you cant understand Miss F. and me, but you ought to be real charitable. I feel like a cloistered nun a good share of the year you know."

And so began Mary's last year as a cloistered nun.

Nervous Energy Spent Teaching

Everything about Northampton chafed Mary by the end: the provincial citizens, the president's tastes, Tryon's absences, the "cloying, embryo intellects" of the students, and the awful feeling that she had turned into "a little old nun." She had long given up bicycling, and by fall 1905 her letters no longer mention golf. Her wit turned more acid every week. The avant-garde of New York appealed to her instead of her women's college world, but then crushing criticisms from a Manhattan dealer arrived. Mary kept herself going by planning to head overseas again.

Her burdens of "maidens to start on the long and endless road" to basic art skills made Dante's *Inferno* seem like "light amusements." She had no time to finish summer sketches to submit to New York shows. She found humor in Tryon's "beautifully arranged" schedule: "South Dartmouth in the fall term; grippe in the winter term; fishing in the spring term;

isn't that clever?"[1] Churchill, meanwhile, had accepted Smith's offer (he arrived in fall 1906, after Mary left), with Seelye's assurances that there would be budget allotted for building the museum collection and the supplies of lantern slides for lectures.[2]

In January 1906, Mary's friend Theona Peck (Smith 1895) returned from New York, having bluntly proposed to Montross that he exhibit Mary's work. Mary, who described Peck as "mistaken enough to be enthusiastic about my pastels," had warned her young fan that the proposal would be "at her own peril." Mary duly reported Peck's summary of the dealer's reaction: "It was a pity I spent all my nervous energy teaching and had not force enough left to attempt anything large, all my things were small."[3]

Mary shrugged off the criticism (though it must have smarted, and she mentioned it again in her letters) and told Henry of her

latest sale to a Smithie: "Well, never mind the natives are beginning to seek me out and one came in this morning and bought one of my small little pastels for a small little sum and wished she had money enough for two." Mary reminisced about all the unhelpful advice that men had given her over the years: "Mr Champney once told me that I had not self-conceit enough to succeed; and I remember how Mr Chase once looked at my work in his dramatic way and then said fiercely 'Too much timidity!' Well, I dont care, I have lots of good times here and in Italy, and who cares if he cant sell canvases for two thousand to the rich Philistines! My works seem to sell pretty well at ten dollars and just think how many more I'll have to make. Dont you think numbers ought to count as well as size?" She disapproved of Montross's eye anyway, she wrote. He did not even understand the best paint colors for galleries: "It is not always necessary nor even decent to always hang pictures on magenta walls I think our distinguished friend Mr Montross has yet much to acquire of taste in that line." She preferred Whistler's choice to hang pastels on walls painted "lovely grayish pink."

The Society of American Artists turned down her pastel and oil submissions for the spring 1906 show (Henry had a Connecticut spring scene accepted). When she found out that Henry wanted to be elected as an academician at the National Academy, she could not imagine herself going so mainstream: "So you want to be an N.A. do you, Henry. I dont aspire to anything so old style. I want to belong to something modern and alive."

She mentioned a Mrs. Robinson, an older artist who had been submitting pieces to the academy jury: "She does right to hang on, for Bellini did his best things after he was sixty—think of that! Isn't that inspiring?" Mary asked Henry what he thought about the New York dealer Sigmund Pisinger's new Modern Gallery (which lasted a few months, at 11 East Thirty-Third Street). It was showing works by the future Ashcan school talents John Sloan, Robert Henri, William Glackens, and George Luks: "That sounds rather fizzy and fine. I dont want to run with the fossils but with the young and ardent." In that letter, she added some doggerel about academicians: "I would not be an N.A. / Nor with the N.A.s hang / Id rather join a gayer, / A smarter, wilder gang."

Ah, what kind of "smarter, wilder" art would Mary have produced, had she survived to run with "the young and ardent" of the Ashcan school, exhibiting without any ungodly juries in control?

Sarah Bernhardt came to Northampton, to perform in Racine's *Phèdre*: "Think of her disporting herself in this hotbed of puritans; wouldn't it be queer if she should leave behind a microbe of Paris gaiety to infect this sleepy place." Mary heard "virtuous spinsters of over fifty cast aspersions" on Bernhardt: "They seem not at all concerned with her artistic gifts, but sit up very stiff and look grave-eyed through their specs as they denounce her character, which it seems to me does not concern them anyway."

As for Smith classes—it seems unimaginable that all her friends were not telling her to quit already. One example from her

letters to Henry: "Today I'm feeling that I'd rather do almost anything than try to teach the young female but most likely by tomorrow I'll be meek again." And another: "I'm deadly sick of casts and young females but of course being only a stupid plodding thing I shall stick to my duty and try to squeeze some joy out of it." One more: "Remember me when you come into your kingdom in Lyme, and drop a tear of compassion for one who is sick of her job."

She could not get away to visit her sisters or the Whites: "My job here is all I have time and strength for. I've told Prexie that I cannot possibly do so much work another year." Henry had attended an acquaintance's funeral, and Mary's response was prescient, given that her own death would come so soon after she realized she was ill: "Wouldn't it be fine if we could always be well and at last drop off and blow away like the leaves."

As she cleaned out nearly two decades of accumulation in her studio (again, presciently), blue-collar careers tempted her: "The housecleaning field of labor is not full and as we seem to be overstocked with artists I'm thinking of changing jobs. . . . I might do something in the magic line, for I've torn up, burnt up, given away, and carried down cellar more things than I thought I had, and still have left more than I want." She was also half-tempted "to go down and 'clean out' Mr Ryder? T'would really be a Herculean task I think—as bad as the Augean stables. The only thing that keeps me from thinking it really is my duty is the fact that I know he'd get it mussed up again right away."

She was assigned to hang a dawn scene by Tryon that Seelye had purchased, although she considered it bland and rote (it is no longer in the collection):[4] "It is a spring morning of the kind that the Master has painted so often; this one looks more like a Corot than ever. I've seen so many similar ones that they do not thrill me as much as they did, and I have an uncomfortable feeling that he might be able to tell one just how to do them." Henry, although he went on to publish many glowing words about his fisherman-artist friend, also apparently criticized Tryon's work to Mary in amusing ways (alas, his side of the correspondence has not surfaced). She longed to share Henry's letters, which were clearly not meant for sharing: "Anything so choice it seems piggish to keep all to myself. Your last in spite of unmerited allusions to my character moved me to mirth. Your remarks on the Masters flooding the market were perhaps a bit irreverent but if you could see the last manufacture you'd feel that you were somewhat justified. However our President is perfectly satisfied with his purchase and considers it the finest thing yet. I'm just a bit weary of the Presidents art appreciations."

She could barely stand the sight of the Hillyer gallery contents: "What a perfectly hideous thing a collection of pictures is anyway. I usually walk though ours with my eyes shut or fastened on the floor." She had grown immune, it seems, to any charms of the masterpieces by Eakins et al. that Smith had acquired before her arrival.

She did take some pleasure in installing a museum show of Japanese prints owned by

Tryon and Henry, while making herself a sensible spring hat, "built to combine lightness with pleasant form—all at the least expense possible." She started planning another summer in Siena: "I'm really going all alone. My sisters will join me in August and we'll all come home together." Numerous artists had begun giving lessons at the Connecticut shore, and she was throwing away mounds of their mailers that "taxed the resources of the wastebasket." She asked Henry if he would join their ranks: "Are you going to have a class in Lyme? I've received so many circulars that I conclude its the natural thing to do in Lyme, and of course when you're in Lyme you should do as the Lymans do. . . . What an artistic people we shall become—too bad!"

And then she accidentally took herself out of the ranks of teachers creating yet more artistic people.

Out of the Harness

In late May 1906, Smith art students underwent Tryon's last critique that Mary would witness; and then there began her befuddling weeks-long ouster.

She sent Henry a plaster bas relief of Nelson (figure 22.1), suggesting he hang it where light "throws the contour of the cheek into relief." She had postponed her summer trip to Siena: "I've got into some trouble here. I rashly and decidedly told the President that I would not return to my work here next year unless I could be advanced to be associate professor, supposing that he would lay the matter before the trustees and that it would be at least two or three weeks in coming to decision." The administration's immediate response: if she would resign if not promoted, then she should just resign.[1]

Friends and colleagues including Louise Capen, a Smith teacher and artist who helped run her family's prestigious Northampton girls' school, put up "a great protest." They urged Mary to fight back, since they "do not approve of Prexie's highhanded way of dealing with his Faculty." Henry warned a Smith trustee in Hartford, the theologian Arthur L. Gillett, that Seelye was forcing out Mary "rather summarily and apparently without consulting the Trustees." Henry told Gillett about Mary's "very efficient and faithful service to the school" and described her as "one of the very best instructors in art in any of our public institutions. She stands high in her profession as an artist, is of the highest character and has all the personal qualities that go to make a successful teacher. I feel that her removal from the position she holds would be a very serious loss to the college, and to art itself." Tryon, Henry added, "would deplore Miss Williams' removal."

Mary thanked Henry for trying: "Your words gave me a sort of shock till I realized

22.1 *Nelson*, 1906 plaster relief, 7 x 5 in. Mary depicted Henry White's son Nelson in paint and plaster, and she cast his hand to make sculptures. WFC (PHOTO: TED HENDRICKSON).

that they were perfectly true and that 'summarily dismissed' really was the state of the case. Dont for a moment imagine that I'm feeling sad or bad over it. It is the way everyone is treated and as I said the list of killed and wounded is a long one and has many worthy names on it. . . . I was expecting to slip off in a mild quiet way but my friends insisted on my kicking a bit so I've been doing my best tho you know it really isn't in my line." She booked her ocean passage for June 21, not sure yet whether she would ever return to Smith.

While the trustees dithered, Mary updated Henry: "Mr Tryon's attitude in the affair I cannot in the least understand I'll tell you all about it sometime as I feel that things sometimes get a little twisted in the writing. He is fishing in Maine I suppose." In limbo, she maintained her sense of humor. She sent Henry a small ad (figure 22.2), clipped from a Hartford theater program, for a new summer school in Waterford for artists and normal school students (meaning teachers in training). Henry was listed among the instructors, with Walter Griffin and the Hartford native Louis Orr (1876–1966). The ad promised "Fine Bathing, Fishing and Boating near hotel." Mary teased her friend: "What do I see and hear! Mio Dio! Dio mio! Why should my friend get into harness? Why should my beloved Waterford be polluted by a Class? And what are you Henry, Academic, Normal or Abnormal? And why did you omit to mention the Golf Links, the huckleberries, and the mushrooms?" Mary hoped that in the

end he would be "mercifully delivered from any summer classes."

By June 20, she had swung through Hartford, visited Mabel in Boston, and heard the verdict: "The 'Trustees' decided to accept my resignation so I'm out of the harness. Prexie in his usual slippery, oily way slid everything on Mr Tryon and the Trustees. I hope I'll never meet up with a meaner man than said President. However it has shown me what a lot of real true friends I have and that is quite worth while."

Tryon, when he wrote to Henry about Mary's departure, shifted the blame onto Seelye: "I am personally sorry to lose Miss Williams' help in the school but she seemed bent on resigning and I left the matter of a final settlement with her and Prest. Seelye and her resignation was accepted. It then turned out that she did not want to resign but it had been acted on and was too late for reconsideration."[2]

Mary had one last exhibition in America, and one last mention in the press in her lifetime. The *Springfield Republican* reported on a Hillyer show "thronged with interested visitors" during graduation ceremonies: "Miss Mary R. Williams, head of the department, received, and several of the college young women served refreshments. . . . Exhibits of special interest were a collection of pastels by

22.2 When Mary came upon an ad for Henry's classes, she worried that art students would overrun Waterford. WFC.

Miss Louise Capen, paintings and drawings done by Henrietta Seelye in Rome, and landscapes by Miss Williams."

That is, Mary had the bitter pleasure of hanging her own landscapes in a museum full of works that she had helped buy and come to despise and would never see again, alongside pastels by her friend and defender Louise Capen and Rome scenes by Prossie, the daughter of Prexie. Mary had been known that year, as usual, as an instructor. The newspaper inaccurately called her "head of the department," an even more elite title than the one she hoped for.

Pangs of Loneliness

Mary recovered from the shock of being "summarily dismissed" by traveling in Italy with her sisters and picking up new skills of woodworking and gilding. She documented her activities for Henry, and Lucy kept daybooks, jotting down what they ate, bought, and saw. Lucy also summarized, in uninflected shorthand, tragic news. Only occasionally does an underlined word or two indicate Lucy's emotions, whether pride in accomplishment or embarrassment at mistakes. And there is much embarrassment recorded; Lucy's daybooks highlight just how much Mary differed from her sisters.[1]

Laura and Lucy sailed a few weeks after Mary. Lucy recorded that the crossing was marred by a gunman's attempted murders and, apparently, his subsequent drowning: "*A steerage* fired 5 or 6 shots hurting two or three men then he jumped over—did not find him."

The sisters explored Rome, Venice, and Florence while Mary stayed for much of the summer in Siena at the Bontade palazzo. Laura and Lucy also spent a few weeks in Siena, where Lucy took Italian lessons and studied lace making with a nun. The sisters made the rounds of gardens, museums, palaces, churches, convents, and ruins (the Venice campanile was still a heap of brick and stone). Lucy noted down expenses for jewelry, fans, toys, gloves, scarves, and postcards, mostly as presents. (Mary told Henry that Lucy would come home with gifts for "everyone she knows and some she has only just heard of.") Lucy invested in film as well; the daybooks contain notes on bridges and canals that she photographed. At times Lucy stayed in the hotel rooms absorbed in her needlework, while Laura and Mary went off to sightsee and sketch. Noise from the street and other hotel guests bothered Lucy, as did mosquitoes. But she shared something of Mary's

pleasure in the novelties of traveling. Lucy noted down observations of meteors, sunsets, moonlight, and a snail meant for dinner that "walked off the plate" and ended up "on wall behind looking glass."

When the sisters' friend Martha Graves Bush died, at thirty, Lucy only wrote down "news of Martha Bush's death." Did Lucy mean to suggest anything about mourning with her next shorthand observation, "Kept light burning all night"? News from Smith also reached them: "Miss Lathrop takes Mary's place," Lucy wrote, referring to the painter Clara Lathrop (1853–1907), Mary's successor.

Lucy almost morbidly tracked her own absentmindedness; she stained a shirt, lost a shawl and an eyeglass case, and sat down on a chair that broke. She added exclamation points for small triumphs: "I found the lace store alone!" Despite Lucy's befuddlement, Mary clearly loved having her sisters in Siena. They played *tombola*, the Italian version of bingo, and Jean Speakman played piano while Laura and Mary sang.

In August, Mary updated Henry: "I'm making picture frames; you may come over and find me selling them along the Quais in Paris. I've always wished to be able to make my own frames. . . . Do you think it would be a profitable business to go into?" She heard from her former colleague Herbert E. Everett that Prexie expected Churchill to be "such a wonder." Everett told Mary that she was "well out of what might be an unpleasant situation," given the department's politics and growing pains. Tryon had suggested to various Smith-

ies that he would leave the job in a year or so. Mary was convinced "he means to hold on if he can pleasantly and conveniently till the new gallery is built and his pictures are hung properly. That is to happen when another Hillyer dies—he may live to 115—I read the other day of a man who committed suicide at 115 because he was tired of life." Mary was likely referring to the nonagenarian Smith benefactor Drayton Hillyer (1816–1908), and to Tryon's plans to give Smith more paintings as the museum expanded. (He died shortly before galleries devoted to his artworks were completed.)

Mary asked Henry for news of Bunce: "Is Gedney in Venice again for the winter with another contract for a few more sunsets?

23.1 Unidentified woman (Signora Bontade?) preparing an outdoor meal at the Bontade palazzo in fall 1906. WFC.

Wouldn't you like to discover a motif that would be such a commercial nugget?" Mary dreaded her sisters' departure, and she asked Henry to write often: "Already I have terrible pangs of loneliness when I think of the winter."

By October, the artist Julia Strong Lyman Dwight (1870–1961), Mary's future roommate in Paris, had arrived in Italy. Mary described her to Henry as "a most exemplary young person; I hope I can live up to her all winter; dont you hope that I will not shock her with any of my bohemian ways?" She had learned that Clara Lathrop was teaching

drawing and painting under Tryon, while Churchill lectured on art interpretation, history, and philosophy: "The new man has none of the practical work tho I was assured that he was to have the painting. Queer world isn't it. . . . Well, I'm enjoying the thought of my freedom immensely. . . . I have the loveliest friends in the world."[2]

She regretted leaving Siena in the midst of the fall's subtle palette: "The trees turn so gently such lovely brownish and golden tones." The hues on Italian hills contrasted with New England autumn's "excited theatrical reds," which she would never see again.

A Peaceful Comfortable Feeling

Back on rue Boissonade, Mary ended up largely homebound but put up a good front. She repaired her clothes and occasionally painted and critiqued paintings. She discouraged her sisters from visiting—she was barely able to take care of herself. She was grateful for news from Smith and cash handouts from friends, and stung by rejections from the Salon jury. She was intrigued as modern transit took hold in Paris; she lived long enough to hear about experiments with airplanes. She seems to have had no idea that she was dying, and her taste for adventure resurfaced as spring returned.[1]

Her studio mate, Julia Dwight, had trained at Smith (class of 1893), the Art Students League, and the Museum of Fine Arts' school in Boston. Her family tree included the eighteenth-century theologian Jonathan Edwards and some Yale presidents, and her Yale-educated father Edward Strong Dwight (1820–1890) had been a friend of Emily Dickinson. (The poet wrote mournfully about his first wife Lucy, who had died from consumption in 1861, and Julia long owned some of those pages.)[2]

Mary reassured her sisters that she would "spare no pains to be comfortable this winter" and felt "so much joy in being lazy!" She sent home a snippet of blue flannel that she was using to make a cozy bathrobe. But she confided to Henry, "Paris did seem so cold and gray and slimy after Italy."

She paid for dinners with her landlords, the Montagnys, who were renovating and adding gas lines to the familiar complex. The two daughters occasionally bickered, which left Mary grateful that the Williams sisters "were brought up to be decently polite to each other and were not allowed to form the habit of disputing." Marguerite Montagny had a toddler daughter "too attractive for words,"

24.1 Mary filled her last Paris studio with metal and ceramic antiques collected on the road, a chair left by a previous tenant, brocaded fabrics, and her framed artworks. WFC.

but Marguerite's rather stuffy physician husband, one Dr. Valérie, "is a real Frenchman—the kind that you think would look well in a glass case."

Mary developed a breakfast routine of cocoa and toast, and she joked to her sisters about the cocoa package instructions: "'dissolution will be immediate and complete.' Isn't that startling!" For lunch, she spent a franc for sardines and eggs at a nearby bistro,

Henriette's, "a favorite haunt of art students." The fellow diners seemed to be "embryo artists I suppose; some of them look as if they'd never leave the shell." The walls were "decorated by two American girls," she told Henry. She was referring to Florence Lundborg, a San Francisco illustrator who had taken Whistler's classes, and Alice Mumford, a Philadelphian who had studied with Robert Henri. They lined Henriette's with murals of

the Queen of Hearts making tarts and fending off the thieving Knave of Hearts.[3]

Mary found Julia "as nice and unselfish as possible" but also "not very strong on practical housework. . . . The things she doesn't know about ordinary every day things is astonishing." Mary waxed the floor daily, and her hair grew sooty as she fed the studio's coal stove. Julia huddled around the stove, hugged hot-water bottles in bed, and struggled to learn French.

When Julia left each morning for art classes, Mary had "a blissful time" alone with pastels and paints, finishing her summer sketches: "It is delightful to work without an interruption." She filled her half of the studio with a bed, easel, antique ceramics, brocade fabrics, and a cane lounge chair "left by a former occupant—the one who left without paying her last term." In contrast with her "squeezed little corner" at Smith, the space measured about twenty by thirty feet. It was on a high floor: "Venus was shining in at my window Jupiter also showed up quite beautiful one night this week." It overlooked formal gardens and an orphanage. The children's uniforms, against a backdrop of foliage and stone buildings, charmed Mary: "I see them out very often running about and playing—all in gray-blue—a pretty note with all the gray and green." She soon had "almost forgotten that I was ever at College taking care of twice too many pupils. I may not do anything worth while this winter but I believe I'm going to have a good time doing it."

As winter settled over Paris, she revisited her favorite Louvre paintings: "they looked

24.2 *La Lampe Italienne*, Julia Dwight's oil on canvas shown at the 1908 Paris Salon, 42 x 25¾ in. The original is unlocated, but cheap prints are available online. AUTHOR'S COLLECTION.

lovelier than ever yesterday in the soft gray light." She discovered upstairs salons full of marine paintings: "I love it up there it has such a flavor of old garrets which I adore; there are always a lot of working men showing their hatless wives or amies the wonderful models of all sorts of craft." Manet's work, including the nude *Olympia*, made Ingres look "mainly accurate and wonderfully

industrious." The sugar magnate Georges Thomy-Thiéry had bequeathed paintings to the Louvre, and his Corots "make a rainbow in my soul." Mary stopped trying to follow much of the contemporary scene: "I get more than I can digest at the Louvre and the Luxembourg."

She did keep up with new technologies. An elevator ride gave her "time on the way up to think of many things that might happen—like having the thing stop between stories or decide to descend suddenly." She toured an exhibition of "wonderful and varied and most elegant autos," but she realized that cars "thick here as huckleberries" were causing "deaths from too fast speeding almost too many to count." On her first Métro ride, she worried that part of her fur stole had been stolen or lost in the crowd: "never, never more will I get into such a horrid jam." But there was a convenient Métro stop near her studio, and she eventually concluded that subterranean travel was "less terrifying than the autobus" and the best way to "burrow all through the vitals of the ville."

She regaled Connecticut readers with tales of her housekeeper, who chatted about gruesome murders, and of the Montagnys' housekeeper Alice, who had dreamed up a husband, son, and in-laws, among other relatives. Alice's stories gave Mary existential thoughts: "After I've had fresh details of her imaginary family I ask myself 'What things are real any way?'"

There was the drudgery of having clothes professionally made or remade, to look at least respectable. One wonders how much

potential productivity among Gilded Age women intellectuals in general was wasted during dress fittings.

Mary gradually warmed to the dressmaker, "a real artist in her line," who had started earning a living at age thirteen. The dressmaker went into some bouts of "artistic frenzy" and drove pins into Mary: "What women endure for their clothes is simply noble." One of her shirtwaists had a nearly unreachable button in the back, and she told Henry about her comical exertions "trying to get out of it all alone, pacing the room, squirming, taking a rest and going at it again." Henry apparently teased her about her efforts to be fashionable, and she replied that although there were other ways she would like to spend her time and money, "the law (made by men) requires us to be decently covered (at times)."

Mary envied menswear, as usual. At a Musée du Luxembourg exhibition, she followed around a young bohemian "dressed in classic Greek costume—brown and white—without a hat, and shod with sandals. He had the most beautiful head and neck I've ever seen and I simply followed and gazed, for I found him far and away more interesting than anything on the walls. He seemed perfectly unconscious of his appearance. Why cant I dress in a simple costume like that?"[4]

She largely avoided other expatriates—there were no more confetti fetes at her rue Boissonade room. When Julia began making towels for a hostel set up by the philanthropist Grace Whitney Hoff, Mary refused to join in: "Sewing societies never were in my line."

The American colony held coed parties, which were "getting so popular that they fear they'll have to shut the women out." When a budding artist named Miss Bradford stopped by, Mary found her "more or less of a butterfly and not fond enough of art to endure hard work." At a tea for women, a disheveled Swede explained that spirits were appearing to her, and also that she had trouble navigating in Paris: "It was a pity she could not have a kind spirit to lead her about gently by the ear," Mary snarked. When one partygoer insisted that Americans admired the English, "Only my settled habits of politeness kept me from throwing my tea at her." Mary's German neighbor, "a real bacchante type," was being "pursued by a long string of admirers. Last night she had in a hurdy-gurdy from the street and I suppose danced with her various followers."

Mary reassured Grace that the Montagnys considered her and Julia "serious-minded females." The rest of the women tenants "have all had men in attendance, but nothing of that sort comes near us." Julia, meanwhile, was "sighing to know some men—what a foolish wish!"

By late 1906, Mary was settled in and living within her means. She mended an umbrella (a new one "would make a large hole in my finances") but splurged on tickets for Bernhardt and *Cyrano* productions—"you see I'm going to be quite dissipated." Mabel sent her one hundred dollars for Christmas: "'Everybody's awful good to me' and I feel like an undeserver. However I shall take it with a thankful heart." Even on her budget, she told

Henry, she was becoming a small-time collector: "What do you think? I too have been buying Japanese prints." She suspected they were reproductions, "but they are lovely just the same."

Her sisters sent over her paintings, and some candy that lasted months before "beginning to deliquesce." As she unpacked her crate of lightly bruised artworks, she realized that with "utter depravity" she had accidentally taken one of Henry's frames. The box's contents brought a "homelike touch to my great studio; they are all tucked away in corners. I shall now do what I can to carry them on a bit and begin something—perhaps." Julia rented another space from the Montagnys to work during daylight hours—Mary then took on a greater share of the studio rent and tried to concentrate.

She told Henry about her "new rule for getting a good time out of painting. If you let your work get to the very limit of badness, then it is perfect joy to slash at it, for as it cannot get any worse it naturally has to improve." She realized that self-deprecation had hindered her career: "The truly great have the gift of not only liking what they get but also making others think it is *the thing* too." She kept "scraping away" at old works, and she experimented with "a memory sketch in pastel of something I saw Sunday afternoon—a figure indoors, dim lamplight." Mary's pastel portrait of a seated woman (figure 24.3) by lamplight, alongside a vase of red flowers, most likely represents Françoise Montagny. The contours seem to have just flowed like a doodle; one would never guess that the artist

24.3 *Mlle M.*, 1907 pastel, 9½ x 6½ in., most likely portrays Mary's artist neighbor and landlady Françoise Montagny. WFC (PHOTO: TED HENDRICKSON).

of this glimpse made from memory had agonized and reworked other works for years.

Her male friends back home reported on their own struggles. Gumaer was living with his family in Jersey City (Mary considered the place "more or less of an infliction"), teaching part time at various places including Columbia, and looking for work "with an interior decorator." After considering a post at an Iowa school, he landed the University of Pennsylvania job (which lasted the rest of his life and allowed him to spend summers in Europe); Mary predicted he "will find it a haven of peace." He wrote her often in return for "a bit from this side once a week." Frederick King had begun working for the *Literary Digest* (where he would spend much of his career), and unemployed Mary was annoyed that her friend "seems to be pitying himself very much because at last he has steady work. Poor thing! Isn't it sad!"

Mary received the terrible news that Marie Champney Humphreys had died at twenty-nine, leaving two small children.[5] Miles Wells Graves, the Williams orphans' guardian, died soon after the death of his daughter Martha: "He was our best friend . . . what a grand good man he was," Mary wrote home, almost for a moment reflecting on her childhood. Miles Graves's widow Ruth suggested to Mary that she "come back in the spring which is kind of course but I do not feel that way just now. She must be terribly lonely."

Jean Speakman, who was finishing her San Gimignano book, sent doggerel attributed to the incorrigible dog, Wolfie. The Bontades sent postcards and thanked Mary to the

point of embarrassment for a gift of cheap coral jewelry. Mary told Henry that she had seen a *Courant* article by Walter Griffin's estranged wife, Lillian, about New York shows with some Connecticut artists' work: "She does not mention her husbands name among the exhibitors. I was pleased to see that she mentioned you Henry as though she bore you no illwill [*sic*]."[6] The Manhattan murder trial of Harry K. Thaw had ended in a deadlocked jury; his victim, the architect Stanford White, was the longtime lover of Thaw's wife, Evelyn Nesbit. Mary described Evelyn Nesbit as "a very naughty girl," and Julia was astonished that White, "who produced so much that was beautiful could have been so depraved in his morals." Parisians in general, Mary told Henry, believed that the jealousy-crazed Thaw "would surely be acquitted by a French court."

Mary was apparently turning a little curmudgeonly about French mores: "Paris seems to be a place where it is easy to be naughty. I used to think it a bad place for young girls but I've made up my mind that it is worse for young men and I hate to think of our young American men doing the things that are considered a part of student life." (She was likely referring to brothel visits—contracting syphilis, after all, was a death sentence at the time.)

Smith friends told her that Churchill "is having a horrid time; the girls think him foolish, and the trustees(!) hear that he is vulgar! all because he had his class do some peculiar stunt in drawing and was so astonished at the result that he exclaimed 'Is that all you know about a man's legs!'" For Churchill's "peculiar stunt," he asked students to "draw heads, fold the paper over, exchange, draw bodies, fold again, exchange, draw legs, unfold and discuss the whole." She asked Henry what Tryon was exhibiting, and whether her former boss had suffered "his customary turn at the grippe." She wondered about the Wadsworth Atheneum's imminent displays of gifts from the Hartford native J. P. Morgan (the addition he funded there opened after her death). She suspected the plutocrat had bought "job lots" indiscriminately in Europe that were "much better left on this side."

Mary had one last show, "a little unimportant exhibition" of four or five pastels at the American Girls' Club, including Italian scenes. She headed over to the installation "in fear and trembling, for my pastels do not look well always by gaslight, but I found them well hung, all together, and beautifully lighted." The club also borrowed Julia's painting of roses and two small views of Capri by Lucy Flannigan, a Bostonian alumna of the Museum of Fine Arts' school. Mary was intrigued by the whiff of avant-garde in Flannigan's paintings; she described them as "very neat in execution, hard unatmospheric and almost black and white; there was not the slightest suggestion of locality in them and they might just as well have been on the coast of Maine. I'm curious to know how she arrived at such a stage."

By mid-February, Mary warned her sisters that she would be writing less, while preparing Salon submissions. The Paris gloom had come to frustrate her: "It is so dark this

morning that it is impossible to paint—one color looks like another." She returned to the frame maker Paul Foinet, who remembered her 1899 visits, and invested in a frame for *Evening*. In laboring over an apple tree scene, she "improved the foreground greatly it is beginning to look worthy of the frame." She eventually submitted four pastels of Italy and three oils including *Evening*, the apple tree canvas, and "a Northampton subject," despite her self-doubts: "I have had moments of thinking the paintings had some slight merit but today they all look lacking to me."

Julia produced a large oil portrait as a Salon submission: "The model who is posing for her used to pose for Whistler." The sun came out one morning, "to Julia's disappointment as she prefers a grey day for painting, having begun her Salon picture on a grey day." Mary previewed her Whistler classmate Henry Salem Hubbell's Salon picture, showing "six or seven ladies doing afternoon tea very prettily." She deemed it "interesting in composition," although the large canvas left him "spread out too thin." During her visit, Hubbell confidently (and, to Mary, irritatingly) passed around "photographs of about all the things he ever painted." She stopped by her sabbatical studio, which George Henry Leonard had taken over: "I did not care for his pastels. I like mine better." He stopped by her studio and "was so appreciative of my 'loose way of working' that he amused us tremendously." At the studio of the symbolist painter Edgar Maxence, a Salon jury member, she ended up "bored nearly to extinction"—she was losing patience with any other artist.

Mary was reintroduced to Alice Kuhn, who had set up La Fayette College for American women in Paris, and she met Lily Beers Berthelot (Vassar 1869), a widowed New York insurance heiress and translator who was establishing "some sort of a finishing school for young ladies" called the Institute Berthelot. Lily Berthelot told Mary that La Fayette College "was a little Sorbonne—but different in a way from the Sorbonne because you could ask questions, and at the Sorbonne you only listen to the lectures!"[7] The Vassar music professor George Coleman Gow and his wife Grace Darling Chester Gow (George had also taught at Smith, where Grace had founded the botany department) invited Mary over. The Gows did not share Mary's love of expatriate life: "They had found some Boston brown bread made by an American which seemed to fill them with satisfaction though I did not find it as good as Paris rye bread—but then I like Paris better than they do—even its bread." Their apartment was "furnished in the way supposed to be artistic, with all sorts of bric-a-brac and pictures—like an overstocked storehouse or museum." Grace Gow told Mary about her taste for the work of Carolus-Duran, "a very banal portrait painter whose work I abhor." The couple brought their small daughter, Serena, to rue Boissonade, which softened Mary's stony heart: "Baby found the studio a delightful place to frolic in and she had some mints to carry home also a paper doll drawn by request."

By early 1907, Mary stayed indoors much of the time. Slogging through winter streets

was "like walking in mince pie." She developed lingering colds "all in my pipes" and self-medicated with quinine, whiskey, and hot rum: "I've coughed up both lungs several times over. . . . I'll try not to take any more such germs." Every unplanned expense—pewter plates and lilacs bought on impulse, eyeglass repairs, dentist visits, customs duties on presents from Connecticut—merited a mention in her letters. She resisted buying Mardi Gras confetti and calculated that her money would last "till the first of December."

What kept her going was the hope of getting into the Salon, and the prospect of a month with Mabel, who arrived in mid-March. To meet Mabel at the Cherbourg port, Mary spent hours in a cold train, her feet propped up on lukewarm hot-water cans. Mabel came with "a cheque from her mother to spend on theatres and operas and take her friends too, I'm likely to get a surfeit of amusements—enough to last a long time." By the time Mary and Mabel headed out for the entertainments, the Salon jury had told Mary "they do not want one of my pictures—not even one! . . . I would not care much if I had not bought a frame; it is sad to have invested money to no purpose." Foinet the frame-maker "is quite put out—says he never had so many of his clients refused. . . . I suppose it may have been because I had no pull." (In 1899, however, she had taken pride in her success without connections.) Mary unpacked the returns with wounded pride: "My pictures have all come home to roost and they look so nice that I think it is a pity that they did not know

enough to take them." Julia was turned down as well (she made it into the Salon in 1908).

Mary and Mabel "played as hard as we could." On a carriage ride through the Bois de Boulogne, they eavesdropped as drivers described sightings of "a flying machine" that was "built to go by air only on the kite plan." At a performance of Alfred Poizat's *Electra*, Louise Silvain looked "beautifully classic and tragic in her clinging black robes and long thin veil," and the stage setting "actually satisfied my critical taste, with one reservation: they lighted up a very shiny crescent moon in the last act in the same quarter of the heavens in which they'd had a sunrise in the first act." Mary tired of over-perfumed audiences with plumed hats and puffy hair extensions: "no one pretends to have hair enough of her own." In the crowds at Saint-Saëns's *Samson and Delilah*, she and Mabel ran into Chicago tourists who "remarked quite casually, 'By the way, what is this opera we are listening to?' They did not look really enlightened when we told them."

Mabel went home after giving Mary money for a gray chiffon gown: "Isn't she good to me. I dont deserve it and dont think I really ought to have such a dress but if I should teach again I presume it would be useful. At any rate I suppose it is right to take what comes to you and be joyful." Mary put springy new heels on her old shoes and reworked clothes and hats, expecting them to last "at least two years if not three." She further economized by eating lunch at home. But she still turned down a paying job, teaching art to girls in France, under the auspices of the

artist and educator Mary Colman Wheeler's school in Providence, Rhode Island. Mary Wheeler "is such a nice lady that I almost decided" to give up the chance for solo work that summer, Mary wrote home.

Deep down she did not want to accomplish much. She made summer plans to sublet the furnished studio, store her possessions in a closet, and head off to Italy. She would return to Paris in the fall and rent the studio by herself: "with strict economy I can manage it." Without a roommate, she would "feel free to paint whenever I want to, which I cannot do now for I'm that fussy." She resigned herself to not selling anything: "I might as well keep on painting tho it is only 'for myself.' It is no doubt better so for I might get conceited and commercial if I could sell my productions." A friend suggested that she seek out a Paris dealer, since her paintings "ought to be seen and not kept in a corner, but, la! me!— imagine me going and telling one of these Frenchys that I'm worth looking at. Even if I could do it he would not believe me nor take the trouble to find out most likely."

Her subtenants, the American illustrator Arthur Garfield Learned and his writer wife Leila Sprague Learned, were collaborating on books of humorous epigrams. Mary found the young couple "too droll for words." Leila Learned, "the business manager" of the pair, bargained hard over the rent, showed off the couple's works, and then "carried them off to exhibit to the other boarders at the pension where they are staying."[8] Julia, "one of the most unselfish of creatures," did not object to being evicted. She made plans to tour Lon-

don and then join Mary in Italy; for the fall, Julia intended to find her own rue Boissonade place.

Julia bought a pastel that Mary had done in Fiesole with Laura. Mary told her sisters about the transaction, seemingly unaware that Julia had recognized her straits: "I have sold a pastel! Think of it. Julia has bought the one *we* did at Fiesole from the theatre and insists on paying $20. for it though I tried to make her take it for ten. Julia is really an inspiration she expresses her admiration for my works so frankly and urges me to paint more, says it is a pity for me to spend my time sewing etc."

Mary almost sold another pastel, to the family of the railroad executive Willard C. Tyler. His wife Emma was traveling with their daughters, Emma (Smith 1905) and Marian. The younger Emma, who had been studying at the Sorbonne, learned about Mary's pastels through the Girls' Club. The family stopped by the rue Boissonade studio: "Emma is the brightest, drollest girl I've ever met, and she kept us laughing so yesterday that Julia said her face ached." Emma rattled off "accounts of college larks too funny for words" and recounted how she disguised herself during a Rome trip "to look like a young widow to make the journey perfectly safe." Mary sketched Marian in pastel, at first "just for my own amusement. . . . She had a gown that I liked her in and she kindly agreed to pose." Once Mary realized that she was "getting something really charming," she wondered whether she could persuade the Tylers to pay twenty dollars for it. Mary skipped a perfor-

mance by the actress Yvette Guilbert (one of Toulouse-Lautrec's muses) to finish the portrait: "It is work before pleasure now."

When the Tylers came to pick up the artwork, Mary was grateful for her sense of humor: "Mrs Tyler asked 'where is my picture,' admired it, and wanted to carry it off—even asked if the frame went with it—one of my carved ones! Did you ever witness such naive innocence. I could not explain to her before so many that it was not my custom to give away my work. . . . So I told her it was not quite done—which was true, and that I would arrange about it with Emma who was coming later." Mary told Emma "just how I stood for she is a sensible girl. So I told her that I could not afford to give away a thing of so much value, but that as her mother seemed pleased with the portrait I would make a copy of the head only, and send her." In the three-quarter-length portrait (figure 24.4), Marian looks strong, confident, and serene. Mary lightly striped the background, rippled the girl's gown, dotted the collar, and added a hint of a gold bracelet. (The head copy that Mary offered to Emma either was never completed or has been lost.)[9]

Mary sent home more reassurances: "I dont believe anyone is more contented than I am at present." She was not lonely, "on account of the nice letters I get." She emphasized the relief of "not rushing about all day showing girls how to make casts and trying to keep them from getting plaster on everything in sight. . . . I've almost forgotten how it seems to hear a girl say, 'Dont you want to look at my drawing?'"

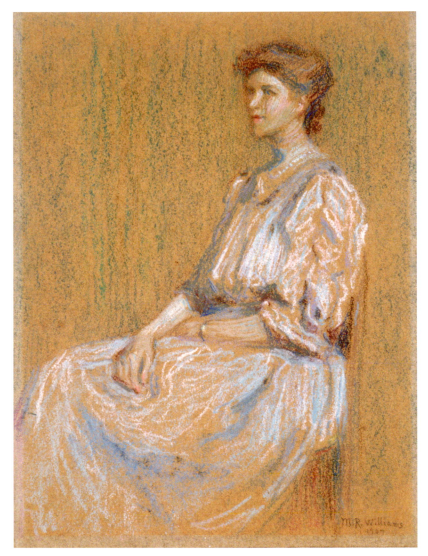

24.4 *Marion Tyler* [*sic, Marian*], 1907 pastel, 12 x 9 in. The sitter's mother mistakenly assumed that impoverished Mary had executed the portrait as a gift. SMITH COLLEGE MUSEUM OF ART, NORTHAMPTON, MASSACHUSETTS, GIFT OF THE SISTERS OF MARY ROGERS WILLIAMS, SC 1911:7–1.

Laura apparently sent reassurances, too. Mary wrote back that Laura's words "gave me a peaceful comfortable feeling. I'm glad you do not let things worry you and hope you never will." In one other melancholy passage from Mary's late correspondence, she described visiting the rat-infested apartment of a half-paralyzed street beggar. Mary listened to the woman's "tale of woe" while her "mongrel, back-alley cur" was torn between biting and nuzzling the visitor: "I thought afterwards how I used to go with father sometimes into the slums and how he would say 'Aren't you thankful that you have a nice home?'" Mary, who had been stepping around Europe's mendicants for years, started longing for a Carnegie fortune, "to build decent places for the poor."

She thanked Henry for sending over "delightful pastel papers, such charming colors I shall save it all for Italy and try to do something worthy on it." Jean Speakman, on a Bontade palazzo postcard, announced her jubilation and "much impatience" for Mary's return to Siena, on behalf of Wolfie, a new cat, and three canaries. Mary hoped to entice Henry over and reminded him how often Bunce painted Venice: "You might perhaps catch a sunset that Gedney had overlooked." Her sisters wanted to join her, but Mary cautioned that Siena was urbanizing rapidly, so their memories of the place with "no factory chimneys, trolley cars or automobiles" were deceptive.

Mary had one last sighting of royals, as Frederick VIII and Queen Louise of Denmark came to Paris to see Grand Prix races:

"The King looked like a real good plain sort o' man and the Queen was homely, but good no doubt; she looked as if she might put away her furs in pepper and do her own preserves." At the Salon that had rejected her, she was drawn to "three canvases, one of them delightfully perfect," by Edmond Aman-Jean, the artist who had dictated the molding arrangements on her 1899 frames. (His work there that most resonated with her was perhaps a portrait of a British expatriate, Ella Carmichael, who posed in a pink gown against a wallpaper backdrop.) Mary found the annual Salon des Humoristes "so depressing that I did not stay long, humor in the bulk is the most serious thing in the world. Our admired [Charles Dana] Gibson had a section all his own, filled with his large neat productions in pen and ink; he is doing the bums of Paris now—they will not be appropriate for sofa pillows." What most interested her at the show was a heavily made-up demimonde woman: "Her eyes were blacked, hair tinted and augmented, lips and ears painted—think of two rosy ears nestling among her curly locks!"

She replied to Henry's gossip about Tryon: "Hasn't our Master been industry itself. I have a sneaking unworthy suspicion that he is getting financial. I cant believe that it can be good for him or his work—this rapid production." Smith by then had acquired nine Tryon paintings: "It will be a one man show pretty soon." (Three of those remain in the collection.)[10]

Elizabeth Czarnomska reported that she had "grown 'enmossed'" at Smith and left to

become the University of Cincinnati's dean of women. She envied Mary's joblessness: "I am busy all the time at things I care nothing for—society & sich. How blest you are to be able to roam at will in the old world & gratify your tastes—satisfying your conscience also with good work." The Czar did not like Mary's successor, Clara Lathrop, whose résumé (see chapter 27) was only slightly less impressive than Mary's: "I imagine Miss Lathrop in your place & see her stirring about & racketing but most inartistic; How does Dwighty stand her!" She asked Mary "what canvases you have finished, and what planned. Someday I want another & a bigger from you though never one that will delight me more than the water at Provincetown. It hangs in my dining-room & I place all my *best* guests opposite it. . . . You know you are the one of all in N. [Northampton] whom I *love*. The others are pleasant friends, but I cannot lose you."

Clara Lathrop died during Smith's June commencement celebrations. Tryon callously wrote to Henry: "Yes Miss Lathrop has passed away, very suddenly of cerebro spinal meningitis and I am examining candidates for the position. Do you know of any very well equipped person for the place. It must be a woman and must reside during college year at Northampton. I would rather live in Hades than in N. but such is fate and some one must be sacrificed."[11]

Mary's letters home mention her successor's death several times. She seemed to be almost making light of it—perhaps it unnerved her: "I suppose the abscess attacked the brain at once. If she'd had all my work to do I should think that killed her, but she had only practical work I believe."

In Paris, there was one more gorgeous mundane sight to describe to her sisters: a produce truck layered with "first the big new white turnips, then carrots with big cauliflowers spread among them, then a layer of new white onions, and a mass of red radishes to crown the arrangement." There was one last landscape on her easel: "It is one I began in Northampton but never really got into. It is something I thought I saw at Aunt Willie's and has Clark's Hill in it with a blue on the hill that I dont see how I ever got I'm really almost pleased with it." And there was one final omen. An eyeglass lens cracked: "Ain't I afflicted! La! La!"

Wild to Go Out on a Comet Hunt

Mary did not have a bad day until she was days from death.

She took a thirty-hour train from Paris to Siena with the Northampton teacher Bessie Faunce Gill (Smith 1887, Louise Capen's cousin), subsisting on "crackers and chocolate." Gill stayed a few weeks; she paid for car rides, while Mary served as tour guide for various groups. Mary hiked around when left alone: "I'm going to try to catch a sketch at Fiesole."[1]

When she settled back at the Siena palazzo, the distractions of Jean Speakman's pets left Mary "rejoicing ever since I came that I decided to stay in my studio this winter and not come down here. . . . I'm enough of an old maid to want my own establishment." Her loftiest summer goal was "to copy the beautiful altar picture" depicting the Annunciation, at Siena's San Pietro a Ovile chapel: "Am I not presumptuous to attempt such an exqui-

site thing?" She persuaded the priests to open thick window curtains so that sunlight glinted on Matteo di Giovanni's fifteenth-century gold-ground painting of the kneeling Angel Gabriel informing the Virgin about her pregnancy. She acquired a photo of the altarpiece and, for a panel to gild, used an old book cover supplied by the war hero turned archivist Niccolò Scatoli. She planned to finish her version in Paris, "where I can be perfectly quiet and uninterrupted. I go to see the picture nearly every day and am learning it by heart. . . . I dont feel that I could do much working in the church, the odor of sanctity is not of a brand that suits me." (It is unclear why, after years of abhorring copyists in museums, she chose that altarpiece to copy, and how she planned to miniaturize its array of saints to fit on a book cover.)[2]

She bought lace from the nuns who had taught Lucy and stationery in various sizes,

"as I dont always feel chatty for everyone." She planned to resell some spoons and lamps "and begin my career as an antiquario." Her sisters wanted her to give five dollars on their behalf to the impoverished family of the violinist and composer Rinaldo Franci, who had died suddenly at fifty-seven. Mary had loved his performances, but she had "just enough for daily necessities" and could not front the money: "It is up to Siena to take care of Signora Franci." Trams had come to Siena—"It is useless to kick against the pricks of progress"—but Mary walked to save on fares: "I often take Wolfie out when I go, aint I good! He is apt to leave me and return home by himself which is rather rude [but] does not trouble me at all."

Mary was appalled, one more time, at provincial Americans: "It is a pity that Italy should be wasted on such." There was one "particularly silly person," a Miss Hoppock, who mangled Italian and developed crushes on men. Mary chaperoned the Italian men who were evading Hoppock's unrequited attention: "I felt like a queen with a bodyguard of young princes for they are handsome all of them. They evidently look upon me as a safe refuge."

A mother and son named Jones were staying with the Bontades, and Mary sneaked out with the young man to see a comet. She woke at 3 a.m. "and found the sky so clear and the stars so bright that I was wild to go out on a comet hunt but did not dare to venture out alone." She did not want to wake young Jones: "I went back to bed but could not sleep for thinking of that comet." She then heard his footfalls "and went into the Garden and called up to know if he would go out with me." But there was confusion at the gate: "I turned my key twice as the nightlatch is double-locked but I found that there was still another lock higher up that my key would not unlock! So there we were I inside unable to get out and he outside shut out of his house." Jean Speakman, who had the right keys, woke up when Wolfie, "bless him, began to bark." Jones observed to Mary, "It would be useless to try to elope from such a house." As the comet streaked, she marveled at "a gorgeous sweep of the sky." A street sweeper passed by: "We asked him if he'd seen the comet and I judge by his grunt he thought it was something we'd dropped in the street."

There were minor irritations in Siena of mosquitoes, soldier musicians playing "discords and crashings," and socialists "said to have destructive designs on the churches." But Mary reveled in having friends there who remembered Laura's singing and did not care that Mary had no new summer clothes: "Apparently they like me just as much, though my sleeves are not made over." She was grateful for her blessings: "What have I done that I should be allowed to be so calm and peaceful." She spent hot afternoons lounging around in her kimono: "I'm a sort of a salamander anyway, you know." On cooler days, "I feel on the tips of my toes all the time." She visited the nuns, and when an archbishop stopped by, she did not join in the sisters' practice of kneeling and kissing his ring: "He hurried on in a sort of smiling apologetic way as though the function were not entirely to

his taste. Maybe like the English bishop he considers it a nasty slobbering habit though I'm sure he'd be too polite and gracious ever to say so."

She heard of Lucy's "countless deeds of mercy," teaching Sunday school and "making innumerable little articles for an Infants Hospital." For Mary's own summer charitable act, she sewed a hat and a pomegranate-colored dress for a doll belonging to "the little cripple who comes to Mrs Speakman's garden."

Lucy reported on a last visit to Northampton. (Mary's possessions at Smith had been packed up in her absence.) Mary was annoyed to learn that her portrait of a nun was somehow on display there: "How did she happen to be on show? If I found it worth while to fuss about such small matters I'd be put out." Lucy had felt sorry for Churchill, but Isabelle Williams told Mary that "he is so satisfied with himself that much of the atmosphere of criticism is lost on him."

Upon learning that Hassam's favorite church in Old Lyme, the subject of his painting at Smith, had burned down, Mary wrote to Henry: "What a calamity! What will C. Hassam do for a motif now! He'll have to confine himself to laurel and ladies. Maybe it will boom his business, however, and make a demand for the church as it was." Edward Bell had been appointed to run the Hartford art school, replacing Walter Griffin, although Mary had been suggested as the successor: "I certainly would have declined with many thanks had they really been rash enough to consider me." The *Courant* ran a feature by

Lillian Griffin, describing Old Lyme as "the most talked about art colony in America." It was at risk, she wrote, of being overrun by students all hoping to paint the same patient cows. The article paid tribute to Florence Griswold, the diplomatic operator of a "holy house" for those "blessed or cursed" with artistic temperaments and "the eccentricities of genius."[3] Mary told Henry that the article opened her eyes: "What would these poor artist men do without Miss Florence! You have never made me see her with such a large, bright halo. She and Lucy are really benefactors of the race."

She encouraged him to visit her in Italy. And she told him, one last time, how much she loved his Waterford home: "I like to sit with you all on your piazza and smell the salt breezes and take a dip—a long one—in that nice water and go hunting mushrooms in the woods—what good times I have had with you!"

She watched Palio races marred by rain and then prepared to head to Florence and points south: "I have an order from Miss Eager for a Venice pastel." On September 1, she wrote home that a sore throat had delayed her departure by a day or so: "Siena is they say full of sore throats and they had so many that they gave me one, to show me I suppose that I'm almost Sienese." Saltwater gargles and strong tea quelled the symptoms. She finished packing, only to "wonder why I have so many things—it is foolish!" On September 5, she settled into the Lucchesi, amid staff asking after her sisters: "Here I be, having a very peaceful quiet time. . . . The mosquitoes in my room make it seem homelike." She was

enjoying herself: "I'm going out towards Fiesole this afternoon to try to find a sketch; it is a gorgeous day and will be fine to be out. I had my hair washed this morning and did the Uffizi a bit; with my free ingresso I can go in when I please."

Those may have been the last words from her pen. Two days later, Julia Dwight found Mary incapacitated in bed.

Henry's last letter, which she likely never read, told of his summer rounds of teaching, fishing, sailing, and sketching. He was planning to spend the fall in Waterford: "I hope I may do one or two things worthy of the place and the season." He and Grace had seen the annual exhibition in Lyme: "The show was about as bad as usual, which is saying a good deal; the proceeds and profits this year are to go to the fund for rebuilding the church; and as they already have about fifty-thousand dollars for it, you will see that Mr Hassam can probably get busy again before long; and continue to immortalize the new structure." He could not join Mary in Italy, because of "family, business and other cares." He was pleased that she was seeing Old Masters, "painting on gold, and doing the interesting things you always do." He wondered if she might "run across Gedney in Venice; do you suppose you can get it by heart as he has done?" He wished he could tell her an anecdote in person about a pompous guest who had stopped by: "How unsatisfactory letterwriting is! and how impossible to inject life into all the trivial, foolish, but funny things that happen!" One of the few things that had marred his pleasant summer, he told his kindred spirit, was "the absence of visits from you."

How Hard It Is for My Sisters

Julia Dwight sent the Williams sisters a fourteen-page account of Mary's last days. It was reread so often that the paper has softened and torn.

Julia had arrived to find Mary "looking quite wretched with what she called a bilious attack." Mary, two days before, had sketched at the Fiesole outskirts and then tried to walk back to the hotel, but ended up taking a car—a luxury she would never have allowed herself if she could have stayed on her feet.

Dr. Adolfo Paggi, a well-known English-speaking physician, "examined her, & looked grave when he felt her abdomen." He found two large tumors: "She had noticed them eight years ago," Julia wrote, "but had never thought anything about them as they had given her no trouble."[1]

Mary was given futile enemas and managed a joke: "What I gets I keeps." When offered a larger room at the Lucchesi, she objected for aesthetic reasons: "She did not want to go on account of the wall-paper, saying that in her room [it] was so reposeful." Throughout her final days, "although she did not talk a great deal, she was her own bright self." Mary brought out some lace that she had bought for Mabel, "to distract our minds." Mary told Julia, "I am not thinking about myself—I am only thinking how hard it is for my sisters."

There was hope for an operation, and then none, and ghastly outpourings of bodily fluids. Julia sent telegrams to Hartford, with ever worsening news. The sisters bought ocean liner tickets (but too late to arrive while Mary was alive). Julia, feigning optimism, told Mary that she would recover best in Hartford rather than Paris: "I said how much I should miss her but that I felt that studio would be no place for her now & that she really ought to go home, & she said, 'Yes, I think I shall have to be very quiet.' She was

so sweet to me, saying that she should hate to leave me there."

An ambulance "pushed by men & running very smoothly & comfortably" transferred Mary to the new English Hospital, in the sixteenth-century Villa Natalia on via Bolognese. (It had been renovated in the nineteenth century for Queen Natalie of Serbia, a Florence native.) Julia followed her friend in transit: "She waved her hand to us. She was taken upstairs & when she saw the lovely light airy room she said 'In cielo' . . . 'my ideal' she said—& she spoke too of how beautifully & skillfully the men moved her. She liked her bed & said 'It was a good thing to come.'"

The hospital was staffed by nuns. The superintendent, the British nurse Amy Turton, was a protégée of Florence Nightingale (a Florence native) and the first woman to run an Italian hospital.[2] Julia slept there. Mary asked for her often: "When I went in she said 'This is pure selfishness.' I rubbed her head & she soon went off to sleep—& whenever she roused in the night the nurse called me & I soothed her off to sleep again."

When a new young nurse was sent in, "Mary liked her at once. She said to her 'I like you. You are sympatica' & with her weak hand she drew up the sister's hand to her lips & kissed it, saying 'I love you already.'" The next morning, "when the doctor came he bade me cable 'Worse, hopeless.' . . . From that time she failed very fast. The doctor asked her if she had any wishes to express, & she said she had made no will but had written you a letter." (It is not clear which letter Mary meant.)

Mary, the long-lapsed Protestant, turned

26.1 Mary's sisters were sent photos of her grave, which they probably never visited. WFC.

down an offer of prayer with a clergyman: "Not this evening." Julia recited the Lord's Prayer and a prayer for the sick, "& she said Amen to both. I told her that she was very ill & that I was afraid she was going to leave us. I said 'You will be waiting for us' & she made a sound of assent." Mary fell unconscious,

& she just lay quietly breathing her life away until the End, about quarter past one. There was absolutely no sign of pain or struggle,—the most beautiful peaceful Ending. She was laid in her

coffin the next afternoon. We put her pretty gray dress on her, and the guimpe she made out of Miss Lucy's lace, and she looked most sweet, with flowers all around her. Signora Lucchesi sent a very beautiful large wreath, and we (Sister Annette & the sisters who had been with her & I) followed her down in a little procession to the gate. Everything was done as sweetly & reverently & beautifully as possible. I cannot tell you how kind everyone has been—the doctor & the sisters & the people here at the pension, who loved her so much & who did everything they possibly could for her.

The funeral was held a week or so later, once Lucy and Laura arrived. The death certificate listed Mary's parents as Eduardo and Maria Anna, as if she were Italian.[3] She was buried in the Allori ("laurels") cemetery, which was set up in the 1870s for Protestants but soon afterward opened to other faiths. When she was interred, already in permanent residence were the German writers Ludmilla Assing and Gisela von Arnim Grimm, the British Italian collector Frederick Stibbert, Robert Browning's sister Sarianna, the American art critic Albert Jenkins Jones, the Irish painter Richard Whately West, and the American artists Francis Alexander and Elizabeth Boott Duveneck. Joining them relatively soon would be the American artists Thomas Ball, Larkin Goldsmith Mead, Henry Roderick Newman, and Howard Pyle; the British pre-Raphaelite painter John Roddam Spencer Stanhope; Robert and Elizabeth Browning's son Pen (Mary had glimpsed "the Browning" in 1894); the British writer Violet Paget; and the collectors Charles Loeser, Egisto Fabbri, and Herbert Horne.[4]

All around are cypresses that Mary would have wanted to sketch.

Exquisite and Unerring Artistic Taste

A few months after Mary's death, she briefly became more famous than she had ever been. In 1908 and 1909, major retrospectives were held, earning rave reviews. But by the 1920s, she had fallen into such obscurity that even Laura gave up hope that the paintings mattered. The Whites were the last holdouts in believing in Mary's work.

The first newspaper obituaries gave some erroneous reports that she had traveled in Vienna and died in Paris.[1] Tryon asked Henry to convey his condolences to Mary's sisters and described himself as "shocked" to hear of her death. His next remark is puzzling: "No doubt this trouble had been developing for a long time and may have been the cause of her mental condition which has been noticeable for so long."[2]

What he meant by "mental condition" is unclear—her letters in her last years show no decline in her intellectual clarity. He would

not have known about her physical ailments and bouts of unhappiness during that last Paris year. While still at Smith, perhaps, she had stopped hiding her distaste for her boss. And maybe he finally noticed.

Lucy and Laura made lists of Mary's friends and acquaintances to notify about her death, using stationery from the RMS *Oceanic*, the ship that brought them back to the United States in November 1907. Along with names that recur in her correspondence are intriguing women she scarcely mentioned, including the artist Susan Ketcham and the editor Emma Demarest. A long obituary appeared in Smith's monthly, by the English professor Mary Augusta Jordan, who had owned at least one of Mary's artworks over the years. It praised Mary's "insistent and curious" nature and noted that in class, her "outward expression" remained steady until a student would "really express something in line or

Laura C. Williams

PICTURES
In OIL and PASTEL

BY THE LATE

MARY R. WILLIAMS

February Fourteenth to Twenty-
Ninth, Nineteen Hundred
and Eight.

HARTFORD ART SOCIETY,
22 Prospect Street.

1. Connecticut Hills, $300.00	15. (b) Trondhjem-Evening, 30.00
2. Figure in White, *Loaned by Miss Mabel T. Eager*	16. Hills-Siena, *Loaned by Miss Mabel T. Eager*
3. Evening-Siena, 50.00	17. Portrait-Miss M., 50.00
4. Portrait, 25.00	18. Gray Day, 35.00
5. Fiesole, 50.00	19. Venice-Morning, 50.00
6. Girl in Blue, 75.00	20. Hills-Northampton, 500.00
6. (a) Bruges, 20.00	21. Child with Doll, 15.00
6. (b) Twilight, *Loaned by Mr. Henry G. White*	22. May, 25.00
7. Spring, *Loaned by Miss B. T. Capen*	23. Florence, 50.00
8. Portrait, 25.00	24. Switzerland, 35.00
9. Cypresses-Siena, *Loaned by Miss Mabel T. Eager*	25. Figure in Gray, 75.00
10. Girl in Black, 50.00	26. Monhegan, 15.00
11. Study, *Loaned by Mr. F. A. King*	27. Interior-Siena, 50.00
12. Naples Harbor, 50.00	28. Figure in Pink, 50.00
13. Portrait, 100.00	29. Portrait-Head, 15.00
14. Evening. (Not for sale)	30. Early Spring, *Loaned by Miss Mabel T. Eager*
15. Figure in Black, 50.00	31. The Arno, 50.00
15. (a) Trondhjem-Norway, 30.00	32. Study, 50.00

27.1a and 27.1b Laura's copy of the checklist for Mary's posthumous retrospective. WFC.

27.2 Henry kept notes for years on sales of Mary's pastels and paintings. WFC.

color." (Was that a hint that Mary tended to look emotionless in class—was it obvious that teaching bored her?) Most of the obituary analyzes the artwork, which "had always a touch of the austere, sometimes of the formidable. . . . The charm of the homely, the revelation of the familiar was her natural and chosen theme." The tribute mentions Mary's skill at capturing Massachusetts apple blossoms, French poplars, Venetian palaces and bridges, "purple cabbages set out along a Dutch canal," as well as "bits of walled masonry and glimpses of curiously tinted sky along desert horizons." Mary Jordan observed that the oeuvre had kept "growing in variety of theme, breadth of interpretation and control of medium."[3]

The following article in the same issue is Mary Jordan's obituary for Clara Lathrop, praising her "seemingly inexhaustible supplies" of enthusiasm for teaching, as well as "her administration and organizing talent." It also notes that Clara's "Salon picture hung among the possessions of the Hillyer Art Gallery." Clara had exhibited a painting of primroses and tulips (whereabouts unknown) at the 1891 Paris Salon and a portrait of a French flower girl at the 1893 world's fair in Chicago (Smith owns that canvas). Clara also exhibited at the Art Institute of Chicago, the Pennsylvania Academy of the Fine Arts, Gill's gallery in Springfield, the National Academy of Design, the New York Woman's Art Club, and the New York Water Color Club. Like

Mary, Clara was survived by two unmarried sisters, Bessie (a woodcarver) and Susanne (a magazine and book illustrator)—Susanne had been Mary's substitute during the Paris sabbatical. The three Lathrops traveled in Europe, and they created a salon in downtown Northampton where they displayed their art and hosted lectures by speakers as prominent as Bernard Berenson. The Lathrops also taught at schools including Northampton's Clarke school for the deaf. They are almost utterly forgotten—they had no equivalent of Henry White to preserve their legacy.[4]

Henry, who had helped settle estates in his youth at his father's probate court, inventoried Mary's possessions in a tiny notebook. He listed about 150 artworks, valued between $10 for a small watercolor to $500 for *Evening*; a few other oils (perhaps a dozen remained) were deemed worth more than $100 each. Some major exhibited works, including *A Profile* and *Job's Pond*, do not seem to appear in the inventory and may have remained with Laura. The notebook also lists Mary's accumulated photos of friends, favorite cities, and, for unknown reasons, a Northampton postman.

Her friends bought some of her worldly goods. Gumaer acquired her Japanese prints; at twenty-five cents each, they must indeed have been reproductions, as Mary suspected. Mabel splurged for about $500 worth of oils and pastels, including a portrait of Françoise Montagny and scenes of Massachusetts, Siena cypresses, the Arno, and a Gruyères gateway. Mabel nostalgically even wanted what Henry listed as "two old dresses for model 25¢ each."

Henry and Grace took home, among other things, Mary's art supplies, the Ottoman velvet that was a gift from George Dudley Seymour, Elbridge Kingsley's engravings of Tryon and Daubigny works, and a sketch by Benjamin Rutherford Fitz (1855–1891), an Art Students League teacher. The Whites also purchased Mary's scenes of Siena, Arezzo, Norway, and Monhegan. It is not clear how long Henry kept recording sales; Lindley Williams Hubbell, who was six years old when Mary died, is named as the buyer of her now-lost *Isle of Jersey*.[5]

Henry sent Mary's works to solo and group exhibitions in Hartford, New York, Philadelphia, and Northampton, tracking the estate's expenses for invitations, brochures, newspaper ads, and frames. In February 1908, the Hartford Art Society showed thirty-six of Mary's works, including views of Connecticut, Northampton, Monhegan, Bruges, Naples, Siena, Fiesole, Florence, Venice, and Switzerland. *Evening* was listed as "not for sale"; Smith friends soon raised $500 to acquire it for the museum. About six hundred people filed through the Art Society show. Lucy and Laura took notes about the visitors, scribbling on flyers printed for a previous society show, devoted to Edward Bell. They recorded the arrivals of Smith and Hartford friends, the servant Mary Colbert, little Lindley, a reporter, "3 strangers," "5 students," and "lady & dog." (Mary would have enjoyed seeing scrap paper made from lists of works by an artist she disliked.)

Henry wrote about the 1908 show for the *Hartford Times*, noting that Mary's work "has not been often seen in Hartford publicly."

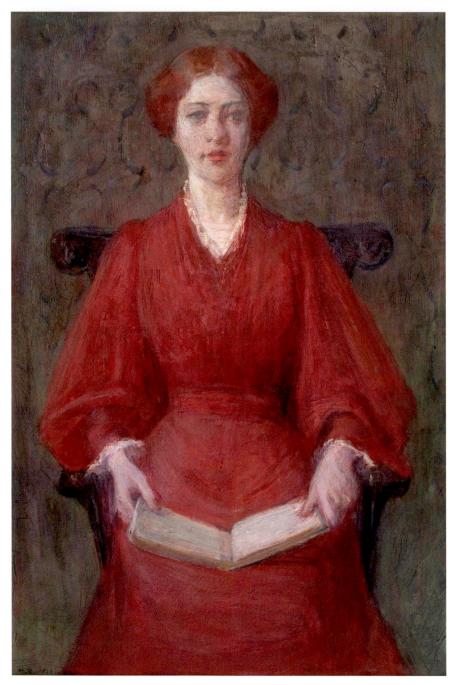

27.3 *A Girl in Red*, undated
(pre-1901) oil on panel,
21 x 14 in. A work of that
title was shown in Mary's
posthumous exhibitions.
WFC (PHOTO: TED
HENDRICKSON).

He praised her "equal facility and success" with portraits and landscapes and her art's "response to the most delicate and subtle phases of nature, and its charming feeling for exquisite and harmonious color." He noted that she spent her last days sketching in Italy. He may have been slyly referring to his and Mary's distaste for hacks by describing her Venice scenes as "entirely personal and original, and not at all reminiscent of other pictures of Venice." *Evening* was headed for one of New England's "finest public galleries," he wrote (the Smith deal was not yet official). He hoped that Hartford buyers would acquire "a representative collection of her exquisite art." He regretted that his article amounted to "an entirely inadequate expression" of his esteem for her "wonderful refinement and exquisite and unerring artistic taste"; he described their friendship as "one of the highest privileges of my life."

The *Springfield Republican* quoted Henry at length and added a quote from Champney about her skill with pastel: "She can teach us all." The *Republican* also reported, "She had an almost pathetic tendency to think less of her work than it deserved." The *Courant* largely paraphrased Henry but added praise for Mary's capturing of the "somewhat unusual country" at Penfield Hill. About twenty of her paintings had sold in the month before the Art Society show opened, the *Courant* reported, and works were headed to collections "in New York, Boston and other cities." Henry, the *Republican*, and the *Courant* all mistakenly gave Mary's title at Smith as "assistant instructor."

The philosopher (and future controversial World War I–era pacifist) Gerald Stanley Lee, in his magazine *Mount Tom*, published a three-page ode to Mary's pastel portrait that "can never be finished—now. . . . The hand that did the little portrait will always be still now." He hung it over his piano: "It makes one play softly." He described it as capturing "the shadow of a woman's soul veiled and vaguely lighted shining through the shadow of a woman's body. . . . They say a pastel is but a pastel, and they say dust to dust and ashes to ashes, but the spirit that has caught a little of the dust up into itself that has caught up color and music out of the world, out of the very chalk in the cliffs . . . still lives."

In June, the Capen and Gill family showed Mary's paintings at their girls' school near Smith. The *Greenfield Gazette and Courier* reported that "all are invited, especially Miss Williams' former students." In the fall, the New York Water Color Club put about ten of Mary's works on display—portraits and views of Connecticut, Monhegan, and Siena—alongside a memorial laurel wreath. The Philadelphia Water Color Club brought out a memorial cluster of eight works, including portraits and views of Siena, Arezzo, the Arno, and the Chateau d'Amboise.

In February 1909, the Hartford Art Society gave Mary a one-person show for three weeks, with about fifty works. Handwritten lists survive, but a checklist does not seem to have been printed—Henry by then may have been trying to economize. The exhibition covered Mary's haunts from Penfield Hill to Trondheim and Naples. Lucy by then

had promised some of Mary's works to the Art Society—the group was amassing a "well chosen collection of pictures by our local artists" (which no longer exists). Seymour gave Mary's Naples harbor pastel and oil portraits of a Smith girl in pink and a "New England Gentlewoman" (his mother) to the Wadsworth Atheneum. (They apparently were never officially added to the collection, and he eventually took them back.) In May 1909, the Atheneum showed them alongside some Tryon paintings. The *Courant* described Seymour as "always appreciative of her genius." The reporter compared the image of Seymour's mother to Terburg's work, probably paraphrasing Henry, and added that the simple small picture "demonstrates forcibly how few are the materials from which the artist may create beauty."

After that, for a century, hardly anyone remembered that Mary Rogers Williams had ever picked up a paintbrush or pastel stick.

Logical Custodians in Chaotic Days

As Mary's name vanished from the art histor-ical record, hardly anyone visited her grave.

The sisters likely never saw Gumaer's marker for Mary; they did receive a package of photos. The sisters sent money to Jean Speakman to pay for the cross, sculpted in Carrara marble by Giovanni Bocchino. After meeting Mabel and Julia at the cemetery, Speakman wrote to reassure Lucy and Laura that the design had been "carried out with exactitude, and the marble is of the highest quality." Bocchino added an extra layer to the base: "otherwise,—owing to the light mixture of the soil at the Allori, the monument would have sunk down after a few years." Speak-man added, "I hope you have not to leave your house? I have taken a villa—*and* move in September. It is higher than Siena, and is charming." Speakman would live out her days as Mary would have liked, as a permanent ex-patriate; among her addresses over the years

was "La Casa Graham Hamilton" in Alassio, on the Italian Riviera.[1]

Lucy and Laura did have to leave their house. To make room for an addition to the high school, the city demolished 1492 and 1500 Broad Street. In 1911, the sisters moved to a new gambrel-roofed house at 181 Girard Avenue, near the Whites' and Hubbells' new homes (and what is now the Connecticut His-torical Society). The architect was the colonial revival specialist Aymar Embury. Henry likely helped pay for it. He and Nelson supported the sisters thereafter. They sent a stream of checks, arranged for house repairs, helped with paperwork, and eventually inherited the Williamses' real estate and paintings.

Lucy joined, of all things, the Connecticut Pomological Society—perhaps she wanted to teach Arthur Tilton and other neighborhood children more about fruit cultivation. She attracted little notice at the club; her death,

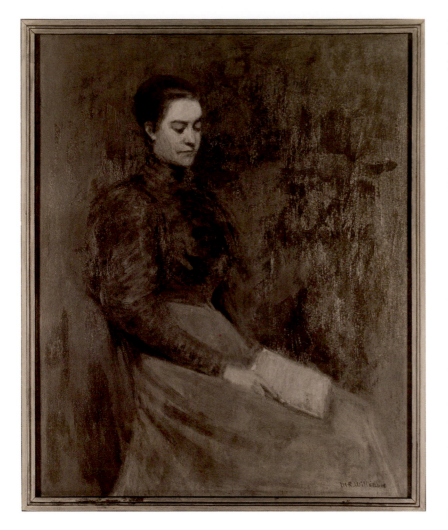

28.1 *Portrait of Laura C. Williams,* undated oil on panel, 17½ x 14 in. A black and white photo survives of this work, location unknown. WFC.

Decades later, Henry reminisced to Laura that when he observed Lucy caring for "other people's children I always imagined how her own would have affected her."[2]

By the late 1920s, Seymour asked the Atheneum to return Mary's paintings, which were "not valued as works of art" and in storage: "It seems a pity to me to have them hidden away."[3] The only institutions that hung on to her works were the Connecticut Historical Society (which sometimes displayed her bust portrait of Seymour) and Smith College. The college museum showed *Evening* in an upstairs corridor for a while, along with some of Lucy and Laura's gifts of a half-dozen pastels, including Italian scenes and the portrait of Marian Tyler. A few graduates remembered Mary as "an inspiring instructor," and even fewer mentioned training with her in their résumés.[4] At Tenney House, the dorm named after Mary's landlady, the 1895 portrait of Mary Smith Tenney was installed over a fireplace. A 1910 article in Smith's quarterly praised Tenney House's harmonious atmosphere and the painting of its "simple, quiet and dignified" benefactress.[5]

Laura drafted and redrafted her will, bequeathing small sums to some cousins (but she outlived them all). She wrote an official memorandum entrusting Mary's paintings to Nelson: "I am very happy and satisfied to be able to leave the pictures to your care and oversight . . . either to keep for yourself, to sell, to give away, to destroy, or to place anywhere you think best. . . . Of course family likenesses or any pictures of only personal interest you would presumably give away to

in 1912 (due to "acute dilation" of the stomach and heart), was misreported in a society report as having occurred in 1911. She bequeathed money to Arthur Tilton and his brother Herbert (who died after a freak baseball accident in 1915, at sixteen), and three of Mary's paintings to the Art Society. Laura's correspondence barely mentions Lucy again.

friends, or destroy. . . . I leave the whole matter entirely in your hands, and agree to make absolutely no criticism!—but to feel only gratitude."[6] The "family likenesses" included at least two portraits of Laura. She wore a red dress for Mary's oil bust (extant), and for a three-quarter-length oil (whereabouts unknown) she posed in an armless chair, gazing at a downturned book in her lap, against a swirled and striated backdrop.

Laura sent a dozen artworks to the Tiltons, including Mary's only published work, *A Friendly Sitting*, from Elizabeth Champney's 1894 article. Laura told the Whites that the Tiltons would "give them up willingly" if anyone asked. That is, even while granting Nelson permission to destroy whatever he saw fit, she tried to share the Whites' optimism that anyone else would want to find Mary's paintings.[7] Laura gave three works to the Art Society, as Lucy wanted. School leaders including Anne Bunce Cheney (Gedney's niece, who had studied with Mary) thanked Laura and noted that the pictures "will soon be hung in one of the rooms of the school." It is not clear whether the society ever showed the now-lost works.[8]

Laura supplemented the Whites' checks with some stock dividends. To cover expenses "appearing suddenly and unexpectedly," she told Henry, she could always sell a small Tryon painting that Mary had bought at some point from Montross for $350 (its title may have been *Evening* or *Moonlight*). Henry persuaded her instead to leave it over her piano, "undisturbed and quite forgotten." Smith friends, as well as Mabel, Gumaer, and Frederick King, contacted Laura from time to time, and Lindley Hubbell kept his adopted aunt company as his career as a librarian and writer took off. He brought newfangled record albums, a phonograph, and a radio to her home. In 1922 he published a pamphlet titled *Humoresque*, described as an "amusing skit on the vagaries of some Theosophists," from 181 Girard—yet another intellectual pursuit that his rugged father Lin probably did not appreciate.[9]

By 1914, Henry and Grace had settled year-round on their Waterford peninsula—they built a palatial stone and shingled house, designed by the Philadelphia architect Wilson Eyre, who had also worked for Freer. *American Art News* lamented Hartford's loss of Henry's "interesting private collection of modern American oils and pastels," including works by Tryon, Hassam, Bunce, and Whistler, plus "impressionistic portraits by the late Mary Williams."[10] The Whites stashed boxfuls of Williams family papers in the Eyre house's sunny front office, known as the Archive Room.

Around 1916, as Grace's health was failing, an Italian American teenager named Aida Rovetti came to work for the Whites as a maid. She was the oldest of five children of a local quarry laborer and stone carver. Henry was immediately "impressed by her intelligence, her modesty and her manner," as well as her beauty and "exceptional executive ability." She became Grace's indispensable nursemaid and companion. After Grace's death in 1921, Henry never remarried. Aida (known in the family as Ida) took over as "manager of our

domestic affairs" for Henry. She was three years older than Nelson, and they fell in love. Their marriage produced three sons—Henry, George, and Nelson, nicknamed Beeb—and lasted six decades. In 1928, Nelson reassured Laura that his new bride "shares with me the appreciation and love of Miss Mary's painting and now joins me in repeated gratitude for all your generosity in letting Father and me have so many beautiful things."

John White (1890–1946), an insurance executive, never forgave his younger brother Nelson for marrying a "foreigner" and largely cut off contact with Henry and Nelson. Henry's mother Jennie followed suit, reverting to her native "narrow New England conservatism and prejudice," Henry wrote in his memoir. Nelson, Aida, and Henry became inseparable. For the couple's honeymoon, they all traveled together in Europe. They went to Mary's haunts, including the Louvre, Barbizon, Puvis murals, and the Lucchesi hotel.[11]

Aida and Nelson raised their sons while taking care of Henry. He and Nelson painted, sailed, fished, and wrote side by side. Nelson and Aida's sons and their families eventually took up residence nearby. On the seashore meadows that Henry and Mary loved to paint, a string of shingled homes is now designated in the National Register of Historic Places as the Hartford Colony Historic District. Laura visited the Whites with her longtime housemates: Edith Bean, a schoolteacher, and Marjorie Bell, an insurance company secretary. Henry jokingly flirted with the trio, offering to marry one of them. He referred to

Laura's teacher friend as "your husband, Mr. Edith B. Williams," and to Marjorie as "that fine buxom young lass your daughter." (Edith and Marjorie stayed together after Laura's death.)

In Henry's 1930 biography of Tryon, he praised Mary as one of Tryon's few successful female disciples. In an essay about visiting Ryder's apartment and trying to buy a painting, he credited Mary for making the original introduction to Ryder. Nelson wrote monographs about the artists Abbott Thayer and J. Frank Currier (1843–1909). Both of them, like Mary, were impractical with money and traveled widely in Europe. Unlike Mary, they both had debilitating mental health problems. Nelson chronicled Thayer's "almost insane condition alternating between high spirits and despondency" and Currier's cycles of mood swings "from exaltation to depression" that ended in suicide.[12]

It seems that Nelson was planning to write a book about Mary, too. His handwritten introductory essay survives, reminiscing about Mary creating a plaster mold of his toddler hand and transcribing her accounts of the 1891 visit to Whistler. Someone, probably Nelson, organized Mary's letters chronologically and numbered the envelopes. Summaries of the letter contents are scribbled on a few envelopes, and squiggles are penciled in the margins alongside her cleverer remarks and descriptions of exhibitions and techniques.

In 1940, Nelson told Laura that he had been "reading Miss Mary's letters and find them of absorbing interest. . . . It all gives

me a great longing for Europe especially Italy and makes me wish I could have been there in those days with you." He asked for details of Mary's résumé and family tree. Laura sent drafts with apologies: "I am poor at statistics." He asked about her parents and guardians and the two siblings who had died young: "I cannot feel that this sort of curiosity is impertinent as it springs from a genuine interest. . . . I should like to know a little more about Miss Mary's life before we, as a family, knew her." As Europe was engulfed in yet another war, Laura unearthed Mary's Norway letters from 1896, and she mused that the descriptions of villages and landscapes "will be like a fairy tale soon."

The Whites kept in touch with Seymour, too. Henry told him that Mary's portrait of Electa was "a beautiful thing, as fine as a Memling." Henry was delighted that Seymour had taken it back along with Mary's other works from the Atheneum, "for they are not understood or appreciated by the present management of that institution and would always remain in storage, together with other neglected works of merit." Henry compared Mary to "those New England women of artistic temperament of whom Emily Dickinson, the poet, was an example" and told Seymour that "your interest in her art was a great inspiration." He described the Williams sisters as "remarkable women who belonged so distinctly to another age, to what I consider a better and happier period in our history. . . . How fortunate we both were to have known them." Seymour remembered his own frequent youthful visits to the Hartford house

of "those four wonderful sisters." Henry felt a duty to steward Mary's paintings, in an art world that had changed beyond his and Seymour's comprehension: "We are, after all, the logical custodians, in these chaotic days, when there is so little love and knowledge of art left. We can at least protect these things for a time and see that the right people enjoy them and the right institutions have the loan of them." (Alas, "the right institutions" did not much notice Mary's work until 2014.) It was a pity, Seymour told Henry, "that Mary did not write the story of her life with recollections of Whistler, Ryder, and Tryon." [13]

Henry grew embittered about contemporary art, describing it as "probably the strangest conglomeration of incompetence, vulgarity and insanity the world has ever seen." He found Picasso's work particularly heinous, representing "the decay and dissolution of French art." [14] In a 1943 letter to Laura, he wondered if death would simply bring "total annihilation, after this brief sojourn on a curious third rate planet, in a second rate solar system." But if heaven did exist and was populated with loved ones, he wrote, "I hope your sister Mary will be among the first to welcome me . . . for, in a barbarous society, she was one of the most civilized people I ever had the good luck to meet." Laura told Henry that she was reading *Sky and Telescope* magazine, awed by discoveries about shooting stars and planets—a faint echo of Mary's determination to escape a locked palazzo and see comets. Laura spent her days gardening, too, "bent over her flowers or busily destroying the beetles." [15]

Laura died of heart failure at the end of 1943. Henry's *Courant* obituary eulogized all the sisters as "highly intellectual and exceptionally talented" as well as boundlessly hospitable to children. The four women's worldliness within their geographic and educational limitations suggested "the same genius that characterized Emily Dickinson in her outwardly secluded life at Amherst." Laura was "no less distinguished" than her sisters, although "the most quiet and retiring of them all. . . . She was the complete mistress of circumstances; and when the world was too much with her, she turned serenely to the stars and the study of astronomy or read the Old Testament for diversion. She had a wit that was as gentle and kindly as it was penetrating and brilliant, a philosophy as broad as it was profound." He wrote one more time about the family artist: "Mary Williams' work as a painter never has received the recognition it deserves. Hers was a rare and beautiful art." He mentioned that she introduced him to Ryder and to Shaw's works, and that she knew Whistler. Given her fondness for Europe, especially Florence, "it is most fitting that she is buried there among the tall cypresses of the beautiful little cemetery of the Allori."[16]

Laura's grave marker was made to match the three rectangular stones for her sisters in a line at Hartford's Spring Grove Cemetery, near their parents and siblings and their neighbor Madge Hubbell Tweed and her newborn. Nelson retrieved Mary's paintings from 181 Girard. Edith dealt with the house contents. She saved memorabilia for Nelson,

including one of the baker Edward Williams's business cards. She sold what she could for pittances and let the Salvation Army take the rest, including "hats of ancient vintage but not quite costume pieces"—were those the hats that Mary repaired with her faithful needle?

And so most traces of what Arthur Tilton considered "the most magic house in the world" were dispersed.

Nelson and Henry kept researching Mary. They told Julia Dwight (who had moved to the Boston area shortly after her 1908 Salon showing) about the Atheneum's disregard for Mary's work. Julia replied, "I am quite sure that *some* of the 'art' that is acclaimed to-day will hardly bear the test of time, and that things that have some real beauty have more chance of surviving. Let us hope so!"[17] Julia and Isabelle Williams, "Cousin Belle," gave the Whites a few of Mary's works, including Italy pastels and an oil portrait of a young woman partly turned away from the viewer. And so some of the art that had been purchased or given away in Mary's lifetime, or right after her death, ended up returned to the unsold stacks in the boathouse.

Smith's museum, in the 1940s modernist spirit, dispersed much of the collection that Tryon and Mary had helped assemble, with so many paintings that Henry and Nelson cared and wrote about. This institutional housecleaning is still known among White descendants as the "Smith Massacre." In 1947, the Kende Galleries conducted the sales, at the Gimbels department store in Manhattan. (Smith faculty members have recently been tracking down the scattered works.) By then

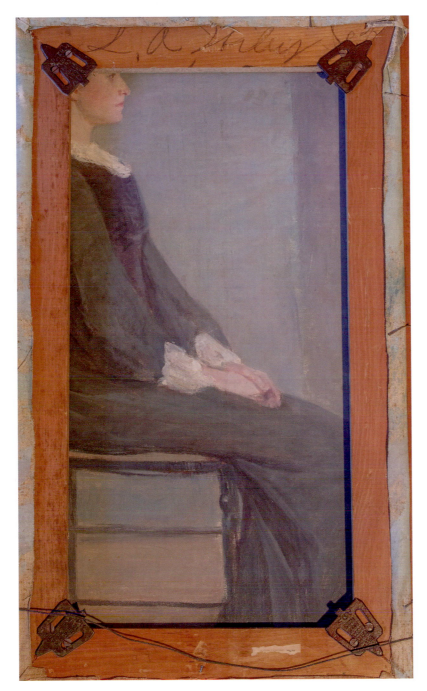

28.2 Mary painted oil portraits of seated women wearing dark gowns on both sides of this undated canvas, 24 x 14 in. Markings from L. A. Wiley, a Hartford frame maker, survive on the stretcher. The White family donated the work to the Mattatuck Museum in Waterbury, Connecticut, which auctioned it in the 1980s. PRIVATE COLLECTION. PHOTO: NICK MURPHY (NAMAJAMPHOTOGRAPHY.COM).

the plaster casts that Mary had cataloged and sketched were gone; as early as the 1930s, they were considered "rather appalling" and cleared out of Hillyer.[18] Unverified legend has it that they were dumped and left to dissolve in the campus's water feature, Paradise Pond.

Henry, who died in 1952, would have been even more incensed to witness the demolition in 1970 of the original Hillyer building and the 1920s wing that Tryon had filled with his own paintings. Nelson, even as Hillyer lay in ruins, stayed in touch with Tilton and Hubbell family members to research Mary. He died in 1989, shortly after the Mattatuck Museum in Waterbury, Connecticut, auctioned off his gift of Mary's double-sided canvas portrait of seated women (figure 28.2). Linda Merrill dedicated her 1990 book, *An Ideal Country: Paintings by Dwight William Tryon in the Freer Gallery of Art*, to Nelson's memory. A footnote states that during the first two decades of Tryon's Smith tenure, "Mary R. Williams conducted the actual teaching of painting and drawing." The book also notes that Clara Lathrop's successor Beulah Strong, who worked under Tryon until 1923, was given a title that would have made Mary happy, "associate professor of art."[19]

Aida died in 2002, at age 104. Her son George and his wife Betsy and their family stayed in the Eyre-designed house. Beeb has lived nearby, when not painting in Florence. Mary's artworks were distributed to various Whites, with the majority stored in the 1910s boathouse that Nelson and Beeb used as a painting studio. Most were kept in their original frames. The family inventoried them and applied assorted labels and inscriptions.

Which is where the author of this book comes into the story, and makes a lot of phone calls.

The Resurrectionists

In 2009, the Whites lent Mary's portrait of Henry to a show of his pastels at the Florence Griswold Museum, and Beeb mentioned to curator Amy Kurtz Lansing that they owned more works by this forgotten woman. In 2012, I turned up at the Whites' doorsteps in Waterford (see introduction). They lent me the Williams papers, from 1870s high school report cards through Laura's funeral records and Nelson's 1970s notes, and showed me stacks of Mary's artworks. In 2014, the Florence Griswold Museum organized Mary's first retrospective in a century, titled *Forever Seeing New Beauties*. It was part of a trio of one-woman exhibitions, collectively titled *Life Stories in Art*. The sculptor Mary Knollenberg (1904–1992) and the glass artist Kari Russell-Pool (1967–) were each given their own room. Mary's gallery contained about thirty works in oil, pastel, and watercolor (many of which Beeb had restored for the exhibition), plus her plaster profile of Nelson and the bronze casting of the boy's hand. A display case was filled with postcards, snapshots, dried flowers, dress scraps, the brazen 1891 note to Whistler, a locket with Mary and Laura's photos, the 1898 catalog of Smith's casts, and confetti from the 1899 Mardi Gras parade. Four paintings by Tryon and Henry were also on view.

To coincide with the Griswold show, I published a feature story on Mary in *Fine Art Connoisseur* magazine. While I was transcribing letters and researching in preparation for the show and article, the tireless and brilliant Kurtz Lansing was reading my raw typing and coming up with her own insightful questions and interpretations. I kept finding more paintings, and more people who knew about Mary and her circle.

Auction houses put me in touch with buyers of the handful of Mary's works that had recently come on the market. A canvas

Life Stories in Art

"FOREVER SEEING NEW BEAUTIES:"
THE ART OF MARY ROGERS WILLIAMS

Kari Russell-Pool:
Self-Portraits in Glass

MODERN FIGURES:
MARY KNOLLENBERG SCULPTURES

29.1 Brochure from 2014–2015
Florence Griswold Museum
exhibition. AUTHOR'S COLLECTION.

29.2 Visitors at Florence Griswold
Museum show. PHOTO: FLORENCE
GRISWOLD MUSEUM (TAMMI FLYNN)

portrait of an old woman, signed "M. R. Williams" and dated 1895, had been auctioned in 2008. After much sleuthing, I identified it as Mary's portrait of Mrs. Tenney—the back of the frame has a ghost of a label with "1492" (Mary's Hartford address) just legible. It is not clear how the painting left Tenney House at Smith. The auctioneers had no idea who "M. R. Williams" was. The buyer told me he just liked the canvas's resemblance to Whistler's portrait of his mother. My husband and I bought Mrs. Tenney's picture, lent it to the Griswold, and then donated it to Smith.

The Connecticut historian William Hosley contacted George Dudley Seymour's collateral descendants. They took Mary's full-length 1897 portrait of the antiquarian off their walls, lent it to the Griswold, and then donated it to Connecticut Landmarks. I visited Seymour's bust portrait at the Connecticut Historical Society, and Smith College museum staff members showed me the institution's half-dozen works given by Mary's sisters and friends. One pastel, *Meadow at Sunset*, is missing at Smith, and a large marine pastel was deaccessioned at some point. *Evening* was rescued by the registrar Louise Laplante after it suffered damage in dorms and closets. I scoured papers from Seymour (at Yale), King (New York Public Library), and Lindley Williams Hubbell (Columbia). I called grandchildren and great-grandchildren of people who knew Mary—how astonishing to learn that a few remembered their forebear's admiration for a painter who died in 1907.

People were strangely receptive to calls from an overexcited historian announcing "I found a messy letter that your forebear wrote when she was a little girl!" or "I have a photo of your forebear when he was a little kid with adorable long locks!" or "Your forebear paid for Mary's theater tickets and clothes," or "Your forebear was a compulsive talker who got on Mary's nerves," or "I know where your grandmother's forgotten pastel portrait is, and I know your great-grandmother hadn't realized that she was expected to pay for it."[1]

In the post-Mary fates of her friends, I found bizarre overlaps and brushes with greatness. Mabel Eager ran her family's office supplies company and became a philanthropist for Boston area institutions, including her alma mater Lasell College and the All Newton Music School. Clara Pease (1856–1941), the high school teacher who circumnavigated Norway with Mary, published a popular science textbook, gave illustrated lectures about her wide travels, donated fossils and earthworm samples to Wesleyan's natural history museum, and had science prizes named after her. Elizabeth Czarnomska traveled in Europe and biblical lands with the photographer Vida Hunt Francis and became an expert on "the authentic literature of Israel." Jean Speakman published her history of San Gimignano (under her maiden name, Jean Carlyle Graham). It was printed in Siena, and I found a copy bound in leather with embossing that resembles medieval hinges. Was it the work of the bookbinders who taught Mary?

Mary's Paris friend Marie Squires Hopper was widowed young. She remained a follower of the Baha'i faith. In photos of early Baha'i

converts in Paris, I also spotted Mary's friend Florence Vincent Robinson, who became known for paintings of American magnates' gardens and views of New York—the latter were reproduced widely on postcards. Jennette and Gerald Lee, who owned Mary's portrait of Jennette (whereabouts unknown), had a daughter, Geraldine, who sat for portraits by George Bellows. After Geraldine's death, her widower, the artist Maitland deGogorza, married his Smith College student Julia Brodt, who was the daughter of Mary's friend Ruth Gray Brodt.

Frederick King's intellectual circles expanded to include Henry James, Ezra Pound, the illustrator Pamela Colman Smith, Lincoln Kirstein, William Butler Yeats (whose lectures Mary enjoyed), and John Sloan (whose paintings Mary admired). Sloan sketched and painted King, who also became known as a book collector and dance historian. Gumaer apparently never designed anything but Mary's marker, in a long career of teaching art and architectural history in Penn's rigorous Beaux-Arts curriculum. He wrote a few articles for *Architectural Record*, he collected books and theater programs, and he visited Europe every summer, unless "wars prevented such travel."[2]

What would Mary have accomplished, if she had aged amid these self-made, curious, cultured people?

In Paris, I walked along rue Boissonade, a quiet side street lined in balconied art nouveau buildings. The gardens where Mary saw uniformed orphans at play are still there. In Italy, my daughter Alina and I followed part of Mary's extensive trail, guided by the historian Alexandra Lawrence. So much, of course, has changed since Mary's time. The crippled child beggars and gorgeously costumed nuns and priests have largely vanished. Hardly any "artists, so called" bring easels to copy anything on exhibit. And so much art that Mary saw has been reattributed, moved elsewhere, or destroyed in wartime.

In Siena, we stayed in a hotel across the street from the Bontades' polygonal palazzo. We stood where Mary sketched archways and domes, and where Wolfie wandered off, horsemen posed in silk and velvet for her camera, and deaf schoolchildren tugged at her heartstrings. In Florence, we stayed at her favorite Lucchesi hotel. I excitedly showed the staff my binder full of images of her artworks and letters on Lucchesi stationery, describing clever waiters and glimpses of soldiers bathing in the Arno. They added my findings to their files about accomplished past guests, including D. H. Lawrence (he wrote parts of *Lady Chatterley's Lover* there).

When we hiked to Florence's San Giorgio gate, Alexandra Lawrence pointed out that the relief of a dragon fighter would have appealed to Mary's macho side. At Fiesole, I realized that Mary had ignored the spectacular bowl below of Florence's creamy-orange domes—so many other artists, after all, had already "caught a sketch" there. She concentrated instead on the arid slopes beyond the lichen-encrusted Roman ruins. I toured Villa Natalia, now a New York University dorm. (It backs onto Harold Acton's lavish Villa La Pietra—the Acton family was in the pro-

cess of buying it in her last days.) I wandered through the property's silvery olive groves and cavernous rooms with gray stone fireplaces. I wondered where Julia Dwight had stayed overnight, and which room had left Mary feeling "in cielo" as she was leaving this world. I visited her grave with the historian Grazia Gobbi Sica, who has written a book about the Allori's permanent residents. I set down my binder and my biography manuscript at the base of the Carrara marble cross and snapped a cell phone shot.

"You're going to like the book—it's a good story," I assured her, although part of me knew that she would have considered my words just more taffy from America for "an undeserver." I was relieved to see her in such good company, among so many interesting people who accomplished so much in between tragedies and died so far from home.

The surprises have kept coming, even as I finished drafts of these chapters. Images of Mary's works have proliferated on the internet, cheap print versions have come to eBay, and Chinese forgery factories now offer canvas copies "in any size with your require!" [*sic!*]. I made a last-minute trip to the Smithsonian's Archives of American Art, to check Macbeth's accounting records from 1902, just in case. When I found long listings of Mary's unsold pastels and Henry's lone purchase, I stood up and covered my mouth and tried not to dance with elation at the discovery. In March 2016, Mary's 1897 pastel of Waterford (figure 12.1) emerged at an auction, and I somehow missed that it was up for sale. I raced to New Hampshire to

29.3 While visiting Mary's grave in 2017, I created a still-life with images of her and her artwork and my book manuscript. AUTHOR'S PHOTO.

meet the successful bidder. Little nudging was required to persuade him that I was obsessed and it mattered to me so much, he should sell it to me. (I paid cash.) "You're a resurrectionist," he said.

During my years on Mary's trail, I also began resurrection work for the Lathrop sisters, the photographer and journalist Lillian Baynes Griffin, William Merritt Chase's artist mistress Annie Traquair Lang, and the Chase protégée Edith Varian Cockcroft—my writings about them include their first Wikipedia entries. Other resurrectionists, meanwhile, have produced books, exhibitions,

symposium sessions, documentaries, and in-depth articles about dozens of other American women artists who were approximately Mary's contemporaries. These resilient souls defied their era's expectations while doubting themselves, and while their male counterparts dominated in classrooms, at galleries, and in the press. As Mary pointed out, only crumbs of art-world attention were left for women: "some men get listened to without any apparent reason."

So it is fortunate, in a sense, that finishing this book took so long. I have become part of a scholarly trend, while researching a character who was anything but a joiner.

The recent academic work is of course built on the accomplishments of the 1970s generation of feminist historians, who were inspired by Linda Nochlin's groundbreaking essay, "Why Have There Been No Great Women Artists?" Scholarly and grassroots groups devoted to the subject keep emerging—the Feminist Art Project at Rutgers, for instance, and the Art+Feminism coalition supported by the Wikimedia Foundation.

To name just a few women of Mary's time whose artistic reputations have been recently burnished or retrieved from dustbins: Maria a'Becket, May Alcott, Anna Richards Brewster, Fidelia Bridges, Romaine Brooks, Matilda Browne, Anne W. Carleton, Emma Richardson Cherry, Kate Freeman Clark, Elizabeth Colborne, Angel De Cora, Gertrude Fiske, Euphemia Charlton Fortune,

Meta Fuller, Anne Goldthwaite, the Hales (Ellen, Susan, and Lilian), Edna Boies Hopkins, Marion Howard, Anna Hyatt Huntington, Susan Ricker Knox, Edmonia Lewis, M. Evelyn McCormick, Violet Oakley, Marie Danforth Page, Margaret Patterson, Agnes Pelton, Jane Peterson, Mary Elizabeth Price, Katharine and Ellen Pyle, Ellen Emmet Rand, Mary Hiester Reid, Anna Stanley, Florine Stettheimer, Mary Bradish Titcomb, Helen Turner, Emily Noyes Vanderpoel, Edith Lake Wilkinson, Mary Vaux Wolcott, and Laura Woodward.

In many cases, the research was possible only because loved ones saved papers and artworks, when no one else cared. I keep meeting young scholars eager to dive into more archives, to find other underexplored figures. I also collect information about unluckier women artists, whose estates were dumped in trash heaps or divided into auction lots that brought pittances.

Mary's artworks in the boathouse and the boxfuls of letters allowed me to put into perspective what she was wearing, eating, sketching, and thinking, on gloomy winter days in Northampton amid "the presence of the young feminine" and during European summers as she buried her New England conscience and forever saw new beauties. The fluke of the Whites' stewardship has enabled me to put Mary back on the art historical map, while the map keeps getting redrawn to include more of her kind.

Acknowledgments

I am grateful for the unstinting support of my husband Brad Kulman and daughter Alina Kulman and my friends Martha Pavlakis and Julie Lasky. I would also like to thank the White family (George and Betsy White, Nelson Holbrook "Beeb" White, Carla White Freyvogel, Grace White Borletti, and Burt, Maura, and Meaghan White); the Florence Griswold Museum's tireless and brilliant Amy Kurtz Lansing (and her colleagues Jeff Andersen, Tammi Flynn, and David Rau) and Suzanna Tamminen at Wesleyan University Press (with invaluable copy editor Glenn Novak and BW&A Books designer Chris Crochetière). Also Katherine Manthorne at CUNY, who unwittingly set me off on this journey; Mary A. Falvey of the Hartford Preservation Alliance; Portland, Connecticut, historians Claire Frisbie, Rick Gildersleeve, and Doris Sherrow-Heidenis; Smith College's Nanci Young, John Davis, Linda Muehlig, and Louise Laplante; Connecticut historians Barbara Austen, Rich Malley, and William Hosley; my mother Renée Kahn, brother Andrew Kahn, sister-in-law Janet Schneider; cousins Renee Jacoby, Linda Rutenberg, David Freudenthal, and Ken Jockers; and lifelong friend George Calderaro (and his family Romeo and Bill Megevick). Not to forget Maggie Humberston at the Springfield Museums; Suzanne L. Flynt at the Memorial Hall Museum in Deerfield, Massachusetts; Marcia Ely at the Brooklyn Historical Society; the Smith Club of New York; Nan Wolverton and Marie Panik of Historic Northampton; Elise Bernier-Feeley at the Forbes Library, Northampton; Lathrop family historian Paul Truax; genealogists Nora Galvin, Michelle French, and especially Arthur Westneat; Mary's French and Williams cousin descendants; and Florence experts Lyall Harris, Jane Fortune, Alexandra Lawrence, Grazia

Gobbi Sica, and Julia Bolton Holloway. Also, Peter Trippi at *Fine Art Connoisseur*; Paul Carlos and Urshula Barbour at Pure+Applied; owners and dealers of Mary's work including Clarissa H. Porter, Scott Downer, Colin Stair, W. Greer Puckett, Doug and Karin Nelson, and the Tilton/Kenney and Healy families; Ellen B. Widmer, the granddaughter of Mary's portrait sitter Marian Tyler; my kindred spirits Lauren Drapala, Janet Tobin, Anne Stewart O'Donnell, and Rena Tobey; underappreciated-women-artist scholars Mindell Dubansky, Lindsy Parrott, Jennifer C. Krieger, Catherine Whalen, Betty Krulik, Fred Baker, Erica Hirshler, and PAFA's Anna Marley and Hoang Tran; photographer Kimberly J. Schneider; my cohorts at the Art Glass Forum, Poster House, the Grolier Club, the Victorian Society, and the Lotus Garden; world travelers Annabel Barber, Tom and James Howells, Linda and Gaston Vadasz, Nora Demeter, and Laszlo and Kristof Foldenyi; everyone who came to my lectures, everyone who listened to my stories, everyone who bought me coffee or lunch; and the feline deities Khufu, Cleopatra, and Sneferu Kahn, who didn't have much to say but never left my side.

Mary Rogers Williams, 1857–1907

Abbreviations

AWCS	American Water Color Society, New York
CHS	Connecticut Historical Society, Hartford
DWT	Dwight William Tryon
FGM	Florence Griswold Museum, Old Lyme, CT
GDS	George Dudley Seymour
HAS	Hartford Art Society
HCW	Henry Cooke White
LCW	Laura Charlotte Williams
LSW	Lucy Sage Williams
MRW	Mary Rogers Williams
NAD	National Academy of Design, New York
NCW	Nelson Cooke White
NHW	Nelson Holbrook ("Beeb") White
NYWCC	New York Water Color Club
PAFA	Pennsylvania Academy of the Fine Arts
SAA	Society of American Artists, New York
WFC	White family collection

Chronology of Exhibitions, Press Mentions, etc.

Following are highlights of Mary's exhibitions and press mentions and a summary of known paintings and pastels. A fuller listing will be on file at Smith's archive. If you find any further information or artworks, contact Smith or me (evemkahn@gmail.com).

1892

AWCS, 25th Annual, NAD (February 1–27): *Old House at St. Jacut, Bretagne*; *Twilight at Sconset*. NYWCC (December 19, 1892–January 7, 1893): three portraits, landscapes including *Connecticut Hills*, Provincetown. *New York Herald*, December 19, 1892, 6. *Hartford Courant*, December 24, 1892, 1. *New York Press*, December 25, 1892, 2. *Critic: A Weekly Review of Literature and the Arts*, December 31, 1892, 379. *Art Amateur: A Monthly Journal Devoted to Art in the Household*, February 1893, 74.

1893

NYWCC (November 20–December 8): pastels including three portraits (one of young man) and *The White Gown, A Pasture, Rolling Ground*. *New York Times*, November 18, 1893, 4. *New York Sun*, November 21, 1893, 6. *Critic*, November 25, 1893, 349. *New-York Tribune*, November 19, 1893, 22, and November 26, 1893, 18. *Art Amateur* 30 (January 1894): 30, 43.

1894

Quarterly Illustrator 2, no. 6 (April, May, June 1894): 111–24, "Woman in Art," by Elizabeth W. Champney: MRW's *A Friendly Sitting* (figure 7.5). NYWCC (December 3–22): *Miss M. M.*; *By the Arno*; *Venice*; *Light*; *Fiesole, Italy*. *New York Sun*, December 1, 1894, 6. *Vogue*, December 20, 1894, 402–3. *Art Amateur* 32 (January 1895): 44. *Art Interchange* 34 (January 1895): 16.

1895

Art Association of Indianapolis (May 11–18): twelve pastels including *The Girl*

in Grey, three portraits, four *Venice,* four *Florence. Indianapolis Journal,* May 11, 1895, 8. *Indianapolis News,* May 11, 1895, 1. Tenney House at Smith College, oil portrait of Mrs. Mary Smith Tenney (figure 4.9), on view for decades. NYWCC (November 11–23): *Pasture and Pool, A Profile* (figure 11.1), *Harmony, The Pink Gown* (figure 11.2), *A Hazy Day, Clouds, Jobs Pond* [sic] (figure 2.11). *Buffalo Evening News,* November 18, 1895, 2. PAFA (December 23, 1895–February 22, 1896): *Clouds, Pasture and Pool, A Hazy Day, Harmony, The Pink Gown* (figure 11.2), *A Profile* (figure 11.1), *Job's Pond, Connecticut* (figure 2.11).

1896
SAA (March 28–May 2): oil portrait, pastel *Hills.* NYWCC (November 9–21): sixteen Norway pastels. *Brooklyn Daily Eagle,* November 8, 1896, 23. *Daily Tatler,* November 9, 1896, 1. *Art Amateur,* December 1896, 136–37. *Independent,* December 3, 1896, 10. PAFA (December 21, 1896–February 22, 1897): oil portrait from GDS.

1897
42 Union Place, Hartford (November): MRW-curated show of her and HCW's work, including her views of Connecticut (Waterford, Penfield Hill/Cobalt) and Norway.

1898
Gill's Art Galleries, Springfield, MA (early January): same roster as 1897 Hartford show? About sixty total of MRW and HCW works; his included Venice, Avignon scenes; hers included *Light* (portrait of woman reading), *Moonlight, Grand Canal* (figure 9.1); scenes of Norway, Massachusetts (Hadley), Connecticut (Penfield Hill, South Glastonbury). *Springfield Republican,* January 3, 1898, 5,

and January 5, 1898, 10. American Girls' Club, Paris (one week, mid-December): Connecticut landscape pastels—two of Waterford, one of Hadley.

MRW's writings: *Smith College Monthly,* March 1898, 289–90, "About College": essay on DWT's *Salt Marshes* and other DWT works acquired by art gallery. *Catalog of Casts in Hillyer Art Gallery, Smith College* (Hartford, CT: Case, Lockwood & Brainard, 1898): fifteen-page booklet about plaster cast collection.

1899
Paris Salon / Champ de Mars (spring): pastels *Clouds, Hazy Day, The Tree* (also known as *New England Pasture,* figure 2.14). NYWCC (November 5–25): *Moonlight, Grey Day,* portrait of Mabel Eager. *Harper's Bazar,* November 18, 1899, 989. *Artist: An Illustrated Monthly Record of Arts, Crafts and Industries* 25–26 (December 1899): lxix. Woman's Art Club, NYC (November 13–18): *M. Marcia, A Pasture, Clouds. Art Amateur,* December 1899, 3.

1900
NYWCC (November 10–December 2): *Penfield Hill in May, Repose, The Sunny Marsh. New York Evening Post,* November 14, 1900, 8.

1901
NYWCC (November 9–December 1): *Sunshine, The Edge of the Wood.*

1902
PAFA (January 20–March 1): pastel *Sunshine.* Macbeth Gallery, NYC (April): about twenty-one pastels, mostly landscapes. *Art Notes,* by gallery owner William Macbeth, April 1902, 300. Woman's Art Club (November 5–19): *Evening* (figure 4.6). *New York Times,* November 6, 1902, 8. NYWCC (November 22–December 14)

(also Copley Society, Boston): *The Chateau Amboise, The Belfry Guyeres* [sic], *Early Morning in Florence. New York Evening Post,* December 6, 1902, 27.

1903
NAD (January 3–February 1): *Evening.* Woman's Art Club (December 1–14): *In Summer, Portrait of Miss Andrews* (pastel, figure 17.3). *New York Times,* December 6, 1903, 7.

1904
NAD (January 2–30): *Spring* (oil on panel), June, decorated Smith campus for Northampton's 250th anniversary. *The Meadow City's Quarter-Millennial Book* (Springfield, MA: F. A. Bassette, 1904), 87.

1906
Smith art department's graduation show (June): landscapes. *Springfield Republican,* June 19, 1906, 5.

1907
American Girls' Club, Paris (February): two 1906 pastels, views of Florence and Fiesole.

1908
HAS retrospective (February 14–29): thirty-six works including a dozen portraits; oils include *Evening, Connecticut Hills, Early Spring;* views of Monhegan (see chapter 17), Northampton, Venice, Siena, Florence, Fiesole, Bruges, Norway, Switzerland. *Hartford Times,* February 13, 1908. *Hartford Courant,* February 13, 1908, 3. *Springfield Republican,* February 15, 1908, 11. Capen school for girls, Prospect Street, Northampton (June): posthumous exhibition. *Greenfield Gazette and Courier,* June 13, 1908, 5. *Mount Tom* magazine, February–March 1908, 113–15, "Mary Williams," by Gerald Stanley Lee: Ode to

a "small, blue-gray" pastel portrait hung over his piano, probably MRW's portrait of his wife Jennette. NYWCC (October 31–November 22): pastels including *Connecticut*, *Monhegan* (see chapter 17), *Mademoiselle M.* (figure 24.3), *Spring at Lyme*, *Cypresses*, views of Siena. *New York Herald*, October 30, 1908, 12. Philadelphia Water Color Club (November 23–December 20): *Mrs. L.* (portrait of Jennette Lee), *The Grey Girl*, *Interior of Cathedral at Siena*, *Cloister at S. Francesco/Siena*, *A Hazy Day*, *The Arno: Florence*, *Interior of Cathedral at Arezzo*, *Amboise* (chateau).

1909
HAS (February 6–27): about fifty works, including *Evening*; scenes of cypresses, birches, Norway, Switzerland (including Chamonix), France (Paris, Azay-le-Rideau, Chateau d'Ussé), Belgium (Bruges), Italy (Siena, Montalbuccio, Florence, Arezzo, Venice, Naples), Paris, Maine (Monhegan), Massachusetts (Hadley, Mount Tom), Connecticut (Lyme, Portland/Cobalt); nine portraits, including of Françoise Montagny, Jennette Lee, *The Red Girl*. *Hartford Courant*, February 12, 1909, 6. Wadsworth Atheneum (May): exhibition with DWT's works, MRW's pastel *Naples* and oil portraits *Girl in Pink* (Smith student) and *A New England Gentlewoman* (GDS's mother).

1912
Smith Alumnae Quarterly, February 1912, 78, "The Improved Art Gallery," by Clara Winifred Newcomb: five MRW pastels on view.

1914
Hartford Courant, May 17, 1914, 26, "Hartford Artists Have Good Season," re HCW's permanent move to Waterford, taking large collection of artworks—MRW

the only woman on the list. *American Art News*, May 23, 1914, 7, "Hartford, Conn.": HCW's move to Waterford with MRW paintings.

1919
Smith/Hillyer gallery, north corridor: group of donated artworks including *Evening*.

1920s
LCW sent LSW's bequest of three paintings to HAS.

1930
HCW, *The Life and Art of Dwight William Tryon* (Boston: Houghton Mifflin, 1930), 98.

1944
Hartford Courant, January 18, 1944, 10, "A Lost Tradition," by HCW: long obituary for LCW and sisters.

1950
Memories, HCW, unpublished autobiography with long tribute to MRW and sisters.

1985
Chris Petteys, *Dictionary of Women Artists: An International Dictionary of Women Artists Born before 1900* (Boston: G. K. Hall, 1985), 759: thumbnail bio for MRW.

1989
William Innes Homer and Lloyd Goodrich, *Albert Pinkham Ryder, Painter of Dreams* (New York: Abrams, 1989), 225: HCW essay mentions he met Ryder at MRW's suggestion.

1990
Linda Merrill, *An Ideal Country: Paintings by Dwight William Tryon in the Freer Gallery* (Washington, DC: Freer Gallery of Art,

1990), 97, n. 262: MRW "conducted the actual teaching of drawing and painting at Smith."

2007
Catherine Whalen, "The Alchemy of Collecting: Material Narratives of Early America, 1890–1940" (PhD diss., Yale University, 2007), 310–32, discusses and illustrates MRW's bust and full-length portraits of GDS.

2009
FGM (April 18–July 12), *Visions of Mood: Henry C. White Pastels*: MRW's portrait of HCW, c. 1896.

2012
Hygienic Art Gallery, New London, CT (September 15–October 13): group show, *Italian Visions / Visioni italiane*, with *Grand Canal* (WFC loan).

2014
Smith College Museum of Art (fall): *Marion Tyler* [sic, Marian], *Green Landscape—Hills in the Distance* (covered in various Smith College blog posts). FGM (October 3, 2014–January 5, 2015), *"Forever Seeing New Beauties": The Art of Mary Rogers Williams*: MRW retrospective, with three dozen works and case of ephemera (photos, correspondence, fabric scraps, Paris parade confetti, etc.). Numerous periodical and blog mentions, also author's major features in *Fine Art Connoisseur*, September/October 2014, *American Art Review*, December 2014.

2015
Margaret Flora MacDonald, "James McNeill Whistler: An Artist on Artists," *Visual Culture in Britain*, June 2015, 15: quotes MRW's 1891 diary entry about Whistler hating the portrait of him by

William Merritt Chase, and not looking anything like it.

Institutional Collections

Measurements of artworks are approximate, in height by width in inches.

CHS

Portrait of George Dudley Seymour, 1894, oil on canvas, 22 x 17, bust portrait. GDS gift (1945.1.13).

Connecticut Landmarks

The Connoisseur, 1897, oil on canvas, 22 x 18, GDS seated, contemplating thin-necked green Chinese vase. Gift of GDS descendants.

Smith College Museum of Art

Evening, n.d. (in progress for years), oil on canvas, 26 x 36, pastureland and rolling hills with high horizon. Alumnae and friends' 1908 memorial gift (SC 1908:5-1).

Green Landscape—Hills in the Distance, 1903, pastel and watercolor on white paper, 12 x 22, view of sunset over green trees, rough meadow. Gift of Williams sisters (SC 1911:3-2).

In Siena Cathedral, 1907, pastel on blue paper, 9 x 6. Gift of Williams sisters (SC 1911:6-1).

Marion Tyler [sic], 1907, pastel on brown paper, 12⅟₁₆ x 9⅟₁₆. Portrait of Marian Tyler, sister of Smith grad Emma Tyler, seated in white gown. Gift of Williams sisters (SC 1911:7-1).

Noon Siena, n.d. (HCW dated 1906), pastel on gray paper, 7⅜ x 10⅜. Orange-sepia cityscape with scalloped teal suggestions of vegetation. Gift of Williams sisters (SC 1911:4-1).

San Domenico and Duomo, 1907, pastel on brown paper, 7½ x 10. Spires with dark stripes of tree trunks in foreground. Gift of Williams sisters (SC 1911:5-1).

Untitled, portrait of Mary Smith Tenney; 1895, oil on canvas, 32 x 25. Gift of Eve M. Kahn and Bradley G. Kulman (SC 1900:63-1).

Smith gifts, unlocated

Marine sketch, 1899, pastel, 11 x 17, gift of Williams sisters, deaccessioned.

Meadow at Sunset, n.d., pastel on paper (measurements, markings, whereabouts unknown), gift of Williams sisters (SC 1912:7-1).

Private Collections (Other Than WFC)

Connecticut

The Pink Gown (also titled *Woman in Pink*), n.d., pastel, 12 x 8.

Interior of Cathedral at Arezzo, n.d., pastel, 9 x 6.

Massachusetts

Portrait of Miss Andrews, n.d. (probably c. 1894), pastel, 9 x 12¼, seated side view of Katharine Andrews Healy, Smith 1894, in white, reading.

Massachusetts, all 1920s gifts of LCW

A Friendly Sitting, n.d. (1894 or earlier), pastel, 17½ x 10, woman in white in black chair, papers in her lap, published in *Quarterly Illustrator*, April–June 1894.

Chateau d'Ussé, 1902, watercolor, 5 x 6½.

Untitled, clouds, n.d., pastel, 6 x 9.

Untitled, meadow and distant hills, n.d., oil on panel, 22 x 27½.

Author's collection:

Morning—Siena [crossed out] *Paysage—Sienne*, 190[?] (date indistinct), pastel, 7½ x 10.

Untitled, probably Fiesole environs, 1904? 1907?, pastel, 9½ x 12.

Early Morning—Waterford (also *Aurore* and *Morning—Waterford*), 1897, pastel, 5½ x 7.

Washington state:

Portrait, Lady (also *Portrait of Unknown Woman*, per Smithsonian database), n.d., oil on canvas (two-sided), 24 x 14, red-haired young woman on chair in scoop-neck, ruffled, puffy-sleeved dark dress; portrait of another young woman (same one? hair hidden by stretcher) on verso in dark monochrome gown, lace collar, cuffs.

Summary of WFC

In Connecticut:

MRW's pencil sketchbook (4¾ x 7½), with about seventy drawings: subjects include girls holding dolls; waterfront scenes; women with books, canes, or parasols, in kimonos holding pleated fan; an elaborately ornamented New England doorway; a plaster cast of a discus thrower statue (no. 62 in MRW's catalog of Smith's cast collection, original marble at British Museum); scenes of woman in hat sketching in field with split-rail fences (Penfield Hill) dated August 15, 1887; 1892 coastal scenes (scrub pine and shingled large houses in background labeled "Where we lunched"); Marblehead cottage view and barn/farmhouse scene; sketches for *Moonrise Provincetown* and *Marine with Sailboats*.

Loose sketches, 11 x 8: dozen ink drawings of women, children, peasants.

Assisi, 1904, pastel, 7½ x 10½.

Assisi (also *Church in Assisi*), 1904, pastel, 6½ x 9¾.

Azay-le-Rideau near Tours, France, n.d. (MRW there in summer 1902), pastel, 9 x 5.

Boerte (Norway) [sic, probably *Båtstø*], n.d. (from 1896 Norway trip), pastel, 8½ x 11.

By the Sea, 1895, pastel, 8 x 11½.

Clouds, n.d., pastel, 6¼ x 7½.

Fiesole, c. 1904, pastel, 6½ x 10¼.

Fiesole—Italy, 1904, pastel, 10 x 17.

A Girl in Red, n.d. (pre-1901), oil on panel, 21 x 14.

Grand Canal (also called *Venice*), c. 1894, pastel, 11½ x 17.

Gruyères, July 4, 1902, watercolor, 5½ x 4¼.

Haukeli-Saetor, Norway [sic, *Haukeliseter*], 1896, pastel, 9 x 12.

Hills, 1896, pastel, 9 x 12.

Job's Pond, Connecticut, n.d. (pre-1895), pastel, 9 x 12.

Man in Profile or *Man's Profile* (White family titles), n.d., oil on canvas, 13⅝ x 9⅝.

Marine with Sailboats (White family title); 1892, watercolor, 10½ x 20½.

Miss Squires, 1899, pastel, 8 x 6.

Mlle M., 1907, pastel, 9½ x 6½.

Monhegan, 1903, pastel, 4 x 5.

Monhegan, 1903, pastel, 4¼ x 5¾.

Moonrise Provincetown, 1892, pastel, 11 x 20.

Near Fiesole, 1907, pastel, 9 x 12.

Nelson, 1906, plaster, 7 x 5, bas-relief portrait.

Nelson Cooke White His Hand, 1903, bronze (right hand), 7 x 4.

Nelson White's Hand, 1903, plaster (left hand), 7 x 4.

Old Lady with Head Dress (White family title), n.d., oil on canvas, 20 x 16.

Osservanza, Siena, indistinct date (probably 1904), pastel, 9 x 12.

Portrait of Henry C. White, c. 1896, oil on canvas, 36 x 20.

Portrait of a Young Woman (White family title), 1897, pastel, 9 x 7.

A Profile, c. 1895, oil on canvas, 21 x 16.

Street in Siena, n.d., pastel, 10¼ x 7½.

The Tree (also titled *New England Pasture* and *Hill Country*), 1895, pastel, 8 x 11.

Tromsö—Midnight (Norway) [sic, *Tromsø*], 1896, pastel, 8½ x 11½.

Trondheim from the Harbor (Norway), 1896, pastel, 8 x 12.

Vadso (Norway) [sic, *Vadsø*], 1896, pastel, 8½ x 12.

The White House (White family title), n.d., pastel, 8 x 7.

Woman in Head Dress or *Woman with Kerchief* (White family titles), n.d., oil on panel, 18 x 14.

Untitled, birches, n.d., pastel, 7½ x 10¾.

Untitled, sunny valley, n.d., pastel, 9 x 12.

Untitled, woman's profile, n.d., oil on panel, 20 x 16.

Untitled, woman with amber hair, n.d., oil on panel, 18 x 12.

Untitled, woman in feathered hat, n.d., pastel, 11 x 8.

Untitled, orchard, n.d., oil on canvas, 14 x 20. Canvas found underneath *Old Lady with Head Dress* during 2014 restoration.

Untitled, large striped landscape, n.d., oil on canvas, 20 x 27.

Untitled, little valley with puffy trees, n.d., pastel, 4 x 6½.

Untitled, probably Norway, 1896, pastel, 9 x 11.

Untitled, New England barn, n.d., pastel, 7½ x 9.

Untitled, birches, n.d., pastel, 8 x 9.

Untitled, puffy bright green tree, c. 1904, pastel, 9½ x 12½.

Untitled, streaky almost abstract landscape, n.d., pastel, 4 x 5.

Untitled, angel, n.d., pastel, 12 x 6.

Untitled, woman in yellow by window, n.d., pastel, 12 x 7.

Untitled, landscape, n.d., pastel, 10 x 13½.

Untitled, snow scene, n.d., pastel, 8 x 10.

Untitled, wintry tree row, n.d., pastel, 7 x 9.

Untitled, landscape with domed tower, n.d. (probably 1902), pastel, 8 x 9½.

Untitled, apple tree in blossom, n.d., pastel, 5¾ x 9.

Untitled, Florence gateway's stone relief of San Giorgio slaying a dragon, n.d., pastel, 8 x 6½.

In Massachusetts:

How Abby Is Spending Her Vacation, August 1885, pen and ink, 5 x 8¼, Abby in Penfield Hill hammock.

Laura C. Williams, n.d., oil on canvas, 18¾ x 16¾.

Portrait of a Girl, n.d., oil on canvas, 24½ x 18.

Untitled, woman in dark blue dress, n.d., oil on canvas, 30 x 25.

Untitled, bust portrait of a boy, n.d., oil on canvas, 6¾ x 7¼.

Untitled, blond mother and baby, n.d., oil on canvas, 11¼ x 8¾.

Untitled, polychrome wildflowers, 1885, oil on panel, 19¼ x 12.

Untitled, red flowers in dark bottle, n.d., oil on canvas (mounted on board?), 10 x 10.

Untitled, woman in white, date illegible, pastel, 22 x 16.

Untitled, sailboats and steeple-studded shore, n.d., watercolor, 9 x 17.

Untitled, stalk of purple flowers, n.d., watercolor, 10¾ x 4.

Untitled, violets, n.d., watercolor, 6¾ x 4.

Untitled, branches of pink flowers, n.d., watercolor, 12 x 8¾.

Untitled, white flower, camellia? n.d., watercolor, 3½ x 5¼ (clover sprigs, watercolor, on verso).

Untitled, boy in cap, n.d., watercolor, 10 x 14.

Untitled, girl in kerchief, n.d., watercolor, 8 x 7½.

About eighty sketches in pencil and ink, various measurements:

Self Examination, n.d., ink (porcelain doll with head removed).

England and France: Moissac cloister (1902), and from 1891 trip: London mu-

seum mosque window, St. Bartholomew-the-Great (London), Barbizon doorway, baby in third-class train carriage, priest asleep in second-class carriage, Saint-Malo doorway, Saint-Jacut church and park, Mont Saint-Michel (doorway with steep steps, doorway with hotel sign, archway layers, house entry flanked with potted trees).

Animals: tabby cats; dead mouse with grimacing classical statue mask.

Renaissance painting of Madonna and child.

Still life: seventeenth-century New England furniture.

Interior: woman's hatted head from behind, looking at dais (courtroom?).

Landscapes/buildings: country bridge with picket railing (round); building with mansard tower; statue of robed man from behind; waterfront with pier, tugboat/ferry; Gothic church with polychrome trim; riverbank with boats and steeples; rowboat alongside masonry wall.

Botanical: lilies, blackberries, dogwood, columbine.

Men: Chinese (holding fan), man holding cane?; mustachioed in shirtsleeves; bearded old man in profile, clean-shaven old man in profile, priest with palm fronds.

Women: seated, standing, lying down, reading, in hammock, playing instruments, working on fabrics or thread, one in toga dated December 7, 1888 (Smith dance performer?), in American dress (22+) and European folk costume (10).

Babies: baby in coffin; black baby in high chair.

Boys: newsboy, hatted boy playing on ground (marbles?), boy in room lined with pictures of soldiers and men on horseback.

Girls: reading or playing in groups (2), somnambulant in apron, seated in chair (3), one shoe, standing, seated/reading with woman.

In suburban Washington, DC:

Untitled, probably Provincetown, n.d. (probably 1892), pastel, 11½ x 20.

Untitled, landscape with trees resembling tumbleweeds, n.d., pastel, 7¼ x 10½.

Untitled, farmhouse/meadow in fall palette, n.d., oil on panel, 12 x 16.

Untitled, valley/city skyline and snowy foreground, n.d., oil on panel, 12 x 16.

Untitled, meadow/valley with church steeple, n.d., oil on panel, 12 x 16; on verso, woman in red dress reading, in wicker armchair.

Untitled, meadow, farmhouse in distance, n.d., oil on panel, 12 x 16.

In Paris:

Untitled, brunette woman's profile bust, n.d., oil on panel, 18 x 14.

Untitled, girl in blue kimono, n.d., oil on panel, 14 x 12.

Untitled, back view of woman in Windsor chair, unknown date, medium (oil on canvas?), measurements.

WFC whereabouts unknown:

Portrait of Laura C. Williams, n.d., oil on panel, 17½ x 14. Black and white photo in WFC.

Auction Appearances, Lost

Christie's NY, December 18, 2003, lot 162, Whistler book, *The Gentle Art of Making Enemies*, with April 10, 1893, letter to one Mary R. Williams looking forward to her visit in Paris, possibly MRW?

Cloister at S Francesco Siena, n.d., pastel, 8⅝ x 6⅜, sold at Sloan's, Washington, DC, May 17, 1997, lot 238, original owner Anna Cutler (Smith professor).

Gateway—Gruyères, 1902, pastel, 10¼ x 6½, sold at Myers Fine Art, St. Petersburg, FL, November 30, 2008, lot 348, original owner Mabel Eager.

Landscape, undated?, pastel, 9½ x 12, sold at Mystic Fine Arts, CT, November 30, 1989, lot 50, $330.

Untitled, interior scene, n.d., oil on canvas, 32 x 25, sold at Mystic Fine Arts, CT, June 30, 1994, lot 76.

Lost (Works Mentioned in Letters, Logbook, Exhibition Listings, etc.)

Portraits:

Henrietta Chapin Seelye, her niece Cornelia Chapin Moodey, Elizabeth Czarnomska, Jennette Lee, Mabel Eager, GDS's mother Electa, "Miss Mackenzie," "Miss Pettingill," "Miss Martin," "Rose Kingsley" and a nun.

Landscapes (regions and sites mentioned as MRW's subjects but no longer verifiably shown in her works):

Connecticut: Glastonbury, Lyme; Massachusetts: Nantucket (Sconset), Provincetown dock, Mount Tom, Hadley; England: Cambridge; Belgium: Bruges; France: Chateau d'Amboise, Seine banks; Isle of Jersey; Italy: Arno banks, Naples harbor; Norway: Hellesylt, Harstad, the Nærøyfjord; Switzerland: Chamonix.

Introduction

1. *New York Times*, April 20, 2012, C32. My interviews for the story with CUNY's Katherine Manthorne were particularly inspiring.

2. *The Merrick Art Gallery: Catalogue of 19th Century European and American Paintings Collected by Edward Dempster Merrick (1832–1911)* (New Brighton, PA: Merrick Art Gallery Associates, 1988), 86.

1. Why She Matters

1. I am grateful for this insight to Claudia Strauss-Schulson, an autographs dealer and collector of illustrated correspondence.

2. A Cosmopolitan Emerges

1. "A Tribute to Abby M. Williams," *Hartford Courant*, December 12, 1895, 6, hereinafter AMW/*Courant*.

2. Connecticut genealogist Nora Galvin's 2013 report (hereinafter Galvin), in author's collection; LCW and NCW 1940 letters, WFC; ancestry.com input from genealogist Arthur Westneat (who pinpoints the Frenches' hometown as Turvey, Bedfordshire); author's visits to Hartford and Portland, CT, cemeteries and archives.

3. Laura Hubbell Burlingame, who was named after Laura Williams, told Nelson that a picture of Eleanor was kept "on the mantel in the front bedroom" at the Williams home. LCW donated a painting of an old church in Eleanor's memory to Portland's Trinity Church; the work (whereabouts unknown) might have been by Mary.

4. J. M. Pelton, *Genealogy of the Pelton Family in America* (Albany, NY: Joel Munsell's Sons, 1892), 388. Emmet's memorial plaque hangs at Yale's Lanman-Wright Hall. Another cousin of the Williams sisters, Charles Fremont Williams, a Civil War hero in the Marine Corps, painted as a hobby—descendants own his oil scenes of low waves breaking on beaches.

5. LCW to NCW, March 2, 1940, WFC.

6. Other addresses briefly listed in newspapers and directories for Edward Williams include 15 Broad Street and 54, 84, and 86 Asylum Street. Servants named in the 1860 census are Mathew Caughlin, eighteen, an Irishman, and Josephine P. King, a Saxon, who was just fourteen. The house at 1492 Broad was demolished around 1911. E-mails from Mary A. Falvey, Hartford Preservation Alliance, July 2015; "City Buys the Hopkins St. Block," *Hartford Courant*, September 23, 1910, 2. The Williamses appear in Trinity Church's records, although Edward and Mary Ann's wedding and Mary Ann's funeral were held at a Baptist church. Death notice for Mary Ann, *Hartford Daily Courant*, November 16, 1861, 2.

7. *Geer's Hartford City Directory for 1853–54* (Hartford, CT: Elihu Geer, 1853), 180; *Connecticut Courant*, January 26, 1856, 3; *Hartford Courant*, July 3, 1856, 2, and December 9, 1859, 3.

8. *Connecticut Courant*, April 2, 1853, 3.

9. *Hartford Courant*, June 9, 1856, 2. The *Courant* also reported on January 2, 1858,

that a Congregational church in Hartford had presented its pastor, Warren G. Jones, with Edward's "magnificent cake, frosted and trimmed with exquisite taste."

10. Galvin; *Norwich Aurora*, March 1, 1871, 4. Trinity Church records list his cause of death as "malignant pustule."

11. Galvin. Edward owned shares in, among other companies, Aetna Insurance, Willimantic Linen, and Hartford Carpet.

12. *The Historical, Statistical and Industrial Review of the State of Connecticut* (New York: W. S. Webb, 1883), 195–96. Hartford directories published shortly after Edward Williams's death list other tenants at the home, including a blacksmith, a teamster, a washerwoman, and a bricklayer.

13. E-mails from Valerie Balint, Olana State Historic Site, Greenport, NY, 2016; Samuel Hart, *Representative Citizens of Connecticut Biographical Memorial* (New York: American Historical Society, 1916), 350–52; *Sacramento Daily Union*, June 7, 1883, 1; *Los Angeles Herald*, March 20, 1889, 2. Bookplates designed by Jay Chambers for Martha and Miles Graves survive at institutions including the Newark Public Library.

14. "Asylum Hill—1870," *Hartford Courant*, April 30, 1937, 16. The author, Caroline E. Kellogg, vividly remembered Edward's wares: "Cow cookies, ah me!"

15. Report cards, WFC; LSW, copy and composition book, 1869–72, Connecticut Historical Society, call no. 65192; Abby M. Williams, "The Holy Grail," in *Memorial of Samuel Mills Capron*, ed. J. H. Twichell (Hartford, CT: Case, Lockwood & Brainard, 1874), 114–20; "Class Day at the High School," *Hartford Courant*, April 17, 1875, 4; "The High School," *Hartford Courant*, April 20, 1876, 2; "Connecticut," *New-England Journal of Education*, April 29, 1876, 215; Laura Hubbell Burlingame to NCW, Decem-

ber 12, 1973, WFC; interviews with Luke Williams, Hartford Public High School historian, 2013–2015. In grammar school, Mary and Laura received Tennyson and John Greenleaf Whittier poetry books, Mary "for superiority in writing seventy five words at written examination" and Laura for reaching "the highest rank of those admitted to the High School." There was an Emma Wenk in Lucy's class. Lucy's notebook was donated to the historical society in the 1950s by the Tilton family, along with the Williams family's plum-colored silk dress trimmed in velvet (1959.4.10a,b), said to have belonged to Mary Ann but probably made in the 1870s.

16. AMW/*Courant*.

3. No Salvation but by Hard Work

1. HCW, *Memories*, unpublished memoir written in Waterford, CT, in 1950, WFC (hereinafter *Memories*).

2. *Report of the Society of Decorative Art of the City of Hartford, Conn.* (New York: Studio Press, 1883). I am indebted to the historian Elizabeth J. Normen's 1999 paper for a Trinity College course, "Women as Cultural Entrepreneurs in the Gilded Age: The Art Society of Hartford 1877–1900." Quotes here are from the annual report and from the Art Society minutes extracted in Normen's paper.

3. MRW to HCW, October 6, 1897, and March 7, 1906, WFC.

4. "Mary R. Williams's Pictures," *Springfield Republican*, February 15, 1908, 11. Marie's childhood letter to Mary, dated March 5, 1885 (WFC), splotched with mistakes, noted that she and her brother Frère (named after their father's Paris mentor Pierre Édouard Frère) thanked Mary and her sister Laura for a gift of some homemade candy. Marie also remarked on the removal of a huge tree alongside her Deerfield home: "Are

you not sorry that the old elm has fallen? Papa went up and took a photograth [*sic*] of it." James Champney, an avid photographer, died in an elevator accident while rushing to have glass plate negatives developed at the Camera Club in Manhattan. Marie, by then an accomplished painter, was despondent after his death and died suddenly at age twenty-nine, leaving two children. "Artist Killed by a Fall," *New York Times*, May 2, 1903, 3; phone conversation with Champney descendant, June 2015.

5. Linda Merrill, *An Ideal Country: Paintings by Dwight William Tryon in the Freer Gallery of Art* (Washington, D.C.: Smithsonian Institution / Freer Gallery of Art, 1990), 23; Harry Willard French, *Art and Artists in Connecticut* (New York: Charles T. Dillingham, 1879), 165–76.

6. *Memories*; Laura recorded Mary's stint at the "New York School—winter of 1883–84."

7. MRW to HCW, March 7, 1906, WFC; Katherine M. Bourguignon et al., *William Merritt Chase: A Modern Master* (New Haven, CT: Phillips Collection / Yale University Press, 2016), 37.

8. The Brooklyn Museum owns a portrait of her by Benjamin Rutherford Fitz (accession number 28.331), another Art Students League teacher.

9. Kirsten Swinth, *Painting Professionals: Women Artists and the Development of Modern American Art, 1870–1930* (Chapel Hill: University of North Carolina Press, 2001), 26.

10. Henry C. White, *The Life and Art of Dwight William Tryon* (Boston: Houghton Mifflin, 1930), 92–98.

11. Galvin; *American Annals of the Deaf and Dumb* (Washington, DC: Gibson Brothers, 1877), 22:58; *The Sixty-Third Annual Report of the Directors and Officers of the American Asylum at Hartford* (Hartford, CT: Wiley, Waterman & Eaton, 1879), 22. Anne

Bunce Cheney (1870–1931), a Hartford philanthropist who helped run the Art Society, told Laura in 1924 that she remembered taking her first drawing lessons with Mary "when I was a young girl." Mary knew and grew to dislike Anne's artist uncle William Gedney Bunce.

12. "City Personals," *Hartford Courant,* October 17, 1887, 8; e-mails from Jean Linderman, American School for the Deaf archivist, 2017.

4. Conveying the Rudiments of Art

1. Everett C. Bumpus, *A Tribute to My Wife, Mary Louise Bates Bumpus* (privately printed, c. 1917). In the 1910s, after her husband's health failed, she earned money by lecturing on art history and "Noted Women of Noted Eras."

2. Dr. Preston (1860–1896) died of lung disease. Dr. Damon (1863–1902) committed suicide while in failing health. *Woman's Medical Journal,* June 1896, 159; "Dr. Mary Damon's Suicide," *New York Times,* July 7, 1902, 3.

3. Smith College, *Official Circulars,* 1888–1906.

4. "The Hillyer Art Gallery," *New York Times,* November 9, 1884, 5.

5. MRW, *Catalogue of Casts in Hillyer Art Gallery* (Hartford, CT: Case, Lockwood & Brainard, 1898).

6. MRW to HCW, October 6, 1897, WFC. Mary's addresses over the years included 33 and 156 Elm Street, 33 Henshaw Avenue, 50 College Lane; 52 Crescent Street was her longtime and final Smith home, owned by the family of her colleague and friend Sophia Cook Clark.

7. "Smith College," *Boston Journal,* June 23, 1891, 3.

8. Mary Byers Smith, "The Need for a Coöperative Dormitory," *Smith Alumnae Quarterly,* July 1910, 182. Mrs. Tenney's home was razed in 1937 to make way for

the alumnae association headquarters. The Tenney House name was then applied to a Victorian residence at 156 Elm Street, where Mary had also lived.

5. Art, Her Boss's Jealous Mistress

1. White, *Life and Art of Dwight William Tryon,* 15, 76–86, 124, 190; Merrill, *Ideal Country,* 61, 73, 84, 87.

2. Alfred V. Churchill, "Tryon at Smith College—1886–1923," *Smith Alumnae Quarterly,* November 1925, 8–10.

3. White, *Life and Art of Dwight William Tryon,* 89, 98, 101–2, 121.

4. Virginia J. Smith, "Dwight Tryon the Educator," *Smith Alumnae Quarterly,* July 1926, 484–85.

5. Linda M. Waggoner, *Fire Light: The Life of Angel De Cora, Winnebago Artist* (Norman: University of Oklahoma Press, 2008), 60–61; Blanche Ames Ames, 1899 diary, Ames family papers, box 53, Sophia Smith Collection, Smith College.

6. MRW, "About College," *Smith College Monthly,* March 1898, 289–90.

6. A Rare Dear Overseas

1. Quotes in this chapter from MRW letters and diary, 1891, WFC.

7. Wholly in Pale Tints

1. Swinth, *Painting Professionals,* 74–76, 234. The two watercolor groups merged in 1941.

8. He Certainly Is Unregenerate

1. GDS's papers related to MRW, including 1889 journal and letters from Williams sisters, 1890–1894, are at the Connecticut Historical Society, Hartford, box 3, folders 1, 4, and 5; box 4, folders 1, 2, and 3.

2. AMW/*Courant.*

3. Emerson's 1841 essay "Art" refers to portraits capturing "the aspiring original within."

4. Yale University Library, Manuscripts and Archives, GDS papers, MS 442 (hereinafter Yale/GDS), series 2, box 49, folder 657.

5. MRW to Whites, November 23, 1898, WFC.

9. Strange and Beautiful Things

1. Quotes in this chapter unless otherwise noted from MRW letters, 1894, WFC.

2. Wall texts for the Florence Griswold Museum 2014–2015 show.

3. HCW, "Exhibition of Pictures," *Hartford Times,* February 13, 1908.

10. Misfit in This Workaday World

1. Information in this chapter, unless otherwise noted, comes from conversations with White descendants, beginning in 2012; quotes are from *Memories,* and HCW's 1928 typescript travelogue of a European trip.

2. MRW to HCW, May 16, 1902, WFC.

3. MRW to HCW, 1895 letters, WFC; *Picturesque Hampshire: A Supplement to the Quarter-Centennial Journal,* Northampton, MA, November 1890, 34. Mary acquired a few of Kingsley's engravings over the years, and she created at least one pastel of his house and dooryard.

11. A Pastel Every Five Minutes

1. Galvin; AMW/*Courant.*

2. Wall texts for Florence Griswold Museum exhibition, 2014–2015.

3. This and further quotes in this chapter unless otherwise noted from MRW letters, 1896, WFC.

4. Clara Pease's textbook, *A First Year Course in General Science* (New York: Charles E. Merrill, 1915), covered topics from geology to astronomy and contained a laboratory manual. Wesleyan professor Ellen Thomas has researched Clara Pease's career.

5. "Woman on Wheels," *Illustrated American*, April 21, 1894, 455.

6. Professor Mead's 1896 diary confirms the hotel encounter: "Miss Pease surprised us at the doorway." E-mail from Leith Johnson, Wesleyan University archivist, August 2015.

7. DWT to HCW, July 26, 1896, Smith College Archives.

8. The catalog did not list them, but in the club's copy, archived at the Salmagundi Club in New York, someone scrawled in pencil that Mary should be notified about the "mistakes" at her Hartford address.

12. *To Exhibit in the Provincial Towns*

1. Quotes in this chapter unless otherwise noted from MRW letters to HCW, 1896–1898, WFC.

2. E-mails from David Hogge, Freer Gallery of Art archives, 2015.

3. Fan Zhang, "Vision beyond Borders: The Legacy of Dwight Tryon and Charles Freer," in *Collecting Art of Asia: Highlights of the Asian Collection of the Smith Museum of Art*, ed. Linda Muehlig (Northampton, MA: Smith College Museum of Art, 2013), 35.

4. Among her views of the Cobalt area (see chapter 2) are *Job's Pond*, *The Tree* (shown at the 1899 Paris Salon), *Hills*, an untitled view of a barn, and *The White House*—historians believe that the structure in Portland remains, at 305 Old Marlborough Turnpike.

5. Moses King, *King's Handbook of Springfield* (Springfield, MA: James D. Gill, 1884), 165–67.

6. E-mails from Smith museum registrar Louise Laplante, 2015 (hereinafter Laplante).

13. *My Own Femme de Ménage*

1. Quotes in this chapter unless otherwise noted from MRW letters, 1898–1899, WFC.

2. The pension owners, Monsieur and Madame Pernotte, advertised "comforts of home life" and "intelligent and cultivated" housemates in English-language guidebooks and periodicals.

3. Irene's mother Esther Andrews, a spiritualist and healer, was married to Stephen Pearl Andrews, an abolitionist, anarchist, suffragist, and utopian who popularized the word "scientology."

4. Mariea Caudill Dennison, "The American Girls' Club in Paris: The Propriety and Imprudence of Art Students, 1890–1914," *Woman's Art Journal*, Spring–Summer 2005: 32–37.

5. Women's basketball was popularized in the 1890s at Smith under the physical education teacher Senda Berenson (later Senda Berenson Abbott), who wrote rules for the women's version of the sport. Mary knew and disliked, for unknown reasons, Senda's famous brother, the art historian Bernard Berenson—see chapter 20.

6. Patent US555211 A. See also Kat Jungnickel, *Bikes and Bloomers: Victorian Women Inventors and Their Extraordinary Cycle Wear* (Cambridge, MA: MIT Press / Goldsmiths, 2018).

7. The patriarch, Étienne Montagny (1816–1895), had been a sculptor and medal designer—his stone caryatids have survived on a rue Boissonade doorway. One of the daughters, Françoise, eventually designed embossed leather panels and bronze and silver medals including commemorations of aviation triumphs and depictions of Joan of Arc; another daughter, Marguerite, a talented singer, married a physician.

8. Mabel's father George Russell Eager, and later Mabel, ran F. S. Webster Co., which manufactured pencil sharpeners, typewriter ribbons, carbon paper, and the like. Numerous artistic Americans in Paris dabbled in the Baha'i faith, including Mary's friend Florence

Robinson. E-mails from Baha'i historian Duane Troxel, 2015.

9. Robyn Asleson, "The Idol and His Apprentices: Whistler and the Académie Carmen of Paris," in *After Whistler: The Artist and His Influence on American Painting*, by Linda Merrill et al. (Atlanta: High Museum of Art, 2004), 74–85.

10. Daniel E. Sutherland, *Whistler: A Life for Art's Sake* (New Haven, CT: Yale University Press, 2014), 328–30.

11. Mary was likely referring to Anna Lillian Winegar (1867–1941), a Michigan native and Wellesley grad who became a teacher and bookbinder in the artists' colony in Bronxville, NY, and was known for paintings of gardens. In Paris she studied art with Mary's neighbor, the Buffalo native Frank Edwin Scott.

12. Clara McChesney's "two things accepted" were a still life and a portrait of the pacifist Moncure Conway. The *San Francisco Call* (June 11, 1899, 24) reported that crowds came to view the Madonna at the rue Boissonade studio and "heralded its magnificence."

14. *The Most Magic House in the World*

1. HCW, "A Lost Tradition: Gifted Family of the Williams Sisters an Inspiration," *Hartford Courant*, January 18, 1944, 10.

2. Hubbell interview with Yoko Danno, January 31, 1994, in David Burleigh and Hiroaki Sato, eds., *Autumn Stone in the Woods: A Tribute to Lindley Williams Hubbell* (Middletown Springs, VT: P.S., 1997), 57.

3. His sister Laura Burlingame long owned two of Mary's Italian scenes (now lost), and into the 1970s she could still picture "every room and every object in the [Williams] house—It was my second home." The large front bedroom, where the sisters kept a portrait of Aunt Eleanor, was known as "'Lindley's room'

whether he was in residence or not." Laura Burlingame, 1970s letters to NCW, WFC; Hubbell family researchers' e-mails, 2013.

4. Arthur Tilton, January 19, 1944, WFC.

15. Crisp and Free in Treatment

1. Quotes in this chapter unless otherwise noted from MRW letters to HCW, 1900–1902, WFC.

2. Charles Noel Flagg, "Art Education for Men," *Atlantic Monthly*, September 1900, 393–99.

3. E-mails from David Hogge, Freer Gallery of Art archives, 2015.

4. NCW, *Abbott H. Thayer, Painter and Naturalist* (Hartford, CT: Connecticut Printers, 1951).

5. Laplante.

6. Keppel (1845–1912) also wrote studies of prints and knew Whistler well enough to have a falling out; in 1904, Keppel published a book of his letters to the prickly artist, titled *The Gentle Art of Resenting Injuries*.

7. Malcolm Goldstein, *Landscape with Figures: A History of Art Dealing in the United States* (Oxford: Oxford University Press, 2000), 62–76.

8. Macbeth Gallery scrapbooks, Smithsonian's Archives of American Art, microfilmed.

9. *Art Notes*, April 1902, 289–91, 300.

10. Macbeth Gallery records, Smithsonian's Archives of American Art, box 85, folder 12, microfilmed (hereinafter Macbeth/85-12); also Macbeth's financial and shipping records, boxes 98 (artist credit books, 1902), 103 (cash books, folder 1899–1903), and 105 (charge/"order" books, folders 1899–1904 and 1901–1904) and Macbeth's inventory records, box 113 (stock books, folder 1901–1902).

16. A Serene and Confident Air

1. Quotes in this chapter unless otherwise noted from MRW letters, 1902, WFC.

2. Alice Kuhn, a few years later, founded the short-lived La Fayette College in Paris, aimed at American women. In a WFC copy of Mary's letter, not in Mary's handwriting, the "jew-parisienne" reference has been edited out.

3. Senate Doc. No. 166, Fifty-Seventh Congress, first session.

4. E-mails from historian Frances Freeman Paden, 2015.

17. I'd Like to Run Away

1. Quotes in this chapter unless otherwise noted from MRW letters to HCW, 1902–1904, WFC.

2. Macbeth/85-12.

3. Macbeth/85-12.

4. Healey was a Smith 1894 grad and Chicago educator who worked with John Dewey. Mary had painted her before her marriage to a Chicago lawyer, John J. Healy.

5. Laplante.

6. *The Meadow City's Quarter-Millennial Book* (Springfield, MA: F. A. Bassette, 1904), 87.

18. Old Friends and Some New Ones

1. Quotes in this chapter unless otherwise noted from MRW letters, 1904, WFC.

2. HCW, "Lost Tradition."

19. I Feel Like Thirty Cents

1. Quotes in this chapter unless otherwise noted from MRW letters to HCW, 1904–1905, WFC.

2. Charles de Kay, "Lessons of the Comparative Art Exhibition," *New York Times*, November 20, 1904, 31.

3. HCW, "A Call upon Albert P. Ryder," in *Albert Pinkham Ryder: Painter of Dreams*,

by William Inness Homer and Lloyd Goodrich (New York: Abrams, 1989), 225–26.

4. Laplante.

5. L. Clark Seelye to Alfred Vance Churchill, February 11, 1905, Alfred Vance Churchill Papers, box 708, Smith College Archives.

20. Light So Exquisite

1. Quotes in this chapter unless otherwise noted from MRW letters, 1905, WFC.

2. *Spectator*, July 4, 1903, 27.

3. Mary may have met him in Northampton; he gave talks there, and his sister Senda taught athletics at Smith. In Speakman's books and essays on art, she disputed a number of Berenson's attributions of Italian paintings.

4. The book was also in progress in summer 1906, when Henrietta Seelye spent weeks in Siena and became enthralled with Jean Speakman. Henrietta Seelye, *Letters from Italy: 1905–1906* (Northampton, MA: Metcalf, 1970).

5. Lillian Griffin contributed articles on art, health, gardening, and crafts to various periodicals, and she was acclaimed for her photos of mansion interiors, society figures, and female nudes. Her father John Baynes was an inventor who collaborated with the tastemaker Lockwood de Forest, her brother Ernest Harold Baynes and his wife Louise were naturalists, and her brother John R. Baynes was a photographer and metalworker.

6. Laplante.

21. Nervous Energy Spent Teaching

1. Quotes in this chapter unless otherwise noted from MRW letters to HCW, 1906, WFC.

2. L. Clark Seelye to Alfred Vance Churchill, July 15, August 5, and Sep-

tember 2, 1905, Alfred Vance Churchill Papers, box 708, Smith College Archives.

3. The student, later Theona Peck Harris, became known for experimenting with batiks. Dorothy Crydenwise Lindsay, "Theona Peck Harris Turns to Batiks," *Smith Alumnae Quarterly*, February 1930, 173–76.

4. Laplante.

22. *Out of the Harness*

1. Quotes in this chapter unless otherwise noted from MRW letters to HCW, 1906, WFC.

2. DWT to HCW, July 7, 1906, Smith College Archives.

23. *Pangs of Loneliness*

1. Quotes in this chapter from LSW's daybooks and MRW letters to HCW, 1906, WFC.

2. Churchill is officially considered Smith's "first resident professor of art history and appreciation," despite Mary's long stints of teaching the topics.

24. *A Peaceful Comfortable Feeling*

1. Quotes in this chapter unless otherwise noted from MRW letters, 1906–1907, WFC.

2. *The Letters of Emily Dickinson*, ed. Thomas H. Johnson (Cambridge, MA: Belknap Press of Harvard University Press, 1997), 246.

3. *San Francisco Chronicle*, September 2, 1900, 27.

4. The object of her fascination was likely Isadora Duncan's brother, Raymond Duncan, who was famed in Paris for his Hellenistic garb.

5. "Artist Killed by a Fall," *New York Times*, May 2, 1903, 3; phone conversation with Champney descendant, June 2015.

6. Lillian Baynes Griffin, "Connecticut Art Seen in New York," *Hartford Courant*, January 14, 1907, 12.

7. Lily Berthelot had disastrously married a divorced French wine and coal merchant, Léon Berthelot. He wangled a sinecure at New York Life from her father William H. Beers that was exposed in the press. She and her husband attached various suffixes to their last name, including de la Boileverie and de la Perrière. "He Intended to Deceive," *New York Times*, January 31, 1892, 16.

8. According to their granddaughter Michael Learned, the actress known for playing the matriarch on the television series *The Waltons*, Leila Learned remained an opinionated force of nature. Conversations with Michael Learned, 2014.

9. E-mails and conversations with Marian Tyler Ford's granddaughter Ellen B. Widmer, 2013.

10. Laplante.

11. DWT to HCW, July 15, 1907, Smith College Archives.

25. *Wild to Go Out on a Comet Hunt*

1. Quotes in this chapter unless otherwise noted from MRW letters, 1907, WFC.

2. San Pietro a Ovile has been deconsecrated. The altarpiece hangs at Siena's Diocesan Museum of Religious Art.

3. Lillian Baynes Griffin, "Art Colony at Old Lyme Expands," *Hartford Courant*, June 4, 1907, 2.

26. *How Hard It Is for My Sisters*

1. Quotes in this chapter unless otherwise noted from Julia Dwight letter, 1907, WFC.

2. "An Italian Nursing Home," *Nursing Record & Hospital World*, December 5, 1900, 483.

3. Galvin.

4. Grazia Gobbi Sica, *In Loving Memory: Il cimitero agli Allori di Firenze* (Florence: Leo S. Olschki, 2016).

27. *Exquisite and Unerring Artistic Taste*

1. *Hartford Courant*, September 18, 1907, 6; *Springfield Republican*, September 20, 1907, 11; *New York Evening Post*, September 28, 1907.

2. DWT to HCW, September 21, 1907, Smith College Archives.

3. Mary A. Jordan, "Ars Longa" and "Vita Brevis," *Smith College Monthly*, October 1907, 41–43. She lent Mary's *A Hillside* to the New York Water Color Club in 1895. Her sister Emily married the book collector Henry Folger; the couple created the Folger Shakespeare Library in Washington, DC.

4. The author's Lathrop research files are a promised gift to Historic Northampton, which owns some of the sisters' correspondence, photos, artwork, and clothing. A portrait of Susanne at her easel appears in Northampton's mural from 1980 by the Hestia Art Collective, *The History of Women in Northampton from 1600–1980*.

5. Buyers with Smith connections included Frederick King, Sophia Clark, Isabelle Williams, the Gill and Capen family, Josephine Daskam Bacon, Anna Cutler, Mary Eastman, Katharine Andrews Healy (she paid fifty dollars for her portrait), Gerald Stanley Lee and his wife Jennette (fifteen dollars for a pastel portrait, possibly of Jennette), Helen Shute Moulton, Emily Norcross Newton, Frances Bell Pinkerton, and Jessie Valentine Thayer. In the Hartford contingent were Seymour (he owned portraits and *Naples Harbor*); Ruth Graves; Elizabeth L. Franklin (*Child with Doll*), who ran an art club; and Harriet E. Bacon, the matron at the insane asylum.

28. Logical Custodians in Chaotic Days

1. Jean Speakman to LSW and LCW, April 21, 1909, WFC; *The Literary Year-Book* (London: George Routledge & Sons, 1921), 173. Branches of her family ended up in Australia; Monash University's Clayton Library owns her 1917 book of poems, *To Italy: odes & episodes* (the proceeds were designated for invalid soldiers); tucked inside is an 1899 photo of her at a Rome hotel.

2. *Report of the Connecticut Pomological Society for the Year 1911*, 312; Galvin; HCW to LCW, July 9, 1941, WFC.

3. GDS to Florence Berger, Wadsworth Atheneum, October 24, 1929, and May 15, 1935, in Yale/GDS, series 2, box 105, folder 1505.

4. An obscure painter named Theresa Isabel Corser, class of 1893, listed Mary among her teachers along with Tryon and, in Paris, Bouguereau. *Springfield Republican*, January 3, 1915, 10.

5. Mary Byers Smith, "The Need for a Coöperative Dormitory," *Smith Alumnae Quarterly*, July 1910, 181–84; Elizabeth McGrew Kimball, "What Alumnae Have Done for the Hillyer Art Gallery," *Smith Alumnae Quarterly*, May 1919, 201–3.

6. LCW to NCW, November 29, 1925, WFC.

7. LCW to HCW, April 9, 1924, WFC; e-mails from Tilton descendants, 2015. Laura's list of Tilton loans includes a piece executed in Raffaëlli paint sticks, "two Norway sketches—a pastel done in France—also a watercolor of the chateau d'Usse—a Penfield Hill spring—Elbridge Kingsley's home & dooryard—a Glastonbury sketch—a figure in chair—'Miss Martin,' a cloud study—a pastel drawing of an Italian relief-sculpture" plus a "large oil landscape." Tilton descendants own an oil landscape, cloud pastel, *Château d'Ussé*, and *A Friendly Sitting*.

8. Cheney and Marguerite Freeman letters to LCW, March–April 1924, WFC.

9. Hubbell's parody of Theosophy's loopier followers was excerpted in an Australian periodical, *Dawn: A Magazine Devoted to the Promotion of Universal Brotherhood*, November 1922.

10. *American Art News*, May 23, 1914, 7.

11. *Memories* and 1920s NCW letters to LCW, WFC.

12. HCW, "Call upon Albert P. Ryder," 225–26; NCW, *Abbott H. Thayer*, 167, and *The Life and Art of J. Frank Currier* (Cambridge, MA: Riverside, 1936), 38.

13. HCW and GDS letters, 1938–1944, WFC, and in Yale/GDS, series 1, box 32, folder 310.

14. *Memories*.

15. Frances Knight Dette to Edith Bean, January 23, 1944, WFC.

16. HCW, "Lost Tradition."

17. Julia also exhibited at the Pennsylvania Academy of the Fine Arts (1913) and the National Academy of Design (1917). Few of her paintings survive. The Cooley Gallery in Old Lyme has offered her portrait of a woman braiding her hair, and her landscape triptych has been at the Hanover Square Gallery in New York. Posters and prints are widely for sale of her Salon painting (whereabouts unknown), *La Lampe Italienne*, of a woman in a white gown lighting a brass lamp in a wainscoted room that might be a rue Boissonade studio. Julia Dwight to NCW, February 2, 1944, WFC; emails from Jane Wald, executive director, Emily Dickinson Museum, 2015. Amherst College owns the Dwight family's 1860s correspondence with Emily Dickinson. The author's Dwight files are a promised gift to Smith.

18. "The Noteroom," *Smith Alumnae Quarterly*, November 1933, 57.

19. Merrill, *Ideal Country*, 97, n. 262.

29. The Resurrectionists

1. Contacts included relatives of Mary's Williams and French cousins; Mary's predecessor Mary Louise Bates; the Champneys; Mary's portrait sitters Marian Tyler Ford and Katharine Andrews Healy; Ruth Gray Brodt; the writer Josephine Daskam Bacon; Mary's 1907 subtenants Arthur and Leila Learned; Arthur Tilton; Laura Hubbell Burlingame; Madge Hubbell's husband John Tweed; and Mabel Eager. A Japanese poet told me she remembered hearing Lindley Hubbell reminisce about his beloved adopted aunt Laura.

2. E-mails and conversations with Robinson expert Janet Tobin; Brodt descendant Patricia deGogorza Gahagan; Delaware Art Museum curator Heather Campbell Coyle; Nancy R. Miller, University of Pennsylvania archives. The author's related files are promised gifts to Smith College.

Italicized page numbers indicate illustrations and photographs. In the subentries in this index "MRW" is used for Mary Rogers Williams and "HCW" is used for Henry Cooke White. Titles of works by Mary Rogers Williams are found as main headings; works by any other artists are under the name of the artist.

42; biography of (by HCW), 26, 210; compared to Whistler, 125; *Dawn—Early Spring* (oil 1894), 42; death of, 179; Florence Griswold Museum exhibition, 215; Freer's Japanese scrolls and screens exhibition at Smith and, 96; Hartford Art Society teacher, 25–26; HCW and, 80, 192, 209; Japanese art owned by, in Smith exhibition, 173–74; Kingsley and, 82; on Lathrop's sudden death, 193; Macbeth Gallery and, 132; Montross Gallery and, 125, 151; on MRW death, 201; MRW final weeks at Smith and, 169–70, 175–77; MRW owning painting by, 209; MRW relationship with and their opinions of each other, x, 22, 40, 44, 48, 92, 96, 97, 114, 118, 130, 145, 146, 150–53, 163, 173, 201, 211, 214; New York studio, 26; photograph of, *25*; *Salt Marshes*, MRW writing essay on, 44; Smith art collection and, 34, 173, 179, 192, 212; Smith art department head, x, 2, 26, 31, 42–44, 80, 81, 118, 134, 175, 179, 180; Steele and, 129; success as artist, 41; teaching style of and opinion of women students, 2, 26–28, 43; Wadsworth Atheneum exhibition of Tryon and MRW works (1909), 206

Turton, Amy, 199

Twain, Mark, 22, 24, 25

Tweed, John H., 122

Twilight at Sconset, 58, 117

Tyler, Marian, and her parents and sister, 190–91, *191*, 208

Vadso (Norway) (1896 pastel), *89*, 92

Van Pelt, E. L., 107

Van Pelt, John Vredenburgh, 107

Vaux, Calvert, 19

Victor Emmanuel III (Italian king), 164

Victoria and Albert Museum (London), 49, *49*

Vigna, Tecla, 154, 164

Vogue review of MRW artwork, 75

Wadsworth Atheneum (Hartford), 23, 125, 187, 206, 208, 211, 212

Warner, Charles Dudley, 51

Waterbury, Jennie Bullard, 106–7, 117

Waterford, Conn.: Archive Room storage of MRW letters at Whites' house, xi–xii, 209; art school, HCW teaching at, 176–77, *177*; author's visit, x–xii, 215; boathouse used as White family painting studio, *xi*, xii, 214; HCW home, *x*, xi, 80, 81, 196, 209, 214; Laura visiting HCW, 210; MRW artwork stored in boathouse, xii, 212, 214, 220; MRW love of visiting HCW home, 97, 163, 196; pastels of, *95*, 97, 114, 117, 118, 125

Weir, J. Alden, 34

Welch, Archibald A. and Ellen, 101

Wheeler, Candace, 22

Wheeler, Mary Colman, 190

Whistler, James McNeill: art classes by, 112, 182; art school started by (Académie Carmen) in Paris, 111, 112–14, 118; Carmen Rossi and, 112–13; color choices for gallery walls and, 172; compared to and influence on MRW, 40, 83, 160; compared to Tryon, 125; critique of MRW artwork, 114; English exhibition attended by MRW, 118; Freer and, 41, 47, 67; *The Gentle Art of Making Enemies* (book), 113–14; HCW and, 94, 163, 209; illness of, 141; Japanese art and, 82; Keppel and, 233n6 (Ch. 15); MRW and, 3, 45, 47–49, 102, 107, 112, 129, 210, 212; MRW note to (1891), *46*, 48, 215; in Musée du Luxembourg collection, 141; Palace of Industry exhibition (1902), 137; Peacock Room, 47–48, *49*

White, Aida (Ida) Rovetti, 209–10, 214

White, Betsy (George's wife), 214

White, George (Beeb's brother), xi–xii, 210, 214. *See also* Waterford, Conn.

White, Grace Holbrook (HCW's wife): disapproval of MRW travel with Gu-maer, 163, 169–70; dressing in drag, 134; health issues of, 209; inheritance of, 80; Lyme annual exhibition (1907), attendance at, 197; marriage suggestion to MRW from, 69; marriage to HCW, 80–81; MRW on Grace and HCW marriage, 163; worried about MRW reputation, 106, 185

White, Henry (Beeb's brother), 210

White, Henry Cooke ("HCW" *in this index*): art collection of (including MRW, Whistler, Tryon), 133, 163, 209; art education of and Tryon's role in, 26–29, 80, 174; as art teacher, 80, 176–77, *177*; artwork and exhibitions by, 78, 81, 93, 99, 152, 162, 172, 187, 215; attitude toward art experts and mainstream artists, 78, 162; attitude toward modern art, 211; Bunce and, 114; cars and boats as hobbies of, 81, 132, 146, 149; close relationship with son Nelson and his wife Aida, 210; death of, 214; family background and education of, 78–80; Griswold boardinghouse and, 80–81; Japanese art owned by, in Smith exhibition, 173–74; lack of ambition due to wife's wealth, 80–81; Lyme annual exhibition (1907), attendance at, 197; marriage to Grace Holbrook, 80–81; on MRW, 2, 29, 75, 78, 175, 203–5, 210, 212; MRW estate and, 203–5; MRW legacy and, 3, 78, 203, 211; MRW's closest friend, x, xiv, 81; MRW's sisters, support and relationship with, 120, 207–14; National Academy election sought by, 172; *Old Mill at Waterford*, 146; painting studio, xii, 80; portrait by MRW (c. 1896), x, *79*, 81, 85, 215; purchasing *Job's Pond* painting, 133, 219; Ryder and, 152, 162, 210, 212; sharing art supplies with MRW, 81, 85, 144, 146, 163, 192; Shaw, MRW suggesting for him to read, 154, 212; travel advice from MRW, x, 81, 85, 94; on Tryon, 43, 173;

bookbinding and woodworking, 166; burial and grave in Florence, Italy, 164, *199*, 200, 207, 212, 219, *219*; called Polly by her family, xv, 70; in Champney article on women artists, 23; children and, 120, *121–22*, 129, 145, 188; Clark's home as residence of, 128, *129*; compared to and influenced by Whistler, 40, 83, 160; compared to Emily Dickinson, 211; critiquing painters at museums copying master-works, 46, 116; death of, 3, 72, 173, 199; desire to escape from her "real life," 43, 46, 85, 101, 128, 130, 134, 145, 149, 161, 163, 169, 173; early education of, 21–22, 230n15 (Ch. 2); epitaph choice by, 8, 131; estate of, Harry involved in settling, 203–5; fame after death, 201; family back-ground, 1, 9–10, 19; final exhibition during lifetime of, 187; framemak-ing and, 178, 179; gilding and, 166, 178; golf and, 5, 125, 129–32; Graves (guardian) as influence on, 21; health issues of, 119, 173, 181, 188–89, 194, 196–97, 198; interview (1894), 3, 63; legacy, 3, 78, 203; misattribution of painting to, *viii*, ix–xiii, *xii*; no self-s, 4; obituaries, 201–2; obscurity of, x, 1, 3, 206; overview of life, 5; person-ality, 4, 5, 105, 151; photographs of, *xvi, 2, 10–11, 30, 103–4*, 215; photogra-phy as hobby of, 167–68, *167–68*, 203; posthumous retrospective of works, *202*, 203–6; religion and, 105–6, 134, 164–65, 166, 195–96, 199; *Salt*

Marshes by Tryon, MRW writing essay on, 44; sculptures by, 145; sexual ori-entation of and desire to dress as man, 7, 51, 134, 163, 184; Smith casts cata-log, writing in, *34, 38*, 44, 102, 106, 214, 215; soldiers in uniform, MRW's admiration of, 7, 45, 51, 57, 70, 92, 111; on Tryon paintings (writing in Smith's monthly), 44; unmarried, and opinions on marriage, 69, 103, 163, 170; waiters and, 51, 139. *See also* letters of MRW; paintings and pastels; sketches; Smith College; travel of MRW; Williams sisters *for general entries pertaining to all sisters; specific names of artists, clients, family members, and friends with whom MRW interacted*

Williams, Sally Clark Norton (paternal step-grandmother, second wife of David Williams), 11

Williams, Sarah Jane (sister), 19

Williams sisters: Broad Street home of Williams family, *18*, 19, 20, *64*, 120–23, 149, 162, 207, 232–33n3 (Ch. 14); Canada travel with MRW (1901), 132; close relationship with Aunts Eleanor Fuller and Wilhelmina Pelton, 11, 13; cordial relationship among, 181; correspondence with MRW in Europe (1902), 139; donating MRW works to Smith College, 208; family background, 9, 11–13; Girard Avenue home, 207, 212; grammar school education of, 21; gravestone for MRW paid by, 207; HCW on, 211, 212; helping each other out, 29; notifica-

tion of death to MRW friends, 201; orphaned as teenagers, 9, 21; during Paris sabbatical of MRW, 120; possible sketch of, *6*; summer vacation (1902) paid for by MRW, 135; support from HCW and his family, xii, 207; travel to Florence at time of MRW death and funeral, 198, 200

Winegar, Anna Lillian, 232n11 (Ch. 13)

Woman in Pink. See The Pink Gown

women: as artists in nineteenth-century America, ix, 23, 27–28, 61, 108, 112, 146, 151, 219–20; basketball playing by, 5, 108, 232n5 (Ch. 13); education of, 22; Hartford Art Society training, 22–26; Macbeth Gallery featuring women artists, 133; nineteenth-century cosmopolitan views on, 2, 86, *87*, 117, 184, 189, 195; Smith College founded to give women comparable opportunities to men, 31; women's art shows, MRW opinion of, 109, 125

women as subjects: Abby in hammock, *28*, 29; artists at work en plein air, *27, 29*; clothing details, *5*, 191; in pairs, *6*; portraits, *5–6*, 61, 63, 67–69, 77, 83, 99, 111, *111*, 114, 133, 150, *150*, 154, 185, *186*, 190–91, *191, 213*, 214; water-colors in New York Water Color Club exhibition (1892), 61. *See also names of specific women sitting for portraits*

Yeats, William Butler, 150, 218

Zhang, Fan, 96

Garnet Books

Eve M. Kahn is a freelance writer specializing in architecture, design, and preservation, and was Antiques Columnist at *The New York Times*, 2008–2016.